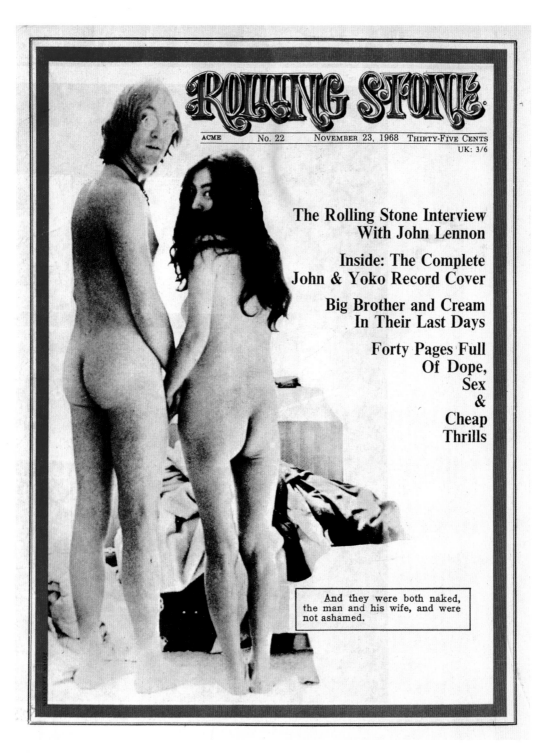

ROLLING STONE

ACME No. 22 November 23, 1968 Thirty-Five Cents
UK: 3/6

**The Rolling Stone Interview
With John Lennon**

**Inside: The Complete
John & Yoko Record Cover**

**Big Brother and Cream
In Their Last Days**

**Forty Pages Full
Of Dope,
Sex
&
Cheap
Thrills**

And they were both naked,
the man and his wife, and were
not ashamed.

Rolling Stone Cover, UK, 1968. **p**: John Lennon. John Lennon and Yoko Ono used a time-delay camera, which was set up by Tony Bramwell, to take nude photographs of themselves for the cover of their album, *Unfinished Music No. 1: Two Virgins*. The photographs were taken at 34 Montagu Square, London, in early October 1968. ©1968 by Rolling Stone LLC. All Rights Reserved. Used by Permission.

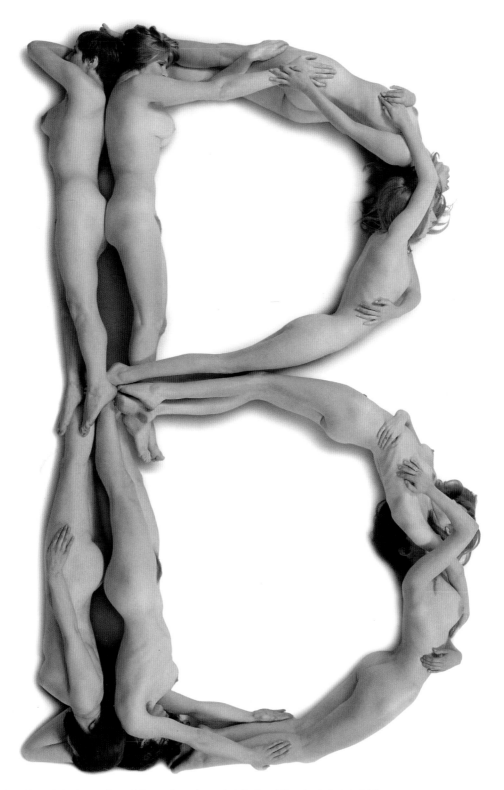

Body Type, The Netherlands, 2011. **client**: Spinhex, **studio**: Anthon Beeke Collective, **cd/d**: Anthon Beeke & René Knip.

2 wereldpremières:
Ted Brandsen - body
Krysztof Pastor - voice
m.m.v. Holland Symfonia
o.l.v. Roy Goodman

body voice

het
nationale
ballet

15 juni - 22 juni
Het Muziektheater
Amsterdam (020) 6 255 455
www.het-ballet.nl

Body / Voice, The Netherlands, 2005. **client**: Het Nationale Ballet, Dutch National Ballet, **studio**: Me Studio, **cd/ad/d**: Martin Pyper, **p**: Erwin Olaf.
A poster announcing a new ballet from choreographer Krysztof Pastor, which features three generations of men.

HEAD

THE NUDE IN G

proton . neutron . electron . moron . milli . micro . nano . pico . kilo . mega . gig

s l e e p i n n o t h i n g n e s s

MIRKO ILIĆ AND

O TOE

RAPHIC DESIGN

the spiritual double

live where you can.

in both cases
there is a picture in
the foreground,
but the sense lies
far in the background.
—L. Wittgenstein

ry . be happy

era . order . chaos . play . dream . dan(c)ance . make sounds. feel . don't wor-

STEVEN HELLER

RIZZOLI
NEW YORK

New York · Paris · London · Milan

Dedicated to
Brad Holland,
as artist and designer,
he is an inspiration to our
generation and beyond.

First published in the
United States of America in 2018
By Rizzoli International Publications, Inc.
300 Park Avenue South
New York, NY 10010
www.rizzoliusa.com

Designed by Mirko Ilić Corp.
Slipcase and cover photography
By Željko Koprolčec

Distributed to the U.S. Trade
By Random House, New York
Printed in Hong Kong

2018 2019 2020 2021 / 10 9 8 7 6 5 4 3 2 1

ISBN-13: 978-0-8478-6165-1

Library of Congress Control Number:
2017958397

Caption abbreviations
cd Creative Director
ad Art Director
d Designer
ill Illustrator
p Photographer
c Copywriter

Thanks to Charles Miers and
Joe Davidson at Rizzoli for their
continued support with this project.

We are also grateful for the support
of Krešimir Penavić, AIC Foundation,
Krzystof Dydo & Dydo Poster Collection,
and the designers and the interns at
Mirko Ilić Corp.: Kristen Sorace, Pamela
Chuy, Laetitia Monier, Sarah Apollo,
Ezra Lee and Sanja Planinić.

Image on previous spread:
Design Quarterly #133, Does It Make Sense?,
USA, 1986. **client**: Walker Art Center / MIT Press,
ad/d/c: April Greiman, **video scan**: Eric Martin,
main body image. The concept for this work
attempts to reconcile the placement and
appropriateness of "personal" with the
"professional" agenda in the design field.

Image above:
The Art Directors Club, 46th Call for Entries,
USA, 1966. **client**: The Art Directors Club,
ad: Robert Reed, **d**: Tom Daly, **p**: Ken Harris,
model: Wanda Embry.

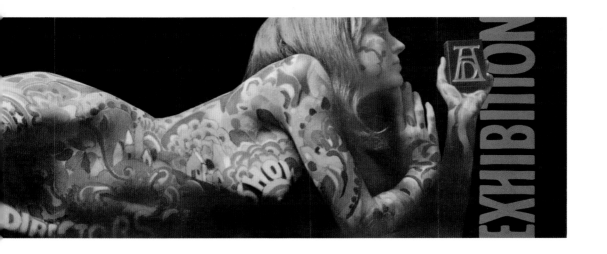

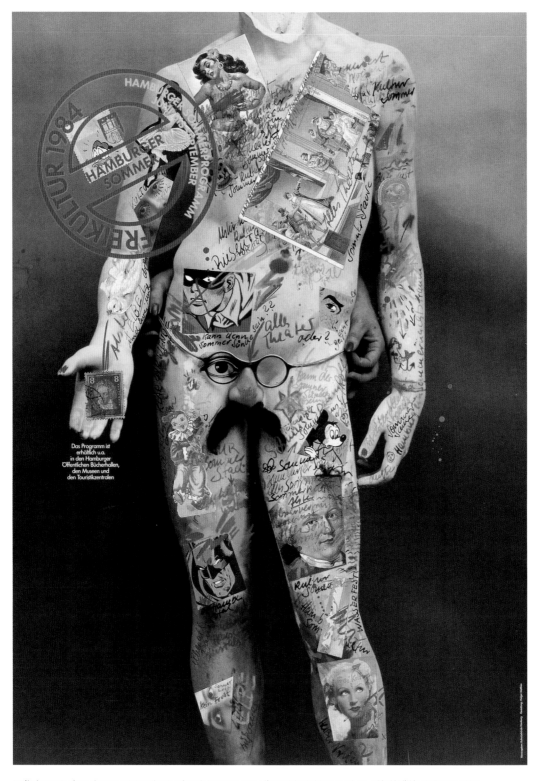

Freikultur 1984 / Hamburger Sommer (Free culture), Germany, 1984. **client**: Kulturbehörde Hamburg, **cd/ad/d/ill/p**: Holger Matthies.
Summerfestival. The Woman triumphs over the man. Now the man is a "Jokenumber."

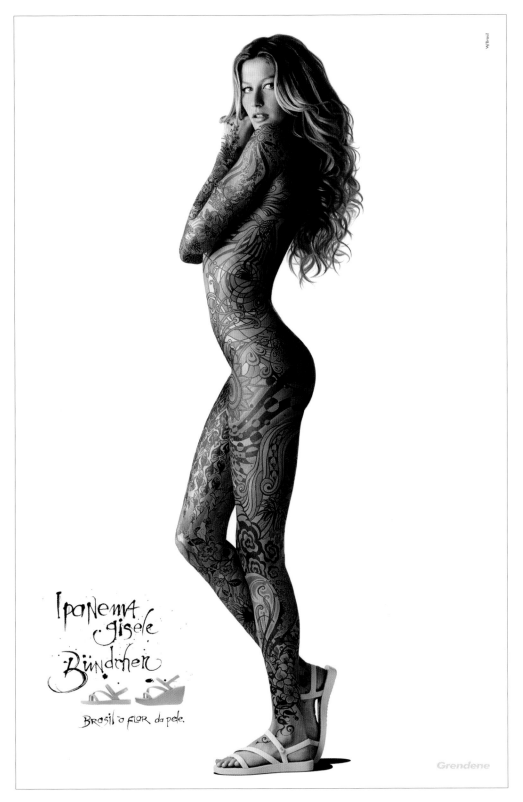

Tattoo, Brazil, 2005. **client**: Grendene, **agency**: McCann Brazil, **cd**: Washington Olivetto, Rui Bnanquintto, **ad**: Celso Alfieri, **c**: Rui Bnanquitto, **ill**: Lobo. CC, **p**: Paulo Vainer. The printed media shoe advertisement shows the supermodel Gisele in several positions with her body covered in different types of tattoos.

BODY

Uttering these benign words—nude, nudity, and naked—send some people into paroxysms of delight, as though not wearing clothes is one of the most euphoric acts humanly imaginable. How can it be that exposing the male and female naked body is so intriguing and risqué—so *au naturale* yet lascivious too? Sex has long been a root cause for fear, folly, and taboos, like in the 1950s when Lucille Ball and Desi Arnaz, for example, were prohibited from saying *pregnant* on their TV comedy *I Love Lucy* when Lucy was with child. For heaven's sake, whatever baby-making was called back then, Mr. and Mrs. Ricardo had to be undressed in order to achieve the unspeakable. Where do these taboos derive?

Well, "nude" comes from the Latin *nudus*, which has a more rhythmic double syllabic cadence than the word that evolved into Middle English to mean "plain and explicit." From this derived "nudity" and "naked," both innocent words in certain usages but nonetheless charged in other circumstances.

"Nudity" conjures up certain pleasurable feelings and these prurient urges trigger desire. But when viewed through the lens of, say, the philosophy of *nudism*, then being at one with nature and practicing it communally, well, unburdens it of sexual connotation in favor of lifestyle. Being nude in the world is one means of improving health and well-being. If only people were not made to feel self-conscious about the body, which enables nudity to be seen as a benefit, then being naked would not be out of the ordinary. Yet standards of what is and is not beautiful make certain kinds of nakedness unpleasant or unaesthetic instead of being the great equalizer.

We were born naked in our proverbial birthday suits. So, the state of nudity is primal, endemic to just about every aspect of life. No matter how much we cover it, nudity is impossible to hide. Therefore, it is a staple of high and low art—as well as soft and hard pornography. Yet in many cultural, religious, and political systems, nudity is exploited because of its potential to

arouse. Since the human body is our common bond as a species, perhaps the problem started with creation:

"Then the eyes of both of them were opened, and they knew that they were naked; and they sewed fig leaves together and made themselves loin covering." (Genesis 3:7)

The Bible tells us that not until Satan appeared did man start wearing clothes. Satan gets blamed for a lot and there are those who believe this mythology, yet the faithful could argue that these clothes "were not devised by Satan but by God," designed to serve as His expression of love, protection, and grace:

"Also for Adam and his wife the Lord God made tunics of skin and clothed them." (Genesis 3:21)

Wearing the mantle of nudity is one heavy load. No wonder, throughout the ages, public nakedness has at times been either tolerated or made to be intolerable. The fig leaf was Adam and Eve's way of keeping modesty in check—or at least artists' interpretive answer to the problem. Nakedness has gone in and out of fashion; it's been lawful and prohibited by law and custom. It has been platonic and erotic, virtuous and profane, celebrated and shunned. History tells us that during the reign of the English Queen Victoria—and the societal mores that bear her name—she encouraged prudery. In fact, the opposite is true. An exhibition at the V&A Museum in 2001 showed that, in her time, the naked body in art was taken for granted with the scandalized actually in the minority.

However, during the more enlightened twenty-first century year of 2002, U.S. Attorney General John Ashcroft demanded that the Department of Justice spend eight thousand dollars on blue curtains to hide the two large, partially nude aluminum art deco statues representing Justice that had long stood in the Great Hall of the Department's Washington headquarters be-

LOVE

cause he didn't like being photographed in front of their naked breasts. There is a bit of irony here, "When former Attorney General [under Ronald Reagan] Ed Meese released a report on pornography in the 1980s," wrote *USA Today*, "photographers dived to the floor to capture the image of him raising the report in the air, with the partially nude female statue behind him."

Shielding minors from explicit sexual content is the usual reason for prohibiting public nudity, although, frankly, that is silly. Nudity is all around us—all over us too. So, the "corruptible child" canard is merely a rationale for banning embarrassing displays and repressing freedoms. In 2015 Fox News reported, "Hollywood is getting a new interactive billboard that essentially 'gets naked' throughout the day, and not everyone is happy about it." The Parents Television Council condemned the advertiser VH1 for programming explicit shows aimed at minors. Interestingly, while the FCC maintains guidelines and penalties for "indecent material," nudity on its own is not on the list. "Indecent material contains sexual or excretory material that does not rise to the level of obscenity. For this reason, the courts have held that indecent material is protected by the First Amendment and cannot be banned entirely. It may, however, be restricted to avoid its broadcast during times of the day when there is a reasonable risk that children may be in the audience."

Cable TV is exempt from FCC rules because its signals are not broadcast over airwaves. Therefore, showing nudity, including pubic (or what were once called private parts), are at the discretion of the broadcaster—and any regular cable customer knows that nudity is like any other costume—in fact, viewers have come to expect it.

Nonetheless, some societal standards should exist. For instance, a worker should probably not go to the workplace in the nude (unless it is a nudist colony) to preserve some degree of decorum. But in recent years, fashions allow more body exposure than ever. Portrayal of the human body in graphic design, especially print,

is routinely viewed in contradictory ways that shift from period to period and in different cultures for various reasons. This book will not even attempt to make a sociological, anthropological, or any other scientific analysis of where or why nudity is accepted or not. Our goal is to aggregate as many approaches to complete or partial nudity as possible, and to show how contemporary graphic design and advertising have employed male and female nudity in order to convey messages and evoke moods. The examples here are mostly from the past two decades, free from many of the prohibitions of more repressive times. We take for granted that puritanism in its many guises still exists, but there is also a greater loosening. The Paris Metro, for instance, shows posters of bare-breasted women, while the New York, Boston, Washington, and other subways are much less liberal. Yet over the past couple of decades the grip against nudity has loosened in the popular visual language. Newsstands, for instance, used to hide the nude covers behind wrappers or under the counter. Today censorship depends on community standards, and in large cities the bar is not excessively high.

Of course, there are always appropriate and inappropriate ways of using nudity in design. Gratuitous nudity is more difficult to justify than when it is essential to the message. What the material here indicates is most nude graphic design is not a priori pornography.

Arguments may arise that nudity is exploited for purposes of transmitting or selling ideas (i.e. sex sells). While sex and sexuality are implicit in some nudity, the material in this book is not solely concerned with sex or eroticism. We all know that sex generally draws attention, seductive imagery draws even more, and unbridled eroticism is the strongest magnet of all. Yet not all nudity falls into these categories. Nudity in the applied arts can be used to show unfettered beauty, ideal states of being, romantic views of life, and more. Nudity is not in an of itself inherently prurient. It certainly stimulates for a wide range of reasons, particularly as a canvas on which ideas and concepts are projected,

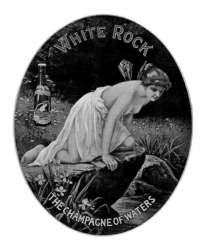

including cultural, commercial, political, social, and religious, but nudity is also a symbol of life, health, and love.

The human body is not a totally blank slate, but it is a handy tool for promoting and propagandizing various things. Nudity can be matter-of-fact, which is the way it has appeared in European design and advertising for ages—or jarring and laden with mystique—as it has been used in American media until recently. Today nudity has taken off, so to speak, and despite greater exposure it still commands attention like no other public attraction.

Comparatively speaking, nudity is not the most frequent component of the designer's or advertiser's toolkit. If the goal is to seduce, nakedness does not always provide enough allure, mystery, or sensuality—arousal demands more than an unclothed body.

This book records an age when there are fewer media taboos in the West regarding the human form. Of course, there are religious dress codes in many parts of the world, but that is not our concern here. When the black bars were removed and it was okay for designers and advertisers to use more of the body, it was used with a vengeance. The sixties "sexual revolution" helped that along. This book is an anatomy lesson, of sorts, about where these bodies are used the most.

Heavenly Bodies

When advertising and graphic design began in earnest as a professional service to promote commercial ventures during the mid-to-late nineteenth century, nudity was a forbidden fruit. Nakedness emerged from a dark well of wickedness that drew its demons from certain biblical fire and brimstone prohibitions that took for granted we were all sinners with lustful urges. Our species was created naked in the garden, yet the natural state was quickly interpreted as sinful. So begat the "X-rating" system.

Scripture wrapped nudity in a swaddling of sin and virtue, but mostly sin. However, the modesty and licentiousness ascribed to nudity have never been decidedly black or white. Throughout history, nudity is at times a glorification of the Creator—and a representation of eternal truth. Then again, it is also rendered indecent because just the impure thought of flesh incites lust and other earthly temptations. This biblical paradox makes nudity something of a problematic issue for art and artists. As 1 Corinthians 8:13 asserts: "If the art I create causes my brother to fall into sin, I will never create art again, so that I will not cause him to fall."

Christian doctrine has never provided handy dispensations for disassociating nakedness from sexuality—and sex. Even nude art conceived for the most innocent circumstances, as a celebration of the heavenly gift of life, is difficult to rectify in Bible passages. So much in the Bible warns that man (and woman) are so insanely wicked that no one is free from even the thought of flesh. Which may be one of many reasons that when nudity became part of the artists' purview, it was a complex evocation of formal, philosophical, and cultural concerns. Writing for the Metropolitan Museum of Art (2008) Jean Sorabella wrote: "Though meaningful throughout the sweep of Western art, the nude was a particular focus of artistic innovation in the Renaissance and later academic traditions of the seventeenth century and after." There was nudity long before. Ancient Greece was a wellspring of bodily celebration. They were the original naturalists, the male body standing for triumph and glory.

This is not a history lesson. But take the Greeks: They were at odds with the rest of the ancient world, where nakedness rep-

White Rock Girl Advertisement, c. 1907. **art**: C. Paul Jennewein.

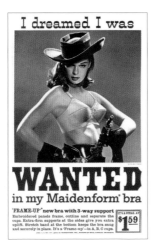

resented the male's disgrace. "The ancestry of the female nude is distinct from the male," wrote Sorabella. "Where the latter originates in the perfect human athlete, the former embodies the divinity of procreation." The goddess Aphrodite is the paradigm of the female nude figure, based on perfect mathematical proportions. "Her pose . . . seemed to present the goddess surprised in her bath and thus fleshed the nude with narrative and erotic possibilities." The nudes that emerge from Greco-Roman periods became paradigms of beauty in much Western art, yet while having a certain sexual allure they were never intended to be prurient. Perhaps that is why early advertisements employed Greco-Roman nude models for some commercial products.

One of the most famously suggestive ads was White Rock Sparkling Water's trademark, "Psyche." For its long run, the company purchased the rights to the painting *Psyche at Nature's Mirror* by Paul Thumann, from the Chicago World's Fair in 1893. Her sometimes scantily, and other times partially, clothed image remained the White Rock logo for over 120 years—apparently without a complaint of indecency from any of America's various decency leagues. Yet breasts were in full view—and what great spin: The White Rock company referred to Psyche as "The Goddess of Purity" and she evolved from being suggestively nude to breasts clearly showing. Psyche's purpose was symbolic but her reality was sexual.

During these same early years of print advertising, full frontal nudity was not as frequent as was the art of suggestion. Total nakedness could trigger legal prosecution—and even a bare ankle could exorcize the protectors of morality. In the early twentieth century, sensual clothes took the onus off of total nudity. A low-cut neckline, tight bodice, or short hemlines were more sexy than flesh. Yet depending on the market, more or less flesh was allowed. Pinups were common on commercial

calendars and ink blotters and in some advertisements skin-tight, shear, and otherwise revealing clothing was infinitely more acceptable than nudity.

A curious example is the bra: For a long time brassieres were allowed to be worn on real women in print advertisements (particularly in the United States). On television, however, it was deemed inappropriate. Yet a revolution took place in the 1950s with the introduction of the famous campaign "I dreamed I . . . [was doing something special] . . . in my Maidenform bra." The campaign, appealing and funny but not salacious, was originated by Harry Trenner and his wife Florence Shapiro Trenner, at the William Weintraub Advertising Agency in New York City. It may not have been the reason for a change in popular attitudes, but it is the reason that, in 1987, NBC aired a Playtex Cross-Your-Heart bra for the first time on a real female model. The loosening of viewer mores, and a downturn in network advertising revenue, were credited for the paradigm change. Similarly, first print and then TV advertising started hinting at and then actually vividly showing otherwise taboo body parts.

Cable TV, as we've discussed, has totally altered the ability to show all body parts, rendering the body free from most taboos. The naked form is no less sexually appealing, but to achieve sex appeal demands more triggers. Although not much nudity was exposed in the late nineteenth century, it was nonetheless decidedly cleverly present in popular visual culture. In that century bodies were stuffed into strangulating under-and-over garments, and that human form was something to be admired and enjoyed. Today the unadorned body is almost taken for granted. There is a difference between nudity as cultural expression, and as a tool for selling products and ideas. It is clear that the line is crossed every day.

Maidenform Bra Advertisement, USA, 1964.
agency: William Weintraub Agency, New York.

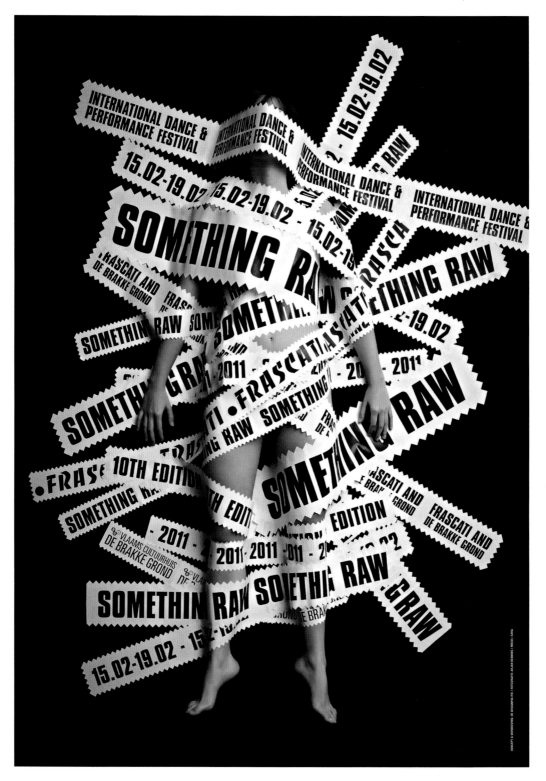

Something Raw, The Netherlands, 2011. **client**: Frascati Theatre Amsterdam, **studio**: De Designpolitie, **cd**: Richard van der Laken, **ad**: Sara Landeira, **p**: Arjan Benning. Dance festival poster.

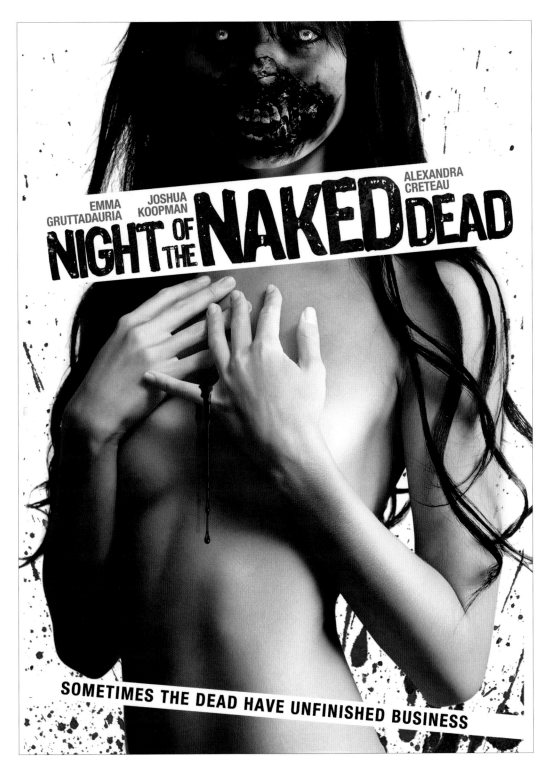

Night of the Naked Dead, USA, October 2013, **client**: Maxim Media Marketing, **cd/ad/d**: Kustom Creative. Film Poster.

BODY LA

In common speech, body language refers to an expressive stance or position of a human or nonhuman form usually communicating or signaling to other human or nonhuman beings. The tilt of a head, the purse of the lip, the tension of an arm or limb, the gritting of teeth, and the direction of a glance telegraphs messages of some kind. There are many: The "come-hither" look, the "you're in my space" stance, the dismissive gesture, the "I'm not going to wait any longer" look, and more. These are examples of a fairly universal pantomime that allows the translator to respond in ways that might calm or exacerbate a situation. For this and other reasons it is necessary to not only fluently understand body language but to be skilled in the practice thereof. An unintended move that sends the wrong message in a tense situation can have unintended consequences. Different cultures, of course, have different body accents and idioms.

Body language is a visually powerful language. But demonstrative graphic linguistics do not always have a universal meaning. In this chapter, body graphics are designs in which the body — as photograph, collage, drawing, or painting — is a foil for a message or commentary. The body serves different purposes, like a clue to part of a mystery that leads to a solution. Male and female pubic areas, for example, are used often for conveying comic, sardonic, and surreal imagery. Take, for example, the crown on the poster of "King Lear" (page 24), a witty visual pun that uses a crown as pubic hair. Or the pubic area as blazing fire on "A Bachelor's Life Abroad" (page 19), which addresses the fever in the loins of man. Pubic hair puns are prodigious, just look at the varieties on pages 20 and 21, among them a bird's nest, an ancient military helmet, a mask, and a splotch of red ink. The multicolored pubic hair on the Milton Glaser poster is a parody of Glaser's famous "Dylan" poster. Of course, the most clichéd of all pubic puns is the penis as gun (page 30).

One body part can be a stand-in or substitute for another part. It does not have to be the sexual organ that it is; it can, if you follow this reasoning, represent something else perhaps less overt. One of the most common visual ironies are lips (sideways) to suggest the vagina (page 32 and 33). In some cases, these lipstick-red lips are explicit, while in others, like the cover of *Nova* (page 33), the lips can be read without any additional contextual aids, like a headline. We all know what it is. The same effect is also possible with the other parts of the body, like the eye in "A Critical Look at the Labia" (page 32). In addition to using body parts to imply other parts, certain objects are impressions of, in this case, the vagina. The cardboard cut in "Tilla's Box" (page 34) is a startling double entendre. The buttonhole in "Tampa" (page 35) is what it is, yet more.

NGUAGE

And the change purse on the *Granta* cover (page 35) does not even need the headline "Sex" to translate the image for the viewer. In fact, what can be more simple than the two parentheses illustrating the theme of Lars von Trier's film *Nymphomanic* (page 37)?

Body graphics are so common that for the image to be more than cliché, the bar must be set high. The thong made of the Eiffel Tower for "Last Tango In Paris" (page 40) is a brilliant visual pun, as it speaks to both the undergarment and the iconic structure. Likewise the zipper forming the spread thighs and vagina for Erica Jong's book *Fear of Flying* (page 41) provides the contour of the body forming the crotch. The suggestive pen point on the poster for "Bringing Up Girls in Bohemia" (page 40) reveals a lower body and legs, while the cross in the form of the crotch that is promoting *Don Giovanni* (page 41) are fairly obvious renderings, particularly given the way pubic parts are so commonly represented.

With some body parts only a little manipulation is necessary. Breasts and buttocks are natural calligraphic shapes. The swirl that forms the breasts in "Playtime" (page 44) is unmistakable. Likewise, the negative space between the swan neck and its feather in "Erotische Plakate" (page 44) does the job with minimal lines and maximal elegance. And what about the high-level wit in which the "Golden Section" becomes the "Golden Ass" (page 45)? It is comprehensible by the simple juxtaposition of two unrelated visual ideas.

Sex is a popular theme, yet sexual references are not necessarily obviously erotic but rather deliberately ironic. The "Clitoral Truth" (page 49) uses the notion of sexuality rather than the experience to convey its message. "Lulu" (page 48) has sexual undertones but the image is more evocative through abstraction than prurient content. And what about "Leba – Shifting Sand Dunes Park" (page 51), where the position of the sand dunes and beach grass are suggestive but more comic than erotic.

There was a time in design history when many art directors, editors, and clients were paranoid that illustrators and designers were deliberately hiding sexual references in their respective works. Penises and vaginas were found in the most innocent imagery. Maybe this is true. But today, the body language is indeed inserted in so much design and illustration that not to see the breast in "H.M. Deserters" (page 53), the butt in "Cigarettes are for Assholes" (page 53), or the vagina in "Eat Me" (page 58) would reveal one is deaf to the naked truth and blind to the obvious.

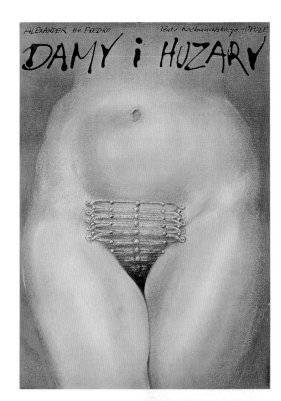

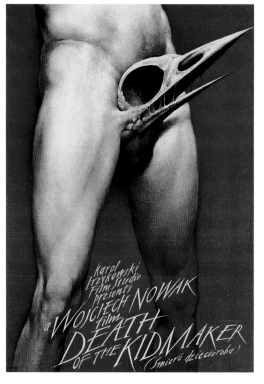

Head to Toe

Death of the Kidmaker, Poland, 1991. **d**: Wieslaw Walkuski. Film poster. (Dydo Poster Collection)

Ladies and Hussars, Poland, 1980. **client**: Jan Kochanowski Theatre in Opole, **cd/ad/d/ill**: Andrzej Pągowski. Poster designed for Aleksander Fredro, a Polish poet and playwright active during the Romanticism period, for his play *Ladies and Hussars*. (Dydo Poster Collection)

The Lover, Poland, 1992. **client**: Solopan, **cd/ad/d/ill**: Andrzej Pągowski. Film poster.

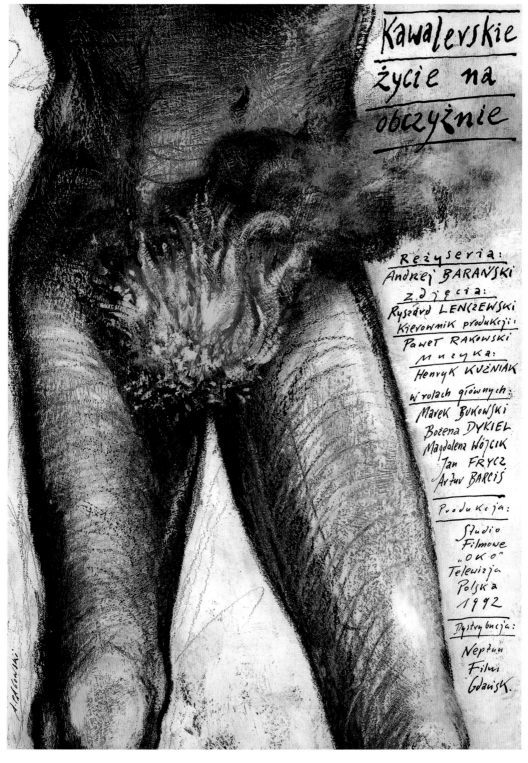

A Bachelor's Life Abroad, Poland, 1992. **client**: Oko Film Productions, **cd/ad/d/ill**: Andrzej Pągowski. Poster for Andrzej Barański's film *A Bachelor's Life Abroad*.

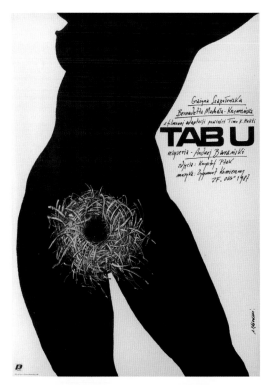

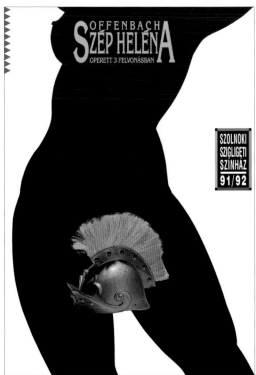

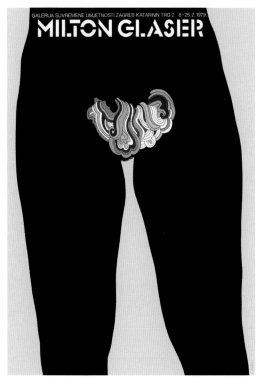

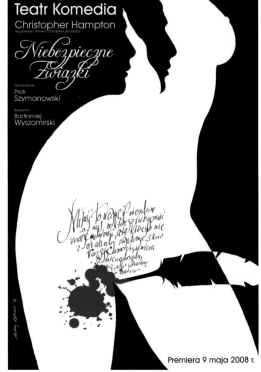

Tabu, Poland, 1988. **client**: Polfilm, **ad/d/ill**: Andrzej Pągowski.
Poster for Andrzej Barański's film *Tabu*. This poster was taken down from
the Polish Poster Exhibition in New York because of "moral considerations."

Milton Glaser, Croatia, 1979. **client**: Gallery of Contemporary Art Zagreb,
d: Boris Bućan. Exhibition poster. (Courtesy of The Museum of
Contemporary Art Zagreb)

Offenbach: Fair Helen, Hungary, 1992. **client**: György Schwajda, Szigliget
Theatre, **cd/ad/d/ill**: Péter Pócs. Theatrical poster for the operetta.

Dangerous Liaisons, Poland, 2008. **client**: Komedia Theatre, Warsaw,
cd/ad/d/ill: Andrzej Pągowski, **typography**: Magda Blazkow.
Theater poster. Outdoor advertising was removed from the streets
because of morality concerns.

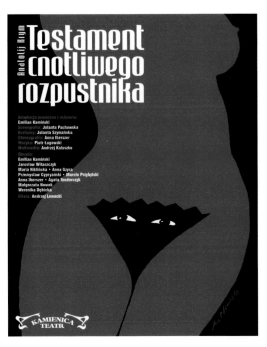

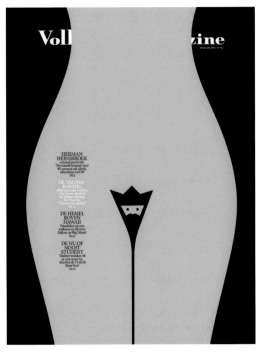

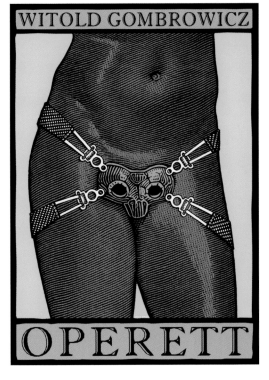

The Last Will of an Old Libertine, Poland, 2010.
client: Kamienica Theatre, Warsaw, **cd/ad/d/ill**: Andrzej Pągowski,
typography: Magda Blazkow. Theater poster.

Venetian Woman, Serbia, 2015. **client**: National Theatre in Pristina,
ad/d/ill: Jovan Tarbuk. Theater poster.

Volkskrant Magazine: The Vagina King, Netherlands, 2015.
client: Volkskrant Magazine, **cd**: Jaap Biemans, **ill**: Noma Bar. A cover
story about Dr. Preecha Tiewtranon, a surgeon who has done over four
thousand gender reassignment surgeries.

Operett, Hungary, 2014. **client**: National Theatre, Budapest,
cd/ad/d/ill: István Orosz. Poster for the play by Witold Gombrowicz.

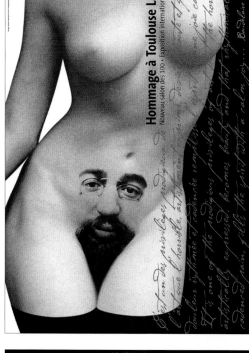

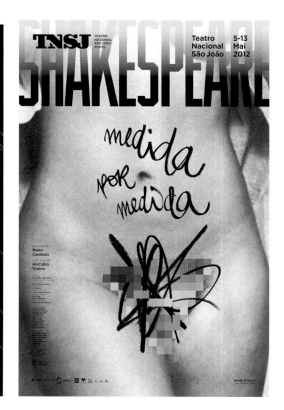

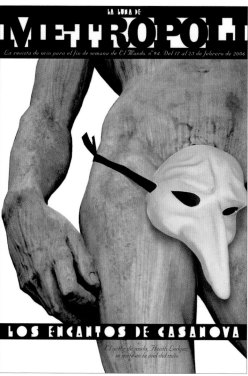

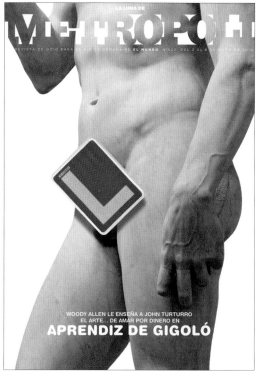

Homage to Lautrec, USA, 2001. **client**: Salon des Cent, France, **cd/ad/d**: Chaz Maviyane-Davies, **p**: Steve Hammom, P. Sescau. A poster commemorating the one-hundredth anniversary of the death of Toulouse-Lautrec.

Casanova's Carnival, Spain, 2006. **client**: Unidad Editorial. El Mundo METROPOLI, **cd/ad/d**: Rodrigo Sánchez, **ill**: Raúl Arias. The cover is for a film about Casanova's life during the Venetian Carnival. The image is a detail of Michelangelo's *David* with a carnival mask in place of his penis.

Measure for Measure, Portugal, 2012. **client**: Ao Cabo Teatro, presented by Teatro Nacional São João, **studio**: DROP, **d**: João Faria. Theater poster.

Learning Gigolo, Spain, May, 2014. **client**: Unidad Editorial. El Mundo METROPOLI, **cd/ad/d**: Rodrigo Sánchez, **ill**: Raúl Arias. This cover is for Woody Allen's film, *Fading Gigolo*. The Michelangelo statue has a "learning driver" sign instead of an erect penis.

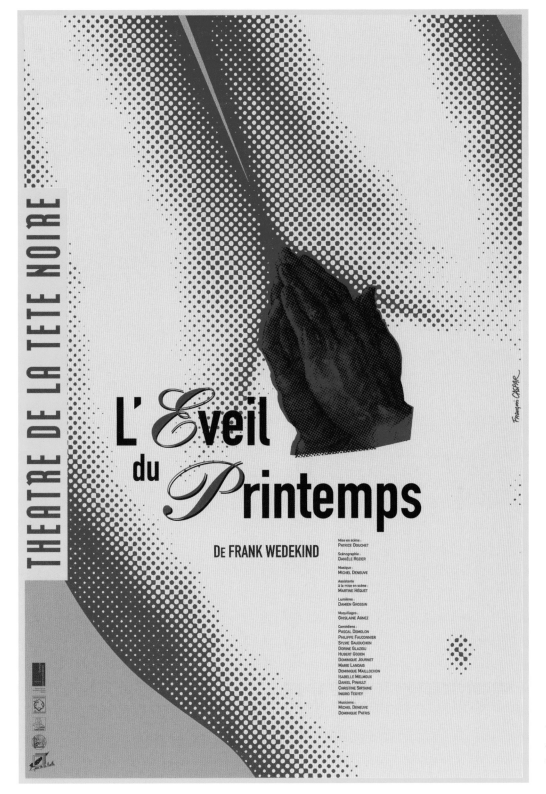

Spring Awakening, France, 1994. **client**: The Black Head Theater, **d**: François Caspar. Theater poster.

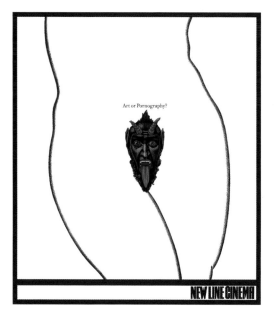

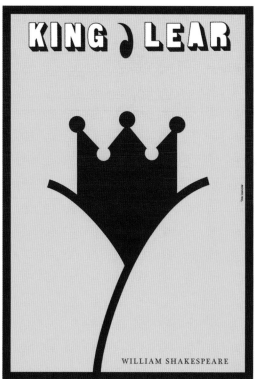

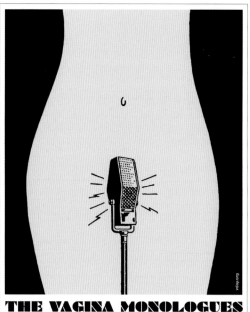

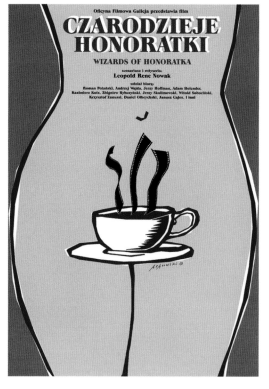

Art or Pornography, USA, 1975. **client**: New Line Cinema, **d/ill**: Seymour Chwast. Poster promoting a series of films for colleges.

The Vagina Monologues, USA, 2010. **client**: Tulane University Performing Arts, **cd**: Eddie Snyder, **ad/d**: Matt Holloway. Theater poster.

King Lear, USA, 2007. **client**: Tadaaa Publishing, **d/ill**: Yann Legendre. Theater poster.

Wizards of Honoratka, Poland, 2012. **client**: Leopold Rene Novak, **cd/ad/d/ill**: Andrzej Pągowski, **typography**: Magda Blazków. Documentary film poster.

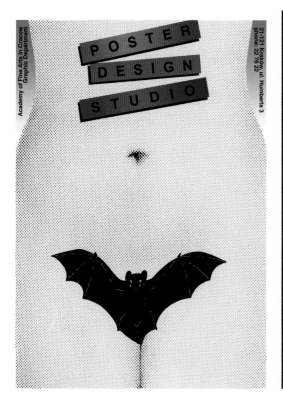

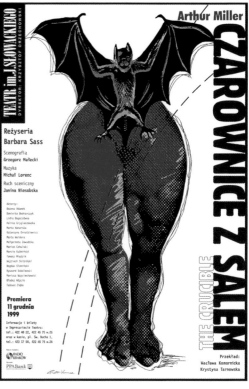

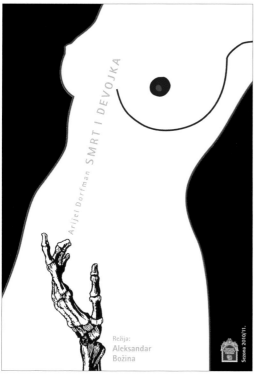

Poster Design Studio, Poland, 1987. **client**: Academy of Fine Arts in Krakow, **d/ill**: Piotr Kunce. Exhibition poster.

Death and the Maiden, Serbia, 2010. **client**: National Theatre Kikinda, **cd**: Aleksandar Bozina, **ad/d/ill**: Mila Melank. Theater poster.

The Crucible, Poland, 1999. **client**: Slowacki Theatre in Kraków, **d/ill**: Piotr Kunce. Poster for the play by Arthur Miller. Created with a drawing that was later rasterized with one color added. (Dydo Poster Collection)

Pachamama, Argentina. **client**: University of Palermo, **d**: Fabián Carreras.

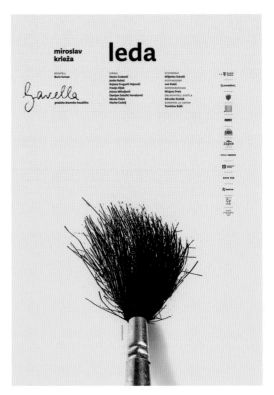

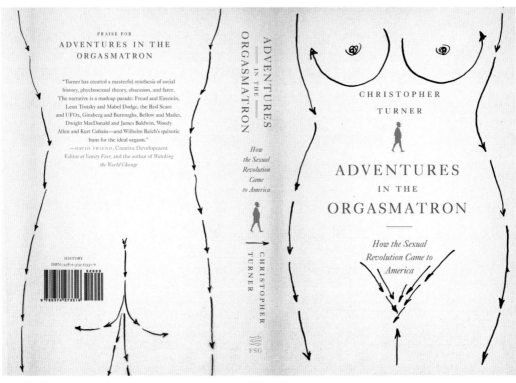

Leda, Croatia, 2011. **client**: City Drama Theatre "Gavella,"
ad/d: Vanja Cuculić. Theater poster. The brush, a symbol of painting
and art, becomes a symbol of femininity.

Adventures in the Orgasmatron, USA, 2011. **client**: Farrar, Straus and Giroux, **cd**: Susan Mitchell, **d**: Marina Drukman. Book jacket. Tells the untold
story of the dawn of the sexual revolution in America.

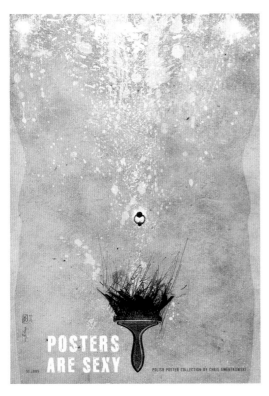

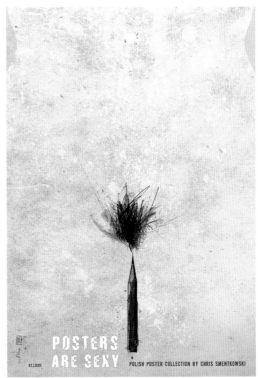

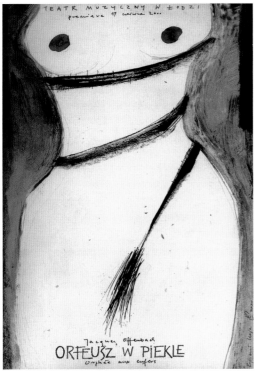

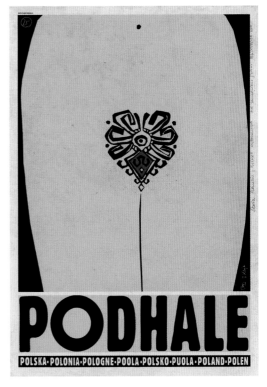

Posters Are Sexy (man version), Poland, 2013.
client: Chris Smentcovski Collection, **cd**: Ryszard Kaja. Collection poster.

Orpheus in the Underworld, 2000. **client**: Teatr Napiecie,
cd: Ryszard Kaja. Theater poster.

Posters Are Sexy (woman version), Poland, 2013.
client: Chris Smentcovski Collection, **cd**: Ryszard Kaja. Collection poster.

Podhale, Poland, 2014. **client**: Polishposter.com Gallery, **cd**: Ryszard Kaja.
Tourism promotion poster.

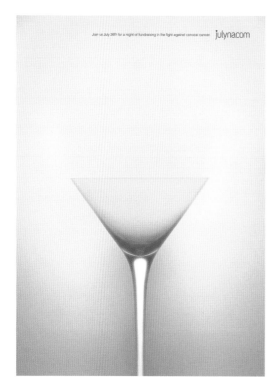

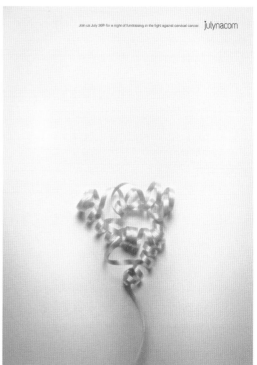

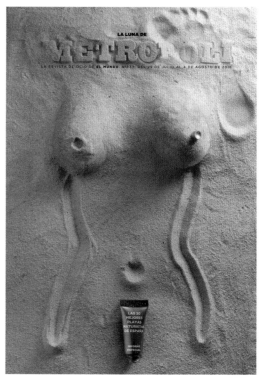

Julyna, Canada, 2012. **client**: Canadian Cancer Society, **agency**: Cossette, **cd**: David Daga, Matthew Litzinger, **ad**: Angela Sung, **c**: Rachel Abrams, **p**: Philip Rostron, **print producer**: Raquel Mullen, **account supervisor**: Angela Rosales, **media agency planner**: Ema Haračić. Julyna is a nonprofit organization that encourages creative grooming to raise money and increase awareness of cervical cancer and HPV.

The 20 Best Nudist Beaches in Spain, Spain, 2016. **client**: Unidad Editorial, El Mundo METROPOLI, **cd/ad/d**: Rodrigo Sánchez, **ill**: Josextu L. Pineiro, **p**: Angel Becerril. Imaginings of a woman's nude body on the beach. All made with sand and drawn by hand.

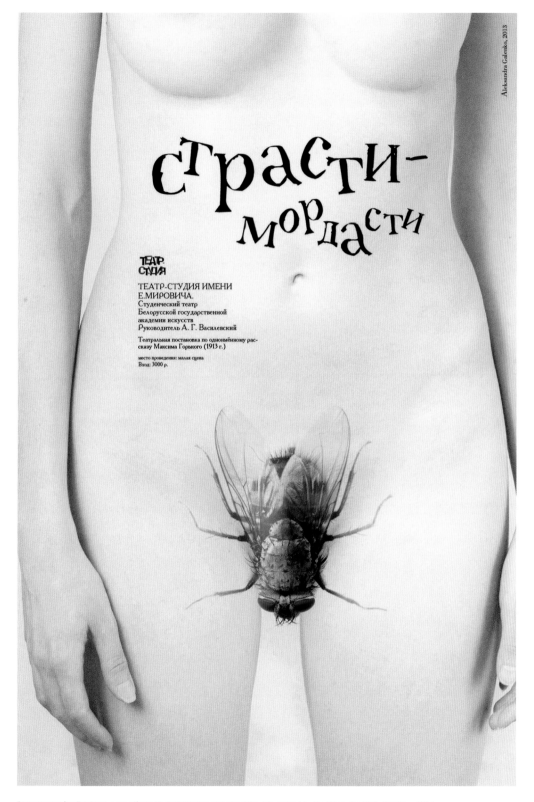

страсти-
мордасти

ТЕАТР.
СТУДИЯ

ТЕАТР-СТУДИЯ ИМЕНИ
Е.МИРОВИЧА.
Студенческий театр
Белорусской государственной
академии искусств
Руководитель А. Г. Василевский

Театральная постановка по одноимённому рас-
сказу Максима Горького (1913 г.)

место проведения: малая сцена
Вход: 3000 р.

"Creepy stories," Belarus, 2013. **client**: Student theater named E. Mirovich, created by the Belarusian State Academy of Arts, **cd/ad/d/ill/p**: Aleksandra Galenko. Theater poster. A story about women who practice the world's "oldest profession."

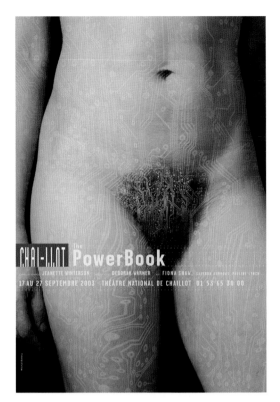

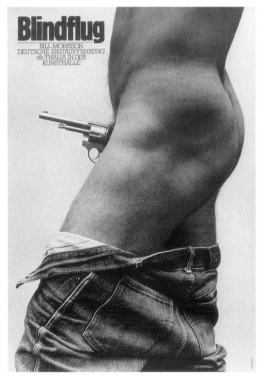

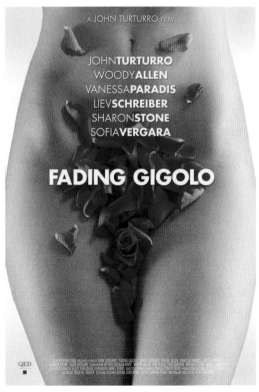

Blindflug (Blindflight), Germany, 1979. **client**: tik-Theater in der Kunsthalle, **cd/ad/d/p**: Holger Matthies. The theme of this play is the oppression of aggressive sexual forces.

Power Book, France, 2003. **client**: QED International, **studio**: Blood & Chocolate, **cd**: Blood & Chocolate; **p**: Maksim Shmeljov. Teaser poster.

Fading Gigolo, USA, 2013. **client**: Theatre National de Chaillot, **d**: Michal Batory. Film poster.

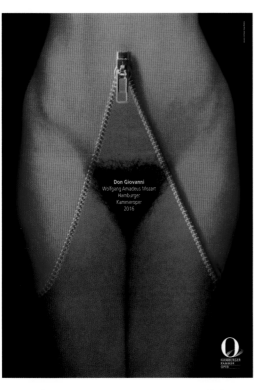

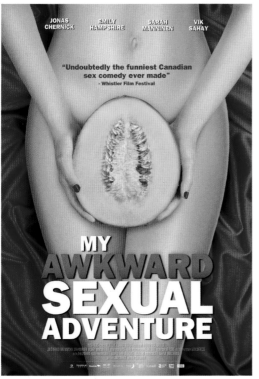

IRINA KULIKOVA by JUERGEN TELLER

Don Giovanni (Don Giovanni), Germany, 2016. **client**: Hamburger Kammeroper, **cd/ad/d/p**: Holger Matthies. Theater poster.

My Awkward Sexual Adventure, Canada, 2012. **client**: Phase 4 Films, **agency**: Agency 71 Inc. **cd/ill**: Chad Maker, **ad**: Liz Szinessy, **d/ill/p**: Cheryl Parsons. The challenge for the project was to capture the outrageous fun of the film.

A3 Magazine, USA, 2013. **client**: Ontwerp.TV (A3 Magazine), **cd/ad/d/ill**: Anthony Neil Dart, **p**: D'Paint. Magazine covers and poster series for experimental e-zine covering local and international design.

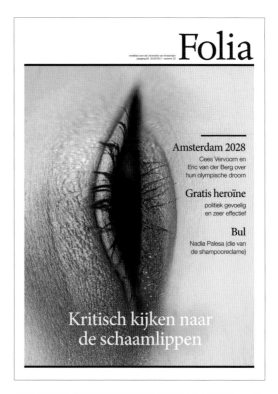

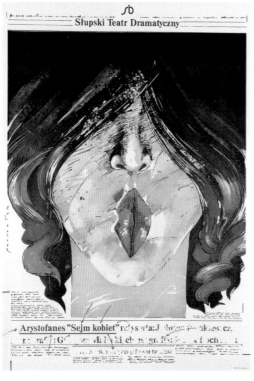

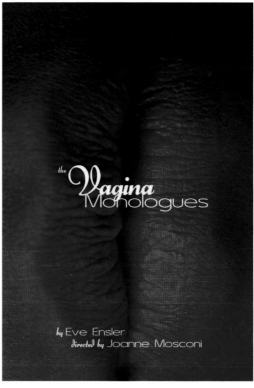

Sejm kobiet (Lysistrata), Poland, 1981. **d**: Grzegorz Marszalek.
Theatrical poster for a play by Aristophanes. (Dydo Poster Collection)

A Critical Look at the Labia, The Netherlands, 2011. **client**: Folia,
cd/ad/d/ill: Pascal Tieman, **c**: Mirha van Dýk. Print media.
This image accompained an article discussing the growing number
of women undergoing cosmetic surgical procedures on their labias.

The Vagina Monologues, USA, 2009. **client**: Hollywood Fight Club
Theater, **cd/ad/d**: Hillel Smith. Theater poster.

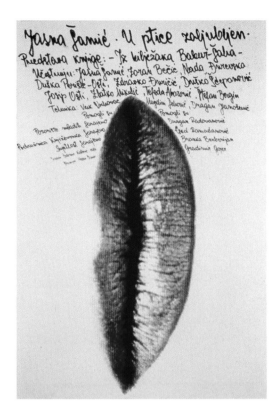

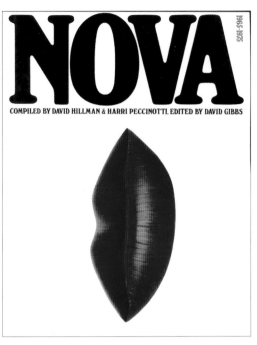

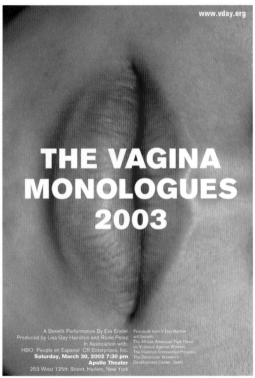

In Birds in Love, Yugoslavia, 1986. **client**: Pozorište Mladih Sarajevo, **cd/ad/d/ill**: Čedomir Kostović, **silkscreen**: Hasan Cakar. Poster for promotion of Jasna Samić's erotic poetry book *In Birds in Love*. After a few days on display, the poster was taken down due to public requests.

Vagina Monologues, USA, 2002. **client**: V Day, **d**: Sagi Haviv, partner, Chermayeff & Gesimar & Haviv. Theater poster.

NOVA 1965–1975, UK, 1993. **client**: Pavilion Books, **ad/d/c**: David Hillman, **d**: Karin Beck, **p**: Harri Peccinotti. Book cover.

Hush…, Croatia, 2013. **client**: Kinorama, **studio**: Šesnić & Turković, **cd/ad/d/c/p**: Marko Šesnić, Goran Turković. Film poster.

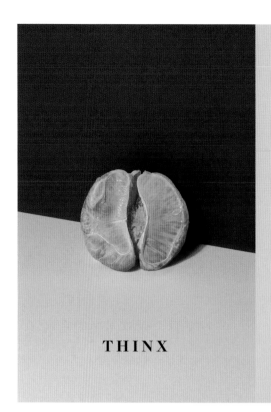

UNDERWEAR

FOR

WOMEN

WITH

PERIODS

—

THINX

hellothinx.com

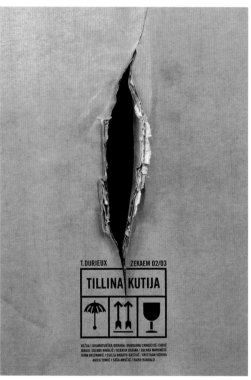

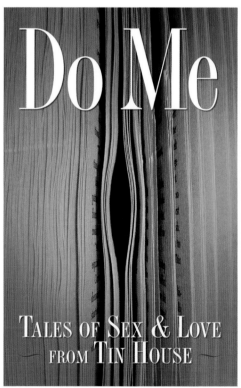

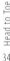

Head to Toe

34

THINX Grapefruit Campaign, USA, 2015. **client**: THINX Inc., **cd**: Veronica del Rosario, **ad/d**: My Nguyen, **ill**: Huy Luong. Promotional poster. The THINX campaign, originally designed for display at the Bedford Avenue subway station in Brooklyn, New York, gained global traction after initially being rejected by the Metropolitan Transit Authority. The scandal not only showcased the quiet but all-too-real taboo surrounding menstruation, but it also drew attention to a new style of advertising for menstrual hygiene—one that was fashionable, highly stylized, self-aware, and honest about the menstrual experience.

Tilla's Box, Croatia, 2003. **client**: Zagreb Youth Theatre, **studio**: Studio Cuculić, **ad/d**: Vanja Cuculić. The fragility of women's position in a society was the key idea this play was exploring. The visual metaphor is simple and straightforward.

Do Me: Tales of Sex and Love from Tin House, USA, 2007. **client**: Tin House, **d**: Sean Tejaratchi. Book cover.

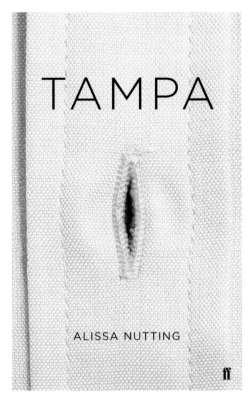

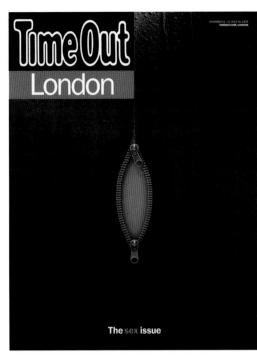

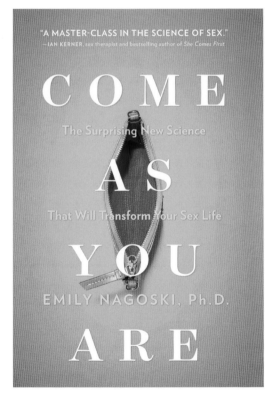

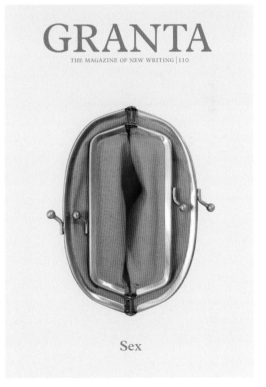

Tampa—Alissa Nutting, UK, 2013. **client**: Faber & Faber,
studio: Gray318, **ad**: Donna Payne, **d**: Jon Gray, **p**: Johnny Ring. This novel
tells the story of a woman preying on young boys. The design needed
to be suggestive rather than overt.

Come As You Are, USA, 2015. **client**: Simon + Schuster, **cd**: Jackie Seow,
ad: Anderson Newton Design, **d**: Gail Anderson, Joe Newton. This cover
is an exploration in comfort levels, and how to evoke the human body
without being explicit.

The Sex Issue, England, 2014. **client**: Time Out London,
ad: Anthony Huggins, **ill**: JSR Agency, **editor**: Caroline McGinn.
Cover design for *Time Out London*'s annual sex issue.

Granta 110: Sex, UK, 2010. **client**: Granta Magazine, **cd**: Michael Salu,
editor: John Freeman, **deputy editor**: Ellah Allfrey, **p**: Billie Segal. This
Granta cover required an oblique but universal approach to something
that affects us all. It was printed on soft-touch, a velvet-like, tactile stock,
playing on our sense of touch.

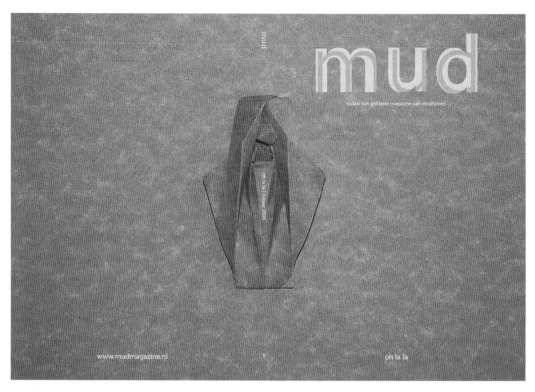

Mud Magazine, The Netherlands, 2016. **client**: Mud Magazine, **cd/c**: Sabine te Braake, **cd/ad/p**: Laury van Eerd. Magazine cover. Each issue of *Mud Magazine* is organized around one central theme. The theme of this issue was "Oh La La."

Sappho, Italy, August 2016. **client**: Corriere della Sera, **studio**: The World of DOT, **ad**: Francesca Leoneschi, **d**: Mauro De Toffol. Book jacket. Created as a part of a poetry series where each volume is dedicated to a different poet. This volume, the sixteenth, was dedicated to the lesbian poetess, Sappho. The forms and pink nuance are intended to visually remind the viewer of human erogenous zones.

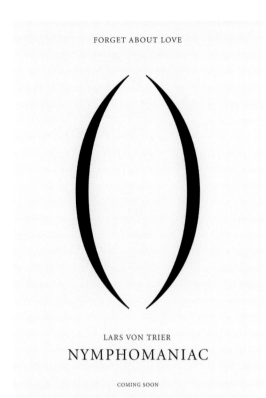

FORGET ABOUT LOVE

LARS VON TRIER

NYMPHOMANIAC

COMING SOON

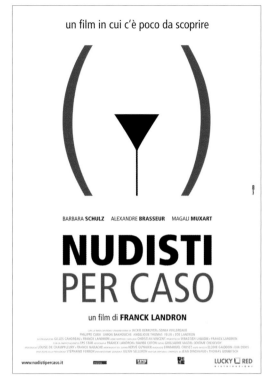

un film in cui c'è poco da scoprire

BARBARA **SCHULZ** · ALEXANDRE **BRASSEUR** · MAGALI **MUXART**

NUDISTI
PER CASO

un film di **FRANCK LANDRON**

www.nudistipercaso.it LUCKY ⫿ RED

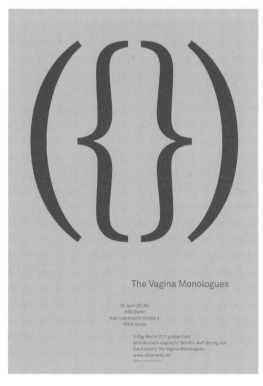

The Vagina Monologues

13. April 20 Uhr
.HBC Berlin
Karl-Liebknecht-Straße 9
10178 Berlin

V-Day Berlin 2011 präsentiert
eine deutsch-englische Benefiz-Aufführung von
Eve Ensler's The Vagina Monologues
www.vdayberlin.de

YONI
von Frauen für Frauen & Freunde
16.03.14, ab 21.00 Uhr
MS Connexion Mannheim
Djane E*star

YONI

Nymphomaniac, Denmark, 2013. **client**: Zentropa Productions / Nordisk
Film, **studio**: The Einstein Couple, **cd/ad**: Maria Einstein Biilmann,
Philip Einstein Lipski, **d**: Tobias Roder, **p**: Casper Sejersen. Film poster.

The Vagina Monologues, Germany, 2011. **client**: V-Day Berlin,
cd/ad: Fons Hickmann m23. Theater poster.

Nudist by Accident, Italy, 2004. **client**: Internozero Comunicazione,
cd/ad/d: Riccardo Fidenzi, Maurizio Ruben, **c**: Internozero Comunicazione.
Poster made for the launch campaign of the film in Italy.

Yoni, Germany, 2014. **client**: Esther Ritschel, **cd/ad**: Götz Gramlich.
Promotional poster. This poster is advertising an event marketed
specifically to a lesbian audience.

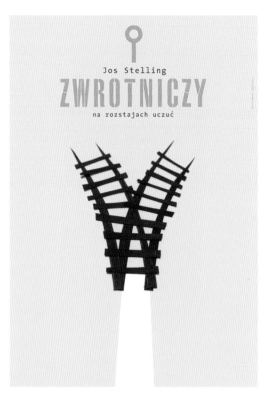

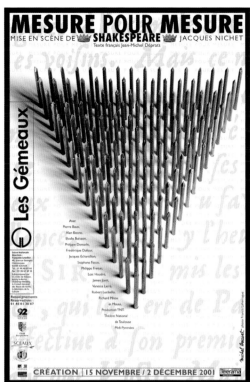

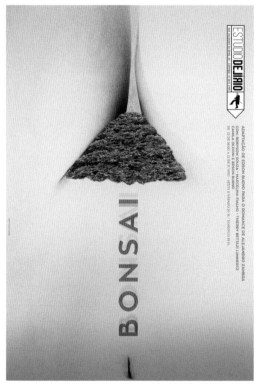

The Pointsman, Poland, 2006. **client**: Vivarto, **studio**: Homework, **cd/ad/d/ill**: Joanna Górska, Jerzy Skakun. Poster for the 1986 Dutch film directed by Jos Sterling, telling the story of a woman who moves in with a pointsman at a remote railway station.

Bonsai, Brazil, 2016. **client**: Estudio Delirio, **cd/d/ill**: Marcos Minini. The bonsai is only considered legitimate if it is with the vessel that houses its roots. This image suggests that the love of the two characters is legitimate only through sex.

Mesure Pour Mesure (Measure for Measure), France, 2001. **client**: Les Gemeaux / Sceaux / Scene Nationale, **cd/ad/d**: Michel Bouvet, **p**: Francis Laharrague. Poster for a play by Shakespeare.

PÓS-LIDA—Christmas Special, Brazil, 2014. **client**: James Martins, **cd/ad/d/p**: Diego Ribeiro. This poster was designed for the Christmas edition of "PÓS-LIDA," a poetry recital held in Salvador.

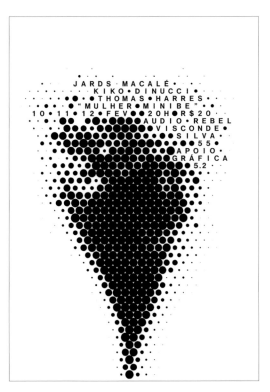

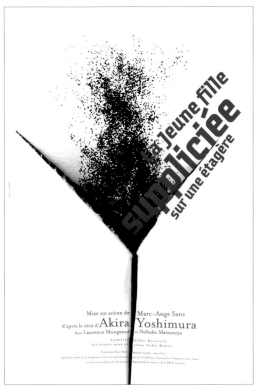

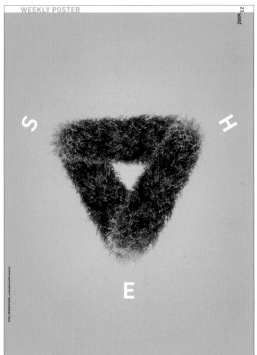

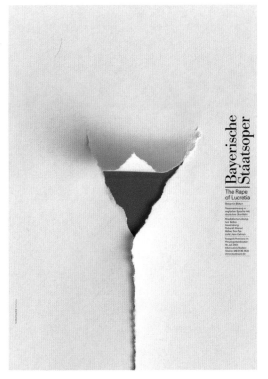

Mulher Minibe, Brazil, 2015. **client**: Quintavant, **d**: Thiago Lacaz. Poster for music concert. The name of the show comes from the phrase "woman inhibits me."

She, Hungary, 2009. **client**: SarkanyLatvany, Szeged, Hungary, **d/p**: Ferenc Kiss.

The Girl Tortured on a Shelf, France, 2005. **client**: The Fingerprint Theater **d**: François Caspar. Theater poster.

The Rape of Lucretia, Germany, 2004. **client**: Bavarian State Opera, **cd/ad/d**: Pierre Mendell, **d**: Ammelt Kroeger, **p**: Hans Doering. An opera by Benjamin Britten that tells the story of ancient Rome. The torn paper illustrates the brutal rape of Lucretia in a simple, elegant way.

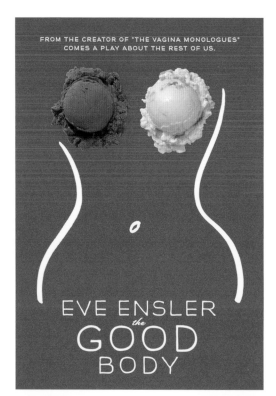

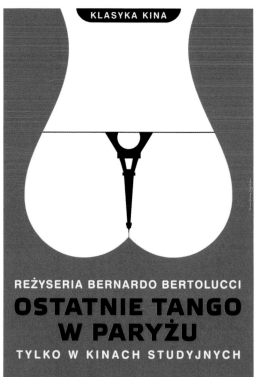

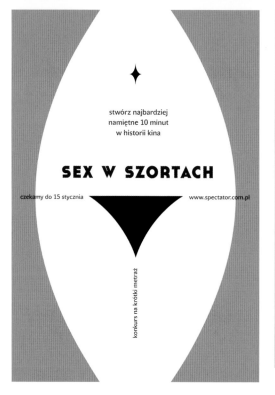

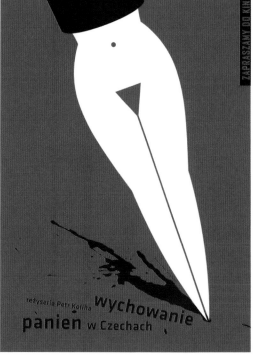

The Good Body, USA, 2004. **client**: Spotco, **ad**: Gail Anderson, **ill**: Isabelle Dervaux. Theater poster.

Sex in Shorts, Poland, 2012. **client**: Spectator, **studio**: Homework, **cd/ad/d/ill**: Joanna Górska, Jerzy Skakun. Poster for a competition of short sex films.

Last Tango in Paris, Poland, 2011. **client**: Vivarto, **studio**: Homework, **cd/ad/d/ill**: Joanna Górska, Jerzy Skakun. Film poster. This image was created to promote an art house review of classical films. In this case, the film being promoted was Bernardo Bertolucci's cult classic.

Bringing Up Girls in Bohemia, Poland, 2007. **client**: Vivarto, **studio**: Homework, **cd/ad/d/ill**: Joanna Górska, Jerzy Skakun. Film poster. This film tells the story of a private writing lesson given to the daughter of a mafia boss.

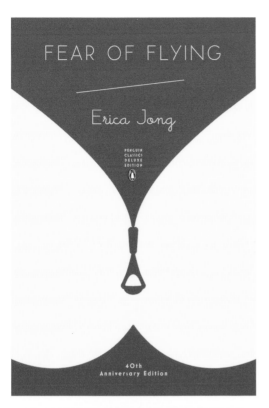

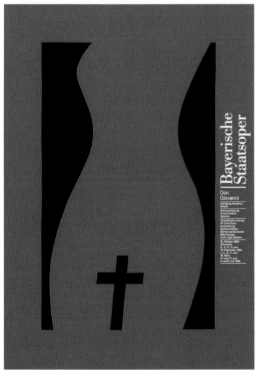

Fear of Flying, USA, 2013. **client**: Penguin Random House / Penguin, **cd/ad/d**: Paul Buckley, **ill**: Noma Bar. Book cover.

Don Giovanni, Germany, 1994. **client**: Bavarian State Opera, **cd/ad/d**: Pierre Mendell. Theater poster. Mozart's famous opera, it tells the dramatic story of Don Giovanni and his daughter, Donna Anna.

Antony and Cleopatra, Germany, 1996. **client**: Imagine Theatre, **cd/ad/d/ill**: Lex Drewinski. Theater poster for *Antony and Cleopatra* by William Shakespeare. (Dydo Poster Collection)

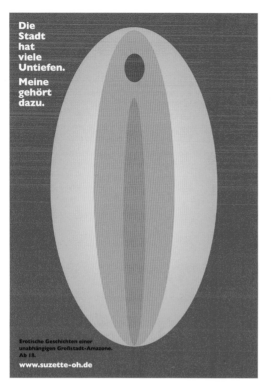

Vagina, Germany, 2010/2011. **client**: Suzette-Oh,
cd/ad/ill: Heiner Baptist Rogge. Promotional poster. This was created
for an advertising campaign focused on the erotic blog "Suzette-Oh."

The Future Is Between Your Legs, Macedonia, 2016. **client**: Sexual
and Health Rights of Marginalized Communities, Skopje, **d**: Igor Delov.
Poster for a festival of sexuality and gender in alternative film
and video in the former Yugoslavia.

Border Post, Poland, 2008. **client**: Vivarto, **studio**: Homework,
cd/ad/d/ill: Joanna Górska, Jerzy Skakun. Film poster.

WO-man, Croatia, 1999. **client**: Studio International, **cd**: Boris Ljubičić.
Poster and calendar. This image features a torso created from 3D
computer-generated shapes, meant to be a comparison to ancient Greek
examples of nude sculpture.

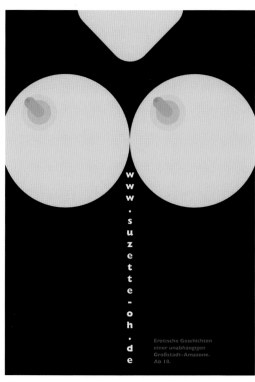

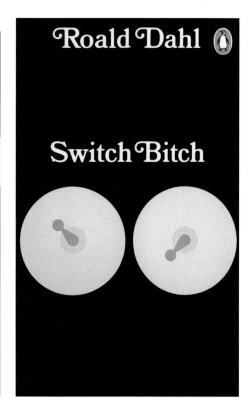

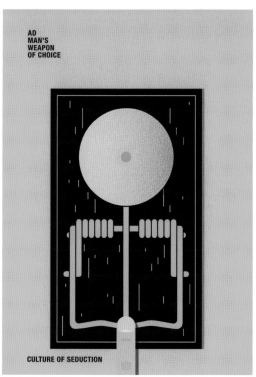

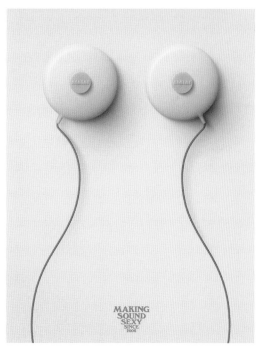

Breasts, Germany, 2010/2011. **client**: Suzette-Oh,
cd/ad/ill: Heiner Baptist Rogge. Promotional poster.
This is another marketing poster for the erotic blog "Suzette-Oh."

The Culture of Seduction, Cyprus, 2015. **client**: International
Conference & Exhibition on Semiotics and Visual Communication,
cd: Omiros Panayides. Exhibition poster.

Switch Bitch, UK, 1982. **client**: Penguin Books, **d/ill**: David Pelham.
Book jacket. *Switch Bitch* is a 1974 collection of short stories by Roald Dahl.

Sexy Sound, Denmark, 2013. **client**: AIAIAI headphones, **cd/ad**: Peter
Michael Willer, **c**: David Lange, **p**: Rasmus Dengsø. Challenged to create
an ad for an issue of *Vice* Magazine devoted to the *Penthouse* Magazine
founder, Bob Guccione, AIAIAI produced an "erotification" of the Tracks
headphones model and an homage to the female silhouette and 1970's
typography.

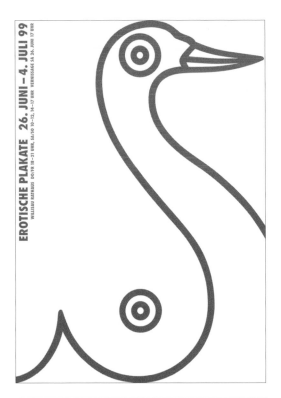

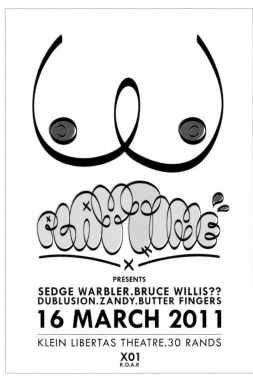

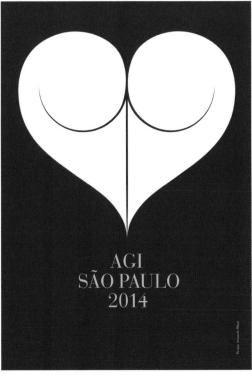

Playtime Posters, South Africa, 2011. **client**: Playtime events, Alex Dalais, **d**: Andrew Ringrose. Music poster. One of a series of posters created for a hip-hop / electronic music festival.

Erotic posters (Erotische Plakate), Switzerland, 1999. **client**: Rathausbuehne Willisau, **d**: Niklaus Troxler. Print media.

Poster for AGI Meeting, Brazil, 2014. **client**: AGI Alliance Graphique Internationale, **ad/d**: Armando Milani. Poster for the AGI Convention in Sao Paolo, Brazil, in 2014.

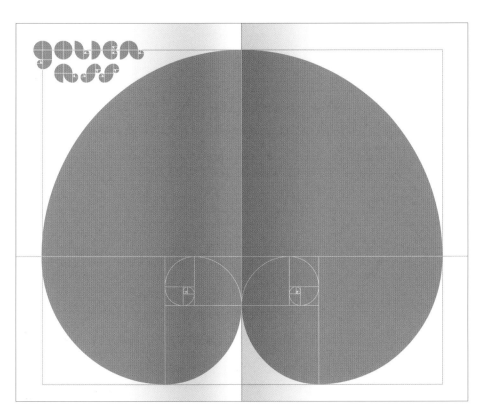

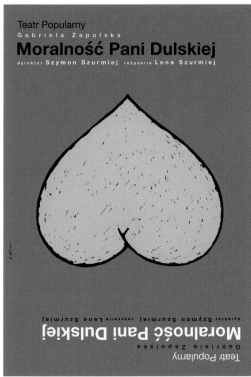

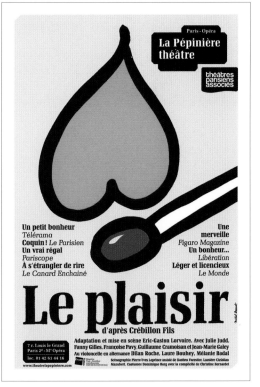

Golden Ass, Poland, 2014, **client**: GraphicDesign&, **studio**: Homework, **cd/ad/d/c/ill**: Joanna Górska, Jerzy Skakun. Print media. This illustration was made for Lucienne Roberts, Rebecca Wright, and Alex Bello's book, *Golden Meaning*.

The Morality of Mrs. Dulska, Poland, 2008. **client**: Jewish Theatre, Warsaw, **cd/ad/d/ill**: Andrzej Pągowski, **typography**: Magda Blazkow. Promotional poster. The poster was displayed on the streets both ways—one as a bottom and one upside down as a heart.

Le Plaisir (The Pleasure), France, 2012. **client**: La Pepiniere Theatre, **cd/d/ill/p**: Michel Bouvet. A play inspired by an eighteenth-century French writer.

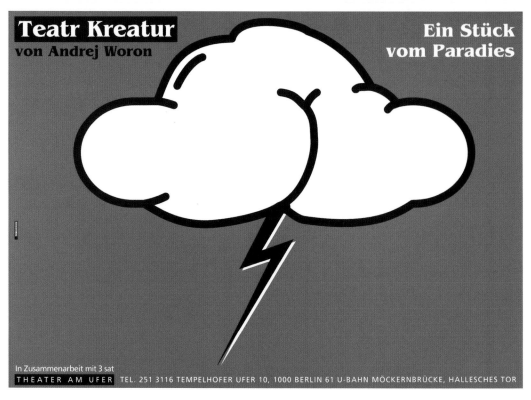

AGI Sao Paulo, Switzerland, 2014.
client: Alliance Graphique Internationale, **cd**: Mattia Marco Conconi,
ad: Gottschalk + Ash Int'l, Zurich. Exhibition poster.

Backside Calendar 2016, Hong Kong, 2016. **client**: Toby Ng Design,
studio: Homework, **cd/d**: Toby Ng, **d**: Ronald Cheung, **c**: Margaret Leung.
Backside Calendar 2016 was created by Toby Ng Design to promote the
studio's creative services. Playing on the sex appeal of "butts" to attract
attention, every month offers its own significant "butt" moment.

The Book of Paradise, Germany, 1992 **client**: Teatr Kreatur von Andrej Woron, Berlin, **cd/ad/d/ill**: Lex Drewinski. *The Book of Paradise* by Itzik Manger.
Theater poster.

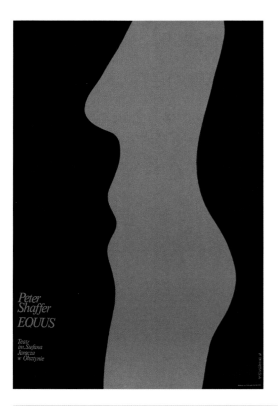

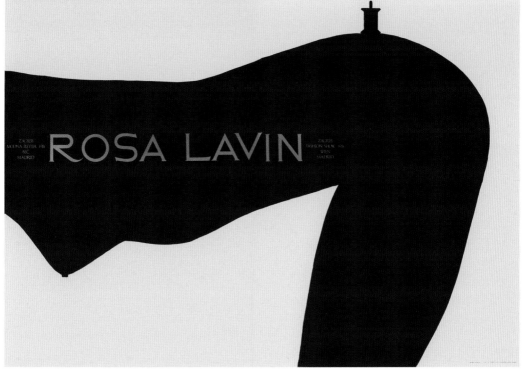

Equus, Poland, 1980. **d**: Bozena Jankowska. Theater poster for a
Peter Shaffer play. (Dydo Poster Collection)

Rosa Lavin—Zagreb Fashion Show 1981 Vienna Madrid, Croatia, 1981, **client**: Rosa Lavin, **d**: Boris Bućan. Poster made for the Rosa Lavin fashion show.
(Courtesy of The Museum of Contemporary Art Zagreb)

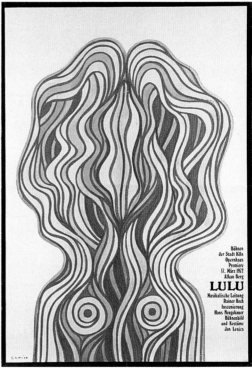

Hommage à Oliviero Toscani and Cicciolina, Hungary, 2013.
client: Ministry of Foreign Affairs of Hungary, **d**: Gyula Molnár.
Cicciolina is a world-famous Hungarian porn star, the former wife
of Jeff Koons, and a member of the Italian Parliament.

Coitus Topographicus, USA, 1980. **client**: Push Pin Graphic,
ad/d/ill: Seymour Chwast, **ill**: Liz Gurowski. Illustration for the "couples"
issue of the *Push Pin Graphic*.

Lulu, Poland, 1972. **d**: Jan Lenica. Theater poster for an Alban Berg play.
(Dydo Poster Collection)

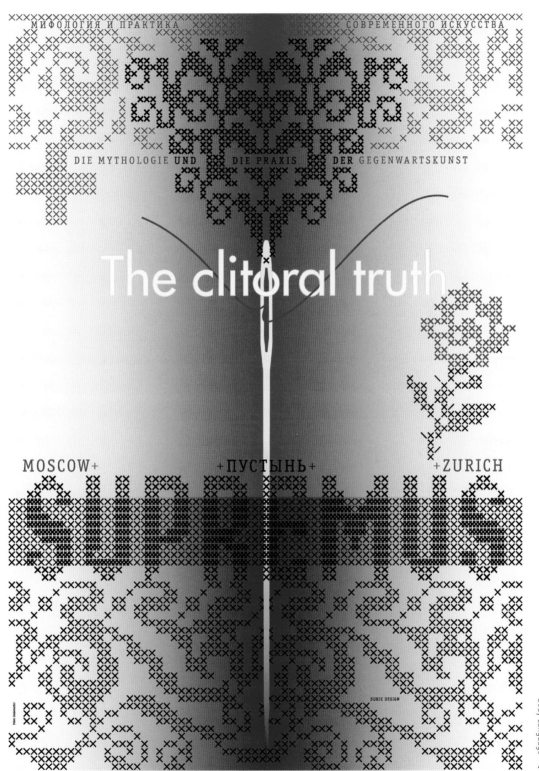

МИФОЛОГИЯ И ПРАКТИКА СОВРЕМЕННОГО ИСКУССТВА

DIE MYTHOLOGIE UND DIE PRAXIS DER GEGENWARTSKUNST

The clitoral truth

MOSCOW+ +ПУСТЫНЬ+ +ZURICH

SURIC DESIGN

Supremus. The Clitoral Truth, Russia, 2003. **client**: Supremus. **cd**: Yuri Surkov. Book cover.

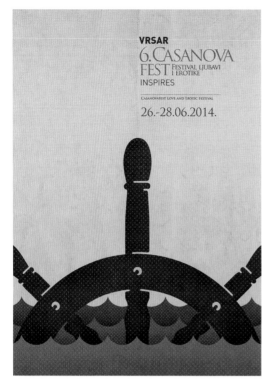

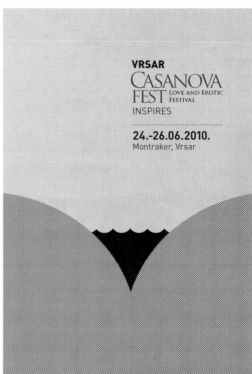

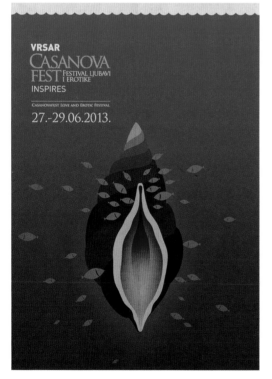

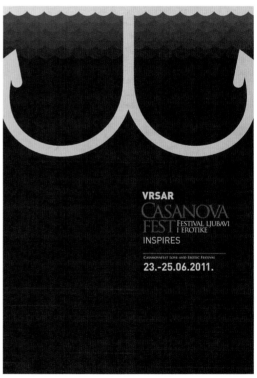

Casanova Fest, Vrsar–posters, Croatia, 2009-2011, 2013-2014. **client**: Vrsar Tourist Board, **cd**: Jelena Fiskus / Sean Poropat, **d**: Aleksandar Živanov.
Promotional posters. These four posters were created to help drive interest in the Casanova Fest, an erotic festival that takes place in Croatia.
The festival, which is held in a small fishing village, offers a spiritual rather than physical approach to love and eroticism, hence the more subtle imagery.

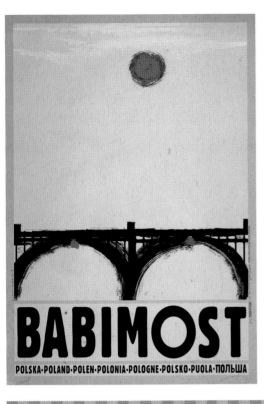

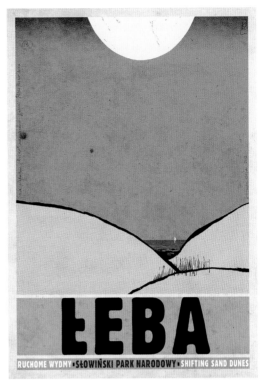

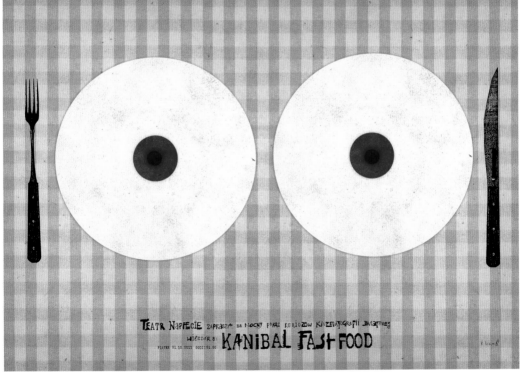

Babimost, Poland, 2013. **client**: Polishposter.com Gallery, **cd**: Ryzard Kaja. This is one poster from a series of touristic posters about Poland.

LEBA—Shifting Sand Dunes Park, 2013. **client**: Polishposter.com Gallery, **cd**: Ryszard Kaja. This is one poster from a series of touristic posters about Poland.

Kanibal Fast Food, Poland, 2011. **client**: Teatr Napiecie, **cd**: Ryszard Kaja. Poster of Oddity movie review.

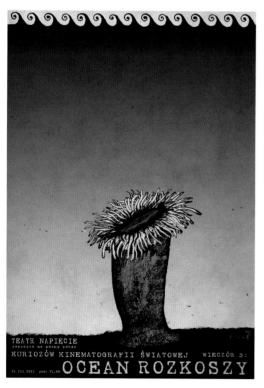

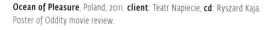

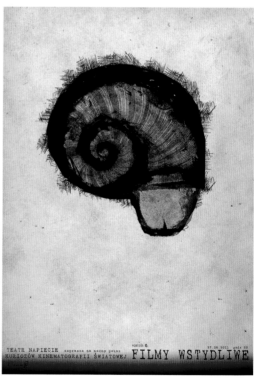

Ocean of Pleasure, Poland, 2011. **client**: Teatr Napiecie, **cd**: Ryszard Kaja.
Poster of Oddity movie review.

Cosmocanto, Poland, 2012. **client**: Teatr Napiecie, **cd**: Ryszard Kaja.
This is one poster from a series of touristic posters about Poland.

Shy Movies Show, Poland, 2011. **client**: Teatr Napiecie, **cd**: Ryszard Kaja.
Poster of Oddity movie review.

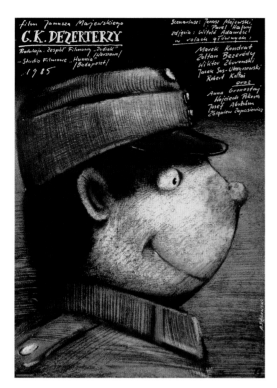

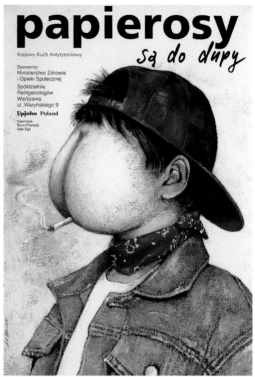

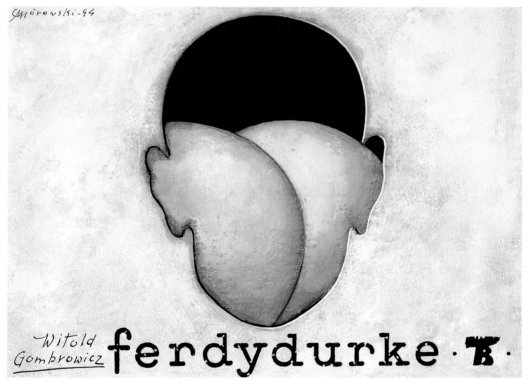

H.M. Deserters, Poland, 1986. **client**: Zodiak Film Company, **cd/ad/d/ill**: Andrzej Pągowski. Film poster. The first version of this poster featured a phallus instead of a nose, but was rejected by the censorship board.

Cigarettes Are for Assholes, Poland, 1994. **client**: Polish Anti-nicotine Society, **cd/ad/d/ill**: Andrzej Pągowski. Promotional poster. Generated for the Polish Ministry of Health, this anti-smoking poster was the subject of much debate in parliament because of concerns about morality.

Ferdydurke, **Witold Gombrowicz,** Poland, 1994. **d**: Mieczyslaw Gorowski. Polish theater poster. (Dydo Poster Collection)

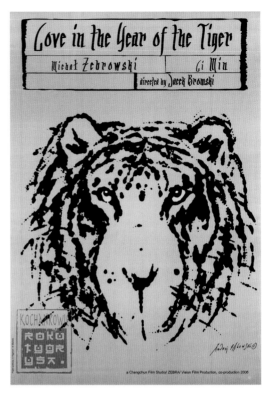

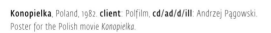

Konopielka, Poland, 1982. **client**: Polfilm, **cd/ad/d/ill**: Andrzej Pągowski.
Poster for the Polish movie *Konopielka*.

Love in the Year of the Tiger, Poland, 2006. **client**: Zebra Film Studio,
cd/ad/d/ill: Andrzej Pągowski, **type**: Magda Blazkow. Poster for the
Polish movie *Love in the Year of the Tiger*.

The Self-Portrait with a Lover, Poland, 1996.
client: TVP (Polish Television), **cd/ad/d/ill**: Andrzej Pągowski.
Poster for the Polish movie *The Self-Portrait with a Lover*.

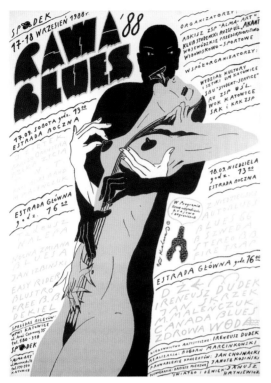

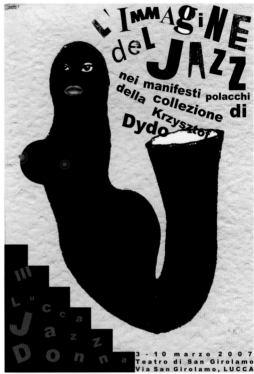

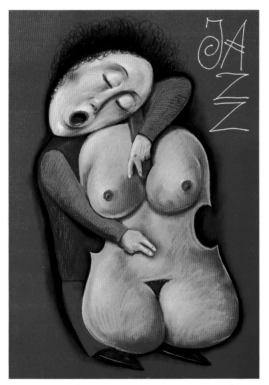

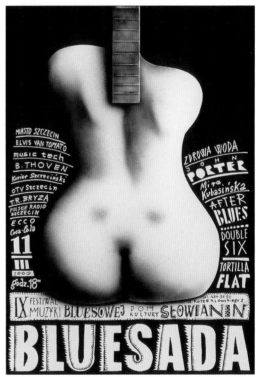

Rawa Blues '88, Poland, 1988. **client**: Spodek Concert Hall,
d: Roman Kalarus. Music festival poster.

Jazz, Poland, 2014. **client**: Polishposter.com,
cd/ad/d/c/ill/p: Leszek Zebrowski. Music festival poster.

III Lucca Jazz Donna, Italy, 2007. **client**: Teatro di San Girolama, Lucca,
d: Monika Starowicz. Music festival poster.

Bluesada IX, Poland, 2000. **d**: Leszek Żebrowski. Poster for a jazz festival.
(Dydo Poster Collection)

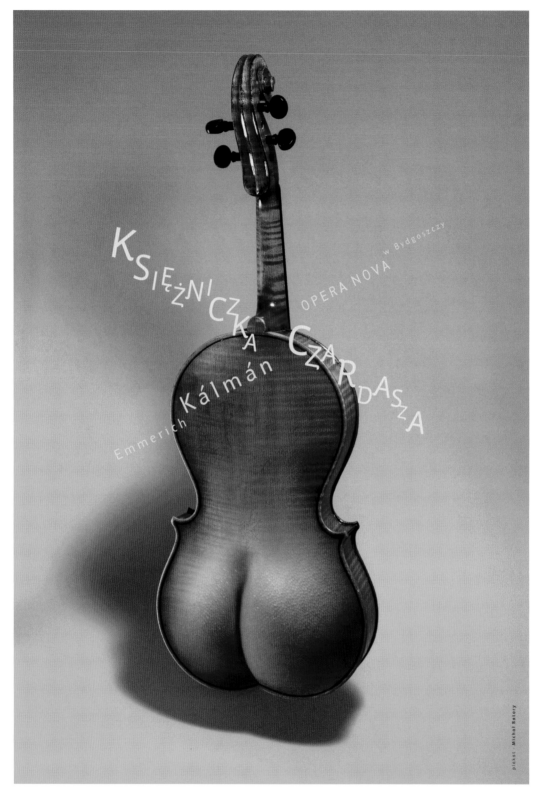

Princess Czardasza, Poland, 2002. **client**: Opera Nova, **d**: Michal Batory. Theatrical poster for the operetta.

La femme sur le lit, France, 1994. **client**: Theatre National de la Colline,
d: Michal Batory. Theater poster.

Canteri, France, 2002. **client**: Theatre National de Chaillot,
d: Michal Batory. Theater poster.

Le Roi S'amuse, France, 2010. **client**: Theatre de L'Aquarium,
d/p: Pascal Colrat. Theater poster.

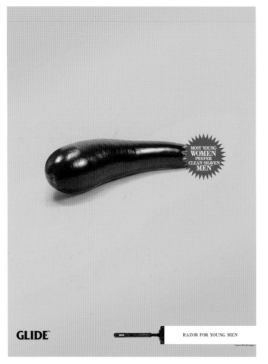

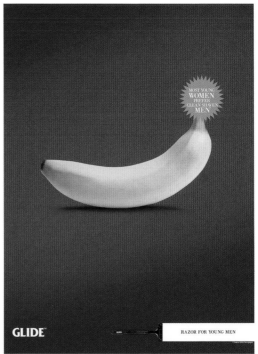

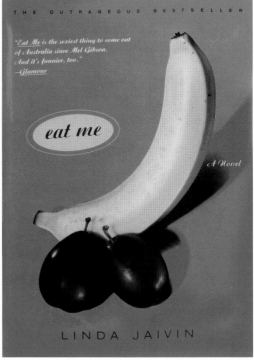

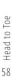

Razor for Young Men (Banana, Eggplant, Cucumber), India, 2013. **client**: Glide Razor, **agency**: BEI Confluence Communication, **cd/ad/d/ill**: Sonu Chandra, **c**: Manish Rajan, **p**: Nitesh Chakravarti. The series of ads tries to humorously capture the attention of college-going youngsters who are addicted to everything instant. The ad tried to bracket itself in the space of youngsters' liking for instant results.

Eat Me, USA, 1998. **client**: Broadway Books, **ad/d**: Roberto de Vicq de Cumtich, **p**: Peter McArthur. Two covers for a book about women who meet and talk about their sex lives. In the first chapter, one character talks about meeting a strange man at a twenty-four-hour supermarket and having sex in the produce section. Later you realize that the strange man is actually her boyfriend and they do this once a week.

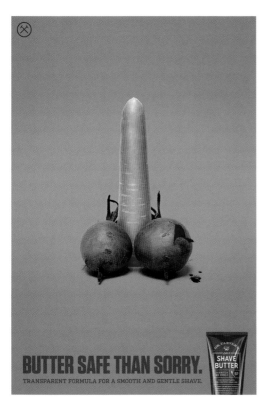

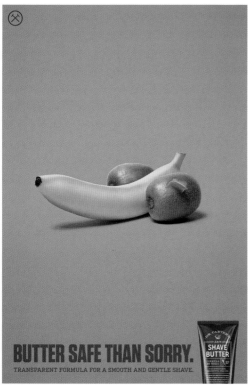

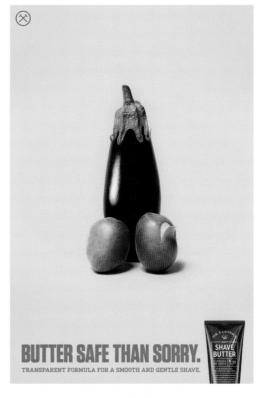

Fruits & Veggies, USA, 2017. **client**: Shave Butter by Dollar Shave Club, **cd**: Alec Brownstein, Matt Orser, Aron Fried, **ad**: Matt Knapp, Matt Orser, **c**: Alex Brownstein, Aron Fried, **p**: Mat Baker, **rt**: Karl Baker. Shave Butter by Dollar Shave Club knows you're "Butter Safe Than Sorry" with their transparent formula for a smooth and gentle shave.

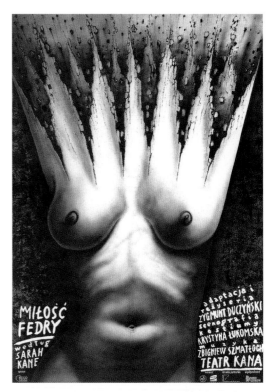

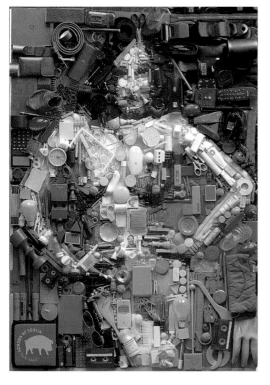

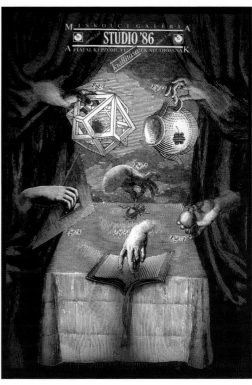

Material Girl, The Netherlands, 2007. **client**: SOS foundation (stitching Schoon of Schijn), **d**: Marlis Zimmerman (letterhand) & Xander Wiersma. Promotional poster.

Miłość Fedry—Phedra's Love No. 2, Poland, 2003. **client**: Theatre Kana, **cd/ad/d/c/ill/p**: Leszek Zebrowski. Poster for Theatre Alternative Kana.

Studio '86, Hungary, 1986. **cd/ad/d/ill**: István Orosz. Exhibition poster for the young artist's studio.

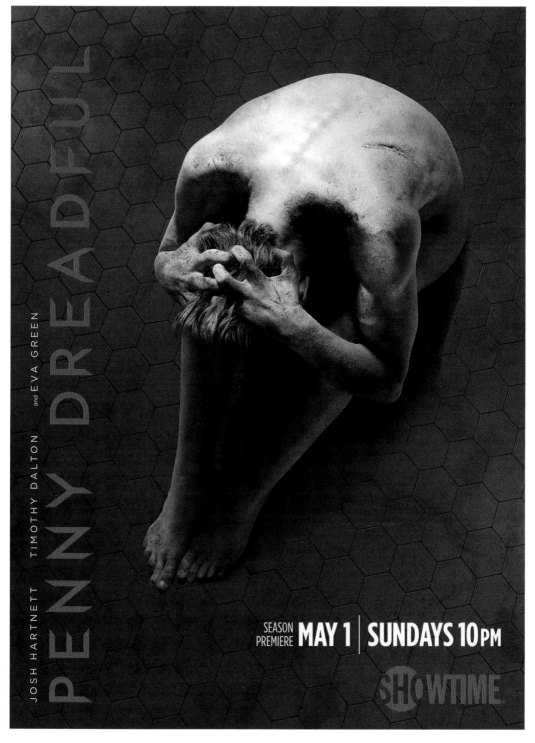

Penny Dreadful: The Final Season Key Art, USA, 2016. **client**: Showtime, **agency**: Concept Arts. Promotional poster. Showtime tasked the creative agency with creating an iconic and memorably dark piece of art for the final season of *Penny Dreadful*.

BODY

There is something eerie yet nonetheless awesome about tight, even clinical close-up photographs of human body parts. In the mind's eye we know what they are, but an extremely close crop can often suggest something totally different as well. The eye can be easily tricked into believing one thing is another — like the crook of an arm mistaken for the cleavage of a breast. Body parts are distinct from body language largely because these details are not, as a rule, symbolically making a statement but rather establishing a mood or atmosphere to suggest or shock the senses. Nonetheless, they can be witty, surprising, and profound. In art the body part is sometimes literal, other times abstract.

"At first glance," wrote William A. Ewing in *The Body: Photographs of the Human Form* (Chronicle Books, 1994), "Twentieth-century fragments appear to fall into three general categories." He notes that these include "the realist fragment," where the recognizable part of the body is the subject of "intense scrutiny" with each minute detail an aesthetic notation in the orchestration of the body. The second is "the formalist fragment," where the photographer casts the eye on the "outline, shape, volume, abstraction, and design." He wrote that "a geometry is constructed from the raw material of the body." The third notion is "the transformative or perhaps ambiguous fragment," which rejects straight on interpretations to "evoke some other order of being."

Of course, Ewing was referring to the concept of an artistic photograph, which is a genre that evolved over the late nineteenth and twentieth centuries starting when nudity—too much exposure of any kind for that matter—was taboo and even paintings of naked women and men, unless used in some exalted context, were frowned upon by polite society. Or accepted only in the netherworld of underground culture. But capturing the body's mysterious and ambiguous qualities ultimately became the subject of art and the basis for creative visualizations.

This section shows how those high-art creative visions have long been adapted to graphic design and advertising. How skin itself, with blemishes, creases, folds, and textures, combines with typography to communicate a kind of direct and indirect message. The most ambiguous of these compositions is "Body in Discourse" (page 64), which suggests writing on an epidermal surface, but other than the word "body" could be just about anything. Where as the three "Shame" posters on page 65, are so obviously a body because the details provide the visual information needed to give context to the

PARTS

forms. Conversely, the image for the "Fine Art of Tattooing" (page 79), showing the belly button as the oculus ceiling mural, is both beautifully clever and aesthetically beautiful.

It can be argued that such unforgiving, clinical details are un-erotic, but turning the page to the breasts, nipples, and buttocks on pages 66 and 67 are just as sexually charged as if the entire bodies were visible. Depending on the crop, lighting, and color, this type of detail—and especially "Silence" (page 67)—can trigger a sense of sensuality even more stimulating than the most intentional and prurient cheesecake pictures.

Some body parts are decidedly less sexually provocative when taken out of the original context. The belly button is a great example: it can be perceived as both sexy and unsexy depending on how it is contextualized. In "Babel," a Polish theater poster (page 68), the slablike chunk is not only void of any hint of sex appeal, the belly button has an unnatural quality. Likewise, the "Ken-Tsai Lee Promotion" (page 69) exudes an abnormal presence. Meanwhile, the cover of *Volkskrant* magazine (page 69) is not only the perfect belly button, and a funny commentary, but it has little erotic substance. Another clever, but not very sensual, depiction is the cover for Charles Buskowski's *Notes of a Dirty Old Man* (page

75), where the crack and a portion of the cheeks are perfectly situated on the book jacket spine. The design is brilliant but far from an actual turn-on. Also, rather than excite the libido of the viewer, the poster for the Dutch performance of *Troilus En Cressida* (page 74), a harnessed, bent-over buttock, is both violent and disturbing, while it makes the case that certain body parts can be powerfully repurposed. This poster was one that caused considerable criticism about female sexploitation when it was initially published.

Magic often occurs when body parts are made into patterns. "Plastics" (page 80), showing layers of skin smashed together in bright colors, transcends the human form while still suggesting human features. There are a few hints but otherwise, the fragments have very little relationship to actual body parts, and although they are so deliberately abstract and asexual, there is a curious sexuality.

Rearranging and distorting body parts, and creating new contexts to serve various alternative editorial or advertising purposes, is also a common trope for the conceptual designer. "Love Thy Body" (page 83) says this best. What is a better representation for a heart than a heart-shaped butt? That is part of the body's riddle.

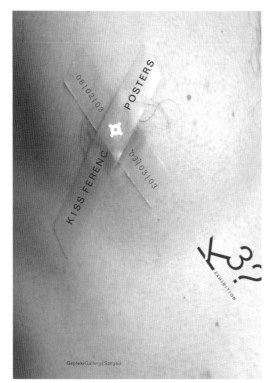

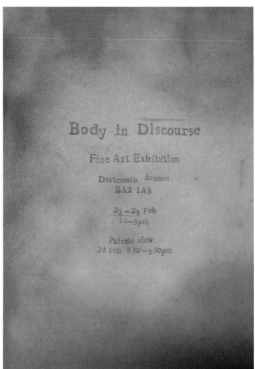

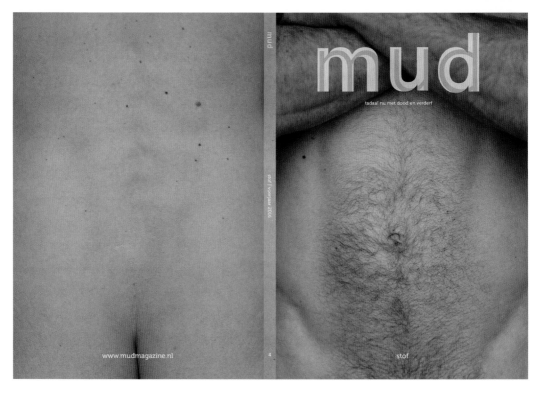

K3?, Hungary, 2004. **client**: In Memoriam Geriub Gepleki, Szeged, Hungary, **d/p**: Ferenc Kiss. Exhibition poster.

Body in Discourse, England, 2014. **client**: Bath Spa University, **d**: Carl Godfrey. Poster for an art exhibition about the human body. Letterpress is stamped into skin and photographed.

Mud Magazine, The Netherlands, 2016. **client**: Mud Magazine, **cd/c**: Sabine te Braake, **cd/ad**: Laury van Eerd, **p**: Hanneke Wetzer. *Mud Magazine* is an independent magazine about the city of Eindhoven in The Netherlands. The subjects in the magazine are art, design, fashion, and the people of the city. Every issue has a theme, and this one (edition #4) was "dust."

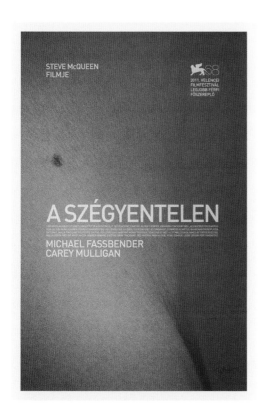

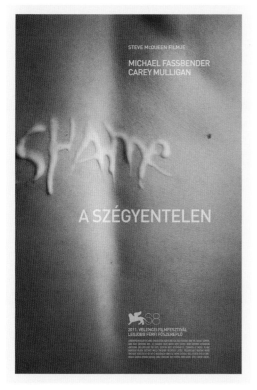

Shame, Hungary, 2011. **client**: Budapest Film, **cd/d**: Marci Kenczler, **p**: Eva Szombat, **food stylist**: Gyorgy Petrovics. Assigned to create a work that was provocative without being explicit in order to attract a younger audience to the film, the designer decided to use the body as a textural component and ended up creating a compelling work of art that raises many questions.

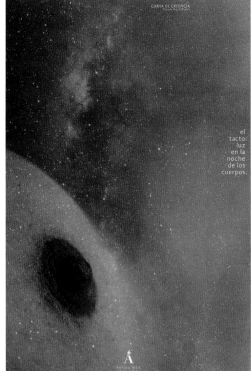

Volkskrant Magazine: Content Page, Netherlands, 2014.
client: Volkskrant Magazine, **cd**: Jaap Biemans, **p**: Robin de Puy. Despite
all the horror stories, young girls are still interested in breast augmentation.

OKT Theater Promo Poster, Lithuania, 2008. **client**: Oskaras Korsunovas
Theatre, **studio**: Moira Visuals, **ad**: Marius Bartkus, **d**: Jolanta Vasiliauskyte.
OKT decided to cut all relations with the theatrical reality of that time and
created a new reality based on a contemporary theater language.

Vrij Nederland: Sex Summer Issue, Netherlands, 2011.
client: Vrij Nederland, **cd**: Jaap Biemans. Magazine cover.

Octavio Paz / el tacto: luz en la noche de los cuerpos, Mexico, 2016.
client: Studio la fe ciega, **cd/ad/d/c/p**: Adán Paredes Barrera. Poster
designed for an exhibition commemorating the one-hundredth anniversary
of the Mexican poet Octavio Paz.

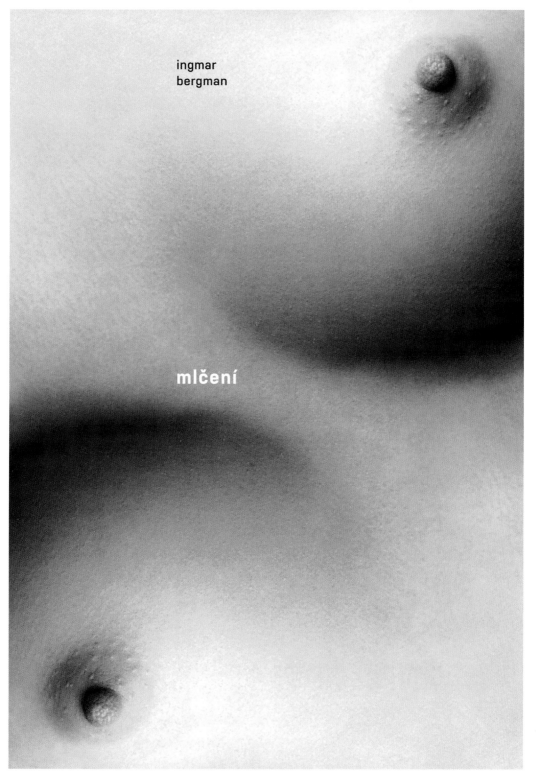

ingmar
bergman

mlčení

The Silence, Czech Republic, 2014. **client**: Studio of Graphic Design 1, FAD JEP University in Usti nad Labem, Czech Republic, **lector**: prof. ak. mal. Karel Míšek, PhD., **d**: Lenka Stukhejlova. Poster for the movie *The Silence*, directed by Ingmar Bergman. This psychological drama focuses on the intimate lives of two sisters.

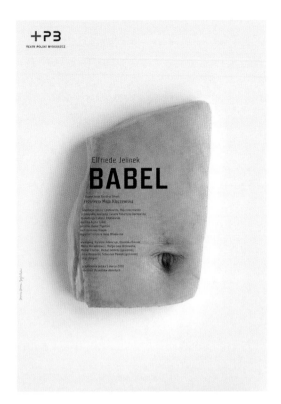

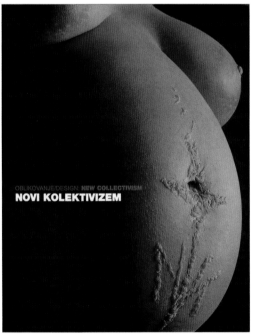

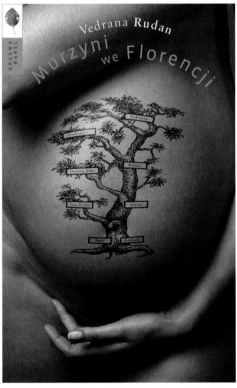

Head to Toe

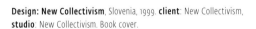

Design: New Collectivism, Slovenia, 1999. **client**: New Collectivism, **studio**: New Collectivism. Book cover.

Babel, Poland, 2010. **client**: Polski Teatre Bydgoszcz, **studio**: Homework, **cd/ad/d**: Joanna Górska, **cd/ad/d/p**: Jerzy Skakun. Theater poster for a modern play by Elfriede Jelinek about victims of war.

Les Africains A Florence, Poland, 2010. **client**: Drzewo Babel, **d**: Michal Batory. Cover for a book by Vedrana Rudan.

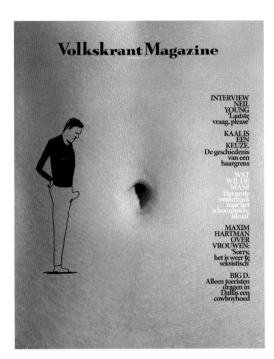

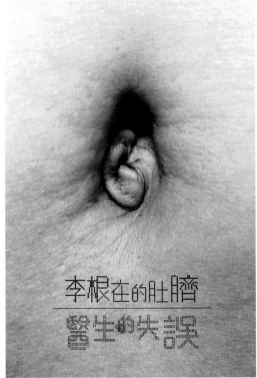

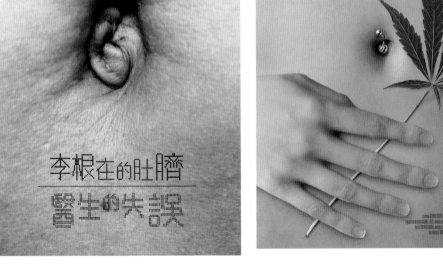

Volkskrant Magazine: What Do Guys Prefer?, Netherlands, 2014. **client**: Volkskrant Magazine, **cd**: Jaap Biemans, **ill**: Paul Faassen. What do guys prefer? A survey about beauty preferences among men.

Ken-Tsai Lee Promotion, Taiwan, 2010. **client**: New Ads Co., Let, **cd/ad/c/ill**: Ken-tsai Lee. New Ads focused on outdoor rentals in order to promote their company.

Lyra Magazine, UK, 2016. **client**: Cool Gray Ltd., **cd**: Georgina Gray, **ad**: Sami Jalili, **p**: Sasha Kurmaz. *Lyra* is a quarterly print magazine offering bold perspectives on society, politics, and the arts.

The Crop, Australia, 2004. **client**: Miracle Productions, **cd**: Demi Hopkins, **p**: Skeet Booth. The film is set around the time random breath testing was introduced in Australia. The poster was a cheeky nod to the *American Beauty* film poster.

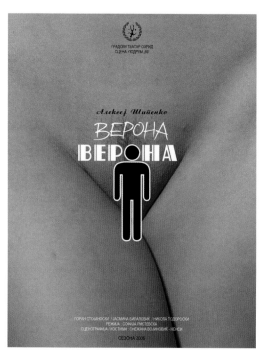

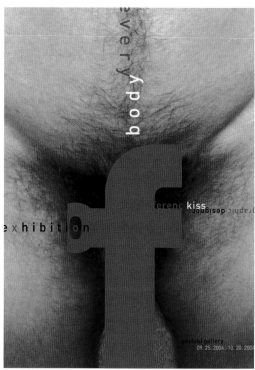

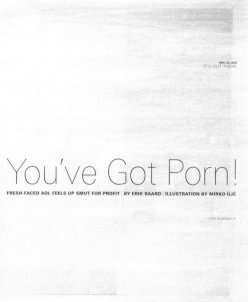

Verona, Verona, by Alexei Shipenko, Macedonia, 2006.
client: City Theater Ohrid, **d**: Vladimir Trajanovski, **p**: stock photo.
The play was about the sexual desires of the man and the rejection
of the woman, and their explicit talk, quarrels, and vulgarity.

Every Body . . ., Hungary, 2004. **client**: In Memoriam Geriub Gepleki,
Szeged, Hungary, **d/p**: Ferenc Kiss. Exhibition poster.

You've Got Porn, USA, 2000. **client**: The Village Voice, **ad**: Ming Uong, **d/ill**: Mirko Ilić. Comically cutting pubic hair to resemble the AOL logo.

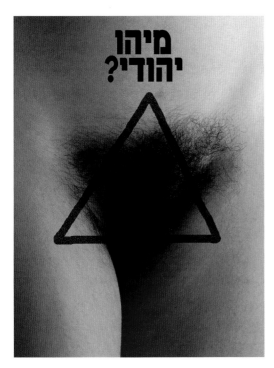

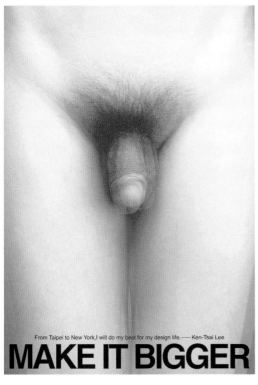

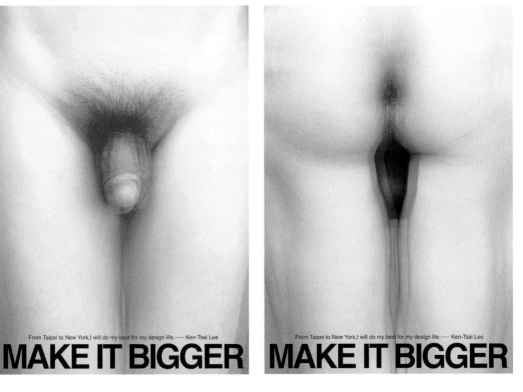

Who Is a Jew?, Israel, 1996. **client**: Tower of David Museum, Jerusalem,
cd/ad/d: Yossi Lemel, **p**: Yair Carmel. A protest against the strict Rabbinical
establishment that controls the convention laws in Israel. This poster was
created for an exhibition at the Tower of David Museum in Jerusalem in
1996 and was later censored.

Make It Bigger, Taiwan, 2004. **client**: Self-Promotion, **cd/d/c/ill**: V Lee. Promotional poster.

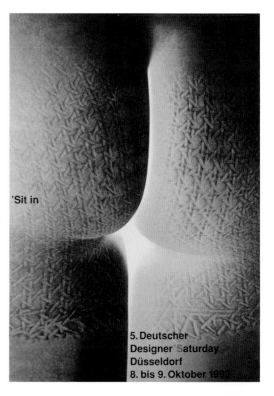

'Sit in

5. Deutscher
Designer'Saturday
Düsseldorf
8. bis 9. Oktober 1993

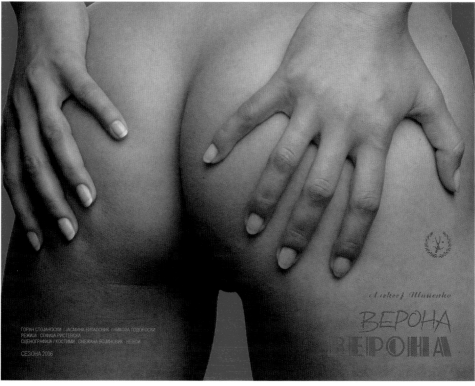

"Sit in. 5th German Designer" Saturday Düsseldorf, Germany, 1993.
client: Design Center North Rhine-Westfalia, Essen, **d**: Uwe Loesch.
The pattern on the butt results after half an hour sitting on the famous
coffeeshop chair, N 214, by Michael Thonet.

"Verona, Verona," by Alexei Shipenko (version 2), Macedonia, 2006. **client**: City Theater Ohrid, **d**: Vladimir Trajanovski. Theater poster.

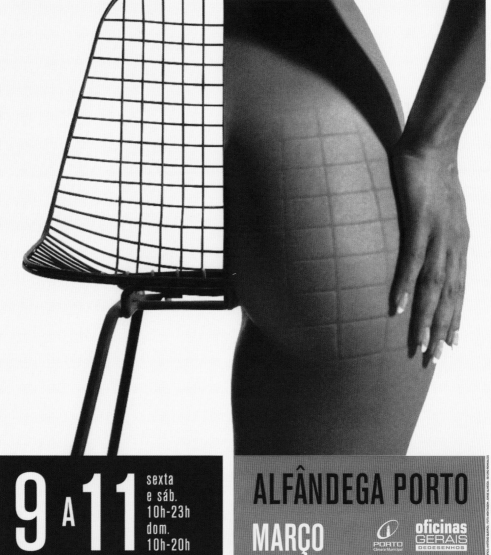

FEIRA DE OBJECTOS

DE DESIGN E DECORAÇÃO

STOCK.OFF.012

9 **A** **11** sexta e sáb. 10h-23h dom. 10h-20h

ALFÂNDEGA PORTO

MARÇO PORTO Câmara Municipal oficinas GERAIS DEDESENHOS

StockOff 2012 – Design and Decoration Objects Fair, Portugal, 2012. **client**: Oficinas Gerais de Desenhos, Lda, **cd/ad**: António Queirós, **d**: Jorge Almeida, **p**: Ciro Romualdi. The idea was to "stop the traffic." The main piece of communication was outdoors and about 16.5 feet high. It was not easy to convince the mayor's office to allow this kind of approach, but after twenty days of discussions, the traffic department finally authorized this artwork to be placed at the exhibition building.

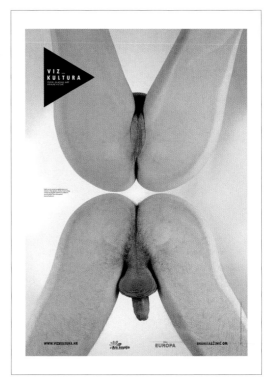

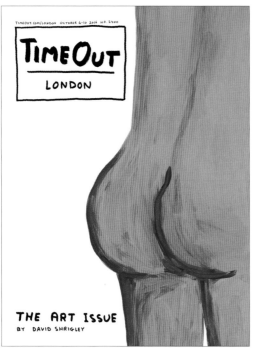

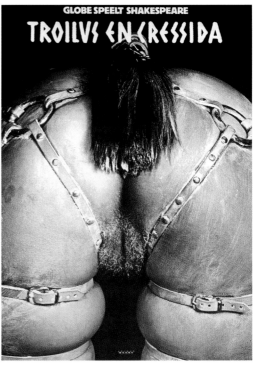

Time Out London, The Art Issue, UK, 2016. **client**: Time Out,
ad: Mark Neil, **ill**: David Shrigley. This *Time Out* Art Issue was designed
by British artist David Shrigley—best known for his distinctive drawing
and hand-lettering style.

Discomfort, Croatia, 2014. **client**: Vizkultura.hr, **agency**: Bruketa&Žinić OM,
cd/ad/d/c: David Bruketa, Nikola Žinić, **p**: Domagoj Kunić. A Croatian
online magazine asked designers to create posters commenting on social
and cultural phenomena and what makes people uncomfortable.

Troilus en Cressida, The Netherlands, 1980. **client**: Zuidelijk Toneel
Globe, **cd/d/p**: Anthon Beeke. The women's movement thought this
poster was a disgrace, but it definitely got people talking.

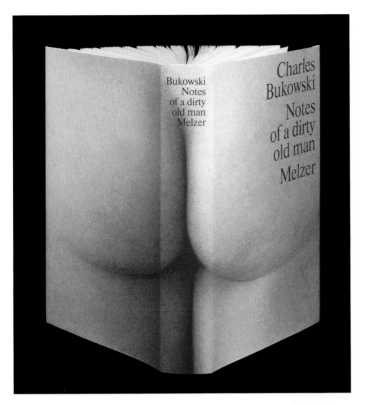

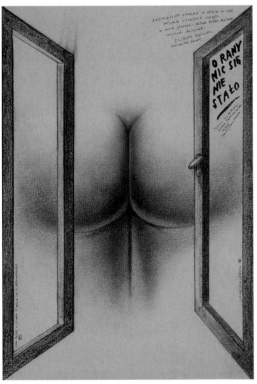

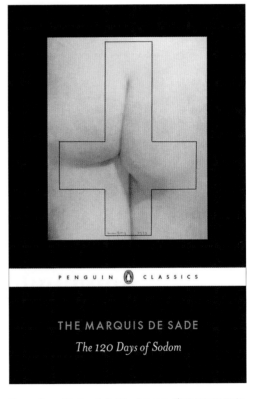

Notes of a Dirty Old Man, Germany, 1969. **client**: Melzer, **cd/ad/d**:
Pierre Mendell, **p**: Klaus Oberer. The book cover design perfectly illustrates
the content of the book.

Oh Boy, Nothing Happened, Poland, 1987. **client**: Studio Filmowe
im. Irzykowskiego, **d**: Lech Majewski. Film poster.

The 120 Days of Sodom, United KIngdom, 2016. **client**: Penguin Books,
ad: Jim Stoddart, **art editor**: Isabelle de Cat, **p**: Monument a D.A.F. de Sade.
A cover for a new translation of Sade's notorious novel.
1933 ©Man Ray Trust/ADAGP, Paris and DACS, London 2016 (Photograph ©Telimwage)

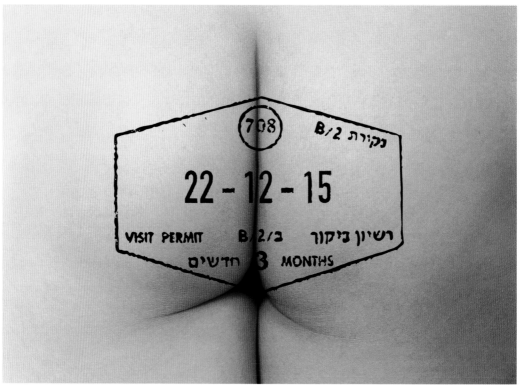

Het Parool, The Netherlands, 2014. **ad**: John Koning, **p**: Rein Janssen, **photo editor**: Michiel van den Berg. This image, by the Dutch artist Rein Janssen, was made for an article about the way prisoners succeed in smuggling things inside the prison walls.

Visit Permit, Israel, 2015. **client**: Beit Ha'ir Museum Tel-Aviv, and Clipa Theatre, **cd/ad/d/c/p**: Matan Shalita. An image created for the catalog edition of an art exhibition entitled "Facility 27" in Beit Ha'ir Museum in Tel Aviv, which simulated a detention facility for artists who voiced subversive opinions challenging the regime in Israel. The exhibition included activist performance pieces from the artists of the Israeli Clipa Theatre, famous for their provocative and groundbreaking works.

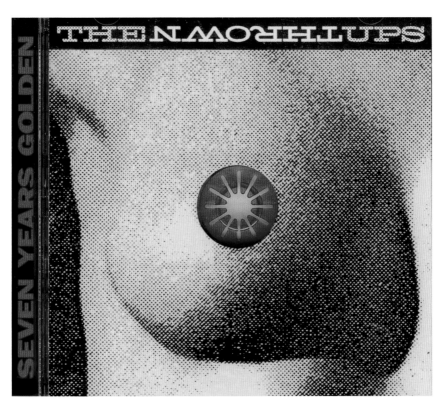

The Thrown Ups, 1993. **client**: Amphetamine Reptile Records, **ad/d**: Art Chantry. The Thrown Ups were a band that existed for seven years in the late 1980s/early 1990s. Based out of Seattle, they were part of the proto-grunge music scene. Their technique was to storm the stage, use the other bands' equipment, and play their songs, which were usually made up on the spot. Graphic designer Marla Katz made a quick sketch of a large breast on the cover of the record. From that, the center was die-cut to reveal the red, plastic "clip" device that holds the CD disk in the jewel box. Conveniently, that clip is commonly referred to as a "nipple." The back cover is simply the logical "end."

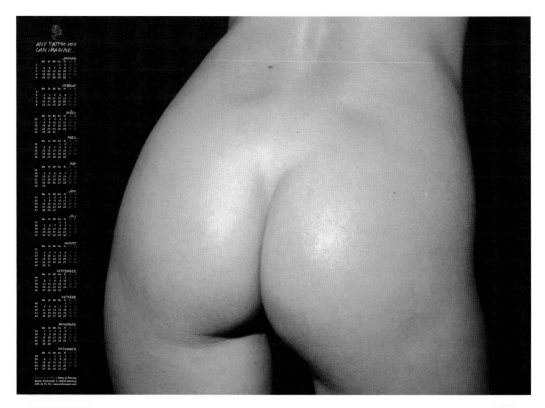

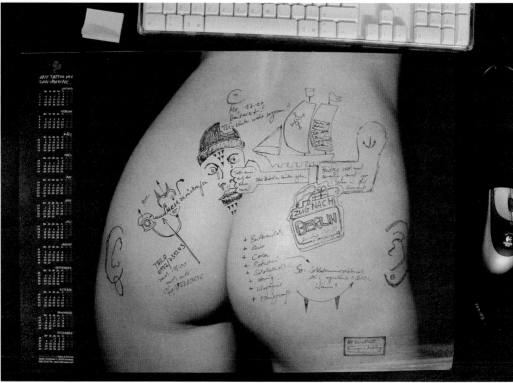

Any Tattoo You Can Imagine, Germany, 2004. **client**: Endless Pain Tattoo & Piercing, **cd**: Kai Eichner, Michael Reissinger, **ad**: Marc Leitmeyer, **d**: Kaja Franke, **c**: Daniel Hormes, **p**: Hans Starck. The famous tattoo and piercing studio Endless Pain in Hamburg, Germany, is the right address for everybody wanting to express themselves with an individual tattoo. The "naked" calendar was handed out to customers so they could design their very own tattoos and return to Endless Pain to get them done.

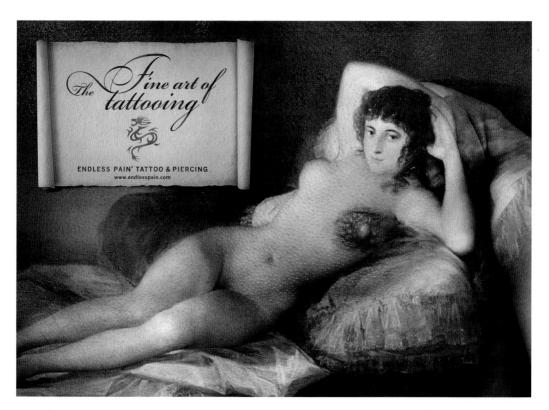

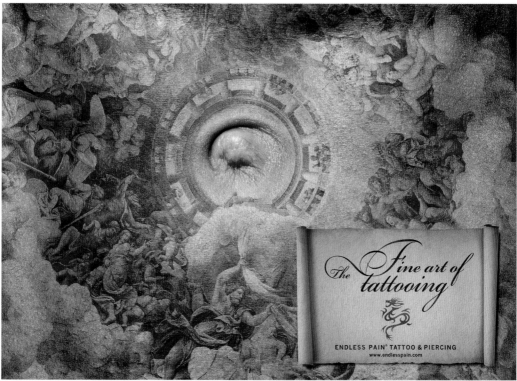

The Fine Art of Tattooing, Germany, 2008. **client**: Endless Pain Tattoo & Piercing, **cd**: Kai Eichner, **ad**: Marc Leitmeyer, **d**: Fabian Hinzer, **c**: Jan Blumenthal, **p**: Hans Starck. In the German tattoo scene, Endless Pain has an exquisite reputation and is well known for its artistic skills and aesthetic tattoos. The campaign, which appeared in tattoo and town magazines, follows the concept that tattoos by Endless Pain are more than just tattoos—they are pieces of art. That's why the print ads show paintings, which only at second glance turn out to be tattoos.

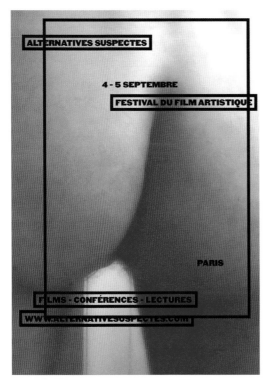
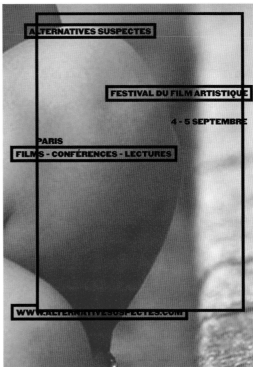
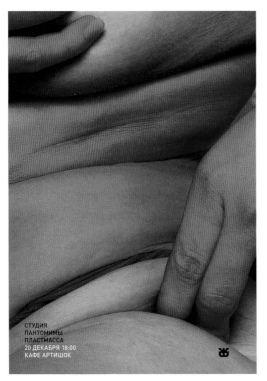
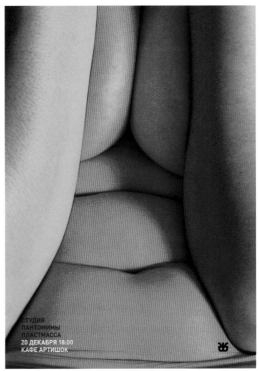

Suspicious Alternatives, France, 2013. **client**: ARF Festival, **cd**: Drenna Velshouweg, **ad/d**: Suleyman Yazki, **p**: Renzo Amadio, Jean Jacques Fotoy, Elodie Martin. The artistic film festival is an essential summer event for the Parisian public. The films shown are created by young emerging talents. The dynamic identity created through the posters relates all these elements with an optical set that evokes moving frames.

Plastics, Russia, 2009. **client**: Studio Pantomime "Plastics," **studio**: Zhishi, **cd/ad/d/p**: Elena Kostirina, **d**: Yuliya Lukyanchenko. The series of posters for Studio Pantomime "Plastics" show an unusual point of view of the human body, transforming it into a colored art object.

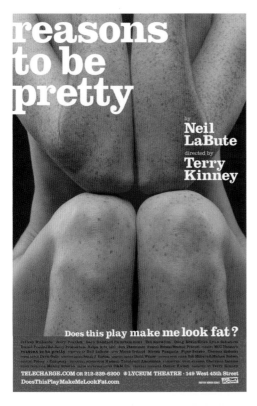

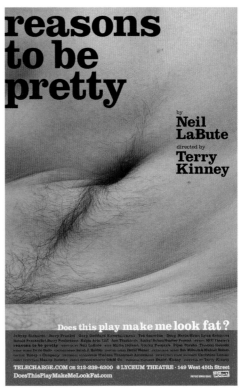

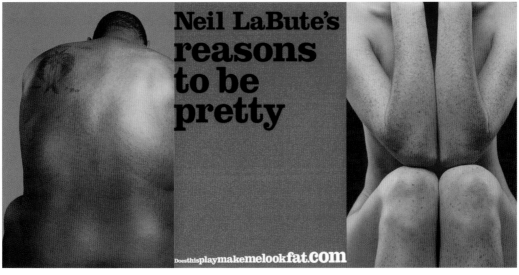

Reasons to Be Pretty, USA, 2009. **client**: SpotCo, **ad/d**: Nicky Lindeman, **p**: Howard Schatz. Neil LaBute's play focuses on America's obsession with physical appearance. Hoping to make the viewer question their own ideas about beauty, the design team chose to use images featuring "real" people instead of models. The posters were mainly displayed in streets and subway stations where the giant nude photos, coupled with the simplicity of the type, made for impactful and unexpected marketing.

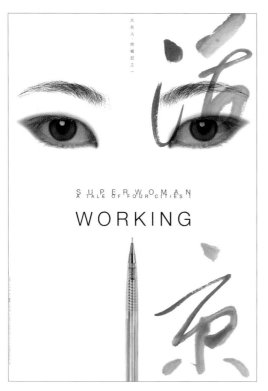

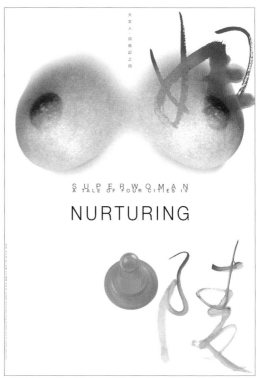

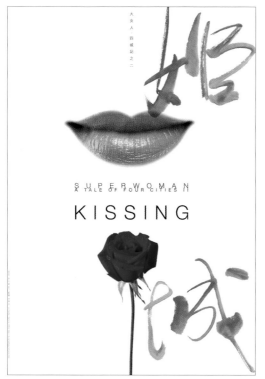

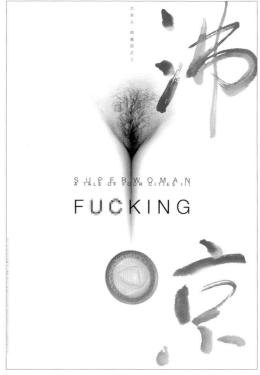

Superwoman—Working, Hong Kong, 2003. **cd/ad**: Kan Tai-Keung.
With the theme on the fictitious city "working" in China, this work tells
about the life of modern women: Working.

Superwoman—Kissing, Hong Kong, 2003. **cd/ad**: Kan Tai-Keung.
With the theme on the fictitious city "kissing" in China, this work tells
about the life of modern women: Loving.

Superwoman—Nurturing, Hong Kong, 2003. **cd/ad**: Kan Tai-Keung.
With the theme on the fictitious city "nurturing" in China, this work tells
about the life of modern women: Nurturing.

Superwoman—Fucking, Hong Kong, 2003. **cd/ad**: Kan Tai-Keung.
With the theme on the fictitious city "fucking" in China, this work tells
about the life of modern women: Fucking.

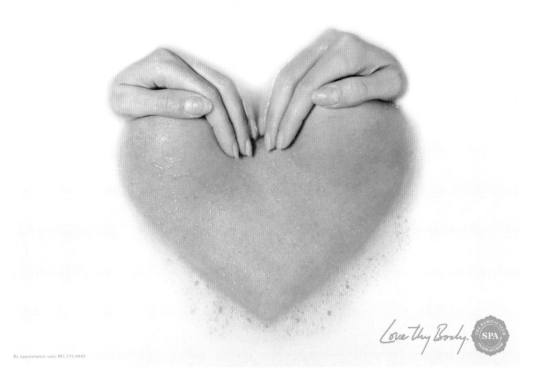

By appointment only 981.173.9863

Love Thy Body. SPA

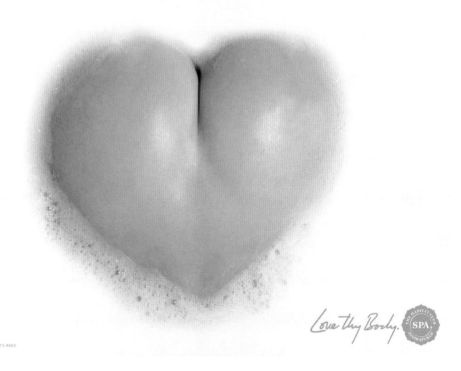

By appointment only 981.173.9863

Love Thy Body. SPA

Love Thy Body, India, 2011. **client**: The Habitat Cub Spa, **studio**: Out of the Box, **cd/c**: Viral Pandya, Sabu Paul, **ad/d**: Viral Pandya, **ill/p**: Sunil Singh, **typographer**: Ajay Yaday. The Habitat Club Spa wanted to tell its clientele to pamper, celebrate, and fall in love with their bodies. And what better way to express this than showing the human body as the universal motif of love: a heart.

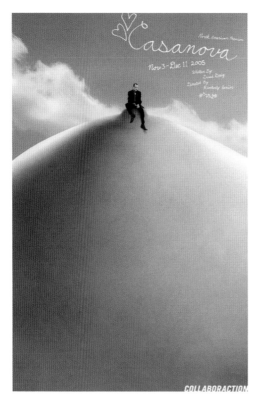

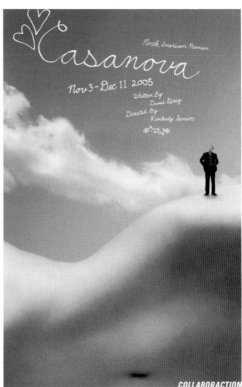

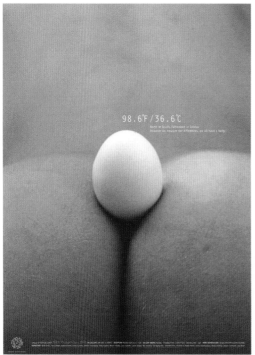

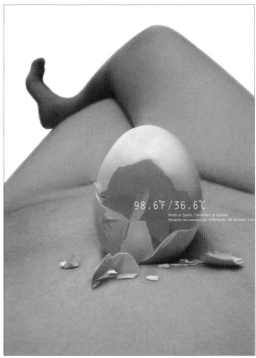

Casanova, USA, 2005. client: Collaboraction Theater Company, Chicago, studio: Bagby and Co., cd/d: Robin Wisser, d: Dan McBride, p: Sebastien Augustin. Theater poster.

98.6°F / 36.6°C, USA, 2002. client: class assignment (School of Visual Arts MFA Design), cd/ad/c: School of Visual Arts MFA Design Class 2003, d/p: Kiki Katahira, Tarek Atrisi. Series of posters for a body-themed graphic exhibition, 98.6°F / 36.6°C.

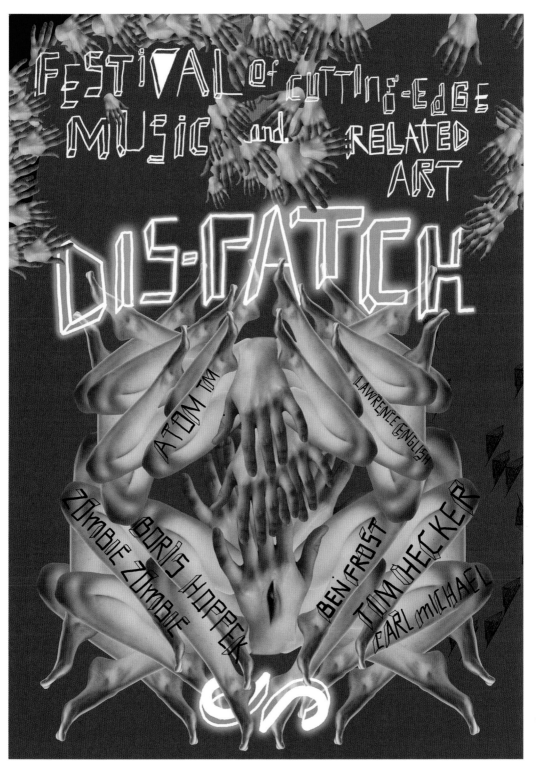

Posters for Dis-Patch festival, Serbia, 2010. **client**: Dis-Patch festival, **studio**: TeYosh, **cd/ad/d/ill/p**: Sofija Stanković, Teodora Stojković.
Dis-Patch is a festival featuring cutting-edge music and related art that is held annually in Belgrade.

BODY

Ghastly as it sounds, human skin has been employed as a drawing and writing surface for thousands of years. Images and letters have been cut, scratched, scrawled, and seared on all parts of the body for all kinds of reasons. Some are permanent; some are temporary. Indelible tattoos and erasable markings in paint, dye, and pigment produced as variously different forms have, for the wearer, symbolized status, belief, and ownership—and, doubtless, scores of other things. They suggest ideas mystical and practical. They've been used to adorn, decorate, and identify as well as celebrate, honor, and punish. They are marks of power and powerlessness. The earliest known tattoos were at one time traced to ancient Egyptian mummies dated to c. 2000 BC but that date was recalculated when it was learned by scholars that primitive man wore them as far back as fifty-two hundred years ago.

For primitives, body art was ritualistic expression, a means of showing position and honor in the community. For contemporary cosmopolitans and hipsters, it is style and fashion. For the average current human being there are dozens of reasons for conceiving and creating body markings—as souvenir, declaration, and memory of, or homage to, person, place, or thing. There are many outlets for discussions and analysis of tattoos, past and present, and countless designs for today's tattoo aficionado to wear. What once was considered (and in some cultures continues to be) body desecration has earned a vaunted place in the art world and has become a business with its own pantheon of tattoo-lettering practitioners.

In the early twentieth century, tattoos were stigmatized (even illegal in some jurisdictions) because of their association with raunchy male imagery. Middle-class women who were tattooed knew they would be considered "loose" or seedy if they showed their marks. By the 1960s and 1970s, tattooing became more directly linked to the counterculture, and remained so until the 2000s. Now tattoos are not as subversive or associated with "bad" women—instead, they have become fashion accessories of the most indelible kind. "The tattoo is no longer quite the symbol of rebellion and subculture it once was," wrote Katharine Schwab for *The Atlantic* (December 3, 2015). "Roughly one in five Americans has one, and that rate is much higher for the Millennial than their Boomer counterparts."

It is no wonder that this once subversive activity has brashly found its way into all manner of graphic design and advertising.

TEXT

Body texts and messages accomplish two things at once: They use nudity (still something of a taboo) as a vehicle for conveying messages and ideas and speedily draw the eye to those words.

Is body text design? The answer, in the broadest sense, is yes. Some of the earliest advertising was somehow affixed to the body. Before T-shirts, there were body texts and tattoos. As the computer and the global society make us indistinguishable from one another, people want to individuate themselves. Today tattoos co-exist with the rise of the DIY sensibility, of hand-crafted goods. There are people who do it to be distinct and then others who simply follow the crowd, lemming-like, not realizing that in fifty years they are going to have unsightly blemishes—or shall we say advertisements—for things they no longer want to advertise.

Not all body text is an indelible mark or figure drawn upon the body. Yet tattoos did give rise to various faux or tattoo-like graphic manifestations, from painting type and image to applying stickers to, as Stefan Sagmeister shows (on page 92) cutting with razor blades so that scabs form the words on his body. They eventually heal and disappear—and it is not recommended since it does hurt. So most body text is produced with paint and marker, some more ambitious than others. In fact, some more legible than others.

While the words for Poezin Party (page 92) and Gut Feeling (page 93) are easily read in a glance, the manifestos on Jeg Skal aldri bli som dem (page 94) and the Count on Me poster series (page 95), demand a little more concentration to follow the body narrative. Complexity is impressive but simplicity like "Obsession and Fantasy" (page 97), which makes a visual pun of a woman's nipple, and the masthead for *Metropoli* magazine (page 102), which uses a woman's breast in the same spirit—as letters in the title—are easier to read and, thus, appreciate.

We must also applaud the ingenuity and consistency of the alluring use of body text for the Théâtre 13 posters (page 90 and 91) and the clever cutting of the poster for Shakespeare's *Julius Caesar* (page 92). Theater Goes Under The Skin (page 98) is eerily surrealistic and Dostotevsky's *Crime and Punishment* (page 98) never looked so startling. However, there is a danger that using too much body text can lose the power to shock and awe. Just as with so many people getting tattoos, the thrill is diminished, so too the body as tabula rasa can be tiresome.

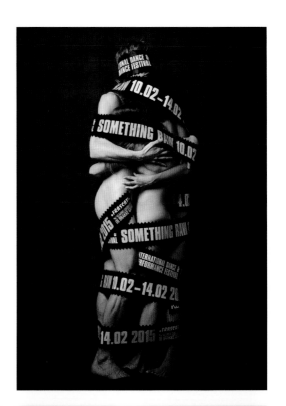

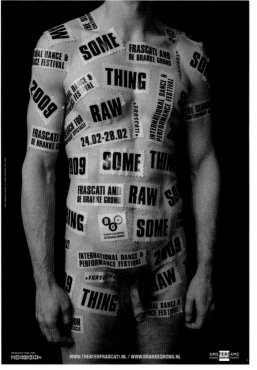

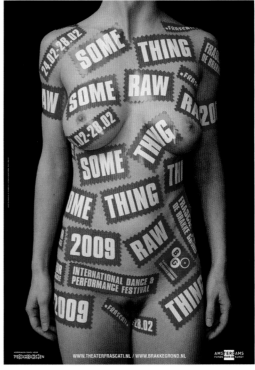

Something Raw, The Netherlands, 2015. **studio**: De Designpolitie,
cd: Richard van der Laken, **ad**: Sara Landeira, **p**: Arjan Benning.
Poster for the dance festival, Something Raw.

Something Raw, The Netherlands, 2009. **client**: Frascati Theatre Amsterdam, **studio**: De Designpolitie, **cd**: Richard van der Laken, **ad**: Sara Landeira,
p: Arjan Benning. Two posters for the dance festival, Something Raw.

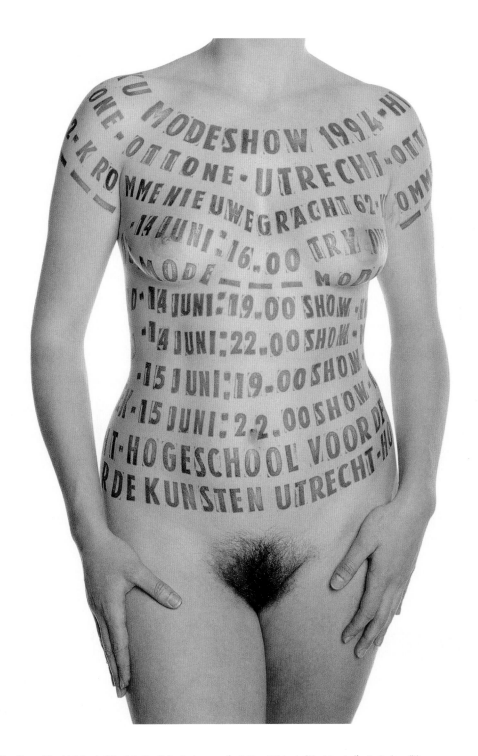

Fashion Show, Utrecht School of the Arts, The Netherlands, 1994. **client**: Utrecht School of the Arts, **studio**: De Designpolitie, **cd/ad/d**: Richard van der Laken. Poster for the final exam show at the Utrecht School of the Arts fashion department. The model is dressed with the information.

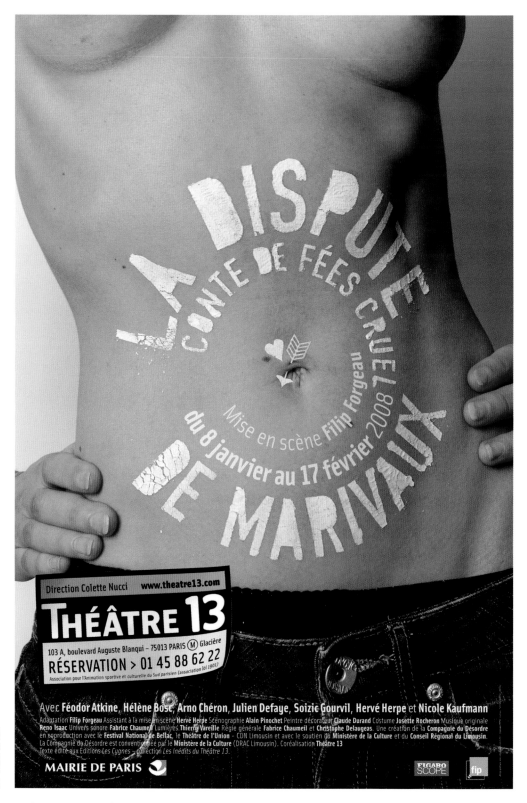

La Dispute, France, 2008. **client**: Théâtre 13, Paris, **d**: Cédric Gatillon. This series of posters uses the body of the actor as the surface for the title using different techniques, always related to the play.

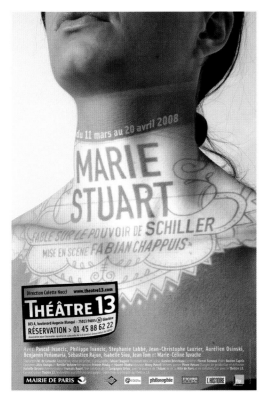

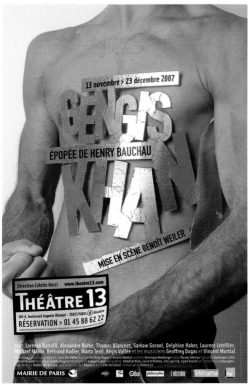

Gengis Khan, France, 2007. **client**: Théâtre 13, Paris, **d**: Cédric Gatillon.
Theater poster.

Le Timide, France, 2008. **client**: Théâtre 13, Paris, **d**: Cédric Gatillon.
Theater poster.

Marie Stuart, France, 2008. **client**: Théâtre 13, Paris, **d**: Cédric Gatillon.
Theater poster.

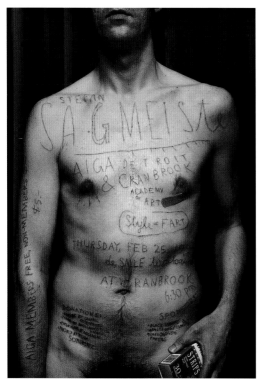

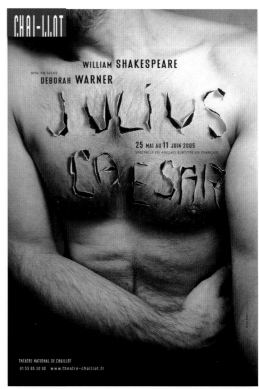

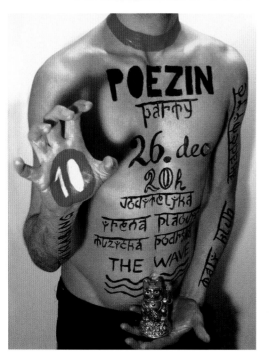

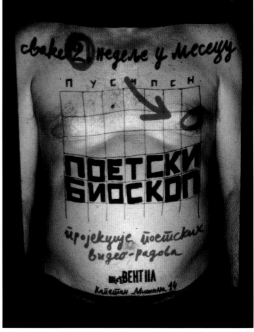

AIGA Detroit Poster, USA, 1999.
client: AIGA Detroit, **ad**: Stefan Sagmeister, **p**: Tom Schierlitz. "For this lecture poster we tried to visualize the pain that seems to accompany most of our design projects. Our intern, Martin, cut all the type into my skin. Yes, it did hurt real bad."—Stefan Sagmeister

Poezin Party 10 Poster, Serbia, 2011. **client**: Poezin,
cd/ad/d/p: Dragana Nikolić. Body art poster for an underground poetry performance event.

Julius Caesar, France, 2005. **client**: Theatre National de Chaillot,
d: Michal Batory. Theater poster.

Poetic Cinema, Serbia, 2010. **client**: Poezin,
cd/ad/d/ill/p: Dragana Nikolić. Posters were made to promote the event Poetski bioskop (Poetic Cinema), a showing of short poetry films and videos.

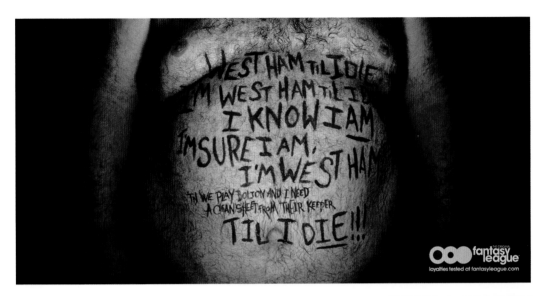

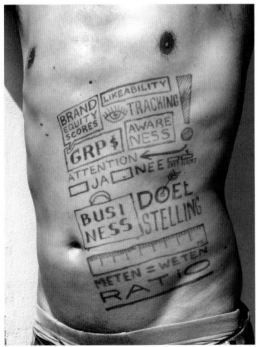

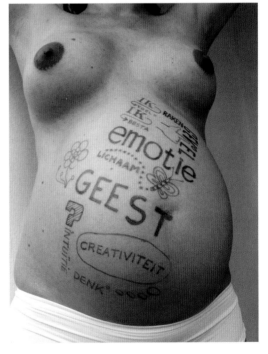

Fantasy League, UK, 2006. **client**: Telegraph Fantasy League, **agency**: CHI & Partners, **cd**: Ewan Paterson, **ad/c**: Matt Coller, Wayne Robinson, **d**: Craig Ward, **p**: Conor Masterson. A visual campaign that targets the thought of "loyalties tested," by taking well known football chants and changing them slightly.

Gut Feeling, The Netherlands, 2008. **client**: Adformatie, **studio**: Me Studio, **cd**: Erick Kessels, **ad/d/c/ill/p**: Martin Pyper. Two illustrations for a magazine article on using intuition and gut feeling versus rational thought and science in marketing. Image one has words such as: intuition, soul, emotion, creativity, feeling. Image two has words such as: brand equity, targets, measures, accountability, etc.

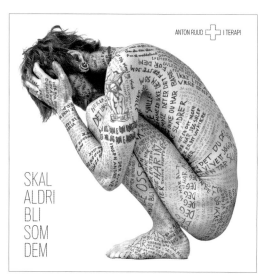

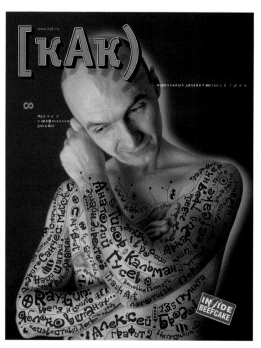

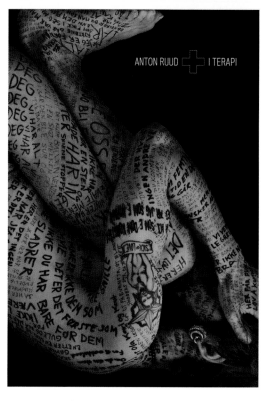

Jeg Skal aldri bli som dem, Oslo, Norway, 2013.
client: Anton Ruud i Terapi, **cd/ad/d/c/ill**: Egil Arntzen,
p: Dan Nachtnebel. Music poster.

kAk Magazine, Russia, 1999. **client**: kAk Magazine, **cd/ad**: Peter Bankov,
d: Mike Loskof, **c**: Denis Požarsky, **ill**: Vlad Vasiliev. Magazine cover.

The New Generation Would Leave Nothing to Chance, Serbia, 2015.
client: Institut français Novi Sad, Serbia, **d/p**: Nikola Berbakov,
c: Guy Debord. Posters and postcards made by compositing an image of
multiple laser drawings. All the works include situationist slogans, mostly
from Guy Debord's work *The Society of the Spectacle*.

Jeg Skal aldri bli som dem, Norway, 2013. **client**: Anton Ruud i Terapi,
cd/ad/d/c/ill: Egil Arntzen. Music poster.

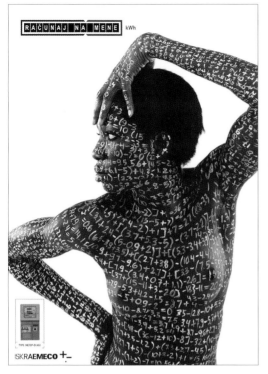

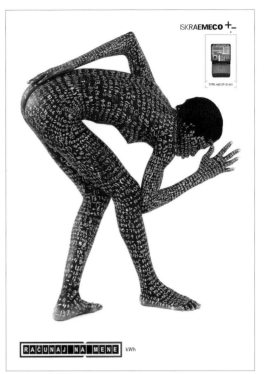

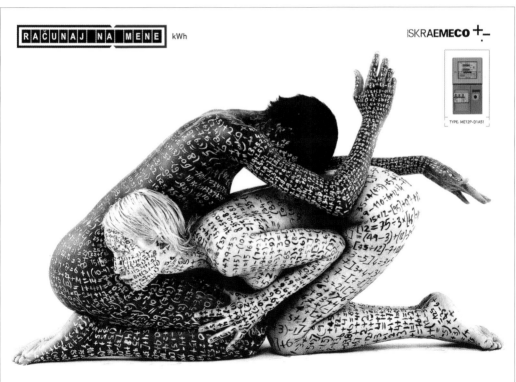

Count on Me (Poster Series), Bosnia & Herzegovina, 2000. **client**: Iskraemeco, **cd/ad/c**: Anur Hadžiomerspahić, **ad**: Ajna Zlatar **d**: Tarik Zahirović, **p**: Max Zambelli. Advertising campaign for a company that produces electricity meters. The client wanted to convey the message of reliability for the future. All of the mathematical operations written out on the bodies of the models are correct and accurate.

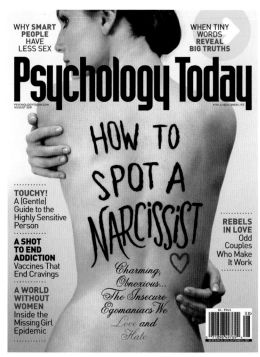

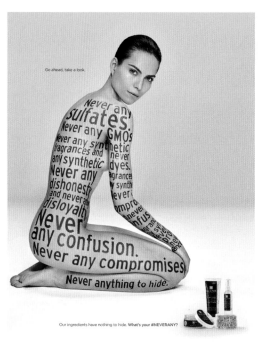

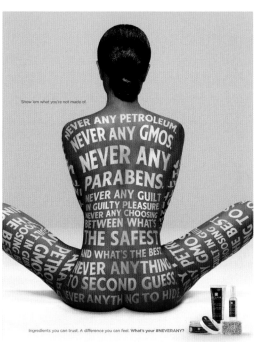

Psychology Today Magazine – Narcissist, USA, 2011. **client**: Sussex Publishing, **cd/ad**: Edward Levine, **p**: Jeff Riedel, **calligraphy**: Joel Holland. Photographing the model from behind created mystery, and allowed for the use of the back as a canvas for type.

Never Any, USA, 2017. **client**: Eclair Naturals, **cd**: Dena Mosti, **c**: Tanya Wasyluk, **p**: Ruven Afanandor, **body painting**: Joanne Gair, **retouchers**: Michal Kicior & John Blumen. By using striking poses and bold declarations, Eclair Naturals made a clear statement of their new product line's commitment to product purity and transparency.

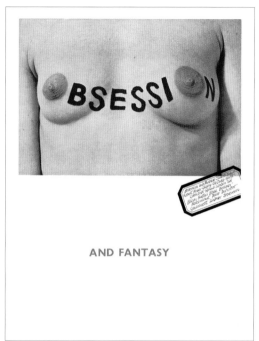

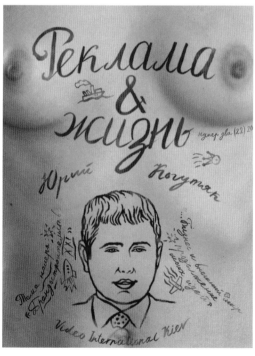

Riverview, Poland, 2012. **client**: Polski Teatre Bydgoszcz, **studio**: Homework, **cd/ad/d**: Joanna Górska, **cd/ad/d/p**: Jerzy Skakun. Theatrical poster for experimental monodrama based on PJ Harvey's texts and music.

Advertising & Life Magazine Cover, Russia. **client**: Grebennikov Publishing House, **cd/ad**: Peter Bankov, **d/ill**: Vlad Vasiliev **d**: Mike Loskof. A project about contemporary Russian advertising.

Obsession and Fantasy, London, 1963. **client**: Robert Fraser Gallery, **cd/d**: Robert Brownjohn. Printed matter.

Henna Cover, Print Magazine, USA, May 2000. **client**: Print Magazine, **cd/ad/d**: Steven Brower, **ill**: Yuko Makamura, **p**: Barnaby Hall. "When an article on henna was scheduled I knew it had to be the cover. I designed a stencil of cover lines and hired Yuko to apply and Barnaby to photograph. It was all done live on camera."—Steven Brower

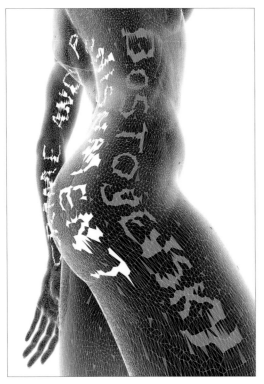

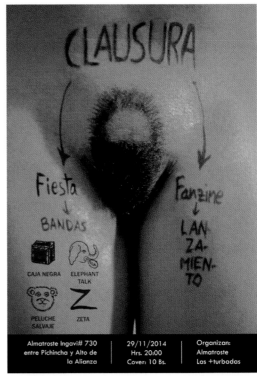

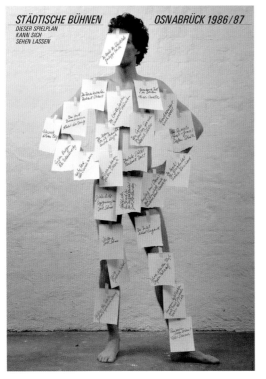

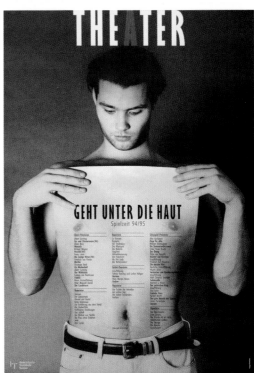

Crime & Punishment, USA, 2015. **client**: Strelka International Design Festival, **cd**: Daniel Warner. Editorial illustration and poster celebrating the 150th anniversary of Fyodor Dostoyevsky's *Crime and Punishment*.

Städtische Bühnen Osnabrück, Germany, 1986–1997. **client**: Städtische Bühnen Osnabrück, **cd/ad/d/p**: Holger Matthies. All pieces of the theatrical season can be found on the body.

Closing, Bolivia, 2014. **client**: Collective "Las +turbadas," **ad/d/ill/p**: Claudia N. Vargas Gorena. Poster made for the closing party of "Las +turbadas," a group focused on gender and LGBTQ+ themes, and premiere of the fanzine called *Closing*.

Theater Goes Under the Skin, Germany, 1994–1995. **client**: Niedersächsische Bühnen Hannover, **cd/ad/d/p**: Holger Matthies. A metamorphosis of the body from man to theater schedule.

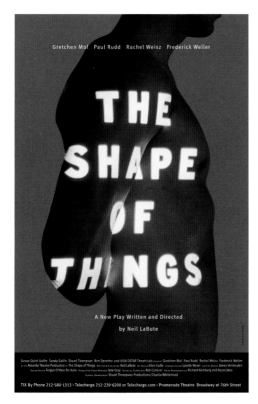

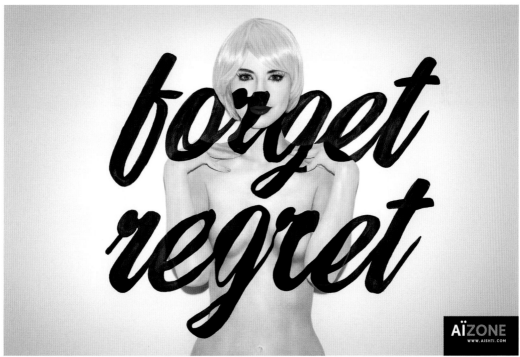

The Shape of Things, USA, 2001. **client**: Neil LaBute / The Shape of
Things, LLC **cd**: Drew Hodges, **ad/d**: Kevin Brainard, **p**: Michael Greenberg,
model: Rex Bonomelli. Theater poster.

Forget Regret, Lebanon, 2012. **client**: Aïzone, **studio**: Sagmeister & Walsh, **cd**: Stefan Sagmeister, **ad/d**: Jessica Walsh, **p**: Henry Hargreaves,
body painting: Anastasia Durasova, **creative rt**: Erik Johansson, **production**: Ben Nabors & Group Theory. Aïzone is a luxury department store in
the Middle East. The vibrant nature of the brand was presented in campaigns that were printed in newspapers, magazines, and billboards throughout
Lebanon. The constraint here was that the agency decided that the ads had to be in black and white and couldn't feature any of the clothing for sale.

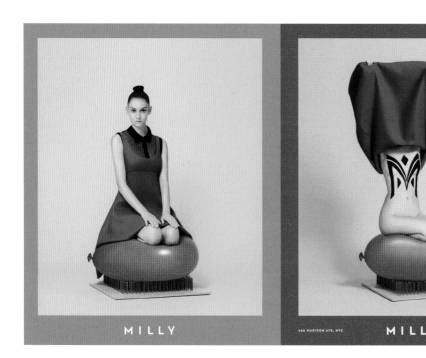

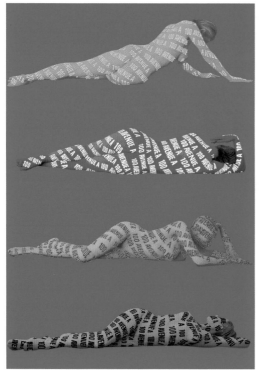

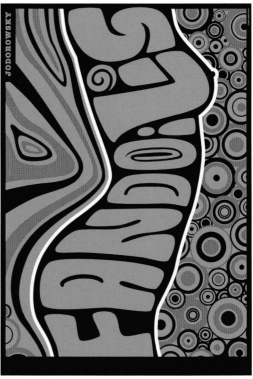

Head to Toe

MILLY Campaign, USA, 2016. **client**: MILLY by Michelle Smith, **studio**: Sagmeister & Walsh, **ad**: Stefan Sagmeister, **ad/d**: Jessica Walsh, **d**: Angela Iannarelli, Aron Filkey, Matteo Pani, Daniel Forero, Valentin Breyne, Olivier Charland, and Dennis Adelmann, **p**: Henry Hargreaves, Aron Filkey, Nick Fogarty, **production**: Group Theory, Molly Brunk, Emily Frank. MILLY (by Michelle Smith) wanted to rebrand its advertising and communications to reflect the attributes of its new collections: edgy, irreverent, bold, and colorful.

100 Avenue A Poster (logo), USA, 2016. **client**: Magnum Real Estate Group, Nest Seekers, **studio**: IF Studio, **cd/d**: Toshiaki & Hisa Ide, **ill/p**: Trina Merry, **managing director**: Amy Frankel. A celebration of the creative roots of NYC's East Village in the building campaign for 100 Avenue A.

Fando i Lis, Poland, 2008. **client**: Vivarto, **studio**: Homework, **cd/ad/d/ill**: Joanna Górska, Jerzy Skakun. Movie poster for the Polish distribution of Alejandro Jodorowsky's early film.

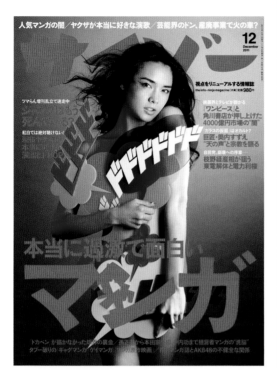

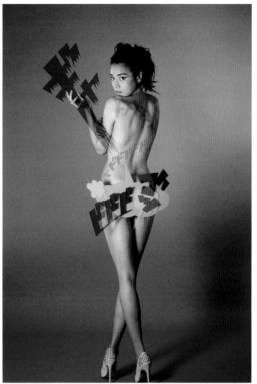

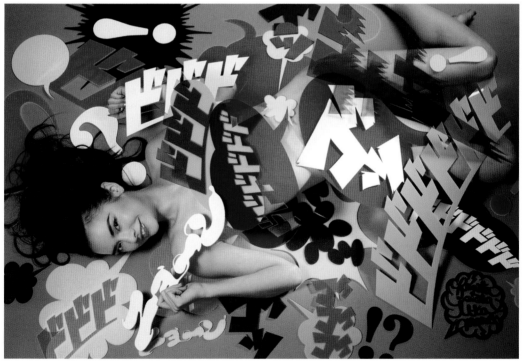

CYZO Magazine—Cartoon Issue, Japan, 2011. **client**: CYZO Magazine, **cd/p**: Mitsuaki Koshizuka, **ad**: Fantasista Utamaro, **model**: Seira Kagami.
This work features Seira Kagami in the CYZO *Magazine* cartoon issue.

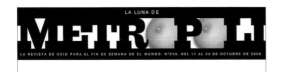

LA LUNA DE

METROPOLI

LA REVISTA DE OCIO PARA EL FIN DE SEMANA DE EL MUNDO. Nº233. DEL 17 AL 23 DE OCTUBRE DE 2008.

EL CINE ESPAÑOL REDESCUBRE EL EROTISMO
CON LAS PELÍCULAS MEMORIAS DE UNA NINFÓMANA Y LOS AÑOS DESNUDOS: CLASIFICADA S

ABCDEFGHI
JKLMNOPQR
STUVWXYZ
() () / / ! @ %
* ' , . — ; _ : " + ?
1234567890

© 2016 Julian Deghy

Spanish Erotic Films, Spain, October 17th, 2008. **client**: Unidad Editorial. El Mundo METROPOLI, **cd/ad/d**: Rodrigo Sánchez, **ill**: Raúl Arias. A woman's breast replacing the two "o" in the nameplate of METROPOLI.

Naked Alphabet—Heavy Font, UK, 2016. **client**: personal project, **cd/p**: Julian Deghy, **model**: Francis Collier. Produced as high-resolution fine art color images through TT fonts (in several weights), clock faces, and other artworks.

Winky (Typeface), South Africa, 2002. **client**: ijusi, **cd/ad/d/c/ill/p**: Garth Walker. Wink is an experimental "porn" typeface published in *ijusi* issue 15 (the "Porn" issue). The complete font is presented as a spoof of a "sex toy" carton (as in flat artwork) found in sleazy "adult stores." The associated posters were exhibited at the first-ever Typographic Biennale in Seoul.

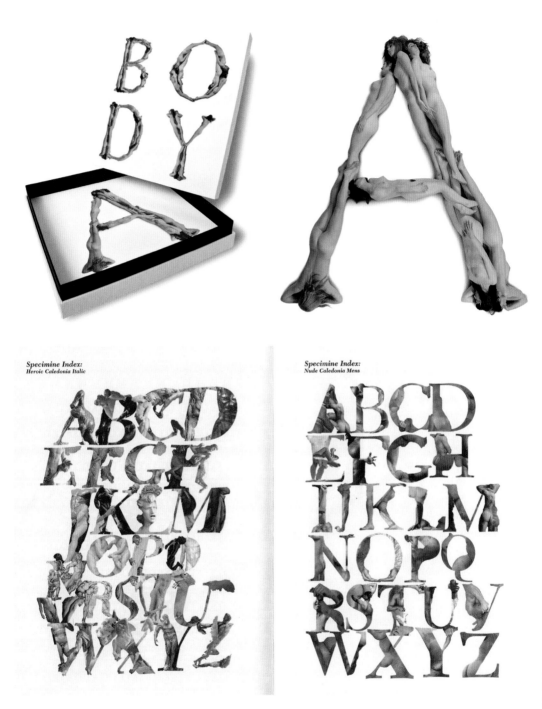

Body Type, The Netherlands, 2011. **client**: Spinhex, **studio**: Anthon Beeke Collective, **cd/d**: Anthon Beeke & Rene Knip. Box with the complete Body Type alphabet and Naked Numbers.

Specimen, or Live Oak, With Moss: Poems by Walt Whitman on Male Intimacy, 1860, originally conceived May 2012, updated spring 2016. **client**: Private commission, **c**: Erik Freer Studio. Specimen is an "illuminated manuscript" containing Walt Whitman's poem, entitled *Live Oak, With Moss*, along with theory, criticism, and poetry dialoging with this work. For the book, which focuses on the themes of homoerotic love, male intimacy, and desire within Whitman's "Live Oak," several custom display typefaces were constructed through photomontage redrawing of the Scotch Roman typefaces employed by Whitman himself.

BODY

The nude is the staple of all art. Fluency in drawing the body is for artists what literacy in the art of typography is for graphic designers. In fact, there are certain notable similarities. Each has an anatomical structure that, when totally understood, is the armature on which all expert practice depends.

It is, therefore, no surprise that this section entitled "Body Art" is the largest in this volume. This entire book is about the body as surface and what's under the surface. Graphic designers tend to rely on the human form as much for what it is as what it symbolizes. In this sense, most graphic designers who use the nude in their work are like the nineteenth-century symbolist artists. In fact some of the greatest members of this romantic movement were designers, to a greater or lesser degree. Aubrey Beardsley's linear illustrations of, for example, Salome and Messalina, and his erotic drawings for the likes of Lysistrata, were not only exemplary of art nouveau, they were influential many decades later on late-twentieth-century graphic designers for both form and content. Beardsley was a master of the naked form and erotic composition.

Many of the illustrators in this section, most notably the creators of the stunning Polish posters on pages 168 to 176, are descended, knowingly or not, from Beardsley and other Symbolists like Félicien Rops and Gustave Moreau, who combined the ideals of romanticism with the extremes of eroticism and made sensual surrealism. Others were inspired by the likes of Gustav Klimt and Egon Schiele in capturing the perverse and diverse aspects of human sexuality.

Although nudity, eroticism, and sensuality have long been ingrained in classic and modern art—and since graphic design, it must be said, is an extension (or, shall we say, a cousin) of modern art—it also has its own roots and routes in nakedness. In fact, most graphic designers make no excuse about using nudity to push the boundaries of their art. Generally the work appearing in this section exposes how designers exploit (often in a positive but occasionally in a negative way) the sensuality and the sensational qualities of the human form. You can see a range of nakedness, from parodies of the tawdry styles, like the poster for the Flaming Lips (page 215) and the tart card porno for The Oblivians (page 215) to the classical poses for Cannibal (page 198) and Hierro (page 196). The reference points for body art can be subtle and raunchy, elegant and shocking. Since the body commands such immediate attention in the

A R T

eyes of every beholder, how it is even used in a poster or advertisement demands that the designer have command of the language of nudity. The public, in turn, is manipulated to give the response the designer is looking for. For a series of posters for Lars Von Trier's *Nymphomaniac* (pages 192 and 193), the designer chooses not to show the titillating portions of the body but rather above the waist, cropping so that rather than being erotic, the nudity combined with the facial expressions of the nude actors focuses the viewer on their emotions. These posters expose the inner as well as the outer condition of each subject. Nudity is used to uncover pain, anger, fear, and more.

It is the ability to, literally and metaphorically, strip bare the body that gives many of the graphic designs in this section their ultimate power as visual icons. Even without the typography, each of these compositions speaks volumes. Take, for example, the orgiastic mass of flesh in the Satyricon Delirio poster (page 189); this powerful image, where many bodies become one, is reminiscent of the devastating jumble of bodies in a mass grave—at once horrible and fascinating.

Of course, not all the examples are this gruesome, ghastly, or solemn. The naked body or parts thereof is the perfect foil for the humorous gesture too. Wonderland (page 109) is a tongue-in-cheek play on typical softcore porn while Life (page 108) with its cascading breasts makes a comic commentary on the male obsession for the most fetishized part of the female body. The comedy is light in these, but in others the body is employed for darker humor. In "Operetta" (page 183) a woman's torso appears through a plastic garbage bag that looks as though it has been singed where the head should be. Maybe humor is not the right word to describe this, but it forces a double take that is both comic and horrific. Comedy is at the heart of the poster for Duel d'Ombres (page 178). The striped woman in the powdered wig holding the crossed swords in front of her crotch, forming an artificial vagina, is a witty way of representing the duel.

Body art in the commercial sense is the overall theme of this book, but this section represents all its formal and commercial possibilities. From the absurdity of The Pleasure Trials (page 160) to the ingenuity of Sennentuntschi (page 160), and the optical fantasy of a modern (un-Beardsleyesque Aristophanes) Lysistrata (page 161). In graphic design today, the body is possibly the most graphic of all tools at the designer's fingertips.

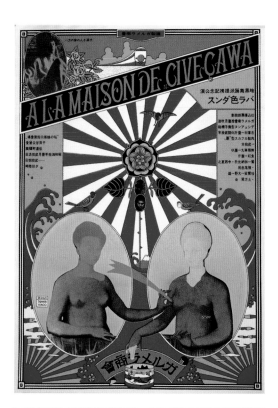

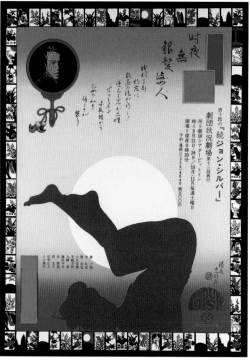

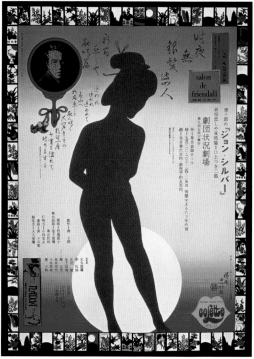

Head to Toe

John Silver: Second View, Japan, 1968. **client**: Gekidan Jokyo Gekijo,
d: Tadanori Yokoo. Silkscreen on paper.

A La Maison de Civecawa, Japan, 1965.
client: Ankokubutoha Garumera Shokai, **d**: Tadanori Yokoo.
Silkscreen on paper.

John Silver, Japan, 1967. **client**: Gekidan Jokyo Gekijo, **d**: Tadanori Yokoo.
Silkscreen on paper.

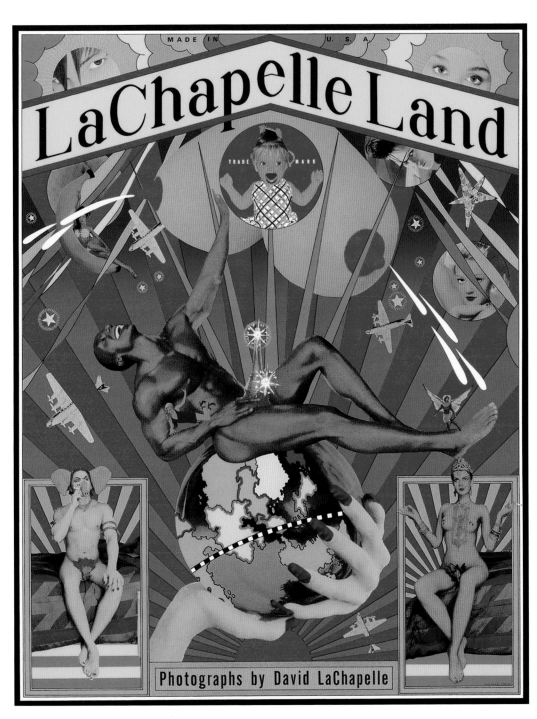

LaChapelle Land, Japan, 1996. **client**: Callaway Edition Inc. **d**: Tadanori Yokoo. Silkscreen on paper.

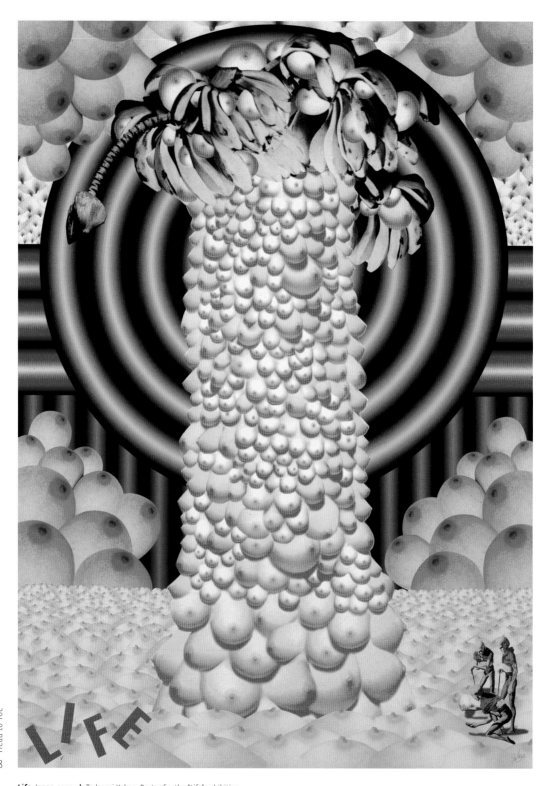

Life, Japan, 1994. **d**: Tadanori Yokoo. Poster for the "Life" exhibition.

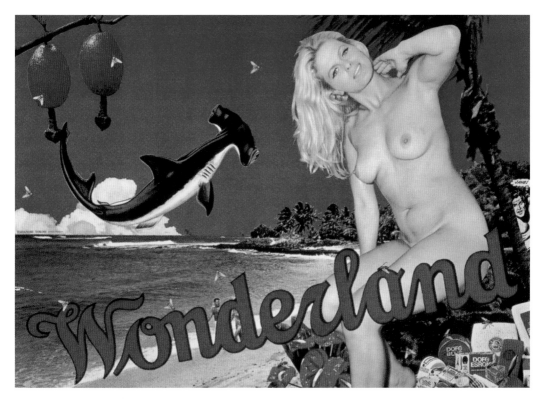

Wonderland, Japan, 1971. **d**: Tadanori Yokoo. Poster for a seaside resort.

The Trip, Japan, 1968. **d**: Tadanori Yokoo. Film poster.

Universiade Kobe '85, Japan, 1984. **d**: Tadanori Yokoo. Poster for the "Universiade Kobe '85" athletic competition.

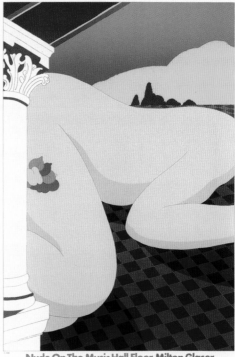

Nude on the Music Hall Floor, USA, 1978. **client**: Theatre Baltimore. **d/ill**: Milton Glaser. A two-part poster that is intended to work individually or as a single horizontal image.

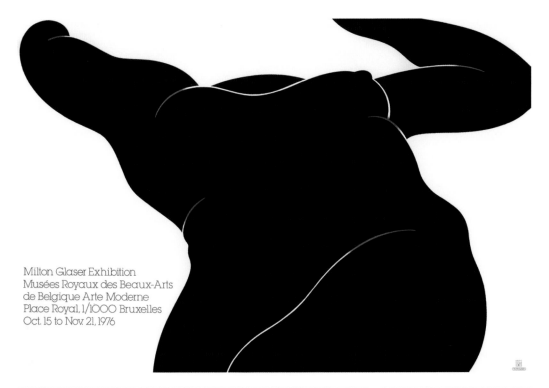

Milton Glaser Exhibition
Musées Royaux des Beaux-Arts
de Belgique Arte Moderne
Place Royal, 1/1000 Bruxelles
Oct. 15 to Nov. 21, 1976

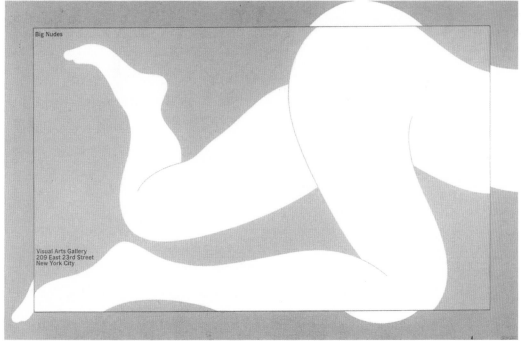

Big Nudes

Visual Arts Gallery
209 East 23rd Street
New York City

Milton Glaser Exhibition (Black Foreshortened Nude), USA, 1976. **client**: Musees Royaux des Beaux-Arts. **d/ill**: Milton Glaser. "Poster for a show of my work in Belgium. There were only two colors available for this poster. In this case, using green and red, we created the black form."—Milton Glaser

Big nudes, USA, 1966. **client**: Visual Arts Gallery. **d/ill**: Milton Glaser. "One of my better known works, the idea here was to show a nude so large that it couldn't fit on the page."—Milton Glaser

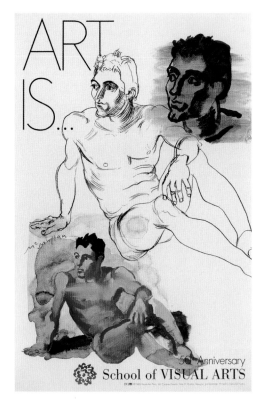

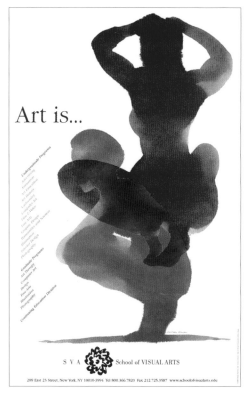

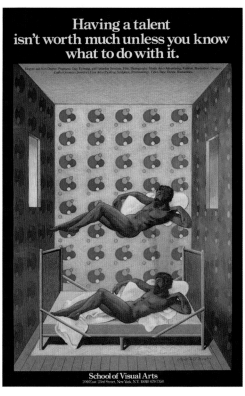

Art Is..., USA, 2000. **client**: School of Visual Arts, **cd**: Silas H. Rhodes, **d/ill**: Milton Glaser. Promotional poster for the School of Visual Arts.

Art Is..., USA, 1996. **client**: School of Visual Arts, **cd**: Silas H. Rhodes, **d/ill**: James McMullan. Promotional poster for the School of Visual Arts.

Having a Talent Isn't Worth Much, USA, 1977. **client**: School of Visual Arts. **cd**: Silas H. Rhodes, **d/ill**: Milton Glaser. To illustrate the quote, the figure depicted has the ability to levitate, but unless he can figure out a way to get out of the room it's a useless "talent."

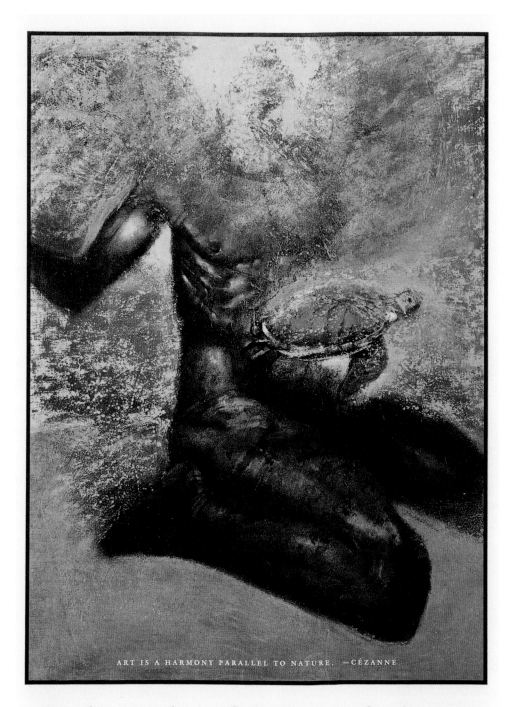

ART IS A HARMONY PARALLEL TO NATURE. —CÉZANNE

School of Visual Arts

Art Is a Harmony Parallel to Nature, USA, 1995. **client**: School of Visual Arts, **cd**: Silas H. Rhodes, **ill**: Marshall Arisman. Promotional poster for the School of Visual Arts.

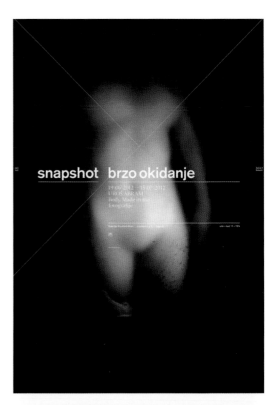

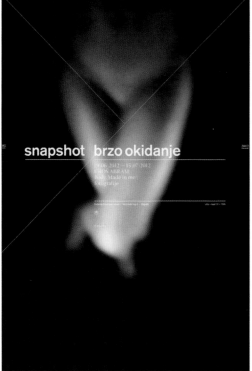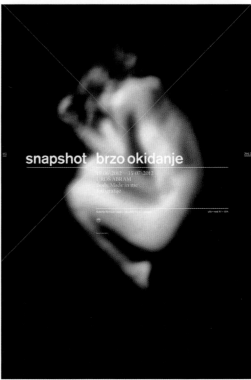

Snapshot—Uroš Abram—Body. Made In Me, Croatia, 2012. **client**: Klovićevi Dvori Gallery, Zagreb, **studio**: Sensus Design Factory,
cd/ad/d: Nedjeljko Špoljar, **d**: Kristina Špoljar, **p**: Uroš Abram, **curators**: Marina Viculin, Saša Brkić. Posters for an exhibition "Body. Made In Me"
by Uroš Abram, part of a snapshot photography exhibition series.

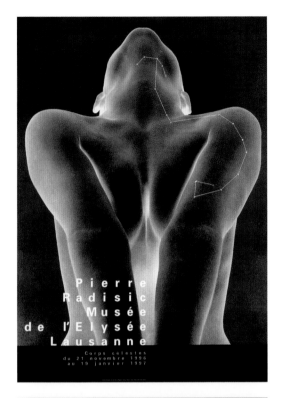

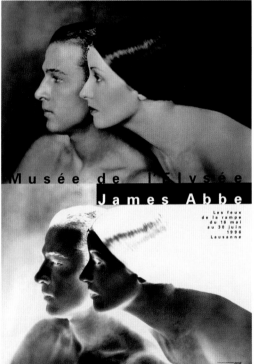

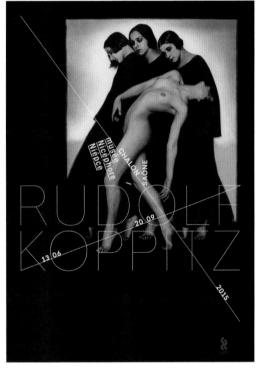

James Abbe, Switzerland, 1996. **client**: Museum for Photography, Lausanne, **cd**: Werner Jeker. Poster for a photo exhibition.

Pierre Radisic, Switzerland, 1996. **client**: Musée de l'Elysée, Museum for Photography, Lausanne, **cd**: Werner Jeker. Poster for a photo exhibition.

Rudolf Koppitz, France, 2015. **client**: Musée Nicéphore Niépce, **d/c**: Michel Lepetitdidier, **p**: Rudolf Koppitz. Poster for Rudolf Koppitz's exhibition at the Museum of Photography of Chalon / Saône, France.

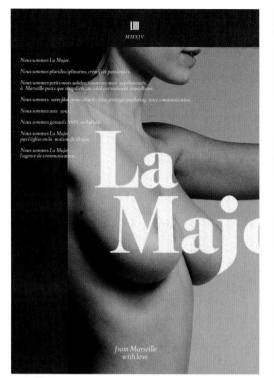

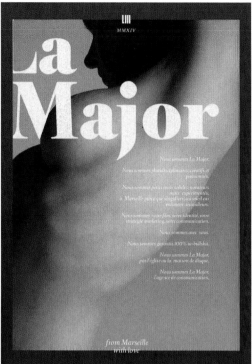

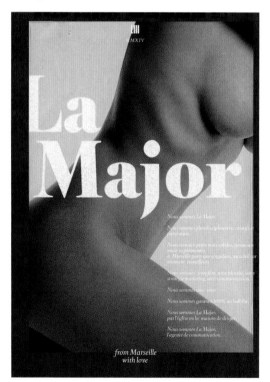

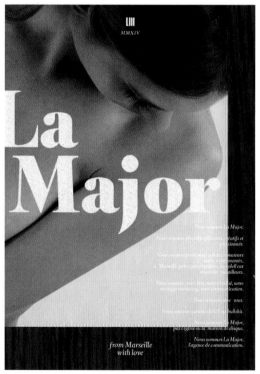

Testimonial, France, 2015. **client**: La Major, **studio**: La Major, **cd/d/c/p**: Florian Fusy. Testimonial poster to present the communications agency La Major.

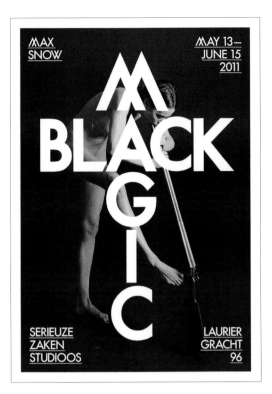

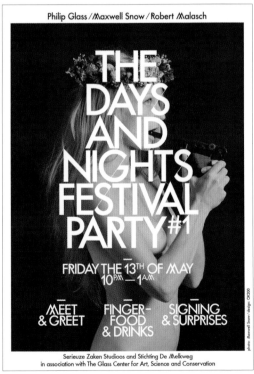

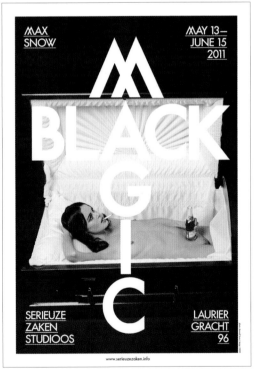

Max Snow / Black Magic, The Netherlands, 2011. **client**: Serieuze Zaken Studioos, **cd**: Mattijs de Wit & Koen Knevel (at OK200),
ad/d/ill: Mattijs de Wit & Koen Knevel, **p**: Maxwell Snow. Campaign design for the New York photographer Maxwell Snow, in the form of posters
and flyers to promote his Black and White photography exhibition.

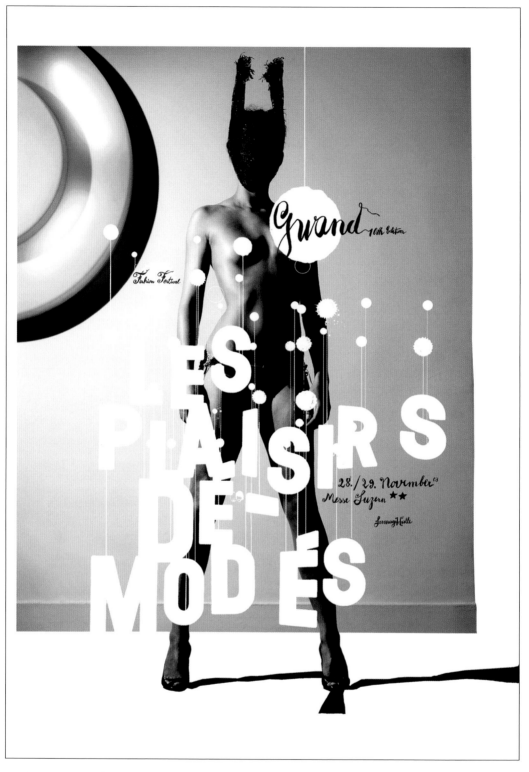

Head to Toe

Gwand, Switzerland, 2003. **client**: Gwand Fashion Festival, **cd**: Patrick Roppel & Adrian Ehrat, **p**: Horst Diekgerdes. Poster for the tenth edition of the Gwand Fashion Festival in Lucerne.

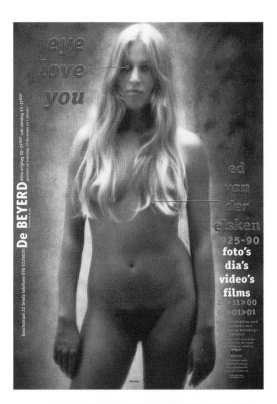

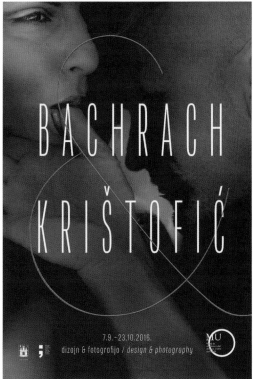

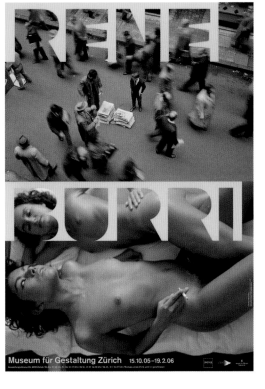

Eye Love You, The Netherlands, 2000. **client**: De Beyerd, Breda, **studio**: Anthon Beeke Collective, **p**: Ed van der Elsken. Poster for an exhibition of photos by the famous Dutch photographer Ed van der Elsken.

Bachrach & Krištofić = Design & Photography, Croatia, 2016. **client**: MUO-Museum of Arts and Crafts, Zagreb, **d**: Tessa Bachrach-Krištofić, Dina Milovčić, Franka Tretinjak (NJI3). Exhibition poster featuring an ampersand, which was the exhibit's focus.

René Burri, Switzerland, 2005–2006. **client**: Museum für Gestaltung Zürich, **d**: Andrea Koch, **p**: René Burri, Magnum Photos. Poster design for the retrospective of Swiss photographer René Burri at the Museum für Gestaltung Zürich.

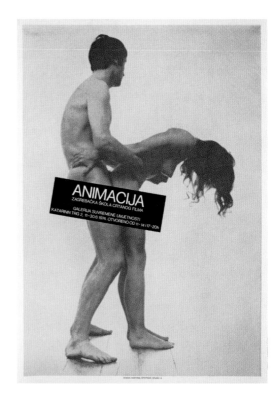

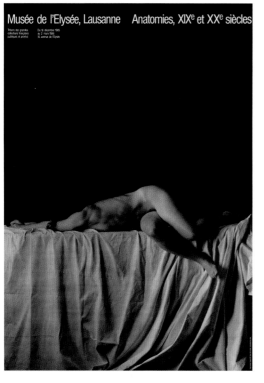

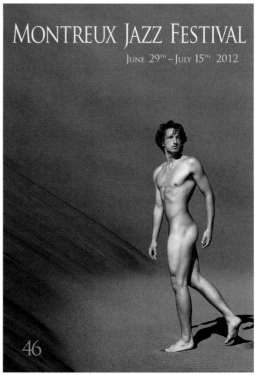

Anatomy, Switzerland, 1985. **client**: Museum For Photography, Lausanne, Switzerland, **cd**: Werner Jeker. Poster for a photo exhibition.

Animation–Zagreb School of Animated Film, Croatia, 1974. **client**: Gallery of Contemporary Art Zagreb, **d**: Dalibor Martinis. Exhibition poster.

Montreux Jazz Festival poster, USA, 2012. **client**: Montreux Jazz Claude, **cd/ad/d/c/p**: Greg Gorman, **rt**: Robb Carr, **model**: Jordan Mines. Shooting a male nude for the poster created quite a controversy and garnered a lot of press.

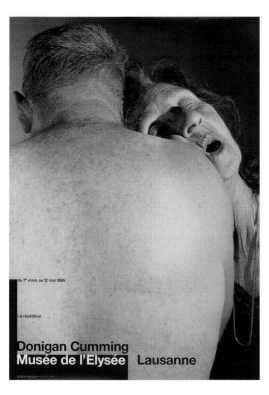

Donigan Cumming, Switzerland, 1996. **client**: Museum For Photography, Lausanne, Switzerland, **cd**: Werner Jeker. Poster for a photo exhibition.

ART ETC., South Korea, 2013. **client**: ART ETC. Gallery, **studio**: Ordinary People, **ad/d**: Jeong-min Seo, **ill**: Harukawa Namio. Poster for an exhibition of Harukawa Namio's works at ART ETC. Gallery. It was designed to match with the artist's work.

NoiseNoiseNoise, Russia, May 2013. **client**: Mikhail Korolev Studio, **studio**: Esh gruppa, **d**: Stefan Lashko, Phillip Tretyakov, Vitaliy Martynyuk, Olga Yakovleva, **c**: Ivan Yakushev, **ill**: Olga Yakovleva, **p**: Valera Kozhanov.

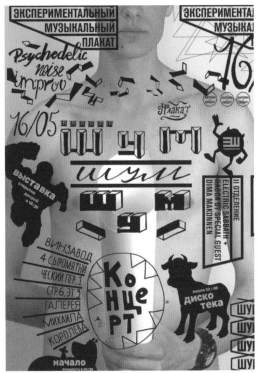
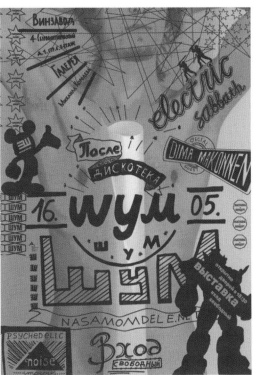
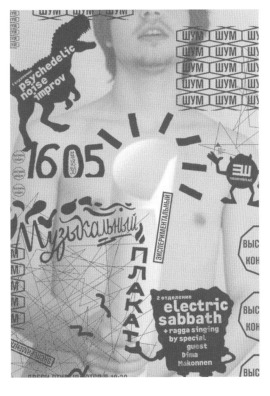

A self-promotional poster series for an exhibition of Esh gruppa's works / opening concert called NoiseNoiseNoise.

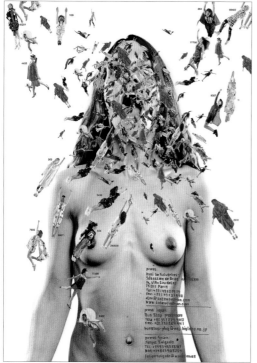

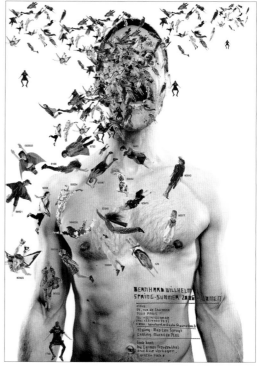

Motion Science Exhibition, Japan, 2015. **client**: 21_21 DESIGN SIGHT, **cd/ad/d**: Masayoshi Kodaira, **c**: 21_21 DESIGN SIGHT. Poster exhibition offering the opportunity to touch and observe the power of expressions that "movements" bring in order to assess the relationship between design and progress in science and technology.

Bernhard, Jutta—BW Lookbook SS 2006, France, 2005. **client**: Bernhard Willhelm, **cd**: Freudenthal / Verhagen & Bernhard Willhelm, **d/p**: Freudenthal / Verhagen. Bernhard Willhelm and Jutta Kraus spit out the superman models that show the 2006 spring-summer women's collection.

AIGA Communication Graphics Poster, USA, 1993. **client**: AIGA, **ad/d/c**: April Greiman. "Annual competition 'call for entries' poster. Illustration utilizes X-ray as symbol and vehicle of communication, located in the seven chakras, or energy centers of the human body. In particular 'seeing' highlighted as visual metaphor—our eyesight is complex and mysterious—we 'see' things upside down, yet the brain turns them right side up! (Our token male juror, in blue type, was Massimo Vignelli!)."—April Greiman

Head to Toe

Ivan Meštrović: Waiting, Croatia, 2003. **client**: Muzeji Ivana Meštrovića, **studio**: Studio International, **cd**: Boris Ljubičić,
p: Damir Fabijanić, Živko Bačić, Nenad Gattin, Ivo Pervan. Ivan Meštrović (1883–1962), the Croatian sculptor, made more than two thousand statues, reliefs, drawings, pictures, and architectural features. This poster shows his sculpture *Waiting* and some of his other works exhibited by the Ivan Meštrović Foundation and the Meštrović Gallery in Split.

First Shot—Damian Nenadić—Mother, Croatia, 2010. **client**: Klovićevi Dvori Gallery, Zagreb, **studio**: Sensus Design Factory,
cd/ad/d: Nedjeljko Špoljar, **d**: Kristina Špoljar, **c**: Saša Brkić, **p**: Damian Nenadić, **curator**: Marina Viculin. Posters for the photography exhibition *Mother* by Damian Nenadić. Part of the *First Shot* exhibition series, presenting works by emerging photographers.

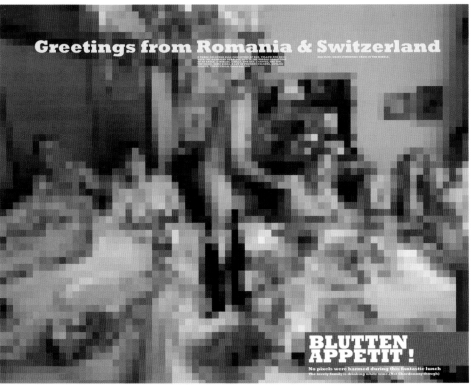

"Nude Men from 1800 to the Present Day" Pierre & Gilles, Vive La France 2016, Austria, 2012. client/cd/d/c: Leopold Museum, p: Pierre & Gilles. Exhibition poster. Large versions of the poster were later censored following a public outcry in Vienna.

BLUTTEN APPETIT !, Austria, 2009. client: Vienna Design Week—Workshop, cd/ad/d/c: Ovidiu Hrin. "This poster came out as a result of a workshop I held at Vienna Design week's Schaulabor."—Ovidiu Hrin

FEBRUAR

MÄRZ

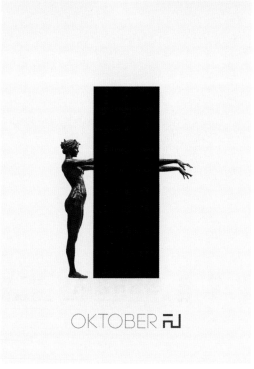

OKTOBER

AU Monthly Posters 2016, Austria, 2016. **client**: AU-Venue, Gallery (Vienna, Austria), **d/ill**: Alena Dizdarević. The series of monthly graphics for the Viennese venue and gallery AU. These are selected works from the months of February, March, and October 2016. Theme: Emotions and seasons.

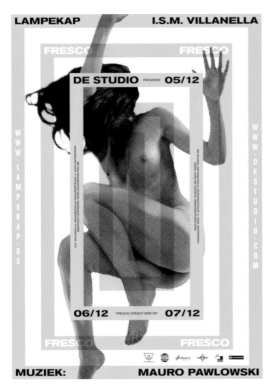

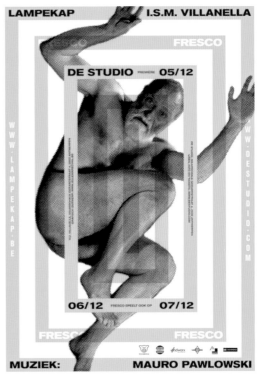

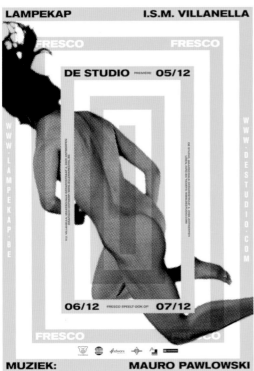

Posters for Fresco, Belgium, 2013. **client**: Lampekap Collectief, **cd/ad/d**: Jelle Maréchal. Fresco is a performance piece by art collective Lampekap. In an interactive video installation we get a glimpse of the human condition. It examines how we structure our lives and bring order to an otherwise chaotic universe. The posters feature four different silhouettes taken from the film, and are intertwined with a stark and colorful grid.

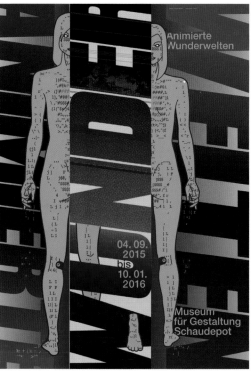

Night Draw Poster Series, Romania, 2011-2013. **client**: Night Draw,
ad/d/c/ill: Andrei Ogradá. "Between 2011 and 2013 I created a series of
posters, almost weekly, to promote a life study drawing club which I held
with a couple of friends."–Andrei Ogradá

The revolving territory, Iran, 2016. **client**: Azad Art Gallery,
cd/ad/d: Reza Abedini, **c**: Mahdiyeh Abolhasan. Poster for the solo drawing
exhibition of Mahdiyeh Abolhasan.

Animated Wonderworlds, Switzerland, 2015. **client**: Museum of Design
Zurich, **cd/ad/d/ill**: Martin Woodtli. The exhibition presents works and
the creative processes behind them, providing insights into the diverse
worlds of animation in the digital era.

Speaking from the Heart, The Netherlands, 2013. **client**: Framer Framed, **cd/ad/d/ill**: Reza Abedini, **c**: Shaheen Mirali. Poster for a group Iranian art exhibition in Amsterdam.

Nude Calligraphy, Russia, 2007. **client**: Nude Calligraphy Solo Exhibition, **cd/ad/d**: Yuri Gulitov. Poster for the Nude Calligraphy solo exhibition. The image is a fast calligraphic drawing of a nude model.

Satyrykon, Poland, 2009. **client**: Satyrykon Legnica, **cd/ad/d**: Mieczyslaw Wasilewski. Press illustration.

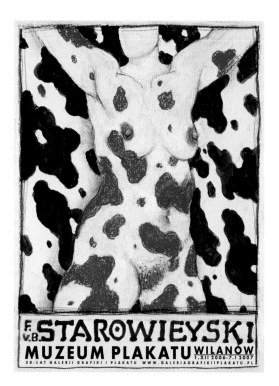

**Poster for the Exhibition at the Yugoslav Press and
Cultural Center**, USA, 1987. **ad**: Nicky Lindeman, **d/ill**: Mirko Ilić,
silkscreen: Nenad Božić. Exhibition poster.

F.v.B. Starowieyski Muzeum Plakatu Wilanów, Poland, 2006.
client: Galeria Grafiki i Plakatu, **ad/d/ill**: Franciszek Starowieyski.
Poster for the 30th Anniversary of the Graphic and Poster Gallery.

Creō (Create), Philippines, 2014. **client**: Bloom Arts Festival,
ad/d/ill: Tof Zapanta, **c**: Samantha Samonte. Poster for a local annual
arts and music festival in Manila, the Bloom Arts Festival, with the theme
of creation and creativity.

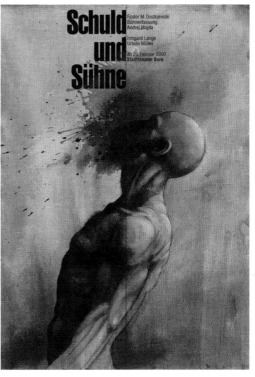

Posters from Hungary, Denmark, 2001. **client**: Dansk Plakatmuseum, **cd/ad/d/ill**: István Orosz. Exhibition poster.

Photography As Art—Art As Photography, Croatia, 1980. **client**: Contemporary Art Gallery Zagreb **d**: Ivan Picelj. Exhibition poster. (Courtesy of Museum of Arts and Crafts, Zagreb)

Crime and Punishment, Switzerland, 2000. **client**: Stadttheater Bern, **cd/ad/d/ill**: Stephan Bundi. Poster for a theatrical performance based on the novel by Fyodor Dostoyevsky.

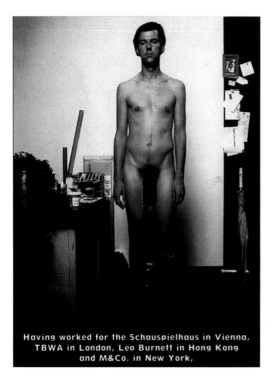

Having worked for the Schauspielhaus in Vienna, TBWA in London, Leo Burnett in Hong Kong and M&Co. in New York,

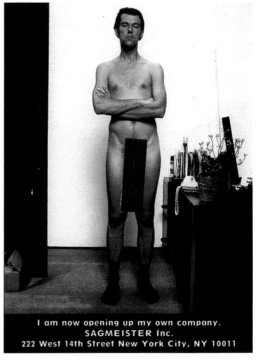

I am now opening up my own company.
SAGMEISTER Inc.
222 West 14th Street New York City, NY 10011

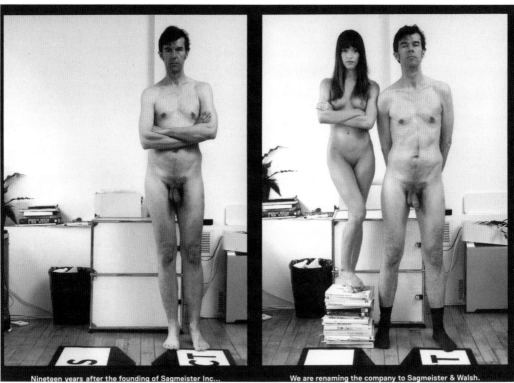

Nineteen years after the founding of Sagmeister Inc...

We are renaming the company to Sagmeister & Walsh.

Sagmeister Inc. Company Announcement, USA, 1993. **client**: Sagmeister Inc., **cd/d**: Stefan Sagmeister, **d**: Erik Zim, **p**: Tom Schierlitz. "With the opening of my studio over twenty years ago, I sent out a card that showed longer and shorter versions of my parts. At that time, this took a little bit of guts. My then-girlfriend recommended heavily against it; she thought I was going to lose the one client I had. The client not only stayed, but loved it."—Stefan Sagmeister

Sagmeister & Walsh Partnership Announcement, USA, 2012. **client**: Sagmeister & Walsh, **cd**: Stefan Sagmeister, Jessica Walsh, **p**: Henry Hargreaves. "Stefan had the idea to do a postcard that was a nod to the original announcement he made when he opened the studio in 1993. His idea was that Jessica would be dressed in conservative clothing, and he'd be naked. Jessica had an immediate gut reaction that it would be better if they were both nude, and that's what they did."—Henry Hargreaves

Sagmeister MAK Exhibition Poster, Austria, 2002.
client: MAK Museum of Applied Arts, Vienna, **cd**: Stefan Sagmeister,
d: Matthias Ernstberger, Sabine Hug, **ill**: Sabine Hug, **p**: Tom Schierlitz.
Poster for Stefan Sagmeister's first solo museum show at the MAK Museum.

Mechanical Woman, Costa Rica, 2015. **client**: z Studio,
studio: Gitanos, **ad/d/ill**: Daniel Montiel, **c**: Carla Pravisani.
Print advertising to promote the retouching services of the company.

Sugar Factory—SSSST!, The Netherlands, 2011. **client**: The Sugar
Factory, **studio**: Me Studio, **cd/ad/d**: Martin Pyper, **c**: Myra Driessen,
p: Marlous vander Sloot. One of a series of posters announcing a monthly
lineup of events.

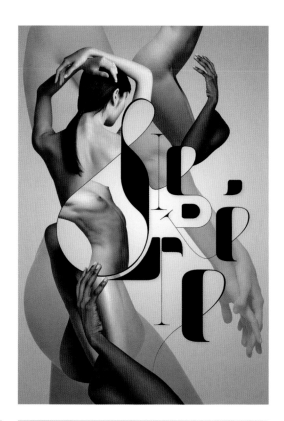

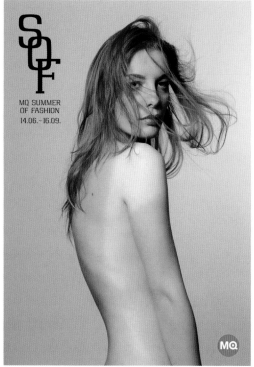

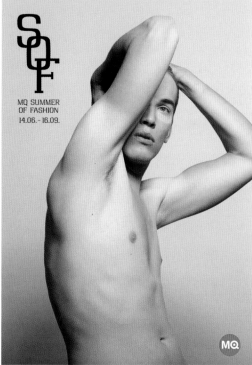

FIERTÉ (PRIDE), France, 2010. **client**: Elle, **cd/ad/d/ill**: Jonathan Budenz.
Teaser poster for the *Elle* exhibition / contest in Paris.

MQ Summer of Fashion, Austria, 2012. **client**: Museum Quarter, Vienna, **c/d**: Andreas Miedaner, Sascha Schaberl, **ad**: Sascha Schaberl,
p: Maria Ziegelböck. Designed to be gender neutral and to abstain from any predetermined notions of conventional beauty, this campaign for a "summer of fashion" focuses less on the fashion and more on the side-effects of summer; mainly, heavy sunburn. The SOF logo was created specially for this ad.

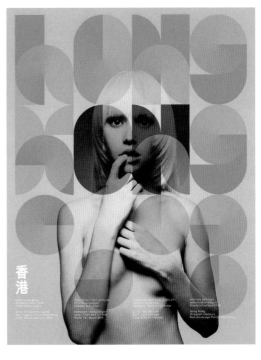

Beautiful Decay, South Africa, 2011. **client**: Beautiful Decay France poster submission, **cd/ad/d/ill**: Anthony Neil Dart, **p**: Harmen Piekema. Fashion poster showcasing the "truth" of beauty.

FASHIONCLASH Festival 2015, The Gender Edition, Netherlands, 2015. **client**: FashionClash Foundation, **cd**: FashionClash: Branko Popović, Nawie Kuipar, Laurens Hamacher, **d**: Studio Noto (Ivo Straetmans), **p**: Lonneke van der Palen. Fashion festival poster.

Neu Hong Kong, South Africa, 2010. **client**: Show Us Your Type, **cd/ad/d/ill**: Anthony Neil Dart, **p**: Mayer George. Exhibition contribution for SUYT Hong Kong. This piece explores the collision of type and image.

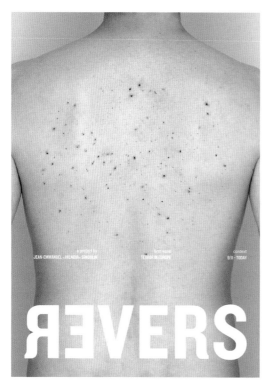

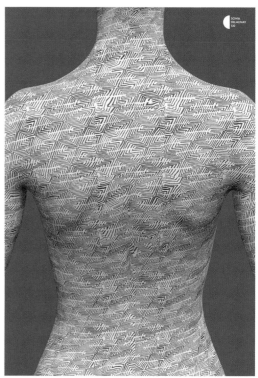

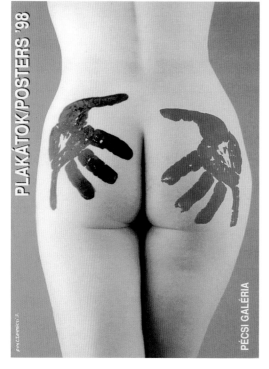

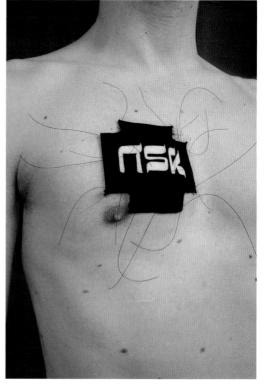

November 13th, France, 2016. **client**: Revers,
cd/ad/d: Jean Emmanuel "Valnoir" Simoulin, **p**: Coline Sentenac.
The image shows stigmatas in the position of the stars above Paris
the night of the massacre on November 15, 2015.

Plakàtok / Posters '98, Hungary, 1998. **client**: Pécsi Galeria,
d: Sàndor Pinczehelyi. Exhibition poster.

Color Is the Skin, Ukraine, 2015. **client**: Sonia Delaunay, 130 Poster
Campaign, **studio**: Grafprom Studio, **d**: Illya Pavlov. This poster series
continues Sonia's concept of applying patterns on everything to its
inevitable conclusion—application on the human body.

The Star, France, 2011. **client**: NSK Folk Art,
cd/ad/d: Jean Emmanuel "Valnoir" Simoulin, **p**: Gui Brigaudiot.
Project executed in the frame of the NSK Folk Art context. The patches
were stitched on the skin without anesthesia (and without Photoshop).

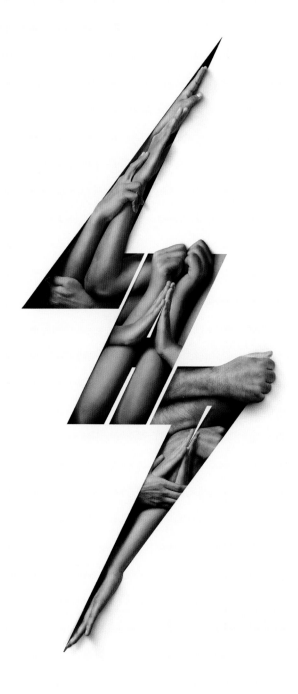

LAD Fest Intervention Poster, Peru, 2015. **client**: Latin American Design Festival, **d**: Cristian Valverde Sandoval. The poster was a personal interpretation about Latin American creativity using the LAD Festival logo as a frame. It's based on the collective effort, traditions, celebration, and religiosity as the main elements of the Latin American identity dynamics.

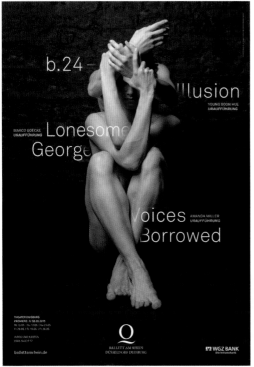

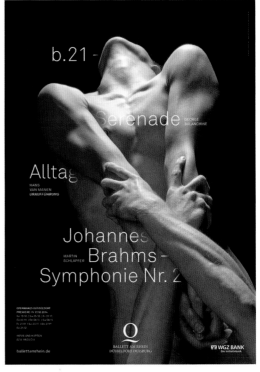

Ballett am Rhein Düsseldorf Duisburg, Germany, 2014. **client**: Ballett am Rhein Düsseldorf Duisburg, **ad/principal choreographer**: Martin Schläpfer,
ad/d: Nicolas Markwald, Nina Neusitzer, Julia Pidun, **p/image idea**: Gert Weigelt. The Ballett am Rhein has thrilled audiences ever since its relaunch in

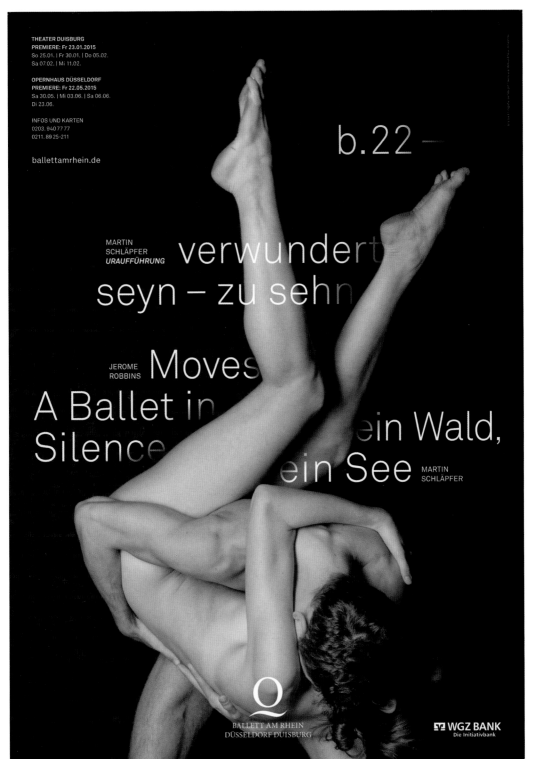

2009 under the direction of Swiss choreographer Martin Schläpfer. For five to six premieres of each season, the artistic director and the photographer collaborate on a different series of promotional images, focusing on the beautiful and powerful bodies of the dancers.

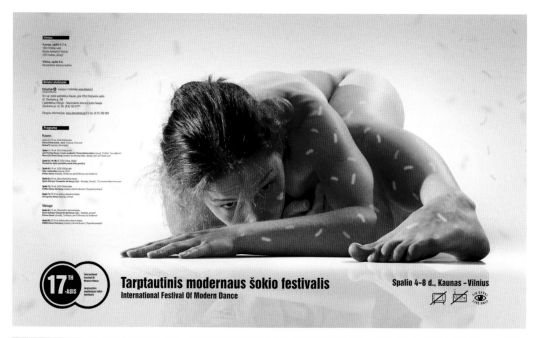

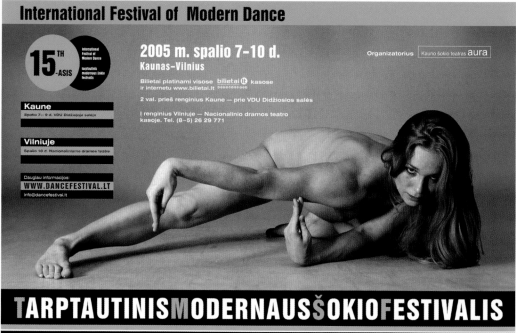

Poster for 17th Festival of Modern Dance, Lithuania, 2007. **client**: International Festival of Modern Dance, **studio**: Mamaika, **cd**: Egle Petreikiene, **ad/d/p**: Darius Petreikis, **model**: Lina Puodžiukaite. A dancer's body language can reveal beauty, strengh, and something about the nature of dance, all without any adornment.

Poster for 15th Festival of Modern Dance, Lithuania, 2005. **client**: International Festival of Modern Dance, **studio**: Mamaika, **cd**: Egle Petreikiene, **ad/d/p**: Darius Petreikis, **model**: Raimonda Gudaviciute.

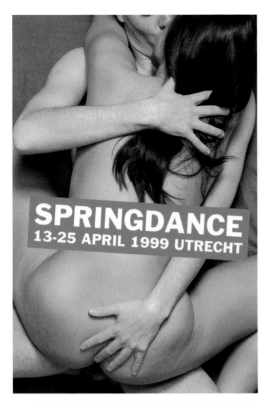

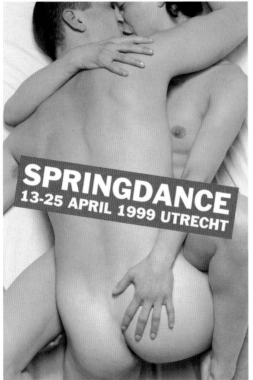

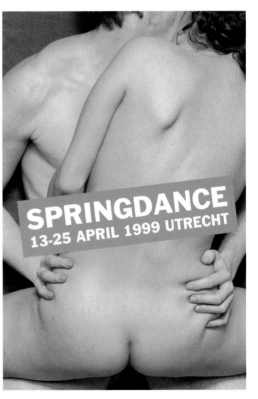

Springdance, The Netherlands, 1999. **client**: Springdance Festival, **studio**: De Designpolitie, **cd/ad/d**: Richard van der Laken, Pepijn Zurburg, **p**: Juul Hondius. Poster campaign for the international dance festival.

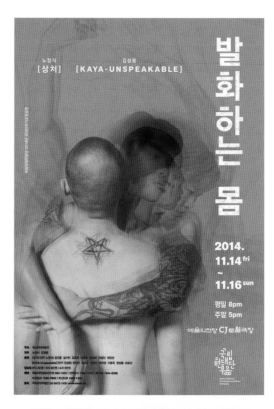

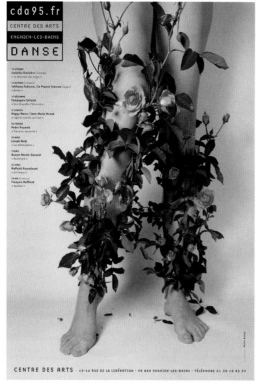

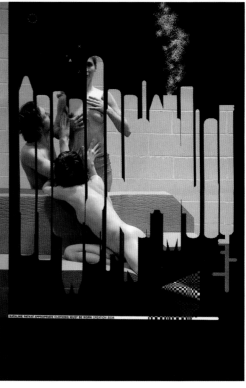

Danse, France, 2005. **client**: C.D.A., Enghien-Les-Bains **d**: Michal Batory
Dance poster.

Body Discourse, South Korea, 2014. **client**: Korea National Contemporary
Dance Company (KNCDC), **studio**: IONOI, **cd/ad**: SoYoung Park, **d**: Eunjoo,
p: Studio Byul. A modern dance performance for KNCDC's annual program.

Appropriate Clothing Must Be Worn, France, 2006.
client: Katalin Patkaï (dancer, choreographer), **d**: Frédéric Teschner.
Silk print poster designed for the choreographer Katalin Patkaï.

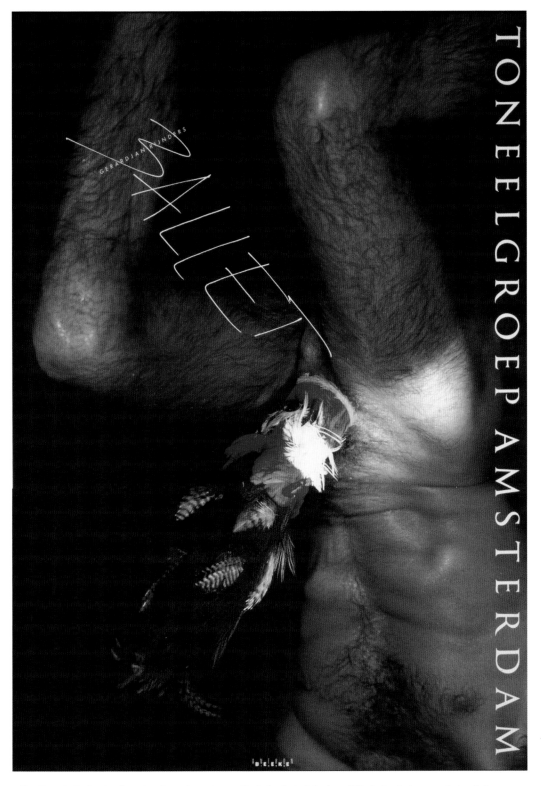

TONEELGROEP AMSTERDAM

Ballet, The Netherlands, 1989. **client**: Toneelgroep Amsterdam, **studio**: Anthon Beeke Collective, **cd/d/p**: Anthon Beeke, **props**: Graham Holic.
"*Ballet* is a piece by Gerardjan Rijnders; it is not an ordinary ballet, but the theater version of a ballet, people who come on stage, say a line, and leave
a narrative in collage. This piece based on the Greek mythological figure of Orpheus, symbol of man's eternal shortcomings. The image I used is of
a man who displays his pride and his power by pointing his penis in the air. I do not allow that penis to triumph."—Anthon Beeke

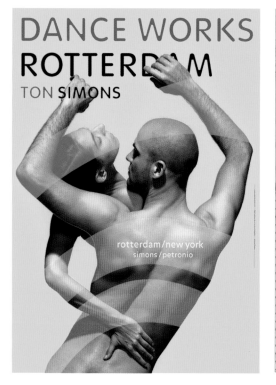
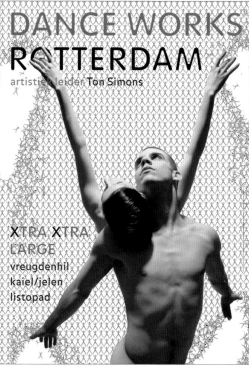

Dance Works Rotterdam Poster Series, The Netherlands, 2008–2011. **client**: Dance Works Rotterdam, **cd/ad/d/ill**: Studio Lonne Wennekendonk,
p: Pieter Leenheer. Too often the choreography is mistaken for the dance, when the dance—any dance—is the dancers themselves; every dance is a dance.
The visual identity created for Dance Works Rotterdam underscores this point. It is not about collaboration, but about exchange: up close and personal.
The exchange continues.

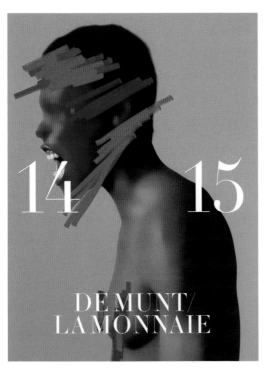

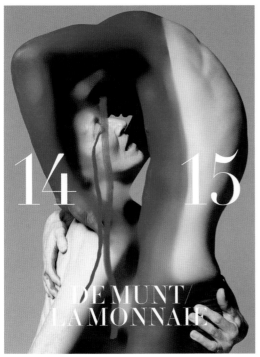

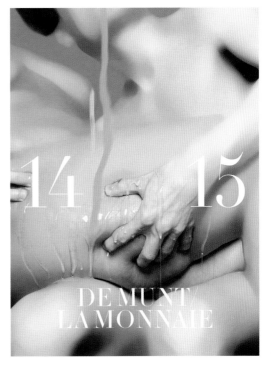

The Seven Deadly Sins, Belgium, 2014. **client**: Théâtre Royal de La Monnaie, **studio**: Base Design, Brussels, **cd**: Thierry Brunfaut, **ad**: Pierre Daras, **d**: Jonas Nicollin, **p**: Pierre Debusschere, **production**: Fumi Congan. In this set of images, each sin is assigned a specific color; each vice is represented through objects, gestures, and makeup.

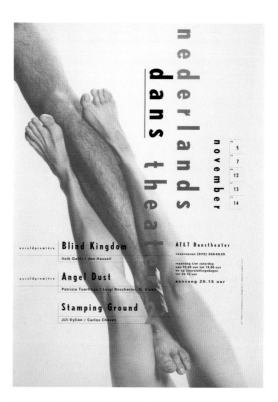

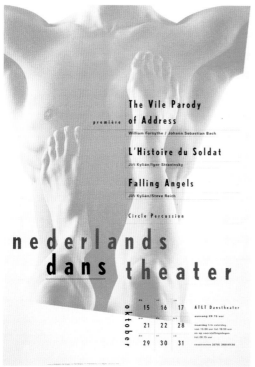

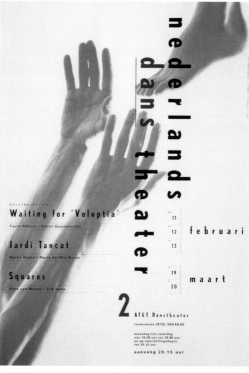

Series of 10 posters for NDT, The Netherlands, 1992–1993. **client**: Nederlands Dans Theater (Dutch Dance Theater),
cd/ad/d: Wout De Vringer, **p**: Gert Weigelt. A series of ten posters (four shown here) designed for the well known Dutch Dance Theater (NDT), a modern dance group from The Netherlands. For each poster, a small part of a photo from an existing series of photographs was selected and blown up to create an alienating background for the typography. Together they create a choreography.

Balett+, Hungary, 2015/2016. **client**: Kecskemét City Balett, **cd**: Dóra Barta, **ad/d/ill**: Rebeka Póth. Balett+ is an experimental performance series that incorporates different creative art forms (like photography, folk music, world music, and poetry) into ballet. These images reflect a similar process of blending borders.

Pat Graney Dance Co., USA, 1995. **client**: Nemzoff / Roth Productions, **studio**: Art Chantry, **p**: Helena Rogers. Pat Graney Dance Co. pioneered using dancers with "normal" bodies.

14th week of Modern Dance, Germany, 1996. **ad/p**: Gert Weigelt, **d**: HG Schmitz. Based on an original photograph entitled, *It Takes Two to Tango*.

Body & Soul, Sweden, 2002. **client**: Stockholm / Sweden Dance Museum, **d/p**: Gert Weigelt. Dance poster.

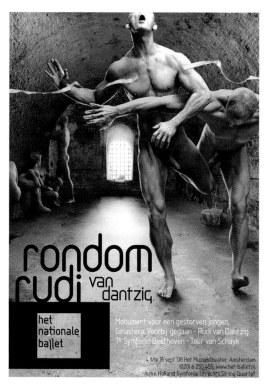

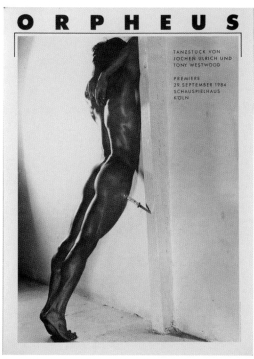

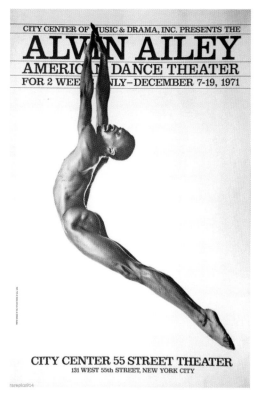

Rondom Rudi, The Netherlands, 2008. **client**: Het Nationale Ballet, Dutch National Ballet, **studio**: Me Studio, **cd/ad/d**: Martin Pyper, **p**: Gert Jan Evenhuis. A poster announcing several ballets celebrating choreographer Rudi van Dantzig.

Orpheus, Switzerland, 1984. **ad/p**: Gert Weigelt, **d**: HG Schmitz Based on an original photograph entitled, *Stiletto*.

Alvin Ailey American Dance Theater: City Center Poster, USA, 1971. **client**: Alvin Ailey American Dance Theater, **ad/d**: Bea Feitler, **p**: Bill King. The dancer, Dudley Williams, reported that many assumed he was posing while on the floor and shot from above. This was not the case: the shot catches him mid-jump.

Holland Dance Festival, The Netherlands, 1995. **client**: Holland Dance Festival, **studio**: Studio Dumbar, **d**: Studio Dumbar, Bob van Dijk,
p: Deen van Meer. In 1995, the festival explored the relationship between music and modern dance. Based on the bold graphic forms of musical scores, the visual palette combined typography and photography to create a series of dynamic compositions.

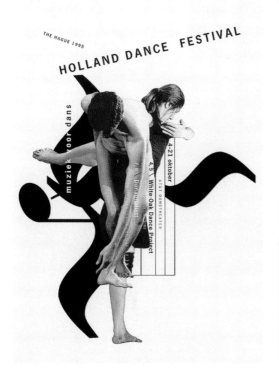

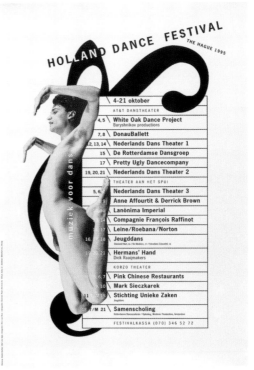

THE HAGUE 1995

HOLLAND DANCE FESTIVAL

muziek voor dans

4-21 oktober

AT&T DANSTHEATER

4,5 \ White Oak Dance Project

7,8 \ Donau Ballett

HOLLAND DANCE FESTIVAL

THE HAGUE 1995

muziek voor dans

	4-21 oktober
	AT&T DANSTHEATER
4, 5	**White Oak Dance Project** Baryshnikov productions
7, 8	**DonauBallett**
12, 13, 14	**Nederlands Dans Theater 1**
15	**De Rotterdamse Dansgroep**
17	**Pretty Ugly Dancecompany**
19, 20, 21	**Nederlands Dans Theater 2**
	THEATER AAN HET SPUI
5, 6,	**Nederlands Dans Theater 3**
9	**Anne Affourtit & Derrick Brown**
	Lanônima Imperial
14	**Compagnie François Raffinot**
17	**Leine/Roebana/Norton**
16, 18	**Jeugddans** Dansend Hart, i.s. / De Munkers, 17 / Vevuslaan Educatief, 14
19, 20, 21	**Hermans' Hand** Dick Raaijmakers
	KORZO THEATER
5, 6, 7	**Pink Chinese Restaurants**
9, 10	**Mark Sieczkarek**
11, 14, 15	**Stichting Unieke Zaken** Ningbibre
16, 17/M 21	**Samenscholing** Rotterdamse Dansacademie / Opleiding, Moderne Theaterdans, Amsterdam

FESTIVALKASSA (070) 346 52 72

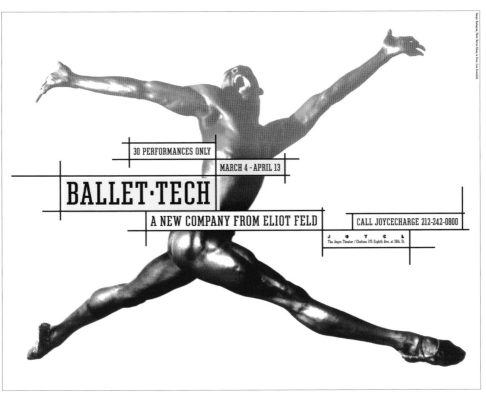

30 PERFORMANCES ONLY

MARCH 4 – APRIL 13

BALLET·TECH

A NEW COMPANY FROM ELIOT FELD

CALL JOYCECHARGE 212-242-0800

J O Y C E
The Joyce Theater / Chelsea 175 Eighth Ave. at 19th. St.

Poster for the 1997 Season of Ballet Tech, USA, 1997. **client**: Ballet Tech, **cd/ad/d**: Paula Scher, **d**: Lisa Mazur, **p**: Lois Greenfield.

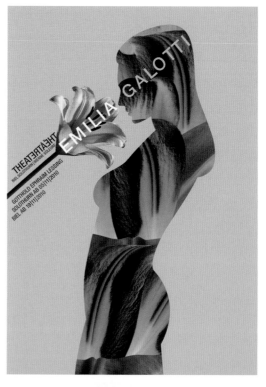

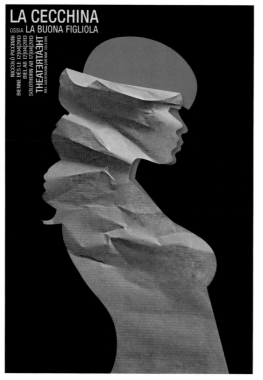

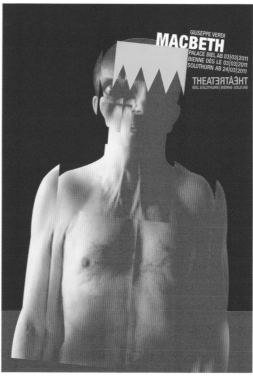

Head to Toe

La Cecchina, Switzerland, 2013. **client**: Theater Biel Solothurn,
cd/ad/d/ill: Stephan Bundi. Poster for opera by Niccoló Piccinni.
This simple country girl turns out to be blue-blooded.

Emilia Galotti, Switzerland, 2010. **client**: Theater Biel Solothurn,
cd/ad/d/ill: Stephan Bundi. Play by Gotthold Ephraim Lessing
about virginity, love, and death.

Macbeth, Switzerland, 2011. **client**: Theater Biel Solothurn,
cd/ad/d/p: Stephan Bundi. Opera by Giuseppe Verdi, after the play
by William Shakespeare. Macbeth, the wrongful king and the murderer.

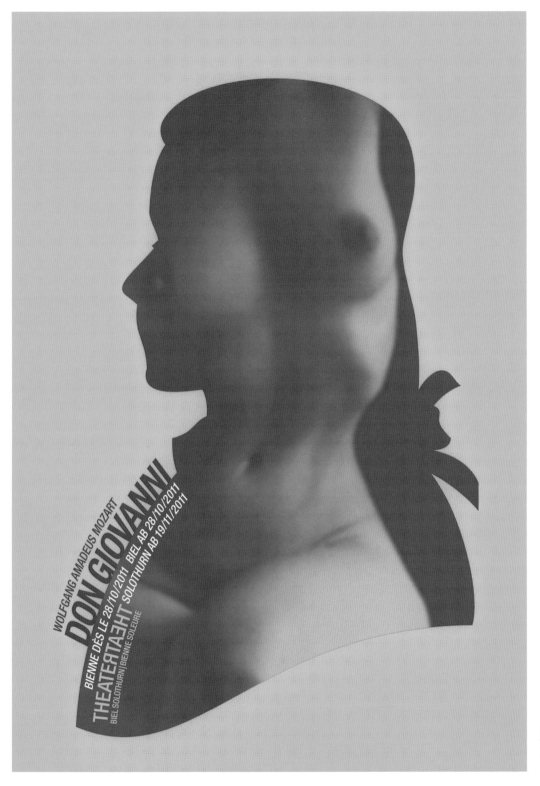

Don Giovanni, Switzerland, 2011. **client**: Theater Biel Solothurn, **cd/ad/d/p**: Stephan Bundi. Opera by Wolfgang Amadeus Mozart. The portrait of Mozart is captured at the same time as the figure Don Giovanni, the womanizer. The silhouette was often-used as a technique in the eighteenth century to draw simple portraits, and it refers to the time the opera was written.

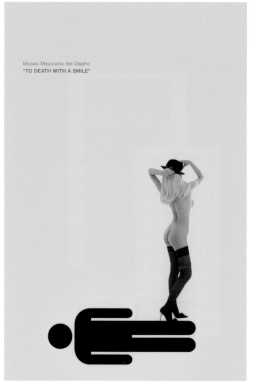

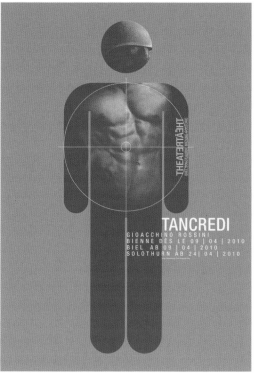

To Death With a Smile, 2007. **client**: MUMEDI / Museo Mexicano del Diseño, **cd/ad/d/ill**: Taber Calderon, **p**: Shutterstock. Poster for an exhibition to celebrate the Day of the Dead in Mexico. Theme and name of exhibition: *To Death With a Smile*.

Le Cabaret de Carmen, USA, 2008. **client**: Baltimore Theatre Project, **cd/ad/d/ill**: David Plunkert. Show poster for the Baltimore Theatre Project's 2008–2009 production season.

Tancredi, Switzerland, 2010. **client**: Theater Biel Solothurn, **cd/ad/d**: Stephan Bundi. The staging sets the action in the present, in a military environment.

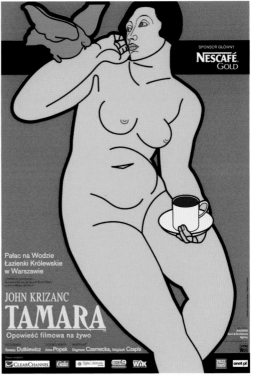

The Decalogue 6, Poland, 2012. **d**: Ewa Bajek
Film directed by Krzysztof Kieslowski. (Dydo Poster Collection)

Martyr, Russia, 2014. **client**: Gogol Center Theatre, Moscow,
d: Peter Bankov. Theater poster.

Tamara, Poland, 2004. **client**: Allegro Company,
cd/ad/d/ill: Andrzej Pągowski. Poster for the play *Tamara*.
The design is in the style of a Tamara de Lempicka painting.

Pelléas et Mélisande, France, 2000. **client**: Théâtre de Rungis, **cd/d**: Anette Lenz. The play *Pelléas et Mélisande* is a tragic love story. The golden square in the poster represents the stage—a defined place in space that relates a story of foreground to the background. Through the choice of its visual style, it connects history with the present. This poster is one of a series of sixteen.

Un Tartuffe / Des Fausses Confidences, France, 2000. **client**: Théâtre de Rungis, **cd/d**: Anette Lenz. The play *Un Tartuffe* (after Molière) / *Des fausses confidènces* (after Marivaux) is about a bigot and a manipulator. The golden square on the poster represents the stage as a defined place in space and time. The cross is like a keyhole, giving a view "behind the scenes." This poster is one out of a series of sixteen.

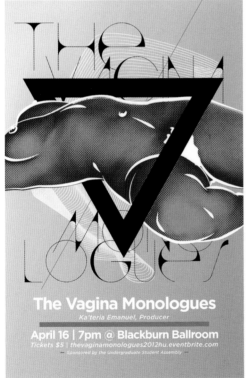

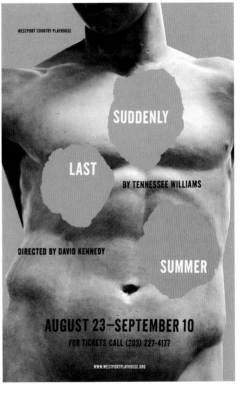

Body Art

"Please Don't Walk Around in the Nude!" by Georges Feydeau, Macedonia, 2006. **client**: Cultural Center "Grigor Prličev" Ohrid, **d**: Vladimir Trajanovsk. A comedy in which married actors have the leading roles.

The Vagina Monologues at Howard University, USA, 2012. **client**: Howard University, **cd/ad/d/ill/p**: Curry Hackett, **c**: Ka'teria Emanuel. Pop art's use of irony and symbolism served as an appropriate point of departure for this theater poster.

Suddenly Last Summer, USA, 2011. **client**: Mark Lamos, Westport Country Playhouse, **cd/ad/d**: Kevin Brianard, **ill**: Kevin Brianard, Darren Cox, **p**: Darren Cox. Poster for the play *Suddenly Last Summer* by Tennessee Williams.

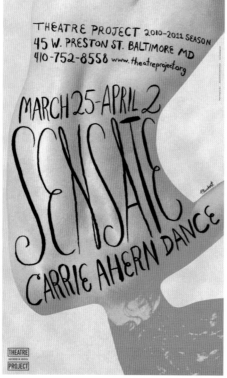

Sensate, USA, 2011. **client**: Baltimore Theatre Project,
cd/ad/d/ill: David Plunkert. Show poster for the Baltimore Theater
Project's 2010-2011 production season.

Sennentuntschi, Switzerland, 2005. **client**: Theater Aeternam,
cd: Erich Brechbühl. Theater poster for a scandalous play from the 1970s
in which two lonely mountaineers craft their own sex doll.

The Pleasure Trials, 2016. **client**: Amphibian Stage,
studio: Alfalfa Studio, **cd/ill**: Rafael Esquer, **d**: Bruno Cervantes,
Rafael Esquer, Jesus Ortega. A play by Sarah Saltwick about women,
sexual desire, and the burden of meeting expectations.

Aristophanes: Lysistrata, Croatia, 1982. **client**: HNK Split / Croatian National Theatre, Split, **d**: Boris Bućan.
Theater poster. (Courtesy of The Museum of Contemporary Art Zagreb)

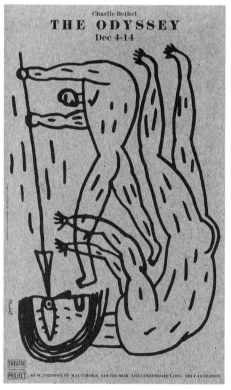

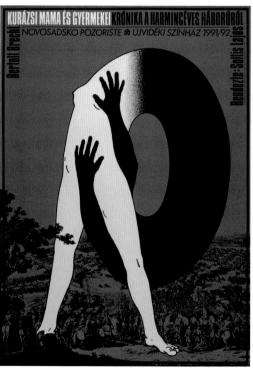

The Odyssey, USA, 2014. **client**: Baltimore Theatre Project,
cd/ad/d/ill: David Plunkert. Poster for the Baltimore Theatre Project's
2014–2015 season.

Zagreb Days in Shanghai, Croatia, 1985. **d**: Boris Bućan.
Theater poster. (Courtesy of The Museum of Contemporary Art Zagreb)

Mother Courage and Her Children, Serbia, 1991.
client: Újvidéki Színház, Novi Sad, Serbia, **cd**: Ferenc Barath.
The cruelty of the long war and the profiteering of Mother Courage.
Theater poster.

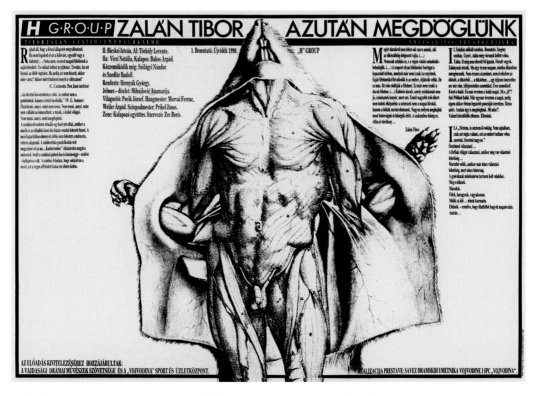

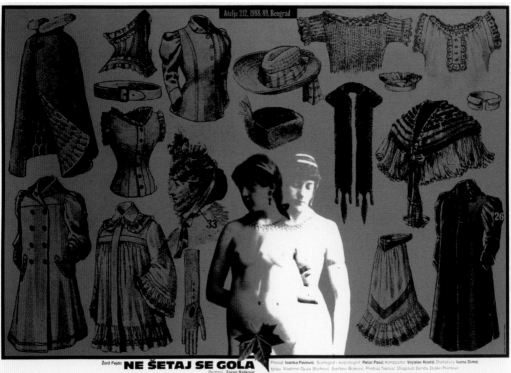

Than We Shall Die, Novi Sad, Serbia, 1990. **client**: Studio H, Novi Sad, Serbia, **cd**: Ferenc Barath. Theater poster. The battle of conscience and a way of life that should be in accordance with the expectations of the society.

Do Not Walk Around in the Nude, Belgrade, Serbia, 1992. **client**: Atelje 212, Belgrade, Serbia, **cd**: Ferenc Barath. Theater poster. A vicissitudinous day for the Ventroux family, a day that creates ups and downs and misunderstandings.

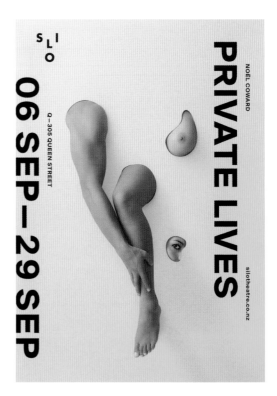

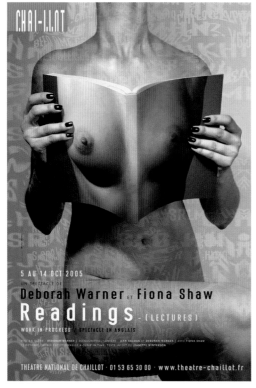

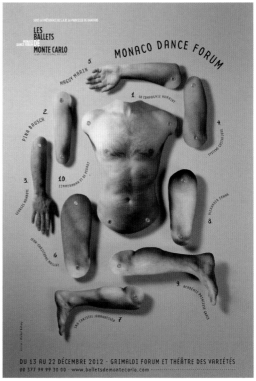

Readings, France, 2005. **client**: Theatre National de Chaillot, **d**: Michal Batory. Theater poster.

Private Lives, New Zealand, 2012. **client**: Silo Theatre **studio**: Alt Group, **cd/ad/d**: Dean Poole, **d**: Anna Myers, Aaron Edwards, Alan Wolfgramm, Emma Hickey, **p**: Toaki Okano. To launch the Silo 2012 season a series of physical collages were constructed to hint at the underlying themes of each play.

Monaco Dance Forum, France, 2012. **client**: Les Ballets de Monte Carlo, **d**: Michal Batory. Dance poster.

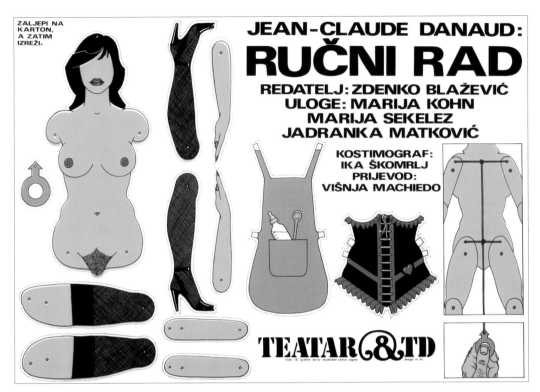

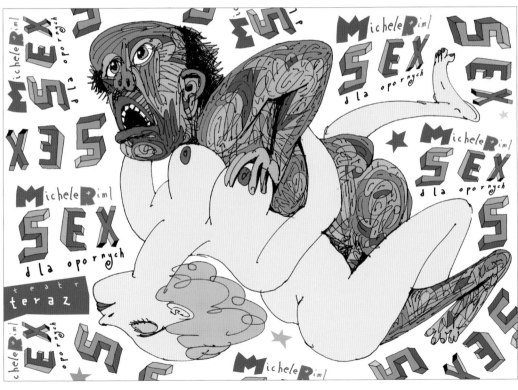

Jean-Claude Danaud: Handmade, Croatia, 1975–1980. **d**: Mirko Ilić. Once the elements of the poster are cut out and assembled, they turn into a Jumping Jack puppet, which can spread her arms and legs, and can be dressed either as a mother or a lover. (Courtesy of Museum of Arts and Crafts, Zagreb)

Sex dla opornych, Poland, 2015. **client**: Teatr Teraz, **cd/ad/d/c/ill/p**: Leszek Zebrowski. Theater poster.

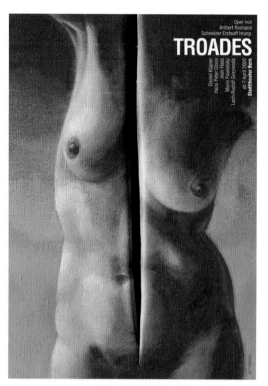

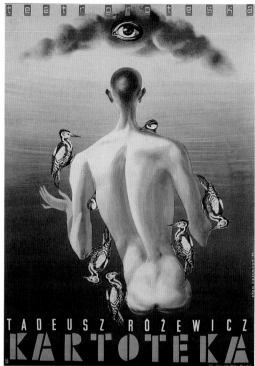

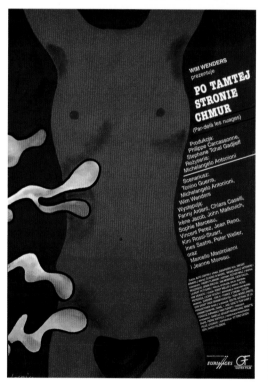

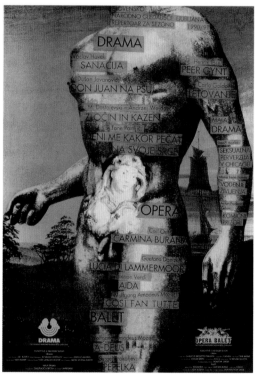

Troades, Switzerland, 2000. **client**: Stadttheater Bern,
cd/ad/d/ill: Stephan Bundi. Opera by Aribert Reimann. The ordeal of the
Trojan women. The torture they suffered is symbolized by a cut through the
poster. At first glance, the trompe l'oeil effect makes the viewer uncertain
whether the poster was damaged or the gash is part of the design.

Po tamtej stronie chmur, Poland, 1996. **d**: Jan Lenica. Film poster.
(Dydo Poster Collection)

Kartoteka, Poland, 1960. **d**: Adam Hoffmann. Theater poster.
(Dydo Poster Collection)

**Repertoire for the 1990–1991 Season, Slovene National Theatre
in Ljubljana, Slovenia**, Slovenia, 1990. **client**: Slovene National Theatre,
studio: New Collectivism. Poster.

La Erotica del Cartel Palaco, Spain, 2011. **d**: Kaja Renkas.
Exhibition poster. (Dydo Poster Collection)

Cet obscur objet du désir, Poland, 1978. **d**: Romuald Socha.
Film poster. (Dydo Poster Collection)

Dies Irae, Poland, 1991. **client**: National Theatre in Warsaw, Poland,
cd/ad/d/ill: Andrzej Pągowski. Poster for *Dies Irae* opera. Collage.

Syn marnotrawny, Poland, 1989. **d**: Slawomir Kosmynka.
Theater poster. (Dydo Poster Collection)

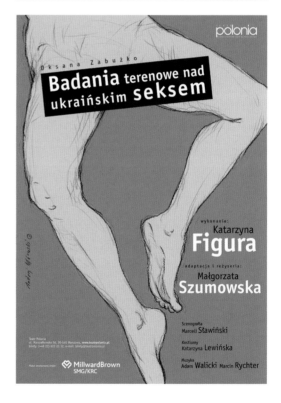

The Taming of the Shrew, Poland, 1987. **client**: Theatre of One Sign, Warsaw, **ad/d/ill**: Marian Nowinski. Poster interpreting the text in William Shakespeare's play. The drawing, in the form of a graphic sign, presents the relationship between a married couple.

Lysa Spiewaczka, Poland, 1989. **d**: Witold Siemaszkiewicz. Theater poster for a play by Eugene Ionesco. (Dydo Poster Collection)

Field Research in Ukrainian Sex, Poland, 2006. **client**: Polonia Theatre, Warsaw, **cd/ad/d/ill**: Andrzej Pągowski, **type**: Magda Blazkow. Andrzej Pągowski poster for the play *Field Research in Ukrainian Sex* by Oksana Zabuzhko.

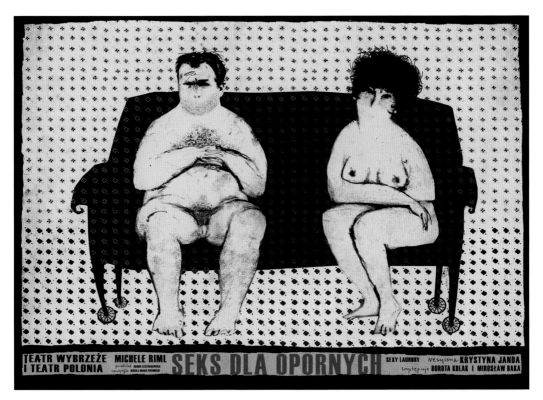

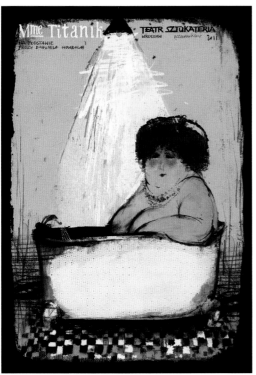

Sexy Laundry, Poland, 2012. **client**: Teatr Wybrzeze / Teatr Polonia, **cd**: Ryszard Kaja. Theater poster.

Mme Titanik, Poland, 2011. **client**: Teatr Sztukateria, **cd**: Ryszard Kaja.
Theater poster.

Henry and Alice—Into the Wild, Poland, 2015.
client: Teatr Wybrzeze / Teatr Polonia, **cd**: Ryszard Kaja. Theater poster.

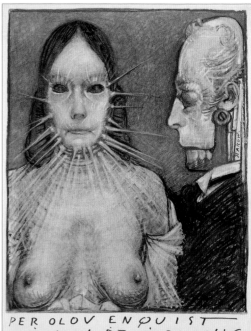

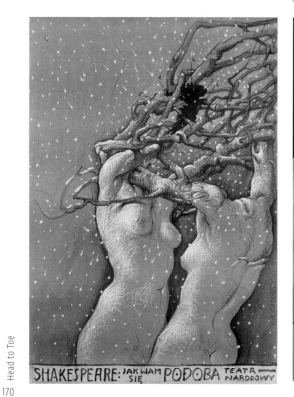

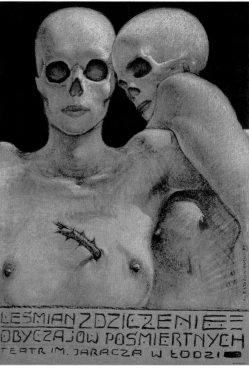

Jak wam sie podoba, Poland, 1976. **d**: Franciszek Starowieyski.
Theater poster. (Dydo Poster Collection)

Z zycia dzdzownic, Poland, 1983. **d**: Franciszek Starowieyski.
Theater poster for a play by Per Olov Enquist. (Dydo Poster Collection)

Posthumous Customs Gone Amok, Poland, 1983.
d: Franciszek Starowieyski. Theater poster for *Posthumous Customs Gone Amok* by Boleslaw Lesmain.

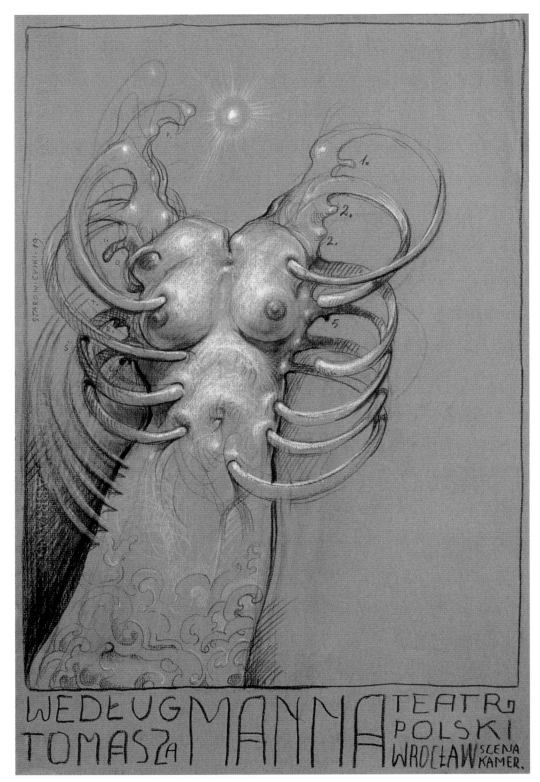

Wedlug Tomasza Manna, Poland, 1979. **client**: Teatr Polski, Wroclaw, **d**: Franciszek Starowieyski. Theater poster. (Dydo Poster Collection)

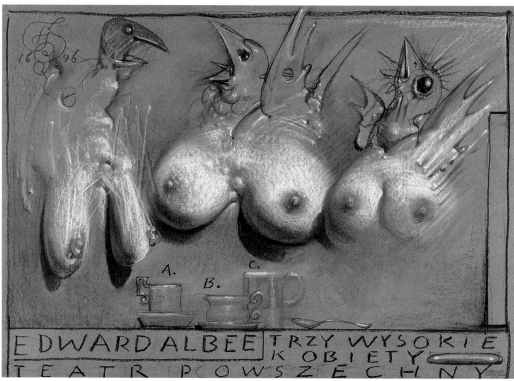

Wherever You Are, If You're There, Poland, 1979. **d**: Franciszek Starowieyski. Film poster. (Dydo Poster Collection)

Three Tall Women, Poland, 1996. **client**: Teatr Powszechny, Warszawa. **d**: Franciszek Starowieyski. Theater poster for *Three Tall Women* by Edward Albee. (Dydo Poster Collection)

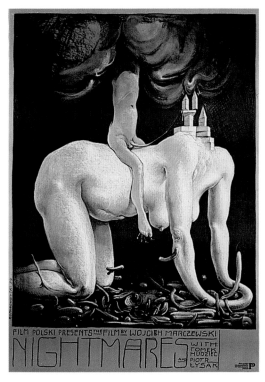

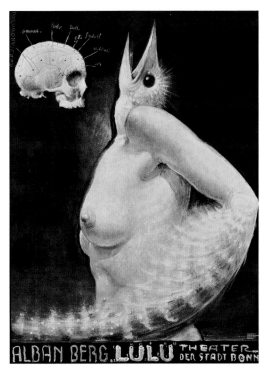

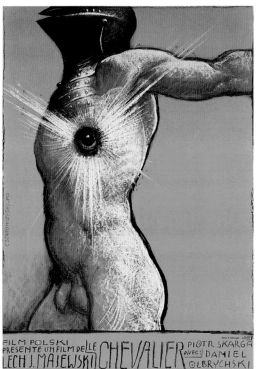

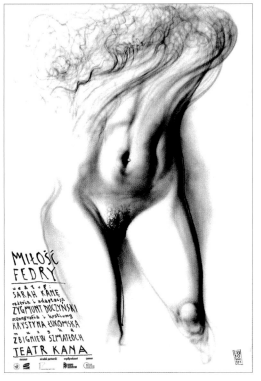

Nightmares, Poland, 1979. **d**: Franciszek Starowieyski. Film poster.
(Dydo Poster Collection)

Le Chevalier, Poland, 1980. **d**: Franciszek Starowieyski. Film poster.
(Dydo Poster Collection)

Lulu, Poland, 1979. **d**: Franciszek Starowieyski. Theater poster.
(Dydo Poster Collection)

Miłość Fedry—Phedra's Love, Poland, 2003. **client**: Theatr Kana-Szczecin,
cd/ad/d/c/ill/p: Leszek Zebrowski. Theater poster.

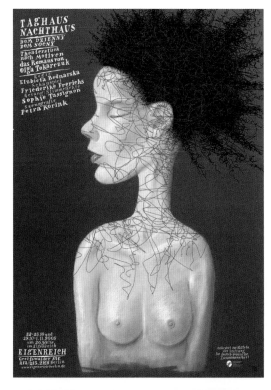

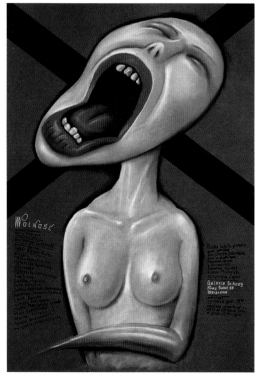

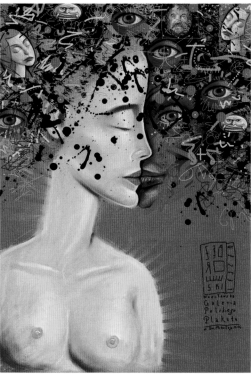

Wolność—Freedom, Poland, 2012. **client**: Galeria Schody, Warszawa, **cd/ad/d/c/ill/p**: Leszek Zebrowski. Exhibition poster.

Taghaus—Nachthaus, Germany, 2009. **client**: Theatre E. Bednarska, **cd/ad/d/c/ill/p**: Leszek Zebrowski. Theater poster.

Wrocławska Galeria Plakatu, Poland, 2012. **client**: Wrocławska Galeria Plakatu Polskiego, **cd/ad/d/c/ill/p**: Leszek Zebrowski. Exhibition poster.

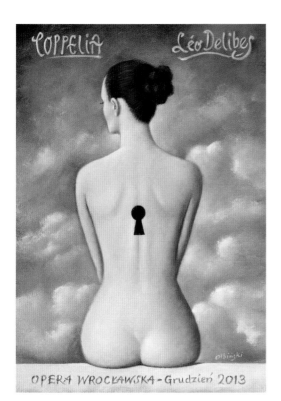

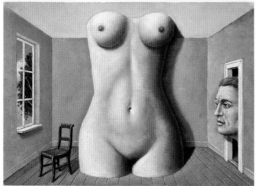

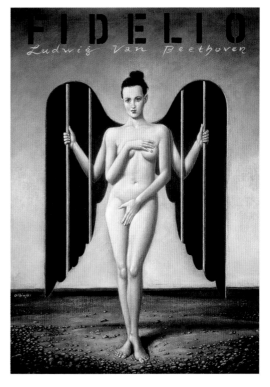

Coppelia, Leo Delibes, Poland, December 2013. **client**: Opera Wroclaw, **cd/ad/d/c/ill**: Rafal Olbinski. Poster for the ballet production *Libretto*, which is based upon two stories by E. T. A. Hoffman; "The Sandman" and "The Doll."

Things We Do For Love, Alan Ayckbourn, Poland, 2005. **client**: Nowy Theater, Lodz, Poland, **cd/ad/d/c/ill**: Rafal Olbinski. Play about a woman who has an affair with her best friend's fiancé. The play was performed on a stage with a three-floor set.

Fidelio, Ludwig van Beethoven, Poland, 2003 **client**: Grand Theatre Opera, Poznan, Poland, **cd/ad/d/c/ill**: Rafal Olbinski. Poster for Beethoven's only opera. The story is about the personal sacrifice of the heroin, Lenore, who rescues her husband from death in political prison while disguised as a prison guard.

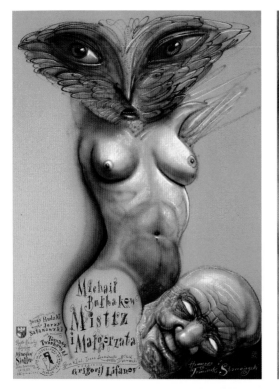

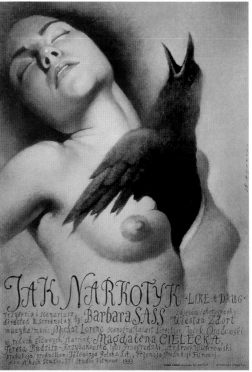

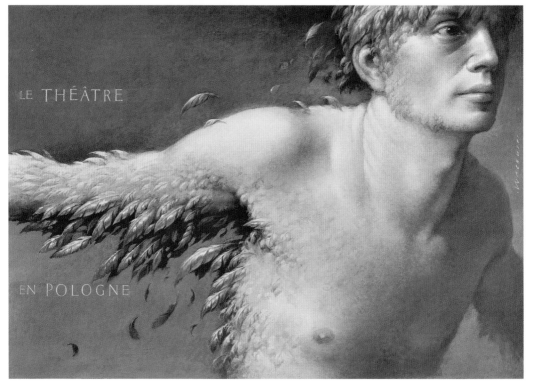

Master & Margarita, Poland, 2013. **client**: Teatr Im Sewruka W Elblagu, **cd/ad/d/c/ill/p**: Leszek Zebrowski. Homage to Franciszek Starowieyski.

The Theatre in Poland, Poland, 1991. **d**: Wieslaw Walkuski. Theater poster. (Dydo Poster Collection)

Like a Drug, Poland, 1999. **d**: Wieslaw Walkuski. Poster for a movie directed by Barbara Sass. (Dydo Poster Collection)

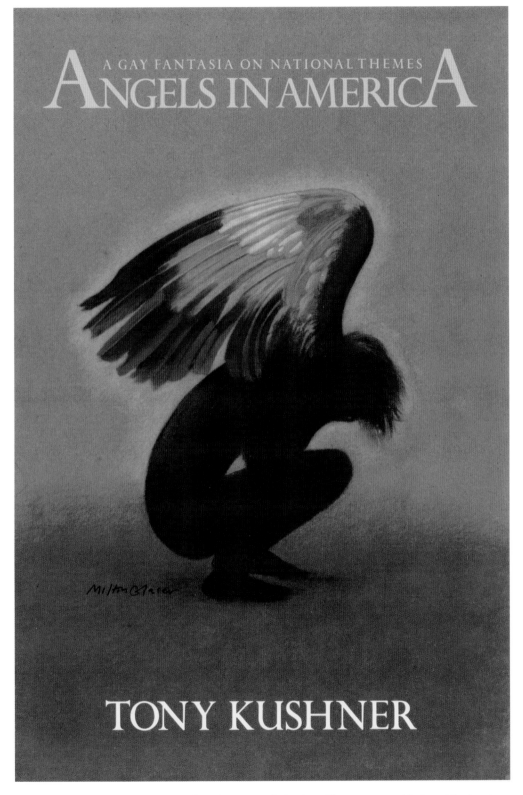

A GAY FANTASIA ON NATIONAL THEMES
ANGELS IN AMERICA

TONY KUSHNER

Angels in America, USA 1993. **d/ill**: Milton Glaser. **client**: Theater Communications Group. This poster was created for the great American play written by Tony Kushner. The wing is based on a famous drawing by Dürer.

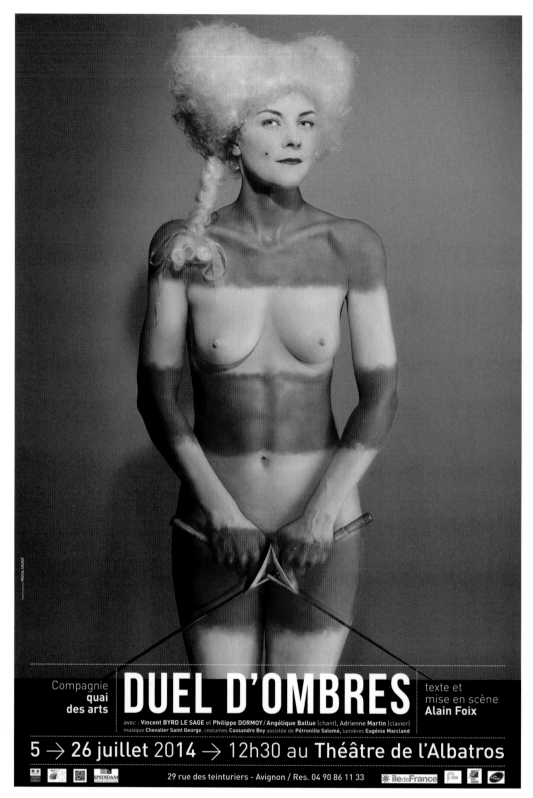

Head to Toe

Duel d'Ombres, France, 2014. **client**: Compagnie quai des arts, **d/p**: Pascal Colrat. Theater poster.

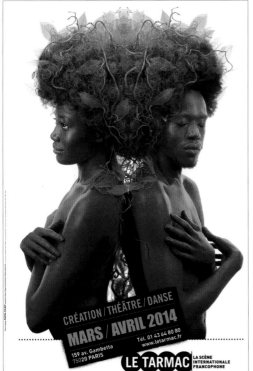

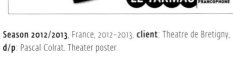

Season 2012/2013, France, 2012–2013. **client**: Theatre de Bretigny, **d/p**: Pascal Colrat. Theater poster.

March/April 2014, France, 2014. **client**: Le Tarmac, **d/p**: Pascal Colrat. Theater poster.

Un Pour Tous, Tous Pour Un!, France, 2012. **client**: Theatre de Bretigny, **d/p**: Pascal Colrat. Theater poster.

Amours et Dépendances, France, 2013. **client**: Theatre de Bretigny, **d/p**: Pascal Colrat. Theater poster.

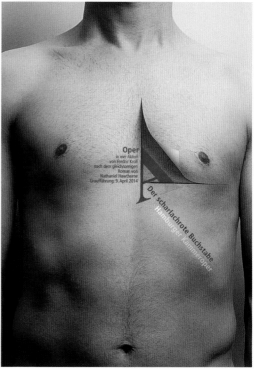

Head to Toe

Mudman (Szeged Contemporary Ballet), Hungary, 1996.
client: Tamás Juranics, National Theatre, Szeged, **cd/ad/d/ill**: Péter Pócs,
p: Peter Walter. A ballet about Genesis.

MESS—International Theatre Festival Sarajevo, Bosnia, 2003.
client: MESS, **cd**: Bojan Hadžihalilović, **ad/d**: Amer Mržljak, **p**: Zijah Gafić.
Male and female nude photography represents a step forward in
something new and experimental.

The Scarlet Letter, Germany, 2015. **client**: Hamburger Kammeroper,
cd/ad/d/p: Holger Matthies. This poster for *The Scarlet Letter* makes an
interesting statement on gender by putting the famous "A" on Arthur
Dimmesdale's chest instead of Hester Prynne's.

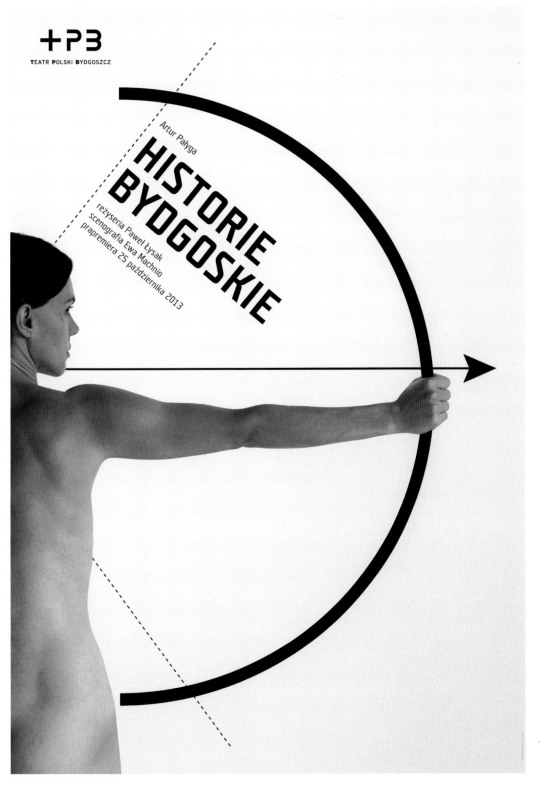

+P3
TEATR POLSKI BYDGOSZCZ

Artur Pałyga
HISTORIE BYDGOSKIE
reżyseria Paweł Łysak
scenografia Ewa Machnio
prapremiera 25 października 2013

Bydgoskie Stories, Poland, 2013. **client**: Polski Teatre Bydgoszcz, **studio**: Homework, **cd/ad/d**: Joanna Górska, **cd/ad/d/p**: Jerzy Skakun.
Theater poster for a play based on stories from the city of Bydgoskie. An archer statue is one of the iconic symbols of the city.

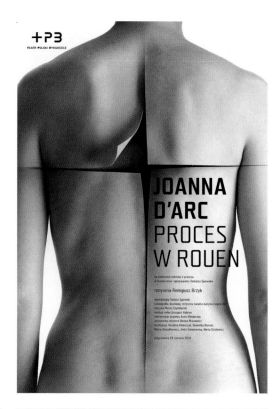

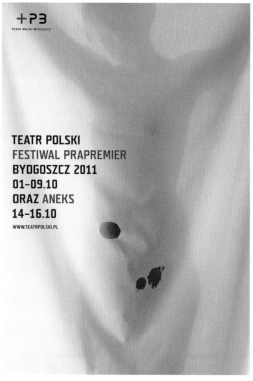

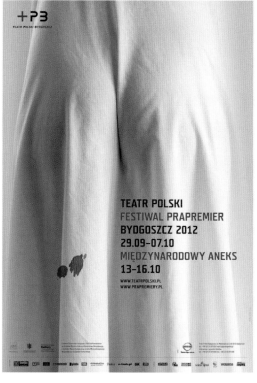

Head to Toe

World Premiere Festival 2011, Poland, 2011. **client**: Polski
Teatre Bydgoszcz, **studio**: Homework, **cd/ad/d**: Joanna Górska,
cd/ad/d/p: Jerzy Skakun. Theater festival poster. The festival premieres
the best Polish dramas.

Joan of Arc, A Process in Rouen, Poland, 2010. **client**: Polski
Teatr Bydgoszcz, **studio**: Homework, **cd/ad/d**: Joanna Górska,
cd/ad/d/p: Jerzy Skakun. Theater poster for a modern adaptation
of the story of Joan of Arc.

World Premiere Festival 2012, Poland, 2012. **client**: Polski
Teatre Bydgoszcz, **studio**: Homework, **cd/ad/d**: Joanna Górska,
cd/ad/d/p: Jerzy Skakun. Theater festival poster. The festival premieres
the best Polish dramas.

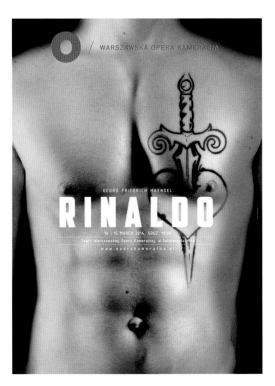

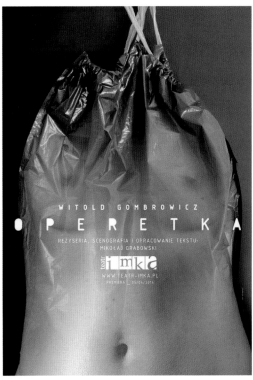

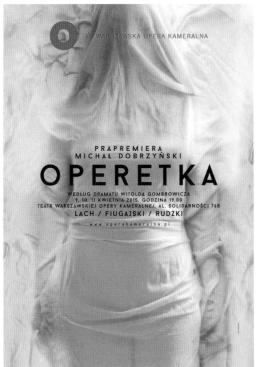

Rinaldo / opera, Poland, 2014. **client**: Warsaw Chamber Opera,
cd/ad/d/p: Ewa Natkaniec, **c**: Warsaw Chamber Opera. Poster for
the G. F. Handel opera *Rinaldo*.

Operetta / Opera, Poland, 2015. **client**: Warsaw Chamber Opera,
cd/ad/d/p: Ewa Natkaniec, **c**: Warsaw Chamber Opera. Poster for the
opera based on the Witold Gombrowicz play *Operetta*. An attempt to show
innocence, nudity, divinity, and purity as a value above all, which kills
mortal discussions and conflicts shown in opera.

Operetta / theater play, Poland, 2014. **client**: Imka Theatre Warsaw,
cd/ad/d/p: Ewa Natkaniec, **c**: Imka Theatre Warsaw. Poster for the play
Operetta, by Witold Gombrowicz. An attempt to show nudity as purity
in contrast to the falseness of people dressed in costumes, even ones as
undefined as plastic bags.

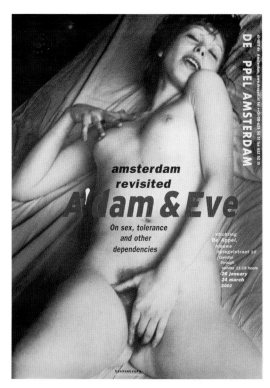

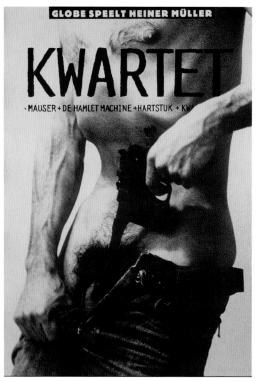

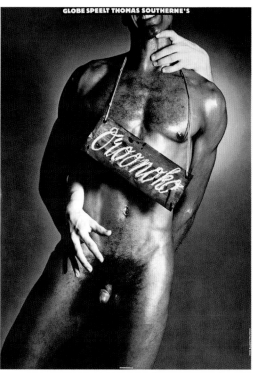

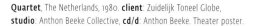

Quartet, The Netherlands, 1980. **client**: Zuidelijk Toneel Globe, **studio**: Anthon Beeke Collective, **cd/d**: Anthon Beeke. Theater poster.

A'dam & Eve, The Netherlands, 2002. **client**: De Appel, Amsterdam, **studio**: Anthon Beeke Collective, **cd/d**: Anthon Beeke, **p**: Anna Beeke. Theater poster.

Oroonoko, The Netherlands, 1983. **client**: Zuidelijk Toneel Globe, **studio**: Anthon Beeke Collective, **cd/d**: Anthon Beeke, **p**: Boudewijn Neuteboom. Theater poster. In 1650, Oroonoko was an African chieftain who was manipulated by slave traders to suppress the revolt of his followers.

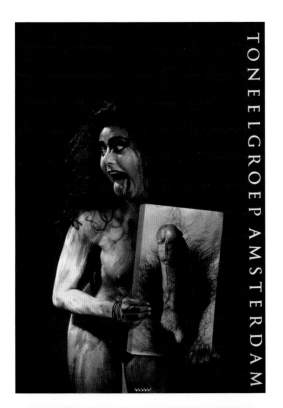

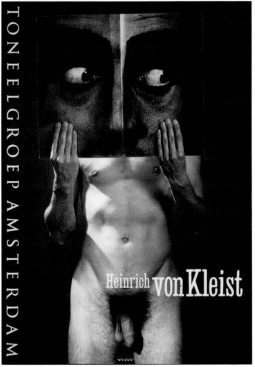

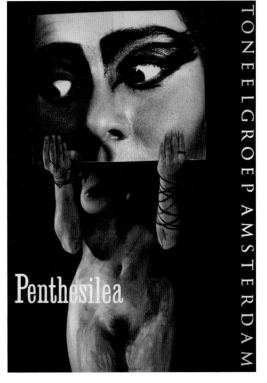

Penthesilea 1, 2, and 3 (triptych), The Netherlands, 1991. **client**: Toneelgroep Amsterdam, **studio**: Anthon Beeke Collective, **cd/d/p**: Anthon Beeke. "It's only after you have seen the show by Toneelgroep Amsterdam and have seen the poster in the street that you understand the statement I am making. That's also the experience you have if you see the poster for the next show before seeing the show itself. For theater posters, I usually look for a metaphor for something that is itself a metaphor. Penthesilea is at the head of a group of very feminist women who only tolerate men to procreate. Naturally she falls in love with Zeus, who completely fucks her up—just as naturally."—Anthon Beeke

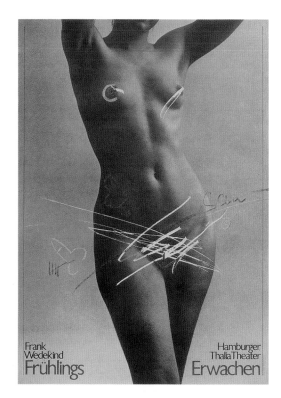

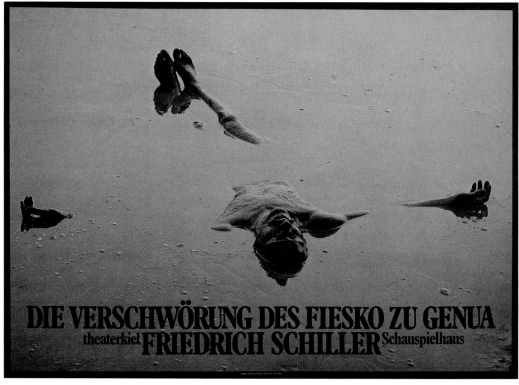

Head to Toe

Awaken of Spring, Germany, 1978. **client**: Thalia Theater Hamburg, **cd/ad/d/p**: Holger Matthies. If sexuality awakens and young people have no sex education, they often develop a neurosis, for example, writing graffiti in toilets.

The Conspiration of Fiesko from Genua, Germany, 1977. **client**: Theater Kiel, **cd/ad/d/p**: Holger Matthies. Fiesko was murdered by his enemies by being thrown into the water and drowned painfully.

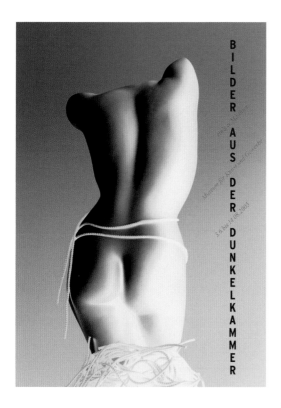

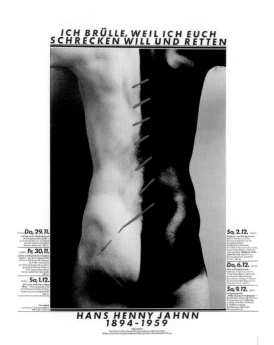

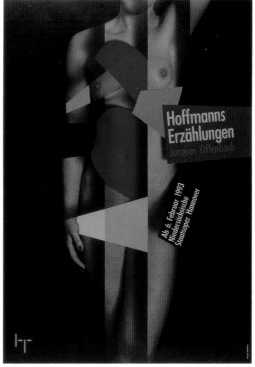

Pictures from the Darkroom, Germany, 2005.
client: Museum für Kunst und Gewerbe, **cd/ad/d/p**: Holger Matthies.
The nude looses the shackles and comes out of the darkroom.

I Cry, Because I Will Shock You and Save You, Germany, 1984.
client: Kampnagel / Kulturfabrik, **cd/ad/d/p**: Holger Matthies.
Hans Henny Jahnn (1854–1959) is a man of pain. This poster symbolizes,
with the cut of the body in dark and light, that these two worlds can only
bind together with a painful, bloody seam.

Stories of Mr. Hoffmanns, Germany, 1993. **client**: Staatsoper Hannover,
cd/ad/d/p: Holger Matthies. The body is evaded, because Mr. Hoffmanns
has sadistic tendencies and tortures women.

Pylade, USA, 2015. **client**: La Mama, **d/ad**: Nicky Lindeman, Mirko Ilić.
Poster for a Pasolini play full of sexuality and violence.

Benvenuto Cellini, 2015. **client**: Dutch National Opera,
cd/d: Lesley Moore, **p**: Petrovsky & Ramone. Part of a poster series for the
Dutch National Opera. The images are stills taken from short films created
to promote the various operas.

Adam and Eve / Shaping, Russia, 2015. **client**: Ermolova Moscow
Theatre, **d**: Varvara Zelenko. This poster was created for an experimental
play that questions what modern art is and if it is possible to use it as
a medium to understand yourself.

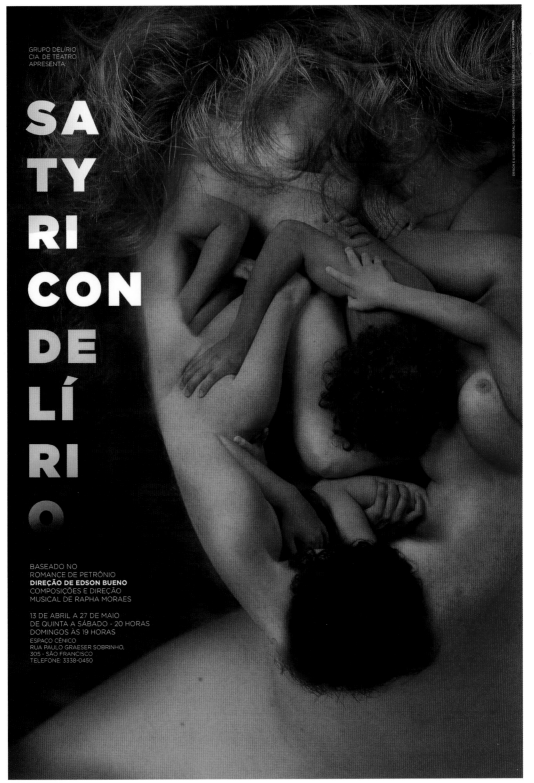

GRUPO DELÍRIO
CIA. DE TEATRO
APRESENTA:

SA
TY
RI
CON
DE
LÍ
RI
O

BASEADO NO
ROMANCE DE PETRÔNIO
DIREÇÃO DE EDSON BUENO
COMPOSIÇÕES E DIREÇÃO
MUSICAL DE RAPHA MORAES

13 DE ABRIL A 27 DE MAIO
DE QUINTA A SÁBADO - 20 HORAS
DOMINGOS ÀS 19 HORAS
ESPAÇO CÊNICO
RUA PAULO GRAESER SOBRINHO,
305 - SÃO FRANCISCO
TELEFONE: 3338-0450

Satyricon Delirio, Brazil, 2012. **client**: Grupo Delirio Cia de Teatro, **cd/d/ill/p**: Marcos Minini, **p**: Elenize Dezgeniski. *Satyricon* is a Latin work of fiction in a mixture of prose and poetry, written by Petronio in 60 BC. It's considered to be the first novel ever. The adaptation made by Grupo Delirio tells a story of sex, politics, and human conditions of an ancient era that is still very relevant today. The thirty-four actors, always on the stage, seduce the audience with looks, expression, and nudity in a very intense way.

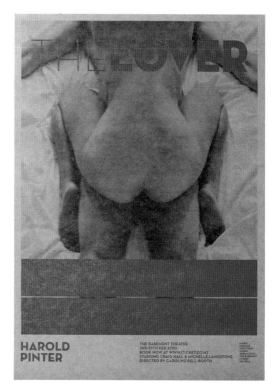

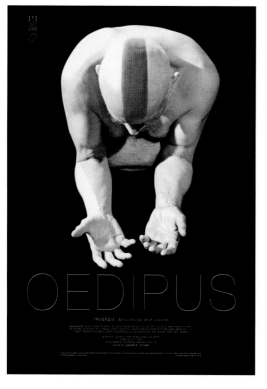

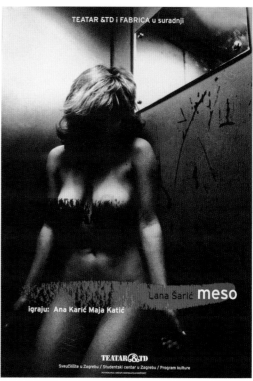

Oedipus, Romania, 2012. **client**: Szigligeti Theater Oradea, **ad/d**: Németh László, **p**: Petru Danci. Theater poster for a production of *Oedipus*. The set contained a windmill and the texture on the character's head is meant to look like a flour bag. The actual play was held in a real mill in Oradea, Romania.

The Lover, New Zealand, 2016. **client**: Basement Theatre, **cd/d**: Brogen Avernill. Poster for a Harold Pinter play.

MEAT, theatre play, Croatia, 2004. **client**: &TD Theatre, Zagreb, **studio**: Bachrach & Krištofić, **ad/d**: Sanja Bachrach Krištofić, Mario Krištofić. *Meat* is about the self-destructive importance of physical appearance in the modern world.

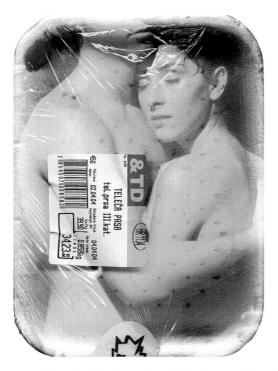

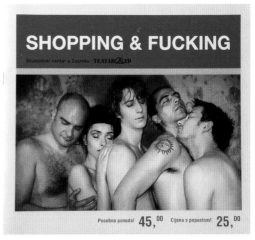

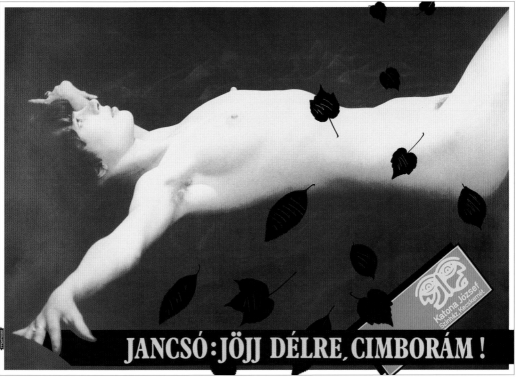

Shopping & Fucking, Croatia, 2004. **client**: &TD Theatre, Zagreb, Croatia, **studio**: Bachrach & Krištofić, **cd/ad/d/p**: Sanja Bachrach Krištofić, Mario Krištofić. The sexual violence of *Shopping and Fucking* explores what is possible if consumerism supersedes all other moral codes.

Jancsó: Come to the South My Fellow!, Hungary, 1983. **client**: Jozsef Katona Theatre, **cd/ad/d/c/il**: Peter Pocs, **p**: Peter Walter. Poster for the opera.

CHRISTIAN SLATER IS

JOE'S FATHER

WILLEM DAFOE IS

L

MIA GOTH IS

P

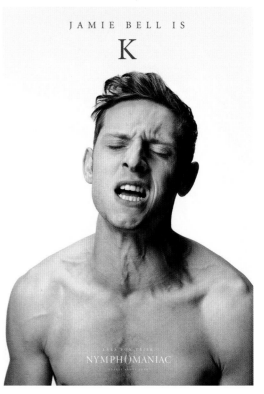

JAMIE BELL IS

K

Nymphomaniac, Denmark, 2013. **client**: Zentropa Productions / Nordisk Film, **studio**: The Einstein Couple, **cd/ad**: Maria Einstein Biilmann, Philip Einstein Lipski, **d**: Tobias Roder, **p**: Casper Sejersen. Film posters.

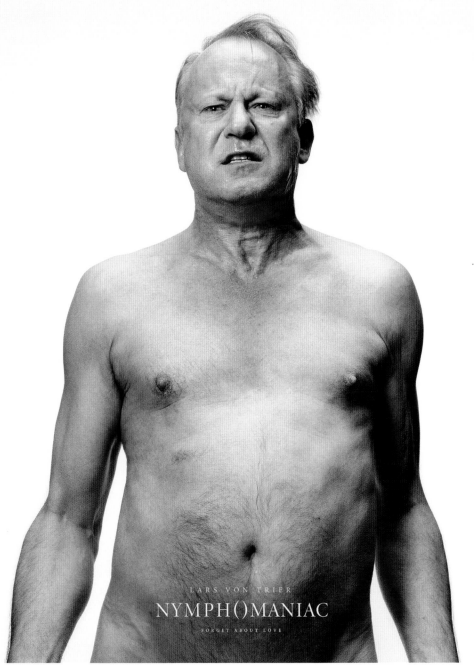

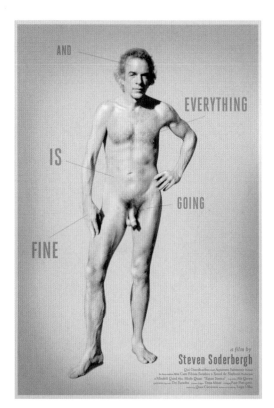

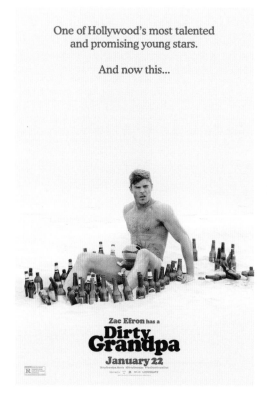

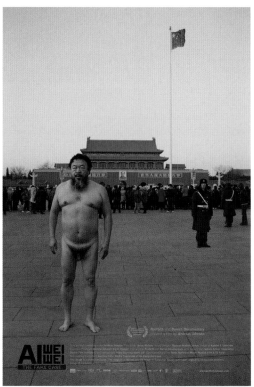

Dirty Grandpa, USA, 2016. **client**: Lionsgate Entertainment,
studio: Ignition / LA, **cd**: David Ikeda, **c**: Ryan Steinke. Movie poster.

And Everything Is Going Fine., 2010. **client**: IFC Films,
cd/ad/d: Neil Kellerhouse, **p**: Kathleen Russo. Film poster.

Ai WeiWei—The Fake Case, 2013. **client**: Andreas Johnsen,
cd: Neil Kellerhouse & Ai WeiWei, **ad/d**: Neil Kellerhouse,
p: Andreas Johnsen. It's a composite photo-montage by Neil Kellerhouse
showing Ai Weiwei naked, standing at attention in Tiananmen Square
just yards away from Mao's portrait and feet away from a policeman,
also at attention.

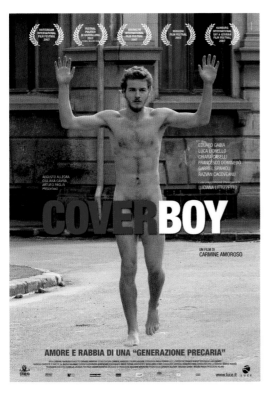

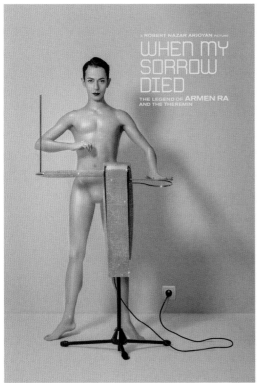

Cover Boy, Italy, 2007. **client**: Internozero Comunicazione, **cd/ad/d**: Riccardo Fidenzi, Maurizio Ruben, **c**: Internozero Comunicazione. Poster made for the launch campaign of the film in Italy.

When My Sorrow Died: The Legend of Armen Ra and the Theremin, USA, 2014. **client**: Lionsgate Entertainment, **studio**: Ignition / LA, **cd**: Jason Lindeman, **p**: Tim Palen. Film poster.

Nurse 3D, USA, 2013. **client**: Lionsgate Entertainment, **studio**: Ignition / LA, **cd**: Jason Lindeman, **p**: Tim Palen. Film poster.

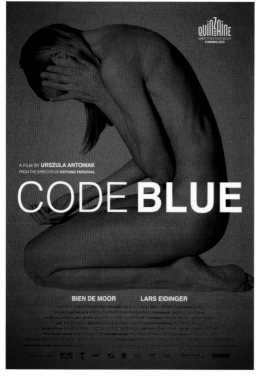

Code Blue, The Netherlands, 2011. **client**: IDTV Film, **studio**: Shosho, **d**: Joost Hiensch, Susanne Keilhack, **p**: Jasper Wolf (cameraman on the film). This movie by director Urszula Antoniak, features a strong female lead with an intense, raw character.

Hierro, Spain, 2009. **client**: Madrugada Films, Telecinco Cinema, User T38, **cd**: Natalia Montes, Sergio Rozas, **ill**: Raul Monge & Carlos Salgado, **p**: Jorge Alvarino. "We asked the main female character (Elena Anaya) to submerge...and we got some really lovely pictures, thanks to the texture provided by the dirty water."–Jorge Alvarino

If I Had a Heart, United Kingdom, 2015. **client**: Simple Pictures, **d/ill**: Rob Fuller, **title designer**: Brother Tak. Poster for a film set in South Korea about a socially detached fighter battling his demons.

Temptation: Confessions of a Marriage Counselor, USA, 2013.
client: Lionsgate Entertainment, **studio**: Ignition / LA,
cd: Jason Lindeman, **p**: Cullin Tobin. Movie poster.

Breaking the Girls, USA, 2013. **client**: IFC Films, **cd**: Michael Boland,
p: Screen Grab. The goal of this piece of key art was to emphasize not only
this film's and this primary character's sensuality but also the ultimate
twist in the film's narrative. In a nod to the film's set design, the target in
this revenge murder plot is displayed as a decorative object and trophy.

Eastern Boys, Australia, 2015.
client: Palace Films, **cd**: Jonathan Coucoulas. **d**: This Time Tomorrow.
Eastern Boys is the story of a middle-aged businessman who solicits
a younger foreigner and after arranging to meet, triggers a series
of incidents that will change them both.

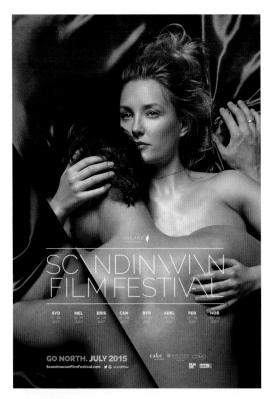

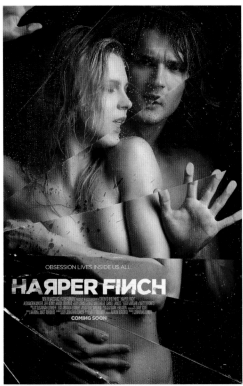

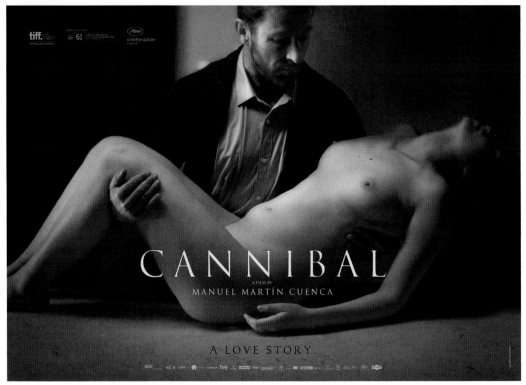

Scandinavian Film Festival, Australia, 2015. **client**: Palace Cinemas, **studio**: This Time Tomorrow, **cd**: Jonathan Coucoulas, **p**: Pal Laukli. Using imagery from a film showing at the festival, the intimate nature of the shot was deconstructed by creating a slice through the image to convey a sense of unease.

Harper Finch, USA, 2016. **client**: New Renaissance Entertainment, **studio**: Ignition / LA, **cd**: Jason Lindeman, **p**: Caitlin Mitchell. Film poster.

Cannibal, Spain, 2013. **client**: Mod Producciones, La Loma Blanca, **cd**: Natalia Montes, **p**: Marino Scandurra. The main objective was to show that even a terrible person, like a cannibal, can fall in love despite his sinister mind and atrocious actions. This powerful image is similar to Michelangelo's *Pietà*, to show Carlos's repression in his Christian environment.

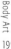

The Time of Love, Italy, 1999. **client**: Internozero Comunicazione,
cd/ad/d: Riccardo Fidenzi, Maurizio Ruben, **c**: Internozero Comunicazione.
Poster made for the launch campaign of the film in Italy.

Memento, Italy, 2000. **client**: Internozero Comunicazione,
cd/ad/d: Riccardo Fidenzi, Maurizio Ruben, **c**: Internozero Comunicazione.
Poster made for the launch campaign of the film in Italy.

A Glass of Anger, Italy, 1999. **client**: Internozero Comunicazione,
cd/ad/d: Riccardo Fidenzi, Maurizio Ruben, **c**: Internozero Comunicazione.
Poster made for the launch campaign of the film in Italy.

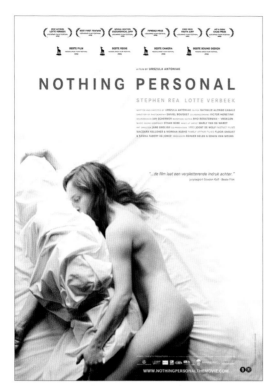

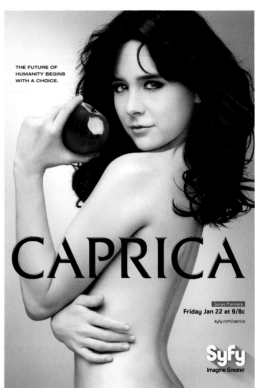

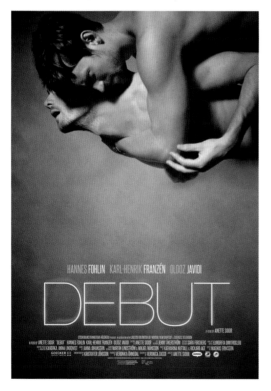

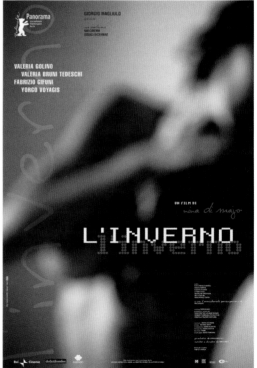

Nothing Personal, The Netherlands, 2009. **client**: Rinkel Film,
d: Joost Hiensch & Susanne Keilhack, **p**: Daniël Bouquet. Film poster.

Debut, Sweden, 2015. **client**: Stockholms konstnärliga högskola,
cd/ad/d: Mårten Kellerman, **p**: Kristoffer Jönsson. Poster for a film directed
by Anette Sidor. The photo was rotated for a less conventional approach,
color and effects were muted for a bleaker, and more restrained feel.

Caprica, USA, 2009. **client**: Syfy, **agency**: BPG Advertising,
cd: Steph Sebbag, **ad**: Marco Orozco, **d**: Richard Ro, **p**: Justin Stephens.
Caprica was a science fiction television drama, showing how humanity
first created the robotic cylons.

Winter, Italy, 2002. **client**: Internozero Comunicazione,
cd/ad/d: Riccardo Fidenzi, Maurizio Ruben, **c**: Internozero Comunicazione.
Poster made for the launch campaign of the film in Italy.

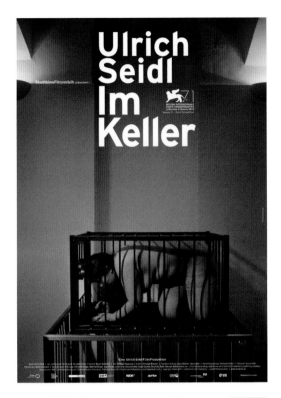

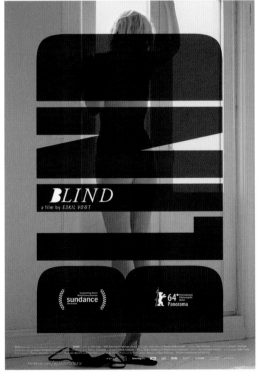

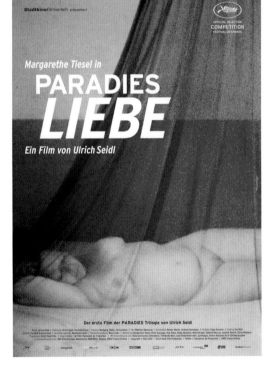

In the Basement, Austria, 2014. **client**: Ulrich Seidl Film Produktion, **ad/d**: Kornelius Tarmann, **d**: Judith Rataitz. The poster "Im Keller" is promoting the documentary film *In the Basement*.

Blind, Norway, 2013. **client**: Motlys AS, **studio**: Handverk, **cd/ad/d**: Eivind S. Platou, **p**: Kimm Saatvedt. The main character is shown naked because she is recently blind and vulnerable.

Paradise: Love, Austria, 2012. **client**: Ulrich Seidl Film Produktion, **ad/d**: Kornelius Tarmann, **d**: Judith Rataitz. Kornelius Tarmann has designed for Ulrich Seidl since 1992. He has developed a specific style, complementing Seidl's work, avoiding perfect film stills and selecting the pictures directly out of the original film material.

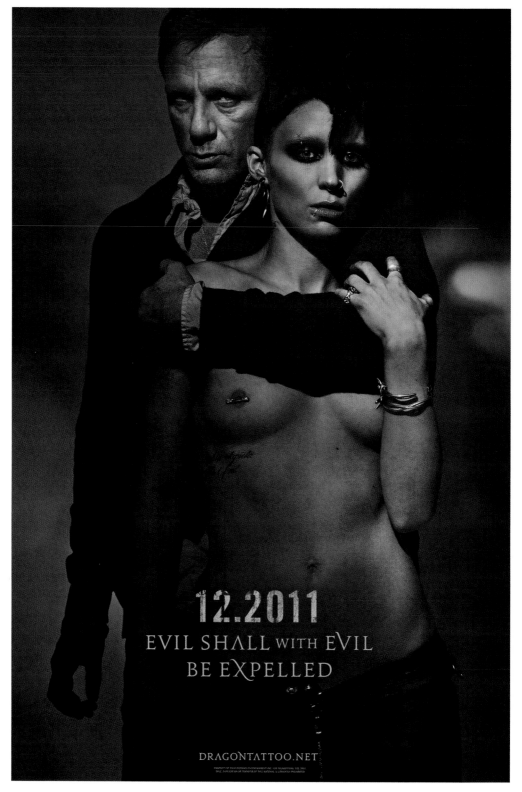

The Girl with the Dragon Tattoo, USA, 2011. **client**: Columbia Pictures, **cd**: David Fincer, **ad/d**: Neil Kellerhouse, **p**: Jean-Baptiste Mondino.
Motion Picture Association of America had major problems with the photograph on the poster.

Contracted: Phase 2, USA, 2015. **client**: IFC Films, **cd**: Michael Boland,
ill: Michael Van Patten, **p**: Milijko for istock. The goal of this piece of key
art was to re-create a unique and quietly touching moment in a film
about the transformation of ordinary people into zombies.

Contracted: Phase 2, USA, 2015.
client: IFC Films, **cd**: Michael Boland, **p**: Screen grab. The goal of this
piece of key art was to illustrate a quiet moment in a film about the
transformation of ordinary people into zombies.

Rat Fever, Brazil, 2012. **client**: Imovision, **cd/ad/d**: Marcelo Pallotta.
A film about an anarchist poet.

Nurse, USA, 2013. **client**: Lionsgate Entertainment, **studio**: Ignition / LA,
cd: Jason Lindeman, **p**: Tim Palen. Film poster.

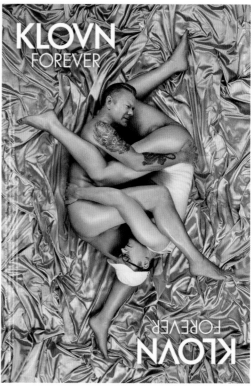

Fatso, Norway, 2008. **client**: Paradox AS, **studio**: Handverk,
cd/ad/d: Eivind S. Platou, **ill**: Rune Markhus, **p**: Pål Laukli / Tinagent.
This poster is an attempt to reflect the film's main character and his
uncomfortable relationships with women.

Klovn the Movie, Denmark, 2010. **client**: Zentropa Productions / Nordisk
Film, **studio**: The Einstein Couple, **cd/ad**: Maria Einstein Biilmann,
Philip Einstein Lipski, **ad/d**: Mikkel Jangaard, **p**: Per Arnesen. Film poster.

Klovn Forever, Denmark, 2015. **client**: Nutmeg Productions / Nordisk
Film, **studio**: The Einstein Couple, **cd/ad**: Maria Einstein Biilmann,
Philip Einstein Lipski, **d**: Tobias Roder, **p**: Casper Jejersen. Film poster.

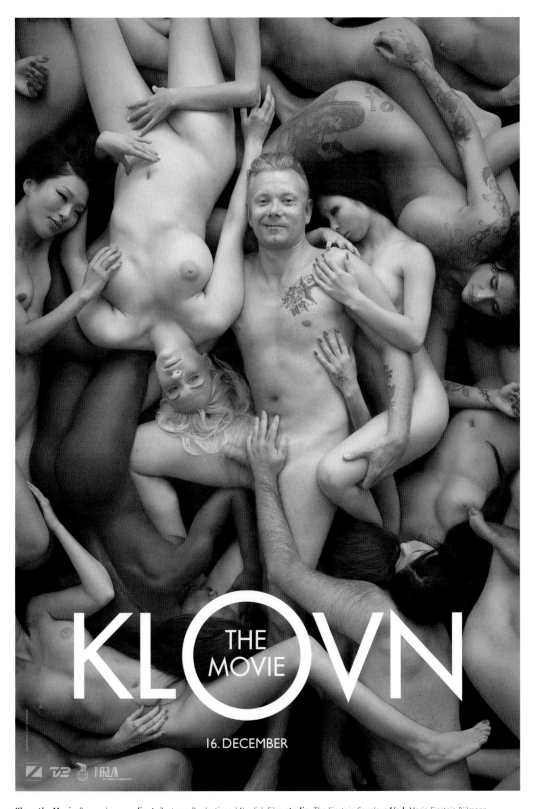

Klovn the Movie, Denmark, 2010. **client**: Zentropa Productions / Nordisk Film, **studio**: The Einstein Couple, **cd/ad**: Maria Einstein Biilmann, Philip Einstein Lipski, **ad/d**: Mikkel Jangaard, **p**: Per Arnesen. Film poster.

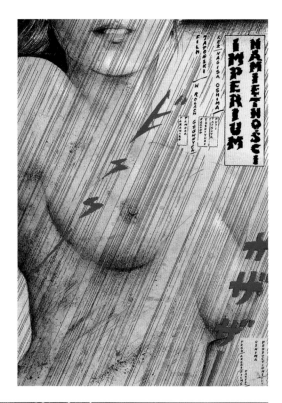

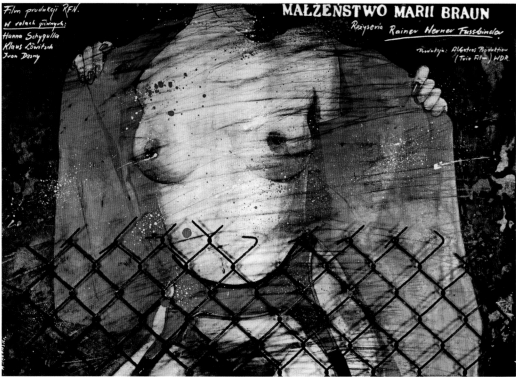

Empire of Passion (Empire of the Senses), Poland, 1979.
client: Polfilm, **cd/ad/d/ill**: Andrzej Pągowski. Poster for *Empire of Passion*, a Japanese-French erotic drama. The poster was initially designed without red signs, but GUKPPiW (the censorship institution in socialist Poland) decided it was too much nudity.

The Marriage of Maria Brown, Poland, 1982. **client**: Polfilm, **cd/ad/d/ill/p**: Andrzej Pągowski. Poster for West German movie *The Marriage of Maria Brown*. The design is kind of an experiment—Pągowski's original graphic is combined with a photo of a wire net brought by the artist from West Berlin.

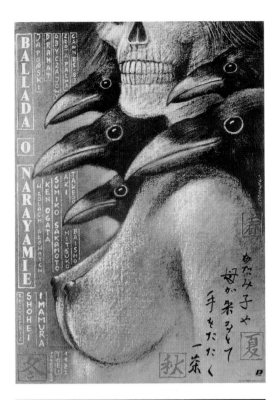

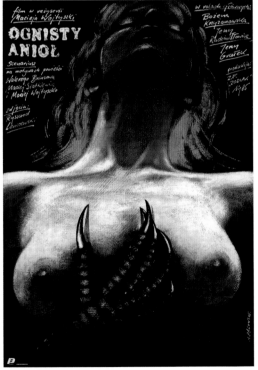

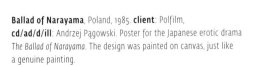

Ballad of Narayama, Poland, 1985. **client**: Polfilm,
cd/ad/d/ill: Andrzej Pągowski. Poster for the Japanese erotic drama
The Ballad of Narayama. The design was painted on canvas, just like
a genuine painting.

Fire Angel, Poland, 1985. **client**: Polfilm, **cd/ad/d/ill**: Andrzej Pągowski.
Poster for the Polish movie *Fire Angel*.

Crab and Joanna, Poland, 1981. **client**: Polfilm,
cd/ad/d/ill: Andrzej Pągowski. Poster for the Polish movie *Krab i Joanna*.
A young sailor dreams about coming back home to his girlfriend Joanna.

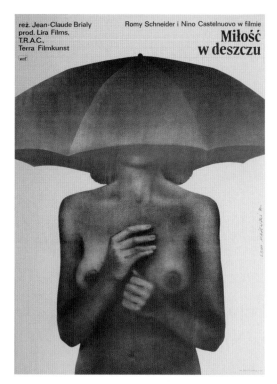

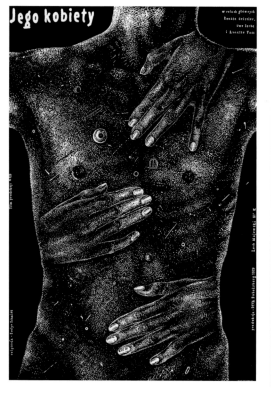

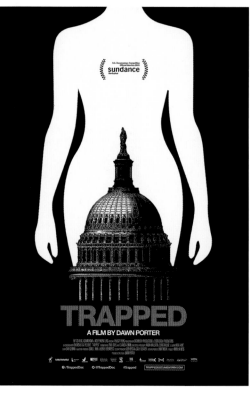

Head to Toe

His Woman, Poland, 1987. **client**: Studio Filmowe im. Irzykowskiego,
d: Lech Majewski. Film poster for a comedy.

Milosc w deszczu, Un amour de pluie, Poland, 1981. **client**: ZRF,
d: Lech Majewski. Film poster.

Trapped, USA, 2016. **client**: Cinetic Media, **d**: Brandon Schaefer. A movie
poster for *Trapped*, a documentary film by Dawn Porter that examines
how abortion laws affect doctors, patients, and clinics in different states.

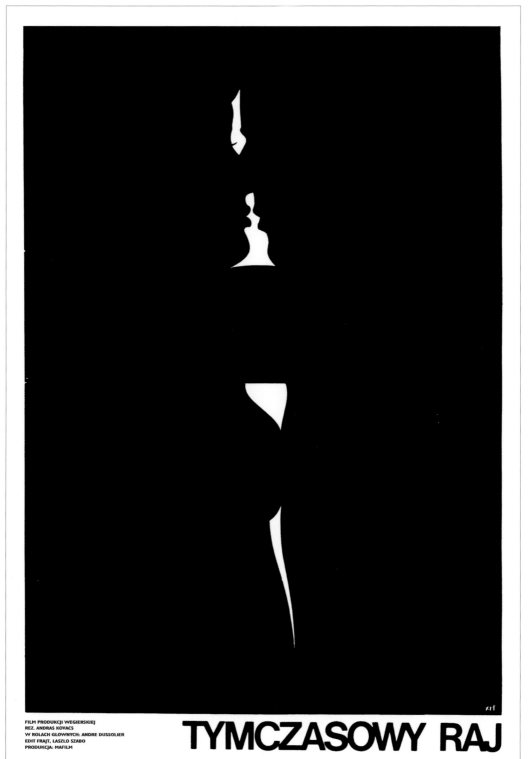

FILM PRODUKCJI WĘGIERSKIEJ
REŻ. ANDRAS KOVACS
W ROLACH GLOWNYCH: ANDRE DUSSOLIER
EDIT FRAJT, LASZLO SZABO
PRODUKCJA: MAFILM

TYMCZASOWY RAJ

Temporary Paradise, Poland, 1981. **client**: ZRF, **cd/ad/d**: Mieczyslaw Wasilewski. Film poster.

Haapsalu Horror & Fantasy Film Festival, Estonia, 2016.
client: Black Nights Film Festival, **studio**: Ruum 414, **d**: Valter Jakovski,
p: Shutterstock. Haapsalu Horror & Fantasy Film Festival (HÖFF) is one
of Estonia's most exciting film festivals, bringing a variety of horror
films, shorts, mystic thrillers and B-class comedies to the audience.

Impulse Theater Festival, Germany, 2015. **client**: Impulse Theater
Festival, **cd**: Fons Hickmann m23, **ad**: Fons HIckmann, Bjorn Wolf.
The Impulse Theater Festival shows the latest productions from
the European independent theater scene.

DIR/ACTORS, South Korea, 2012. **client**: Korean Film Archive,
cd: Ordinary People, **ad/d/c**: Jae-ha Lee. The event showed movies in
which a director performed as an actor in their own film. This poster
illustrates the special circumstance of screen-crossing people.

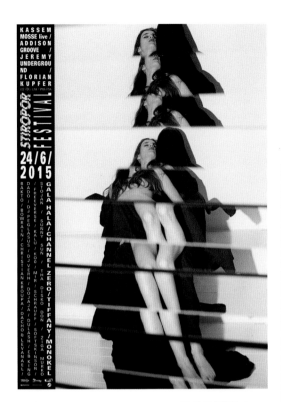

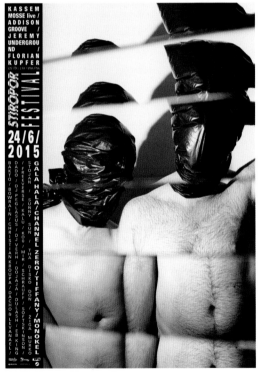

Stiropor Festival, Slovenia 2015. **client**: Zavod Stiropor, **cd/ad/d/p**: Primoz Zorko. Series of posters for the Stiropor Music Festival—raw, deviant, and the wildest party of the summer. The horizontal "cuts" were a subtle part of the festival's identity in its debut year, but this time it was used through photography.

St. Louis International Film Festival, 2002. **client**: STL Film Festival, **studio**: Art Chantry. This festival poster was printed on clear mylar plastic. The film sprocket holes were done via die-cut. The posters (standing 28 inches tall) were actually giant pieces of film strip.

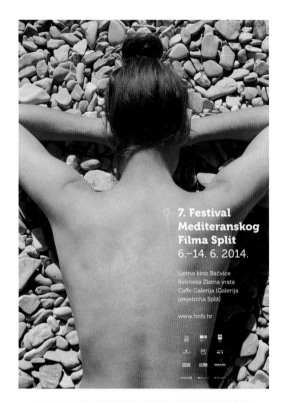

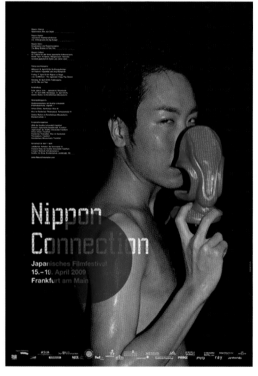

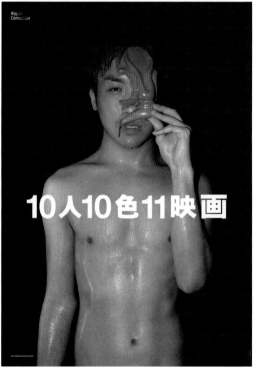

7ᵗʰ Mediterranean Film Festival Split, Croatia, 2014.
client:Mediterranean Film Festival Split, **d/p**: Karlo Kazinoti. In seven years the festival has become an important cultural event. Its timing also indicates the beginning of swimming and sunbathing season so the poster warns about the negative effects of exposure to UV radiation.

Kappa (Campaign), Germany, 2009. **client**: Nippon Connection Film Festival, **cd/ad**: Kai Bergmann, **d**: Kai Bergmann & Alex Lis, **p**: Laura Nickel.
Nippon Connection is the largest platform for Japanese movies today. The Festival's main topic in 2009 was sexuality. This campaign refers to the "Kappa," a mythical Japanese water demon.

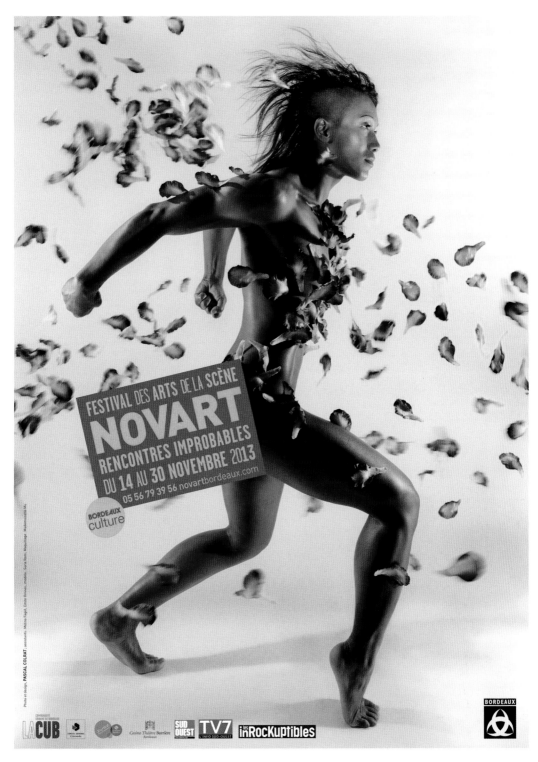

Novart, France, 2013. **client**: Ville Bordeaux, **d/p**: Pascal Colrat. Arts festival poster.

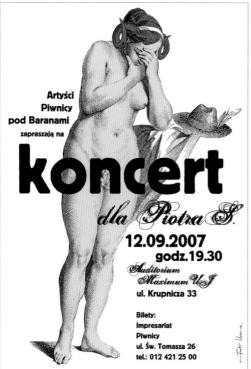

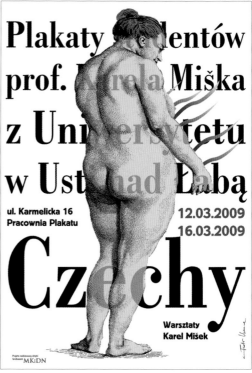

The Concert of Piotr S, Poland, 2007. **client**: The Cellar Under Rams, Kraków, **d/ill**: Piotr Kunce. The Cellar Under Rams is the most famous cabaret in Poland. Every year they celebrate the memory of its creator, Piotr Skrzynecki, by preparing a special concert.

...It's a Drag! Cabaret, 1995. **client**: The Swedish Housewife, **d**: Art Chantry. This poster was designed for a drag performer who would rent performance spaces, gather all her friends, and put on a show.

Posters of Students From Usti nad Labem (Cz), Poland, 2009. **client**: Academy of Fine Arts, Kraków, **d/ill**: Piotr Kunce. Exhibition of Karel Misek students—University Purkyne in Usti nad Labem, Czech Republic.

Flaming Lips, USA, 1995. **client**: Moe Cafe, **studio**: Modern Dog Design Co., **cd/ad/d/ill**: Vittorio Costarella. Screen-printed gig poster, with a split fountain.

The Oblivians / The Hentchmen / The Dirt Bombs, 1997. **client**: The Gallery, **d**: Art Chantry. "For this poster I simply used the ace of spades from a deck of nudie playing cards. The typography was done with the same label maker gun I bought at a thrift store for 25¢."—Art Chantry

The Oblivians / Impala / 13 Frightened Girls / The Defilers, 1996. **client**: The Gallery, **d**: Art Chantry. A poster done for the erstwhile band The Oblivians, along with the bands Impala, 13 Frightened Girls, and The Defilers. Censor bars are a great way for a graphic designer to make an innocent picture look obscene.

BODY

Nudity on magazine covers, the most treasured of all periodical publishing real estate, was once forbidden—even illegal in many countries, and sometimes considered pornographic to boot. Sexily and alluringly clothed women and men were allowed to show more than a little skin (think *Sports Illustrated* Swimsuit issues) and models appearing on tease-magazines like these helped sell a slew of American and European products, along with those appearing in advertisements as well.

Invariably, in American magazines at least, the standard was for women to be more scantily clad, whether the periodical was aimed at men or women. Nudity was hinted at, not shown, in its full frontal fashion. Then men's magazines came along. *Esquire*, then *Playboy* and a gaggle of other look-a-like so-called "bachelor-pad magazine" competitors hit the newsstands and candy store racks. However, even these increasingly risqué periodicals had to cover their fleshy assets with brown craft paper covers. It is hard to say why news dealers were reluctant to show what was already exposed, but the idea that children should be protected from the evils of the naked body (aka smut) justified this particular loss of press freedom. After all, these magazines were actually sold to whomever asked for them. The fact is, few of these men's magazines actually showed "lewd-ity" on their front covers. The publish-

ers understood the rules of the newsstand and actually gained status among their audiences from contraband status. They also realized the various religious and secular moral groups in the United States had the power to boycott advertising that would cause the closure of magazines that did not comply.

In the early 1960s, libertine publishers that were not afraid to challenge the religious morality groups were more brazen about challenging taboos on nudity. These intrepid pioneers started to have a huge cultural impact in the marketplace, changing tolerances and extending boundaries. There came a time when, rather than legislate against nudity and sexuality, the United States Supreme Court decided to let the states decide their own rules regarding what could or could not be published. Concerns over morality decay notwithstanding, the majority of Americans as well as the more liberal Europeans protested against the sanctimony that limited the natural freedom to enjoy nudity; and this lead to decidedly less restrictive censorship during the end of the late 1980s. By the 1990s and early 2000s, nudity came out of the closet and into the open, where it was more matter-of-fact than prurient.

In fact, sexuality was no longer considered one of life's embarrassments, and nudity (albeit in most instances sans showing

COVER

long-taboo pubic parts) was not something to be afraid of but rather enjoyed—and not only enjoyed but celebrated for its boldness and shock value. Perhaps the most influential public outlets in the graphic design universe were magazines and posters, especially mainstream publications that reached large audiences. In 1968 readers may have been shocked yet enjoyed seeing the *Rolling Stone* cover (page 1) featuring John Lennon and Yoko Ono naked—blemishes and all—in the most candid of poses. The photo was a variation of the cover of their album *Two Virgins*. Although considered to be obscene by some critics, it was the duo's artistic way of supporting a newfound sexual liberty. Still, as Lennon noted, these "two slightly overweight ex-junkies" in the nude proved to be too shocking for music retailers, who sold the album in brown wrapping paper. Nonetheless, it opened the floodgates for more ambitious uses of the human body in many art forms, including a cover of *Rolling Stone* with a naked Lennon embracing a clothed Yoko (page 218) and subsequent covers featuring a dozen or more celebrities in the raw.

Western Europe was always more willing to experiment and more enlightened than the United States when it came to exposure of the naked form. Nudity came early to Germany's leading mass market newsweeklies *Stern* (page 220) and *Der Spiegel* (page 221 to 223). It would be disingenuous to say that nakedness did not raise circulation, yet it was also used to make serious and satiric or comic editorial commentaries of the age. It also goes without saying that well-photographed, sensual nudes were pleasures for the reading audiences.

Book covers had for a long time been more liberal with nudity as a promotional, narrative tool, especially the so-called pulp paperbacks. The plots of various novels continue to call out for nudity and sexual representation. Surrealism is one of the erotic tools—see the strangely contorted figure "hugging" the roof on Maartje Smits's book (page 237) that draws the viewer into the mystery of a book through this decidedly magical landscape. Nudity need not be simply overt or overly serious to be effective. The covers for Alan Richter's "Sexual Slang" (page 235) take the quintessential male and female nudist images and superimpose ironic clichés. Speaking of clichés, look at the send-up exploitative pulp nudity on pages 242 and 243, an impactful way to repackage the 007 Goldfinger series by Ian Fleming.

Then there is music packaging, where nudity, especially female come-hither bachelor-party burlesque of the late 1950s and 1960s, was such a popular record cover style. It is not surprising that in the current period, it is repurposed in a deadpan manner for hipsters. Rock on!

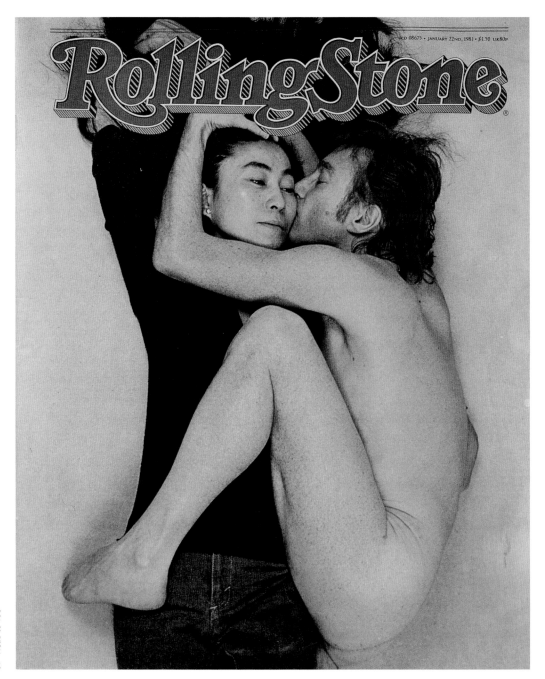

Rolling Stone, January 22. 1981. **ad**: Mary Shanahan, **p**: Annie Leibovitz.

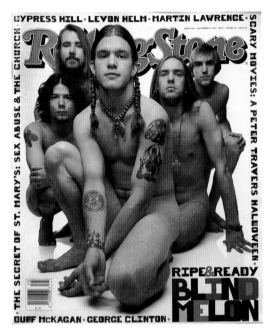

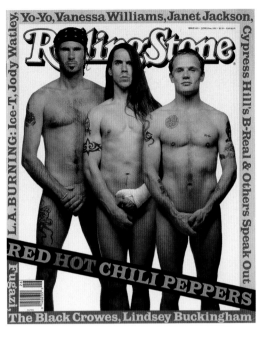

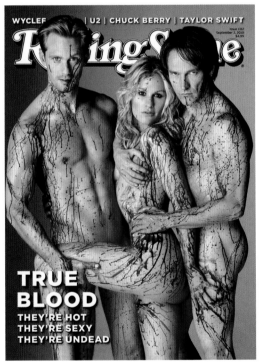

Rolling Stone, November 11. 1993. **p**: Mark Seliger.
©1992 by Rolling Stone LLC. All Rights Reserved. Used by Permission.

Rolling Stone, September 2. 2010. **p**: Matthew Rolston.
©2010 by Rolling Stone LLC. All Rights Reserved. Used by Permission.

Rolling Stone, June 25. 1992. **p**: Mark Seliger.
©1993 by Rolling Stone LLC. All Rights Reserved. Used by Permission.

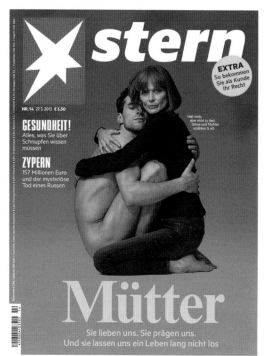

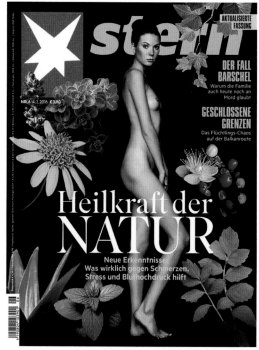

Mothers, Germany, March 27, 2013. **client**: Stern Magazine,
cd/ad: Johannes Erler, **d**: Manuel Dollt, **p**: Joachim Baldauf.

Naturopathy, Germany, 2016. **client**: Stern Magazine,
cd/ad: Frances Uckermann, **d**: Michel Lengenfelder, **p**: John Davies.

Strong Back, Germany, 2016. **client**: Stern Magazine,
cd/ad: Frances Uckermann, **d**: Michel Lengenfelder, **p**: Martin Bauendahl.

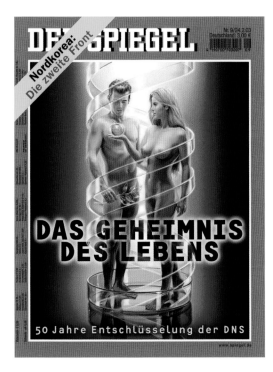

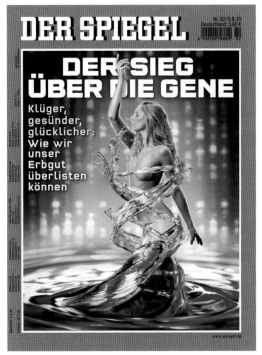

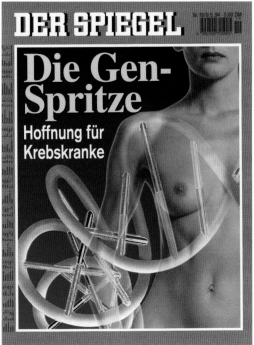

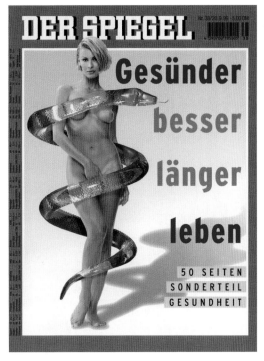

Der Spiegel, Germany, 2003. ad: Stefan Kiefer, ill: Jean-Pierre Kunkel.

Der Spiegel, Germany, 1994. ad: Thomas Bonnie, p: Monika Zucht.

Der Spiegel, Germany, 2010. ad: Stefan Kiefer, ill: Leonello Calvetti, p: Frank Wartenberg.

Der Spiegel, Germany, 1999. ad: Stefan Kiefer, p: Frank Wartenberg.

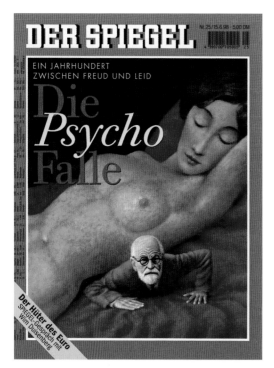

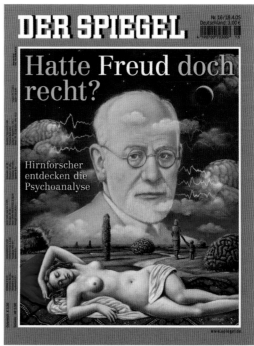

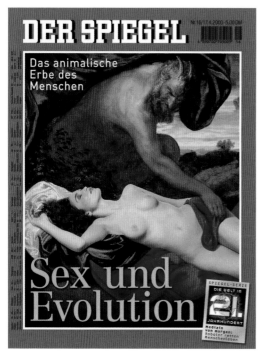

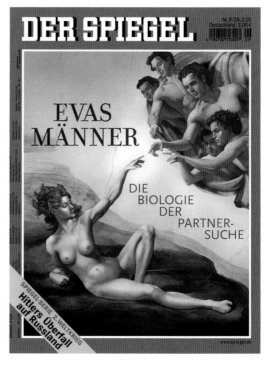

Der Spiegel, Germany, 1998. **ad**: Stefan Kiefer, **ill**: Ludvik Glazer-Naude.

Der Spiegel, Germany, 2000. **ad**: Stefan Kiefer, **p**: Frank Wartenberg.

Der Spiegel, Germany, 2005. **ad**: Stefan Kiefer, **ill**: Rafal Olbinski.

Der Spiegel, Germany, 2005. **ad**: Stefan Kiefer, **ill**: Roberto Parada.

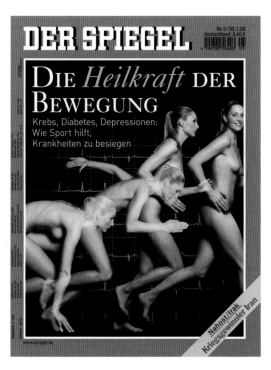

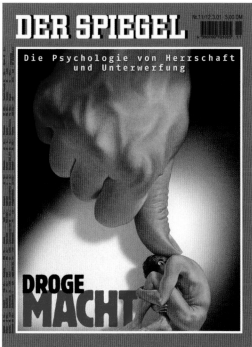

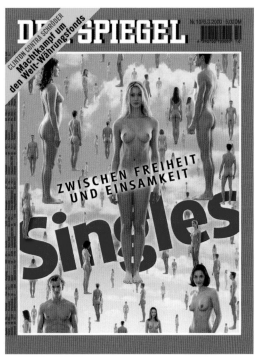

Der Spiegel, Germany, 2006. **ad**: Stefan Kiefer, **p**: Axel Martens.

Der Spiegel, Germany, 2001. **ad**: Thomas Bonnie, **ill**: Alfons Kiefer.

Der Spiegel, Germany, 2000. **ad**: Stefan Kiefer, **p**: Frank Schumann.

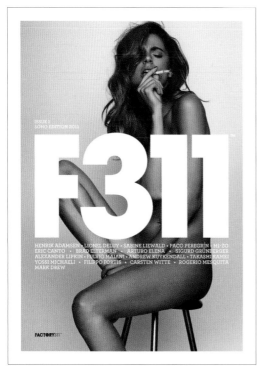

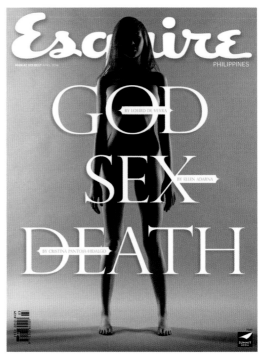

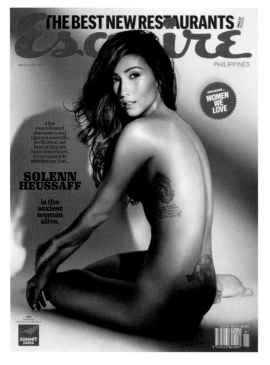

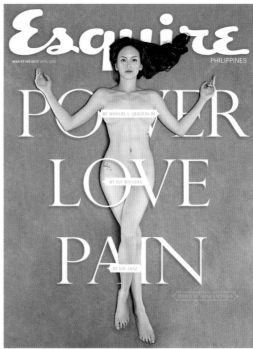

Head to Toe

F311—Issue 1, UK, 2011. **client**: Factory 311, **ad**: Anders Bundgaard, **p**: Henrik Adamsen. F311 is a publication to promote the photographs of critically acclaimed photographers represented by the creative agency Factory 311. The publication was printed as a newspaper.

Sexiest Woman Alive, Philippines, 2013, **client**: Esquire Philippines, **ad/d**: Ces Olondriz, **p**: BJ Pascual. To illustrate the title, it was essential to capture Solenn Heussaff's natural beauty in her most raw form.

Esquire Philippines, Philippines, 2014. **client**: Summit Media Publishing Co. Inc., **cd**: Norman Crisologo, **ad**: Ces Olondriz, **c**: Erwin Romulo, **p**: Jake Verzosa. The cover image of Ellen Adarna was the result of an accident. While photographing her, the flash did not go off, creating areas of shadow over her naked body.

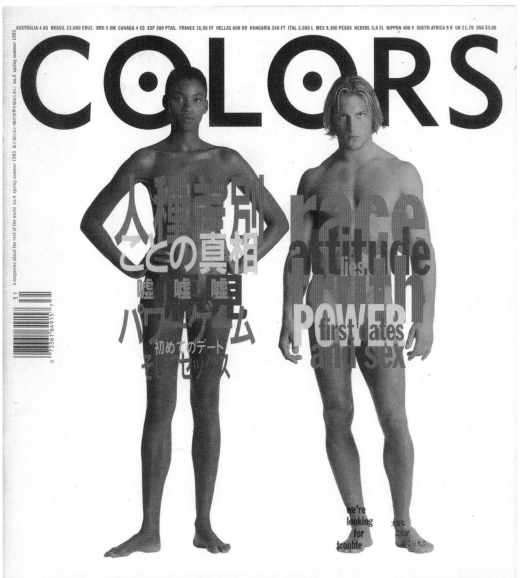

Colors Magazine #4 Race Issue, USA, 1993. **client**: Colors Magazine, **cd**: Tibor Kalman, **p**: Oliviero Toscani.
An issue about race, stereotypes, slurs, and semantics.

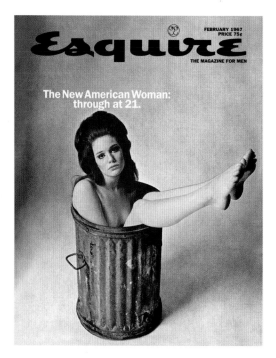

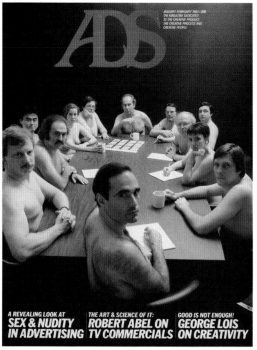

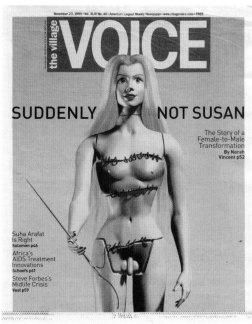

Esquire: The New American Woman, USA, 1967.
cd/ad/d/c: George Lois, **p**: Carl Fischer.

Ads Magazine cover, 1983. **cd/ad/d/c**: George Lois, **p**: Tasso Vendikos.

Suddenly Not Susan, USA, 1999. **client**: The Village Voice,
ad: Ming Uong, **d/ill**: Mirko Ilić.

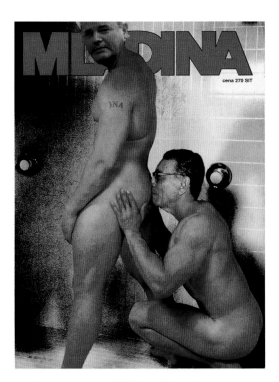

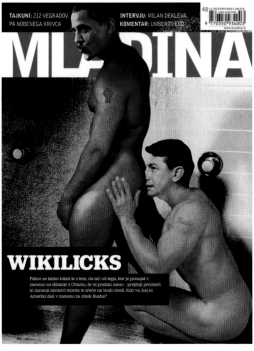

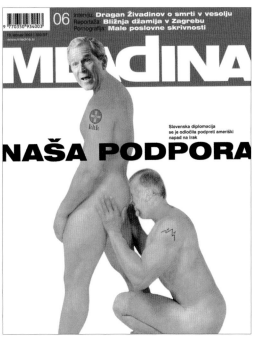

Boutros Boutros Ghali–Milošević, Slovenia, Bosnia, 1995.
client: Mladina **cd**: Robert Botteri, **ad/d**: Bojan Hadžihalilović.
Boutros Boutros Ghali, General Secretary of the United Nations,
and Slobodan Milošević, President of Serbia on the cover of *Mladina*.

Wikilicks, Slovenia, 2010. **client**: Mladina **cd**: Robert Botteri,
ad: Bojan Hadžihalilović, **d**: Damjan Ilić, **p**: Borut Krajnc. Barack Obama and
the former Slovenian Prime Minister, Borut Pahor, on the cover of *Mladina*.

The Coalition of the Willing, Slovenia, 2003. **client**: Mladina,
cd: Robert Botteri, **ad**: Bojan Hadžihalilović, **d**: Damjan Ilić, **p**: Borut Krajnc.
George W. Bush and the former Slovenian Minister of Foreign Affairs,
Dimitrij Rupel, on the cover of *Mladina*. Slovenia backed the USA, which
claimed to have evidence of the weapons of mass destruction in Iraq.

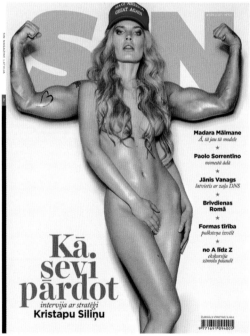

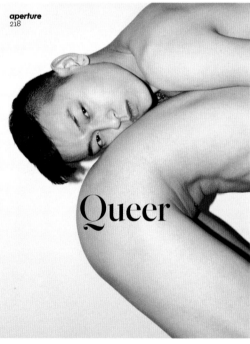

SIN Magazine, Latvia, 2017. Magazine, **ad/ad/d/c**: Davis Davids Sakne, **p**: Martins Cirulis.

Insomnia Magazine #3, Portugal, 2016. **client**: Goncalo Pinto Jorge LDA, **cd**: Goncalo Pinto Jorge, **d**: Rodrigo Schanderl, **p**: Ana Dias, **model**: Olga Kobzar. A free digital and print publication about erotic photography, art, culture, and lifestyle.

Aperture Magazine #218 "Queer," USA, 2015. **client**: Aperture Magazine, **d**: A2/SW/HK, **p**: Ren Hang, **editor**: Michael Famighetti. *Aperture*'s "Queer" issue offered a wide-ranging discussion of the role photography has played, and continues to play, in the LGBTQ community.

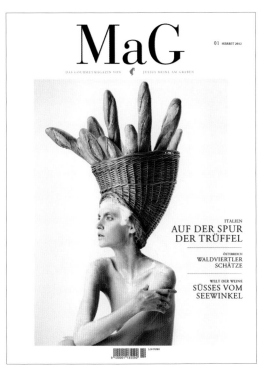

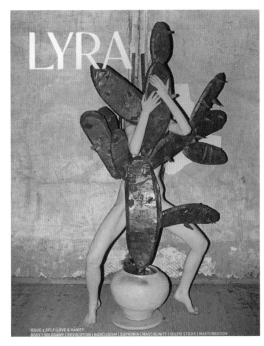

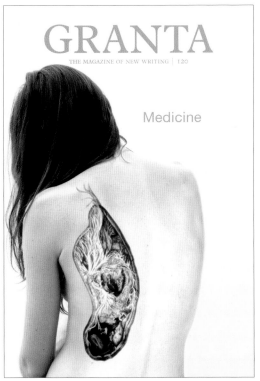

MaG, Gourmet Magazine by Julius Meinl am Graben, Austria, 2012.
client: Julius Meinl am Graben, **cd**: Roman Globan / peng!,
ad: Phillipp Roller / peng! **p**: Mario Schmolka, **model**: Jana W. / Wiener
Models, **Makeup**: Nicole Jaritz, **Hair**: Wolfgang Lindenhofer.

Granta 120: Medicine, UK, Summer 2012. **client**: Granta Magazine,
cd: Michael Salu, **d**: Daniela Silva, **i**: Kanitta Meechubot, **p**: Nadege Meriau.
Granta 120: "Medicine" is an entirely illustrated issue of the magazine.

Lyra Magazine, UK, 2016. **client**: Cool Gray Ltd., **cd**: Georgina Gray,
ad: Sami Jalili, **p**: Sasha Kurmaz. *Lyra* is a quarterly print magazine
offering bold perspectives on society, politics and the arts.

Elephant Issue 25, UK, 2015–2016. **client**: Frame Publishers,
studio: Atlas, **ad**: Astrid Stavro & Pablo Martín, **ill**: Brea Souders.
The winter 15–16 issue took as its theme the new generation of women
artists redefining how we look at and think about the female body.

A3 Magazine, USA, 2013 **client**: Ontwerp.TV (A3 Magazine)
cd/ad/d/ill: Anthony Neil Dart, **p**: D'Paint. Magazine covers and poster
series for experimental e-zine covering local and international design.

Database of Desire, USA, 2017. **client**: New York Magazine,
cd: Thomas Alberty, **ill**: Ben Wiseman. Cover and interior illustration for
New York magazine for Maureen O'Connor's article on the 10th anniversary
of Pornhub.

Hypno Woman, UK, May 2015 **client**: Volt Magazine, **ad**: Matt Duckett.
Magazine cover.

Hayzed Magazine, The Netherlands, March 2014. **ad**: Ljubica Jovanova,
Orietta Batzakis, **d**: Rafael Miranda Bressan, **ill**: Mihai Munteanu.
Hayzed is a magazine featuring young artists from all over the world,
and the cultural and political issues they are confronted with.

CENTREFOLD, UK, 2013. **client**: Centerfold Magazine, **cd**: Tom Lardner, **ill**: Michael Gillette. Wraparound cover for a fashion magazine.

Gazela i Kosac
Margaret Atwood

Čarobna
prodavaonica
igračaka
Angela Carter

U tijelu
Christa Wolf

Pola jedanaest
jedne ljetne večeri
Marguerite Duras

Femina Biblioteque, Croatia, 2003–2004. **client**: Profil International, **cd/ad/d/p**: Ivana Vučić, **editor**: Alica Gracin. Book covers for Biblioteque FEMINA (female writers + women's issues). Books are published in a series. The cover for each book is a fragment of one photograph. Together, the covers compose the complete image.

Forbidden Colours, UK, 2008. **client**: Penguin Books, **a/d**: Jim Stoddart, **art editor**: Isabelle de Cat, **p**: cover photograph ©Eikoh Hosoe. *Forbidden Colours* is a depiction of a male homosexual relationship, in which a rich older man buys the love of a young man who is stunningly handsome but who lacks the ability to love.

In Praise of Older Women, UK, 2010. **client**: Penguin Books, **a/d**: Jim Stoddart, **art editor**: Isabelle de Cat, **p**: cover photograph: *Nude 1927* ©Jaromir Funke. Originally published by the author himself in 1965, *In Praise of Older Women* became an international bestseller and renowned classic.

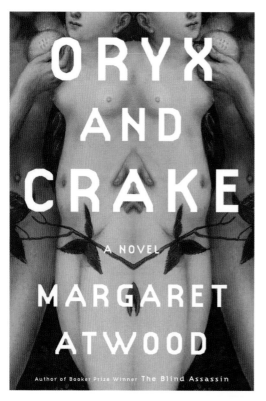

Oryx and Crake, USA, 2003. **client**: Doubleday, **ad**: John Fontana, **d**: John Gall. Book cover for a dystopian novel by Margaret Atwood.

Dabogda Te Majka Rodila, Croatia, 2010. **d**: V.B.Z. studio, Zagreb, **ill**: Mirko Ilić. Book cover.

My Cleaning Lady book cover, Croatia, 2007. **client**: Fraktura Publishing, **cd/ad/d**: Iva Babaja, **p**: Rino Gropuzzo. Book cover for Christian Oster's novel *My Cleaning Lady*. Original photograph was a classic nude, which was blurred and cropped to objectify the body as much as possible. The dots were raised and UV varnished.

Dress Your Family in Corduroy and Denim , USA, 2004. **client**: Little, Brown & Co., **d**: Chip Kidd, **p**: Oote Boe. Book cover.

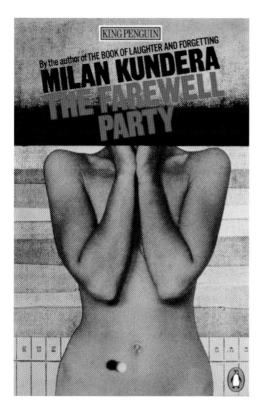

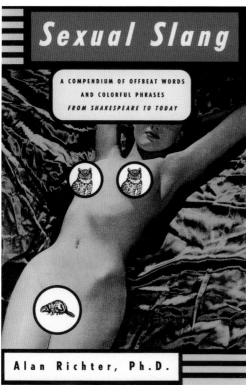

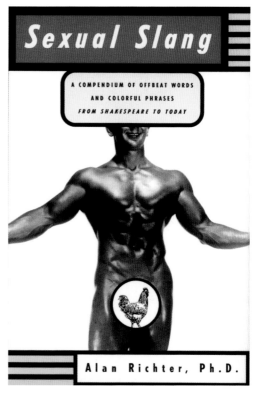

The Farewell Party, UK, 1984. **client**: Penguin Books, **ad/d**: Ken Carroll,
ad/d: Mike Dempsey, **ill**: Andrzej Klimowski. Mid-1980s King Penguin
series of contemporary fiction with cover design by Ken Carroll and
Mike Dempsey and commissioned illustration for each title.

A Compendium of Offbeat Words and Colorful Phrases From Shakespeare to Today, USA, 1995. **client**: HarperCollins, **ad**: Joseph Montebello,
d: Chip Kidd. "My idea was a cover for each sex, and the publisher proofed both, but finally went to press with only the female version. The male freaked
out the sales force—which only proves Maggie Paley's point (overleaf): *Penises, even when only hinted at, are the last taboo!*"—Chip Kidd

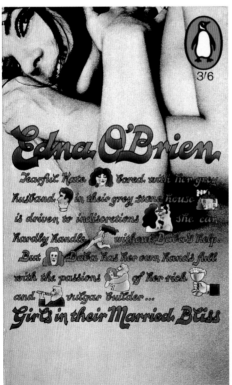

How the Hippies Saved Physics, USA, 2011.
client: W.W. Norton & Company, **cd/ad**: Ingsu Liu, **d**: Mark Melnick,
p: Olli-Pekka Orpo / Getty Images. Clearly there was no attempt here
to present anything approaching an idealized body; though one has to
imagine that a large portion of the audience for this book is—for lack
of a better phrase—"pasty white guys," so they're likely inured to it.

Girls in Their Married Bliss, UK, 1967. **client**: Penguin Books,
d/ill: Alan Aldridge. Book cover.

Gray's Anatomy, UK, 2010. **client**: Penguin Books, **ad**: Jim Stoddart,
p: ©Ryan McGinley, **picture editor**: Samantha Johnson. John Gray
smashes through civilization's long-cherished beliefs, overturning
our view of the world and our place in it.

Life Without Me, Italy, 2012. **client**: Bur Rizzoli, **studio**: The World
of DOT, **ad**: Francesca Leoneschi, **d**: Laura Dal Maso, **p**: Federico Erra.
This book belongs to a series of women's fiction / romance novels.

Als je een meisje bent
Maartje Smits

De Harmonie

White, Iceland, 2004. **client**: De Harmonie Publishers, Amsterdam, **cd**: Scarlett Hooft Graafland, **p**: Marisa Navarro Arason.
A naked woman lying on top of a small white shelter in the middle of the outstretched moss fields of western Iceland.

THE STORY OF SEX FROM APES TO ROBOTS · PHILIPPE BRENOT · LAETITIA CORYN

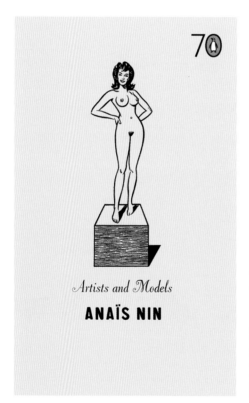

70

Artists and Models
ANAÏS NIN

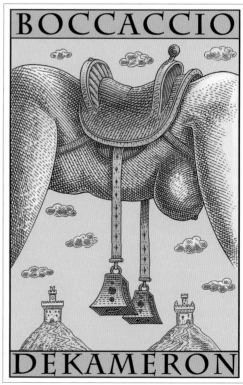

BOCCACCIO

DEKAMERON

Artists and Models, UK, 2015. **client**: Penguin Books, **ad**: John Hamilton. The pocket Penguin series consists of seventy unique titles published to celebrate Penguin's ninetieth birthday. They are emblematic of the renowned breadth of quality of the Penguin list and epitomize Allen Lane's vision of "Good Books for All."

The Story of Sex, UK, 2016. **client**: Penguin Books, **ad**: Jim Stoddart, **d**: Matthew Young, **ill**: Laetitia Coryn. The only history of sex in graphic novel form, written by a leading expert in the field.

Dekameron, Hungary, 2002. **client**: Utisz BT, **cd/ad/d/ill**: István Orosz. Book cover.

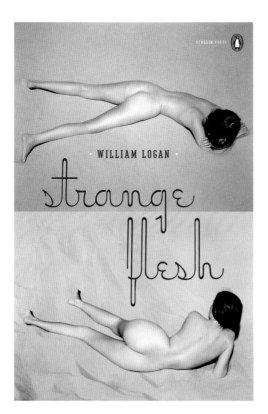

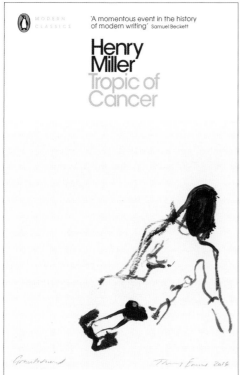

Strange Flesh, USA, 2008. **client**: Penguin Poets, **cd**: Paul Buckley,
ad: Margaret Payette, **d**: Mark Melnick, **p**: Edward Weston, *Nude*, 1936.
Book cover. ©1981 Center for Creative Photography, Arizona Board of Regents.

Tropic of Cancer, UK, 2016. **client**: Penguin Books, **ad**: Jim Stoddart,
picture editor: Samantha Johnson, **ill**: Tracy Emin, *Gravitational*, 2014.
One of the most scandalous and influential books of the twentieth century.

Tropic of Capricorn, UK, 2016. **client**: Penguin Books, **ad**: Jim Stoddart,
picture editor: Samantha Johnson, **ill**: Tracy Emin, *On Top*, 2014.
A story of sexual and spiritual awakening, *Tropic of Capricorn* shocked
readers as much as Henry Miller's first novel, *Tropic of Cancer*.

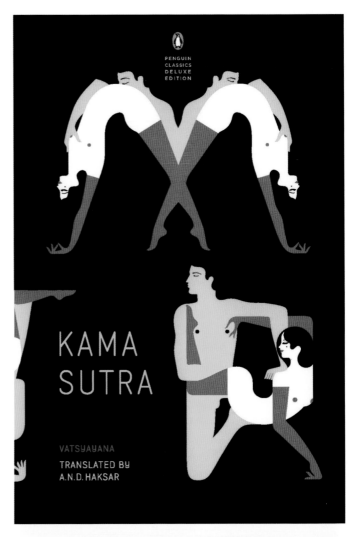

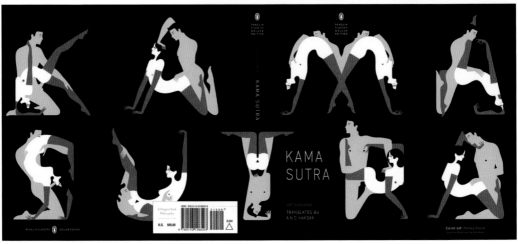

Kama Sutra, USA, 2012. **client**: Penguin Random House / Penguin, **cd/ad**: Paul Buckley, **d/ill**: Malika Favre. Book cover.

Decameron_#GB, Poland, 2014. **client**: Neon Gallery, Academy of Art and Design in Wroclaw, **d**: Weronika Kowalska. The "Decameron_#GB" is part of a series of ten posters inspired by Giovanni Boccaccio novel *Decameron*, exhibited in June 2014.

Renata Salecl: Against Indifference, Croatia, 2016. **client**: Arkzin, What, How & for Whom / WHW, **d**: Dejan Kršić, Ruta dd. *Against Indifference*, selected essays by Renata Salecl, published as part of "Project: Broadcasting, Reader#02," curated by the collective What, How & for Whom / WHW.

Goldfinger, USA, 2002. **client**: Penguin Random House / Penguin, **ad**: Roseanne Serra, **d**: Richie Fahey.

Live and Let Die, USA, May 2003. **client**: Penguin Random House / Penguin, **ad**: Roseanne Serra, **d**: Richie Fahey.

On Her Majesty's Secret Service, USA, 2003. **client**: Penguin Random House / Penguin, **ad**: Roseanne Serra, **d**: Richie Fahey.

For Your Eyes Only, USA, May 2003. **client**: Penguin Random House / Penguin, **ad**: Roseanne Serra, **d**: Richie Fahey.

Limits of Desire, USA, 2005. **client**: Small Black, **cd**: Scarlett Hooft Grassland, visual artist, **p**: Reino Hooft Graafland-Schorer. A naked couple holding each other, balancing on a ladder with sixteen steps, and an alligator with an open mouth and around seventy-six teeth, with many alligators approaching.

White Zombie "Supersexy Swingin' Sounds," USA, 1996. **client**: Geffen Records, **cd**: Rob Zombie, **ad/d**: Rob Zombie, Wendy Sherman,
 p: Peter Gowland. This record featured remixes of songs from White Zombie's previous album—*Astro-Creep: 2000*. The photos are vintage 1960s shots taken for *Playboy* magazine by pinup photographer Peter Gowland.

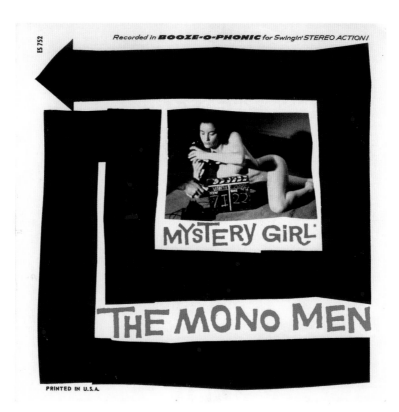

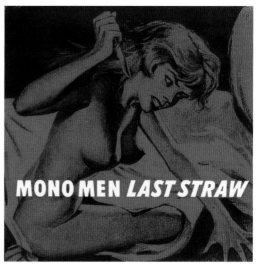

The Mono Men "Mystery Girl," USA, 1995, **client**: Estrus Records, **d**: Art Chantry. The photograph on the cover of "Mystery Girl" is one of those trimmed off clapper shots from a 1950s stag film. The design of the rest of the cover is intended to echo the bachelor-pad culture that gave market to this sort of movie. Even the lettering and the ad lines refer to this culture—part Saul Bass, part exotica jazz, part girlie magazine.

Frolic Diner vol. 3, USA, 1993. **client**: Column Records, **d**: Art Chantry. This is a collection of odd and obscure lost 45-rpm recordings by forgotten bands—and each one of them is about food and love.

Mono Men "Last Straw," USA, 1992. **client**: AuGoGo Records, **d**: Art Chantry. The nude on the album cover was lifted from some girlie magazine from the 1950s.

Mathilda (EP), France, 2011. **client**: Mathilda, **cd/ad/d/ill/p**: Jonathan Budenz. Music packaging and artwork for the French rock / metal band Mathilda.

Apme, France, 2012. **client**: Apme, **cd/ad/d/ill**: Jonathan Budenz. Music packaging and artwork for the French rock / metal band Apme.

Pupil, Philippines, 2015. **client**: MCA Music Inc., **ad/d**: Ces Olondriz, **p**: Tim Serrano, **album concept**: Erwin Romulo, Jason Tan. For this album jacket Tim Serrano agreed to contribute a series of nude images with jolting blocks of color draping the writhing bodies—ultimately revealing the letters of the album name through the journey of opening the album jacket.

THE ORWELLS TERRIBLE HUMAN BEINGS

1994, France, 2012. **client**: Glaciation, **cd/ad/d**: Jean Emmanuel "Valnoir" Simoulin, **p**: William Lacalmontie. Cover artwork for Glaciation's album "1994."
The specificity of this artwork is that the patches were stiched on the skin without anesthesia (and without Photoshop).

The Orwells "Terrible Human Beings", 2017. **client**: The Orwells,
cd: Matt Reinhard, **ad/d**: Mihai Draganescu, Justine Martin,
d: Whiskey & Banana Design **p**: Kelly Puleio. Album cover.

Kojii, Ireland, 2005. **client**: Kojii, **p**: Cyril Helnwein. Album cover.

BODY

Before the late 1960s very little mass market advertising contained nudity. It simply was not de rigueur or even acceptable, according to the media standards of the era. Yet following the sexual revolution of the 1960s, when everything was exposed for all to see, the Western world was altered, international advertising transformed, and the mass attitudes and mores changed from moderately puritanical to full-on libertine—more or less. Magazines, billboards, and other advertising venues became veritable strip shows. Certain fashion and lifestyle brands throughout the globe introduced sexuality to their promotional and marketing strategies. "Sex sells" was the mantra. Even though hardcore exposure was out of the question, racy softcore and less-than-subtle innuendo came to rule the roost. Advertisements with unclothed and partially clothed male and female models reflected the new sexualized sensibilities of the younger generation. This is what "Body Shop" is all about—the freedom to normalize nudity.

There have, however, been shifts in the tides. Sexual intensity has been recently reduced enough to be the subject of advertising industry media articles on new trends. Brands once

famous and infamous for their risqué representations have, according to industry reports, dumped their notoriously sexy ways and wiles. In a 2015 story on Abercrombie & Fitch, *Business Insider* wrote that "the sex is noticeably absent. Amid declining sales, the teen brand has been slowly but surely chipping away at its raunchy reputation to become more palatable to the modern consumer." It further stated that American Apparel, which was known for its high degree of carnal exploitation, had reduced the heat. "Models are no longer nearly naked and sprawled out in suggestive positions; instead, they are covered up. Necklines are higher, and hemlines are lower."

According to *Business Insider*, the rationale may be that, since advertising is supposed to both titillate and thrill men and women in visceral ways, "if people see sexual imagery every day, an advertisement that uses sex faces added difficulty standing out." The notion that nudity can be tiresome is probably hard to believe, but it is true. What's more, too much of it can be objectionable to some consumers, especially parents of impressionable children. Sex may never go out of fashion, but as an advertising trope

S H O P

it can provoke discomfort, even anger, particularly since a majority of advertising sexploits women.

In 2016 the paradigm for (some of) sexploitation, *Playboy* magazine, suspended publishing its signature female nudity. Covers were tamed, centerfolds were removed. For those raised on the hyperrealistic, unattainable, airbrushed buxom *Playboy* bunnies, the magazine made history. It shocked the male world when it announced that it would eliminate full-frontal nudity as part of a larger redesign aimed at appealing to more millennial men. Perhaps realizing it was no longer a pioneer but a remnant of an earlier sex-addled generation, *Playboy* decided that its nude content no longer appealed to its core advertisers. Since newsstand sales, according to *AdAge*, comprised less than 10 percent of its circulation, losing naked bodies was preferable to reducing advertising revenues.

Yet despite a shift away from nudity in some advertising markets, especially in the United States, in Europe and East Asia the body continues to draw a healthy number of consumers. Clever eroticism is still a lure. The New Black & White Coffee ad (page 250) from Vilnius, Lithuania, is a rather witty way to show the beverage without showing the beverage. And the Magnum Light ice cream ad (page 251) from Paris, France, avoids showing the product entirely. There are but a small number of advertisements for products having little or no relationship to sex and sexuality. On the upswing, however, are a growing number of ads that sell intimate clothing and body care products. A series of ads for K-Lynn Lingerie from Lebanon, very elegantly shows a cropped naked figure with little bows where the bra and panties would otherwise be. The suggestion, no doubt, is that this underwear is so shear you don't even know you're wearing it.

The most clever use of nudity, and also possibly the most disturbing (if one is disturbed by such things), is actually not very erotic at all. The "Don't Be Stupid, Protect Yourself" condom ads show naked men in various states of vulnerability (pages 267): In a toxic waste dump, helping put out a fire with members of a HazMat team, and carrying an automatic weapon with a police SWAT unit are brilliant depictions of protection, but creepy at the same time. Nudity has that power, it seems.

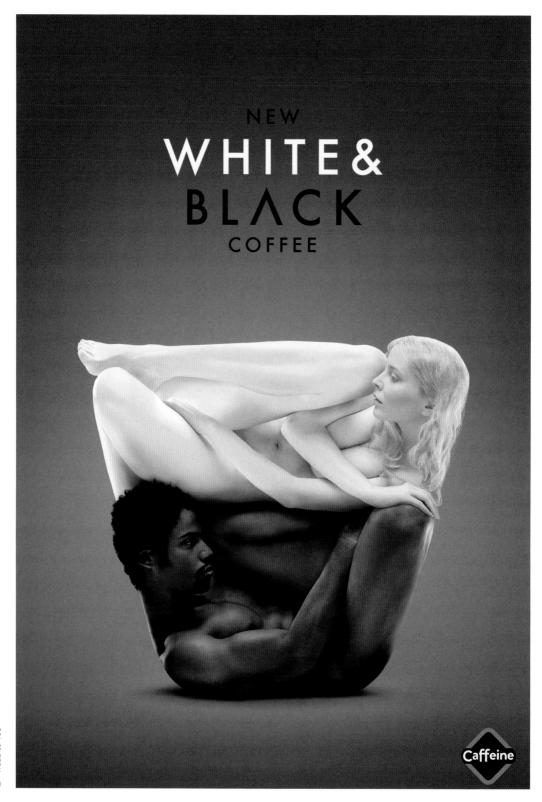

White & Black Coffee, Lithuania, 2010. **client**: Coffee Inn, **agency**: Not Perfect / Y&R Vilnius, **cd/ad/c**: Paulius Senuta, **p**: Irmantas Savulionis, Karolis Polikša. A simple art direction–intensive award-winning poster for a coffee with two separate layers of cold milk and hot coffee named White & Black.

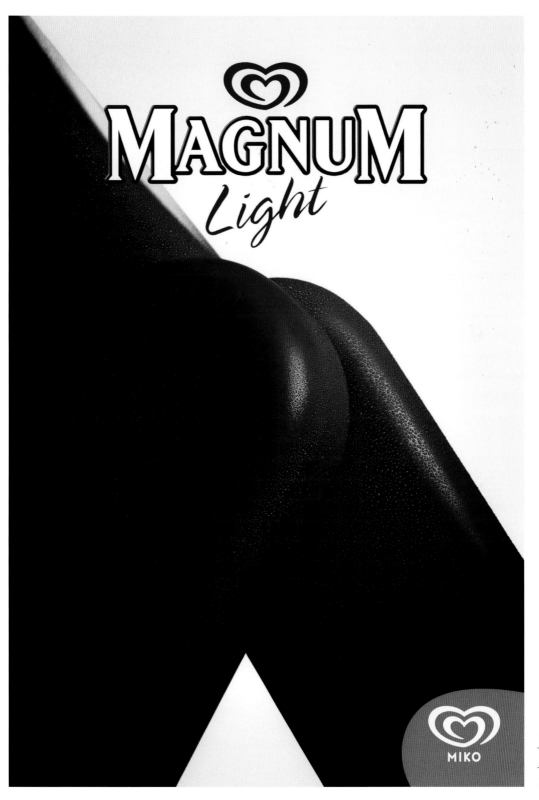

Magnum Light Ass, France, 2004. **client**: Miko / Cogesal, **agency**: McCann Paris, **cd**: Bernard Naville, **ad**: David Leliard, **c**: Cyril Cannone,
p: Daniel Schweitzer. Ice cream advertisement.

Holiday is wherever I can be with you

Alpitour World group always has pet-friendly solutions. Because abandoning is never a solution.

FRANCOROSSO | alpitour | Karambola

www.alpitour.it

Holiday is wherever I can be with you, Italy, 2016. **client**: Gruppo Alpitour, **agency**: TBWA\Italy, **cco**: Nicola Lampugnani, **cd**: Mirco Pagano, **ad**: Federica Facchini, **d**: Danila Cericco, **c**: Andrea Pinca, **p/post-production**: LSD, **account manager**: Matteo Piagno. TBWA\Italy's pet-friendly campaign for Alpitour Group, who stood up in defense of animals and reminded consumers that they can travel with their pets.

Bra, Panty, String, Lebanon, 2008. **client**: K-Lynn Lingerie, **agency**: JWT Dubai, **cd**: Chafic Haddad, **ad/d/c**: Rania Makarem, Sally Tambourgi, **p**: Tina Patni. K-Lynn was promoting the Second Skin line of lingerie, featuring nothing but ribbons on bare skin. The collection is so sheer, you feel like you're wearing nothing at all.

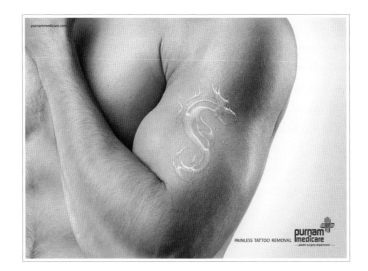

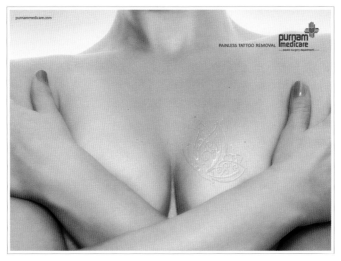

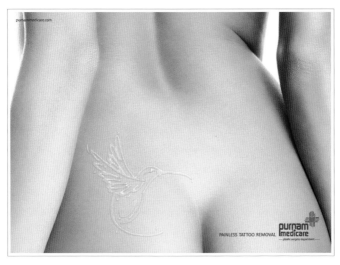

Painless Tattoo Removal, India, 2016. **client**: Purnam Medicare, **agency**: SoS Ideas, **ecd**: Souvik Misra, Soubhik Payra, **cd**: Sourya Deb, **ad**: Soubhik Payra, **c**: Sourya Deb, **p**: Suprotik Chatterjee, **rt**: Indrajit Nandy. These images were created for a hospital in Kolkata known for its unique tattoo removal service.

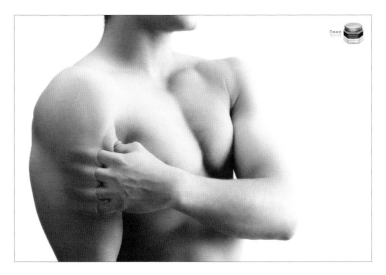

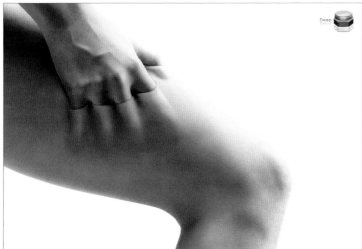

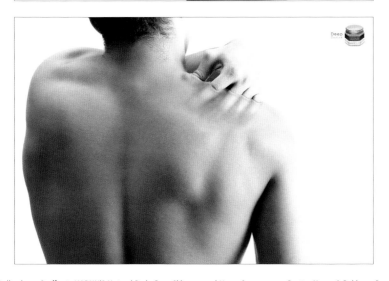

Body Shop

Arm, Leg, Back, Thailand, 2008. **client**: HARNN'S Natural Body Care, Skincare, and Home Spa, **agency**: Dentsu Young & Rubicam, Bangkok, **cd**: Trong Tantivejakul, **ad**: Nares Limapornvanich, **c**: Denchai Kererug, **ill/p**: Anuchai Secharunputong (Nok). Skincare advertisement.

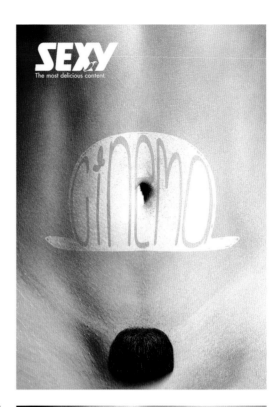

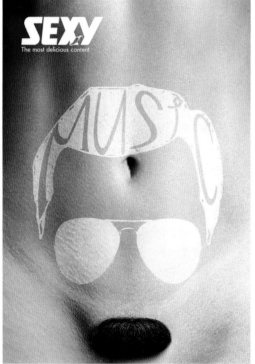

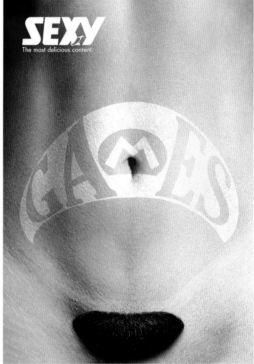

Moustache Campaign, Brazil, 2013. **client**: SEXY Magazine–Rickdan Publishing, **agency**: Innova–All Around the Brand, **cd/ad/d**: Sergio Barros, **c**: Humberto Pacheco, **p**: Luti Melhado. SEXY is a Brazilian adult entertainment magazine for adults founded in 1992. This series of images was created to show the magazine's growth over time, and to let people know that they cover other topics besides sex.

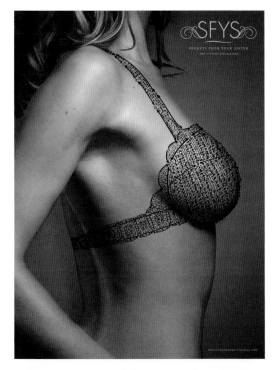

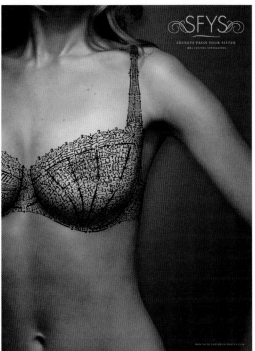

Measurements, Canada, 2008. **client**: Secrets From Your Sister, **agency**: Juniper Park\TBWA, **cd**: Alan Madill, Terry Drummond, **ad**: Jeff Cheung, Noreel Asuro, **c**: Andrew Chisholm, Heather Hnatiuk, **ill**: Sarah J. Coleman, **p**: Todd McLellan. Advertisement for a bra-fitting boutique.

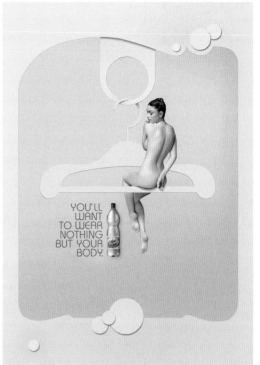

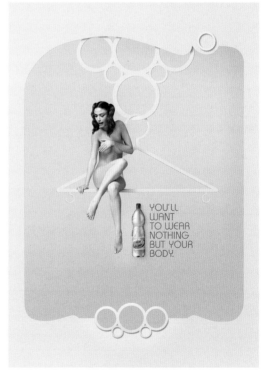

You'll Want to Wear Nothing But Your Body, Vitasnella–Hanger, 2009, Italy. **client**: Ferrarelle SpA, **agency**: Havas Milan, **cd**: Erick Loi, Dario Villa, **ad**: Tiziana Di Molfetta, **d**: Volume 14, **c**: Anna Triolo, **p**: Emilio Tini, **art buyer**: Nadia Curti, **model**: Iris Ceckus (Major Milan). Advertisement for sparkling water.

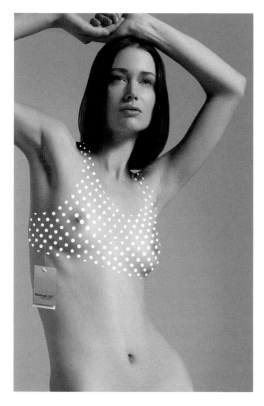

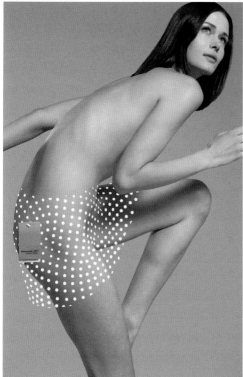

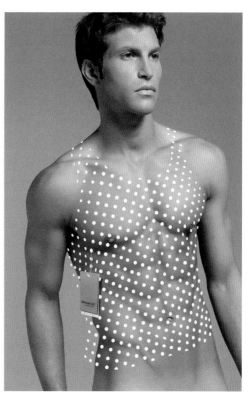

Breathe, Singapore, 2006. **client**: Reebok / Royal Sporting House, **ad/d**: Birger Linke, **c**: Audra Tan, **p**: Jean Leprini, **retouch**: Miracle Factory.
This poster campaign for Reebok PlayDry brings to life the breathability of its apparel range by constructing a tank, skirt, and crop top out of holes, demonstrating how air can flow freely, allowing the athlete's skin to breathe.

6,969 colores sexy

colores en *Paleta*

jogi

NEU IN LUZERN

BLEICHI **23**

VEGETARISCHER GENUSS

LIEFERN & ABHOLEN WWW.BLEICHI.CH

Jogi Meblo, Slovenia, 1960–1970. **client**: Meblo. Advertisement for Jogi Meblo matress. (Courtesy of Museum of Arts and Crafts, Zagreb)

6,969 Sexy Colors, Guatemala, 2016. **client**: Palenta Paints, **cd**: Víctor Alfredo Robles, **ad**: Andrés Rosales, Oz Rodriguez, **d**: Francisco Rodgriguez, Rocío Boy, **ill**: Armando Pereira. A print and poster campaign, that's not "about color," but about the powerful feelings color can create and how there's never just one color related to an emotion.

Bleichi 23, Switzerland, 2006. **client**: Stephanie Mambelli, Lucerne, **d/p**: Melchior Imboden, Switzerland. This poster was made for a new vegetarian restaurant in Lucerne.

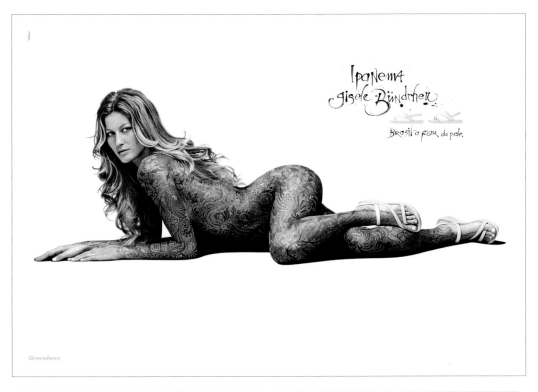

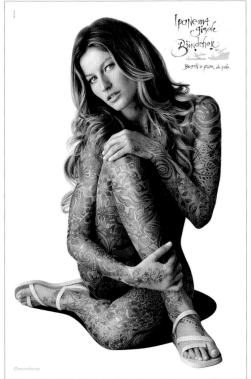

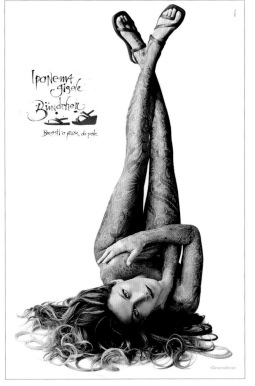

Tattoo, Brazil, 2005. **client**: Grendene, **agency**: McCann Brazil, **cd**: Washington Olivetto, Rui Bnanquintto, **ad**: Celso Alfieri, **c**: Rui Bnanquitto, **ill**: Lobo. CC, **p**: Paulo Vainer. This print campaign shows Gisele in several positions covered with different types of tattoos. It has a strong appeal and visual impact.

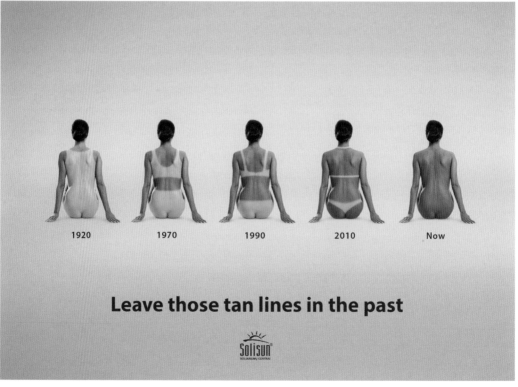

Leave those tan lines in the past

Obuvalnica Butanoga, Slovenia, 2001. **client**: Matjaž Vlah, Butanoga,
d: Borut Kajbič, **c**: Maja Babič Košir, Matjaž Vlah, **p**: Urban Modic.
Promotional poster for the opening of a shoe store featuring the original
and unique designs of Matjaž Vlah.

Leave those tan lines in the past, Lithuania, 2016 **client**: "Solison" Solarium Network **cd**: Lina Vigarite, **agency**: "EZCO" Agency, **d**: Kateryna Tkachenko.
Get your perfect suntan easily. No fuss, no stuff, no lines. Creative idea and design for Solarium Network advertising campaign.

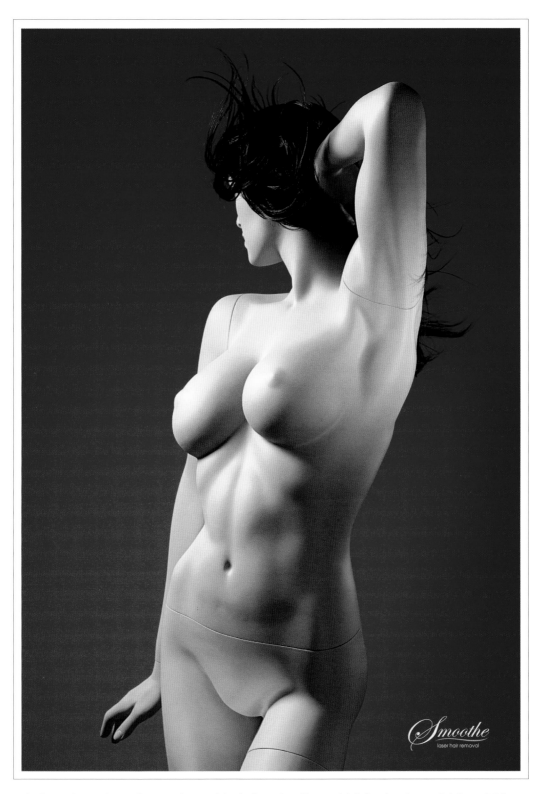

Perfectly Smoothe, Canada, 2011. **client**: Smoothe Laser Clinic, **cd**: Mike Meadus, **ad/c**: Sean Mitchell, **d**: Mark Lovely, Sean Mitchell, **p**: Noah Fallis.
For some, it's not simply about being smooth—it's about achieving an impossible level of unnaturally pristine, doll-like perfection. Without any actual nudity, this idea highlights the product's intimate focus and shows the fun and freedom of being perfectly "Smoothe" forever.

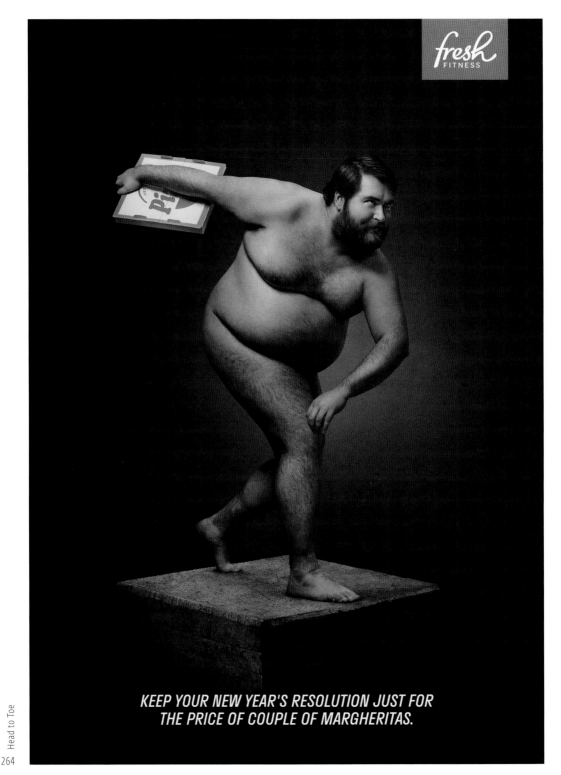

KEEP YOUR NEW YEAR'S RESOLUTION JUST FOR THE PRICE OF COUPLE OF MARGHERITAS.

The New Year's Resolution, Finland, 2017. **client**: Fresh Fitness, **cd/c**: Juuso Kalliala, **ad/p**: Miika Kumpulainen, **post production**: Kasimir Haivaoja. Fresh Fitness is a low price gym with edgy brand personality. This ad is a humorous comment on the New Year's resolution—and the cheap training.

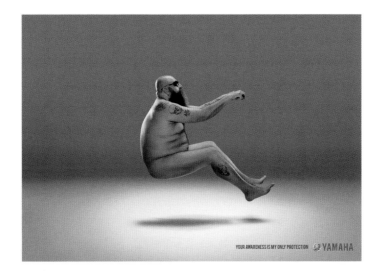

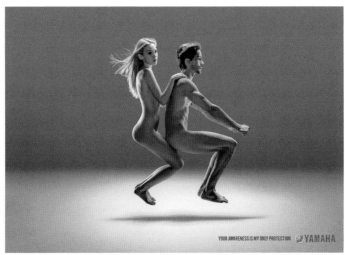

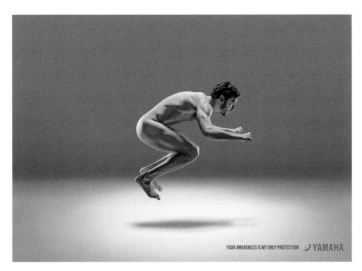

Naked, Mexico, 2016 **client**: Yamaha, **agency**: Archer Troy **cd**: Mike Arciniega, **ad**: Miguel Angel Suarez, **d**: Habacuc Guerrero, **c**: Joaquin Garcia, **p**: Gustavo Duenas. Social campaign for the awareness of vehicle drivers about the security of motorcyclists. Because of the loose driving culture, the motorcyclists are more exposed to injury without the protection of a motor vehicle.

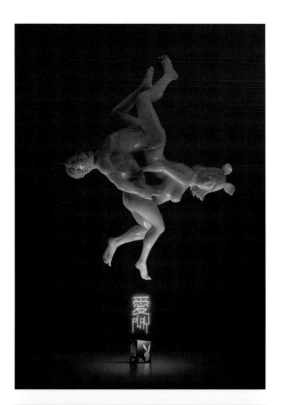

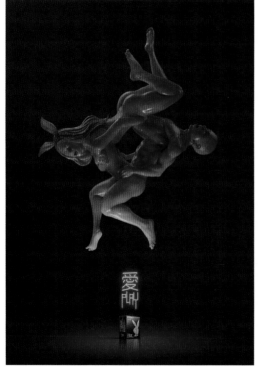

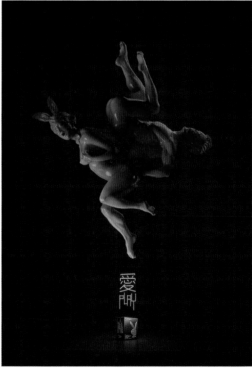

Love to Play, China, 2017. **client**: Playboy Condoms, **agency**: McGarryBowen Shanghai, **cd**: Danny Li, **ad**: Danny Li, Lucky Guo, Bingo Xu, **d**: Huangzong Duan, **c**: Yunzhuang Zhou, Sihan Jin, **i**: Illusion, Bangkok. These images were created for Playboy Condom's debut in the Chinese market. Based on the traditional Chinese mascot "Four-happiness doll."

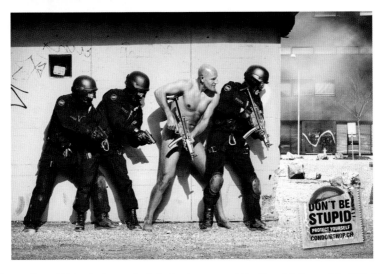

Don't Be Stupid, Protect Yourself, Switzerland, 2005. **client**: Condomshop, **agency**: Advico, Young & Rubicam, **cd**: Urs Schrepfer, Christian Bobst, **ad**: Christian Bobst, **c**: Jan Harbeck, **p**: Roger Schneider. Print campaign to advertise the use of condoms.

NO SHAME

Periods are nothing to be ashamed of. They're natural. And period products should be natural, too. Easy delivers 100% organic tampons and pads right to your door, because periods should be easier. Learn more at **easyperiod.ca**

easy.

Easy. "No Shame," Canada, 2016. **client**: Easy. (President / CEO: Alyssa Bertram), **agency**: Cossette, **cco**: Carlos Moreno, Peter Ignazi, **ad/d**: Natalie Mathers, **c**: Simon Rogers, **senior retoucher**: Trevor Gauthier, **producer**: Raquel Mullen, **account executive**: Dane Armstrong, **account supervisor**: Olivia Figliomeni, **VP, brand director**: Michelle Perez, **VP, strategy/planning**: Michaela Charette, **chief strategy officer**: Jason Chaney, **director, connection strategy**: Tim Beach, **communications supervisor**: Leigh Morgan, **p**: Chloë Ellingson, **makeup**: Lori Fabrizio, **media agency**: Newad.

NO SHAME

Periods are nothing to be ashamed of. They're natural. And period products should be natural, too. Easy delivers 100% organic tampons and pads right to your door, because periods should be easier. Learn more at **easyperiod.ca**

easy.

"Periods are nothing to be ashamed of. They're natural. And period products should be natural, too. Easy delivers 100% organic tampons and pads right to your door, because periods should be easier."

BODY P

The 1960s sexual revolution, like other social and cultural upheavals of the time, was politically transformative. The revolution was about radically changing mass behavior, but it began with underground imagery and design. What started in the 1930s and 1940s with "cheesecake" drawings and photographs of semi-naked women on pinup calendars, pulp novels, and tawdry magazines, evolved in the 1950s as a gateway to softcore nude depictions, which, in turn, gave way in the 1960s to more revealing, erotic, publicly displayed bodies often in sexual activity. That female nudity was the definition of sexual freedom was a dubious liberty.

On one hand, puritanical social taboos were loosening up. On the other, women were increasingly becoming commoditized objects of desire. The payoff of the sexual revolution may have been more power for women but the cost was more exploitation. Nonetheless, the battles against propriety were hard-fought and the result was more, although some might say excessive, amounts of sexual liberty, mostly in the form of nudity, and mostly female nudity, in media all over the world.

"Body Politic" shows how, for some arguably well-meaning, politically focused advertisers, the nude body was, in fact, used as a propaganda weapon. Obviously, some of these ads, including those for PETA (pages 272 to 275), employ female and some male nudity as a kind of Trojan horse. The naked individuals are sexy bait for the anti-animal cruelty messages that PETA is known for. While the editorial focus is to boycott the use of animal fur, there is also a come-hither sensuality that intensifies the concept more alluringly than if it were simply protestations about animal abuse. Of course, not all the ads are pleasant. In "Leather is a Rip Off" (page 275), the violent peeling of skin off the model's back, and in "Wearing Exotic Skins Kills" (page 275), the model on a blood-soaked floor, are not meant to titillate but rather vividly show through analogy that in no uncertain terms using animals for clothing is akin to the human experience. PETA's campaigns have been very effective as a one-two-knock-out punch of sensuality and violence.

The animal rights issue is not the only example of politics in the raw. The "Stop AIDS" ads (page 279) also employ the male and female bodies to show vulnerability to the disease. Through photographs showing naked people in sports—fencing and playing hockey—that require protective gear, the headline "No Action Without Protection" is further made vividly clear.

OLITIC

In the lusciously produced, "Colors of Love" (page 277) naked couples are painted with the flag colors of different nations. This political body painting trope celebrates "universal love, tolerance, and sexual diversity" without resorting to the more aggressive messaging found in an advertisement like "No Glove, No Love" (page 280). The job of the latter is to remind the public that condoms are essential to stem the rise of STIs in Cork, Ireland. Likewise the "Broadway Bares" ads (pages 281 to 283) use more overt imagery and typography to get its AIDS advocacy ideas into the public's face.

There is, in fact, an entire genre of AIDS prevention posters and ads in various parts of the world, from Holland to the Ukraine. Some of these use more subtle graphic and illustrative methods. "Button Up" and "Zip Up" (page 284) are witty ways of promoting abstinence. While "AIDS, The Killing Bite of Love" (page 285), shows a penis as a serpent, suggesting the horrific consequences of unprotected sex; the audience was secondary school children. This latter example is but one of many cautionary posters that attack AIDS head on. The most startling and unambiguous of these, "Don't Get Trapped" (page 287) memorably shows an open coffin in place of a vagina—a piece of dark humor to be certain. On the lighter, yet no

less serious, side "Endangered Butts" (page 294) is a cautionary reminder about colorectal cancer and "Are You Obsessed with the Right Things?" (page 294 and 295) are body-painting cartoons that address the calamities of an unhealthy body.

Breast cancer is an illness that cannot be treated too lightly, yet is handled in overt and covert ways. The "Beloved Bust" poster series (page 298) shows women who are shamelessly recovering from surgery. The photographs are bold and memorable. The "Stay Aware" campaign (page 299) is more subtle, but no less sobering for the receiver of the message.

Invariably, the most extreme, if not common, examples of the body politic are images that raise awareness of brutality against women. These messages for genital mutilation and various kinds of rape focus on the pubic area with images that must show violence and violation. The body can be a weapon and a victim; both are depicted here. Whether it is the symbolic wit of the "Female Genital Mutilation" posters (page 291), using cut up fruits, or the numerous painful razor blade depictions (page 292), the message is that sexual aggression is a political act and a crime against the entire body politic.

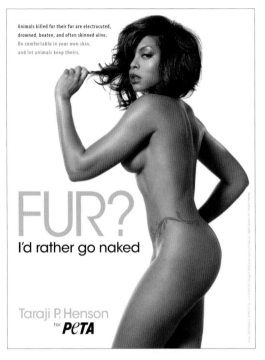

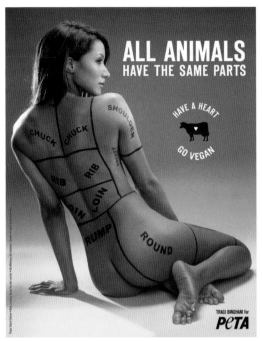

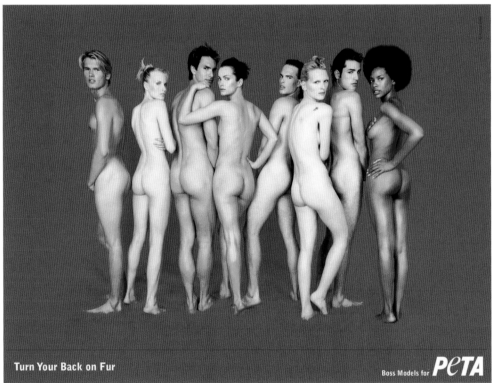

Turn Your Back on Fur

Boss Models for **PeTA**

Taraji P. Henson: Fur? I'd Rather Go Naked, USA, 2011. **ad/d/c**: PETA, **p**: Don Flood. Peta unveiled this provocative ad during NY Fashion Week.

Traci Bingham: All Animals Have the Same Parts, USA, 2008. **ad/d/c**: PETA, **p**: Robert Sebree. For this revealing ad, PETA launched the campaign focused on getting people to consider becoming vegetarians at a nightclub in New York City's meatpacking district.

Boss Models: Turn Your Back on Fur, USA, 1996. **ad/d/c**: PETA, **p**: Judson Baker. In 1996, Boss Models director Jason Kanner wrote a letter to PETA that said, "In addition to the many top models who support your anti-fur efforts, you can now add to your roster an entire modeling agency. To show our love and respect for animals, Boss Model Management will no longer provide models for print advertising, magazine / editorial work, catalogs, or runway shows featuring fur."

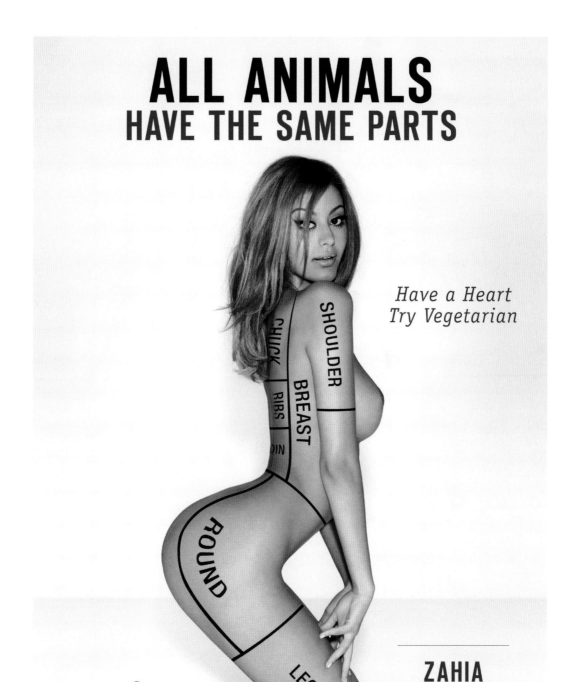

ALL ANIMALS
HAVE THE SAME PARTS

*Have a Heart
Try Vegetarian*

ZAHIA
by Bryan Adams for
PeTA

Zahia Dehar: All Animals Have the Same Parts, USA, 2015. **ad/d/c**: PETA **p**: Bryan Adams. Wearing nothing but bodypaint to mimic a butcher's diagram—and with her flesh marked "breast," "round," and "ribs"—luxury lingerie designer Zahia Dehar starred in PETA's "All Animals Have the Same Parts. Have a Heart—Try Vegetarian" ad, shot by musician and photographer Bryan Adams. Dehar partnered with PETA—whose motto reads, in part, that "animals are not ours to eat"—to remind everyone that animals are made of flesh, blood, and bone, just as humans are, and that they have the same five senses and experience the same range of emotions.

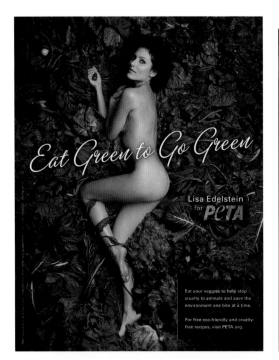

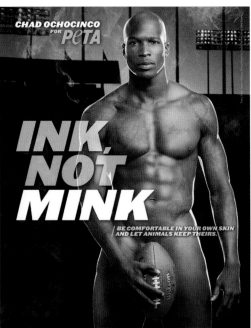

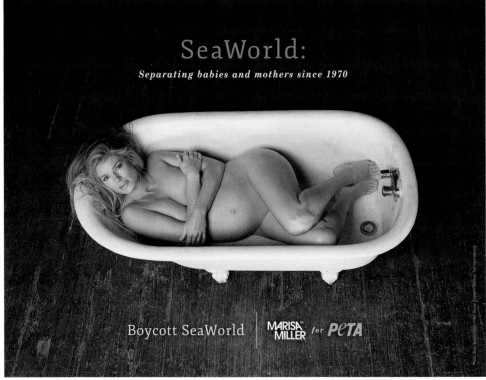

Lisa Edelstein: Eat Green to Go Green, USA, 2012. **ad/d/c**: PETA,
p: Jack Guy. Lying naked on a blanket of fresh green vegetables, actor Lisa
Edelstein posed in an ad urging people to "eat your veggies to help stop
cruelty to animals and save the environment one bite at a time."

Chad Ochocinco: Ink, Not Mink, USA, 2010. **ad/d/c**: PETA,
p: Robert Sebree. Using only a football to preserve his modesty, Chad
Ochocinco showed off his tattoos—and more—in a PETA ad proclaiming, "Ink,
Not Mink. Be Comfortable in Your Own Skin, and Let Animals Keep Theirs."

Marisa Miller: Boycott SeaWorld, USA, 2015. **ad/d/c**: PETA, **p**: Brian Bowen Smith. Posing in a bathtub, supermodel Marisa Miller—nude and pregnant
with her second child—put herself in the place of captive orcas at SeaWorld, who spend their lives in tiny concrete tanks, for an ad that proclaimed,
"SeaWorld: Separating Babies and Mothers Since 1970." Miller—who was due to give birth just a few weeks after the photo shoot—said, "Being a mom
and seeing Blackfish, it was extremely emotional. I think any mother knows the sense of protection and connection you have with your baby."

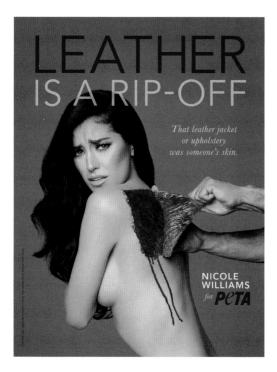

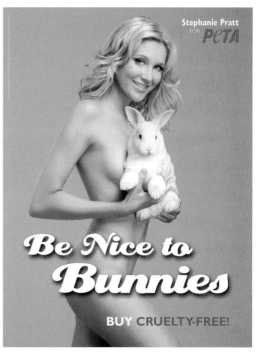

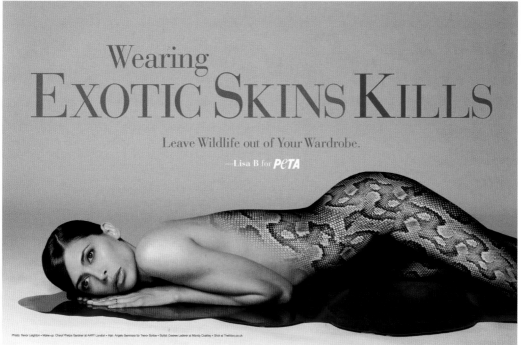

Nicole Williams: Leather Is a Rip-Off, USA, 2016. **ad/d/c**: PETA,
p: Mike Ruiz. Reality star Nicole Williams partnered with PETA to expose
the cruelty in leather production.

Stephanie Pratt: Be Nice to Bunnies, USA, 2010. **ad/d/c**: PETA,
p: Robert Sebree. The Hills star Stephanie Pratt was happy to bare her
buns to save bunnies for the cover of PETA's "Be Nice to Bunnies"
cruelty-free shopping app.

Lisa B: Wearing Exotic Skins Kills, USA, 2007. **ad/d/c**: PETA, **p**: Trevor Leighton. On the heels of fashion shows in London, Milan, New York, and
Paris, Lisa B unveiled her "Wearing Exotic Skins Kills—Leave Wildlife out of Your Wardrobe" ad in London to let people know that farmed alligators are
frequently beaten with hammers then skinned, and that it can take up to two hours for them to die. In addition, snakes are commonly nailed to a tree
and then skinned alive.

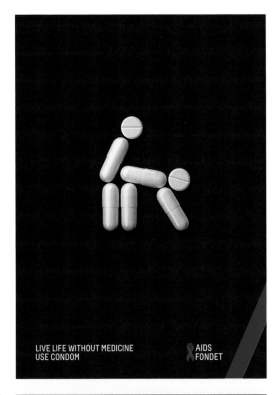

LIVE LIFE WITHOUT MEDICINE
USE CONDOM

AIDS
FONDET

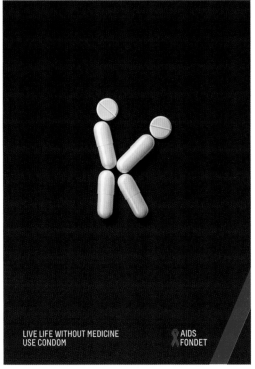

LIVE LIFE WITHOUT MEDICINE
USE CONDOM

AIDS
FONDET

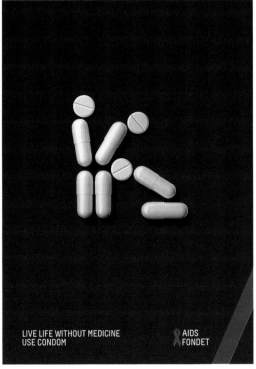

LIVE LIFE WITHOUT MEDICINE
USE CONDOM

AIDS
FONDET

From Behind, Doggy Style, Denmark, 2016. **client**: AIDS Fondet, **agency**: JWT Copenhagen, **cd**: Joachim Rosenstand, **ad**: Erik Dahlström,
c: Jan Sverker, **ill**: The Image Faculty. Danish AIDS Fondet wanted to raise awareness for gay men to use condoms when having sex, not only to avoid HIV
and other sexually transmitted diseases, but also to say that scare campaigns do not work according to tests and research. You may not die of HIV, but
people living with the disease take medication every single day. Live life without medicine. Use a condom.

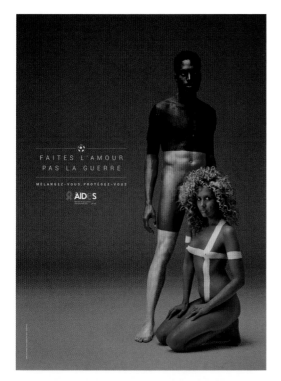

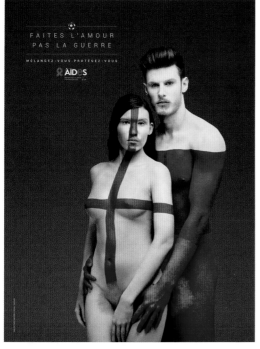

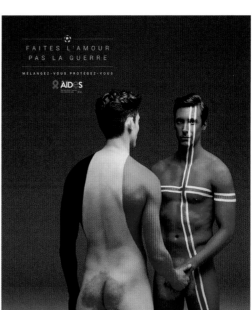

Colors of Love, France, 2016. **client**: AIDES ONG, **agency**: TBWA\Paris, **cd**: Benjamin Marchal, Faustin Claverie, **ad**: Olivier Mularski, **c**: David Philip, **p**: Eric Traoré. This campaign aims to celebrate universal love, tolerance, and sexual diversity during the European football cup—"Make Love, Not War."

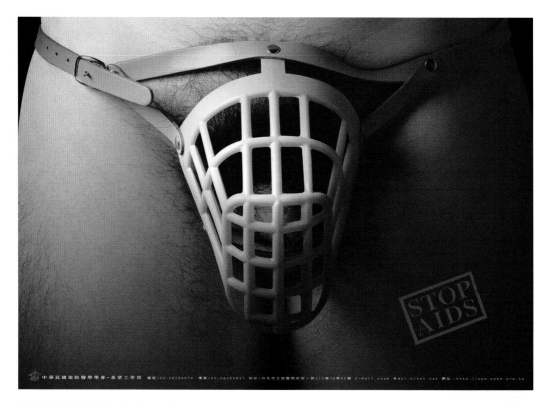

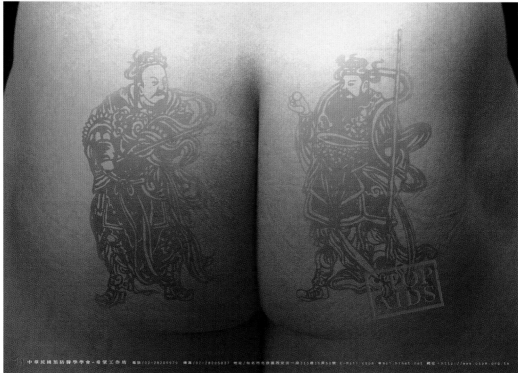

Stop AIDS [Dog Cage], Taiwan, 1999. **client**: Living with Hope Organization, **cd/d/ill/c**: Ken-tsai Lee. Living with Hope Organization is an AIDS awareness foundation based in Taiwan. People make their dogs wear muzzles when they take their dogs outside, because they worry that their dog will bark on the streets. In front of a penis, the muzzle means "don't make love with strangers when you go outside."

Stop AIDS [Door God], Taiwan, 1999. **client**: Living with Hope Organization, **cd/d/c/ill**: Ken-tsai Lee. Local visual language was used to create the images to promote the "Stop AIDS" campaign. The Chinese paint "God" on doors of their houses so that God will protect them. "God" was tattooed on people, meaning that God should protect them.

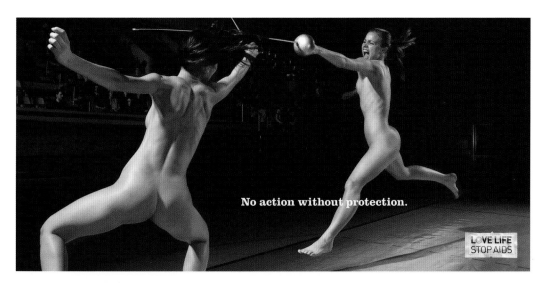

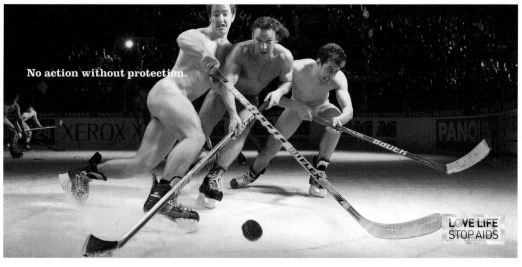

Love Life—Stop AIDS: Fencing, Hockey, Switzerland, 2006. **client**: BAG, Stop AIDS, **cd**: Frank Bodin, Petra Bottignole, **ad**: Dominik Oberwiler, Patrick Beeli, **c**: Serge Deville, **ill**: Daniel Burgisser, **p**: Finlay Mackay. The idea of self-protection is at the core of the creative strategy. The campaign depicts thrilling situations of daily life in which one would normally protect oneself. Self-protection should be as self-evident for sexual activity as it is in other situations, where protection is also a fundamental issue.

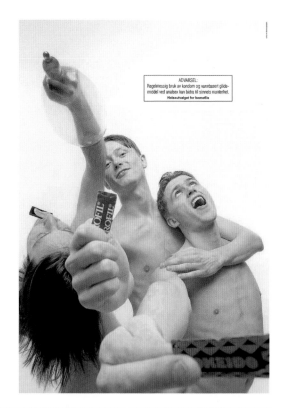

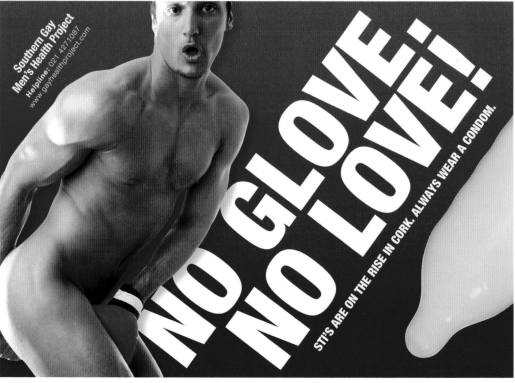

Advarsel (Warning), Norway, 1997. **client**: Gay and Lesbian Health Norway, **cd**: Gay and Lesbian Health Norway, **ad**: Arne-Harald Hanssen, **d**: Tron Hirsti, **p**: Fin Serck-Hanssen. Condom campaign for Gay and Lesbian Health Norway. A spoof on warnings found on Norwegian cigarettes.

No Glove, No Love, Ireland, 2016. **client**: Southern Gay Men's Health Project, **cd/ad/d/c**: Peter O'Toole. "This was pro bono work for 'Southern Gay Men's Health Project in Cork City, Ireland. The client approached me looking for a campaign which would stop people in their tracks and make them think about their sexual health."—Peter O'Toole

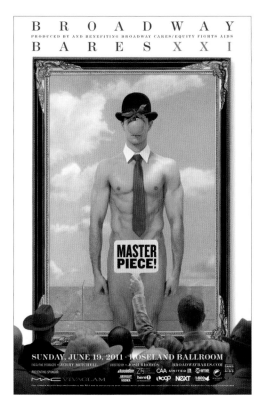
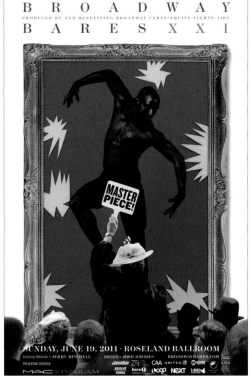
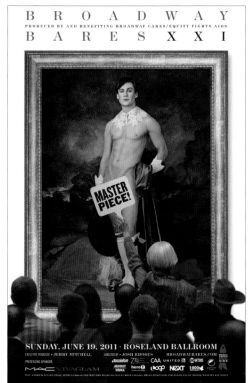
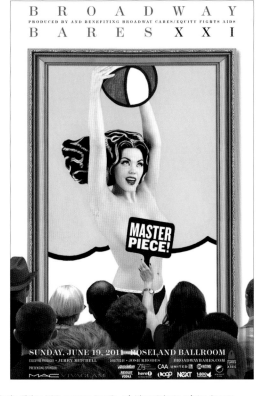

Broadway Bares XXI—Masterpiece, USA, 2011. **client**: Broadway Cares / Equity Fights AIDS, **agency**: SpotCo, **cd**: Vinny Sainato, **ad**: Jay Cooper, Darren Cox, **d**: Dan Forkin, **p**: Andrew Eccles, **rt**: Rob Kolb. "Bares XXI" features dancers from the Broadway community as famous works of art, each strategically covered by an art collector's auction card.

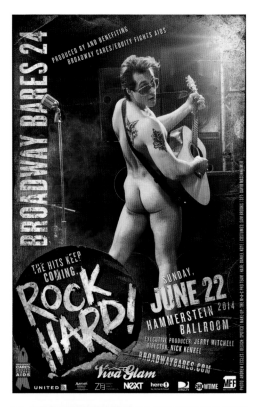

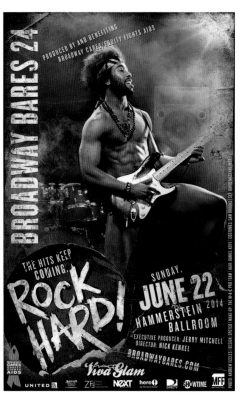

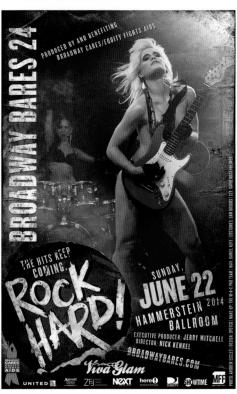

Broadway Bares XXIV–Rock Hard!, USA, 2014. **client**: Broadway Cares / Equity Fights AIDS, **agency**: SpotCo, **cd/ad/d**: Jacob Cooper,
p: Andrew Eccles, **rt**: Bill Schultz. "Bares XXIV" is a grungy send up to some of the most iconic musical acts of all time. The campaign features Broadway
dancers as 1: Elvis, 2: Heart, 3: Madonna, 4: Motley Crue, and 5: Jimi Hendrix.

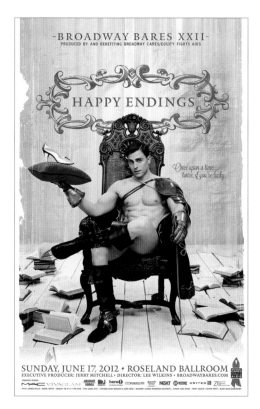

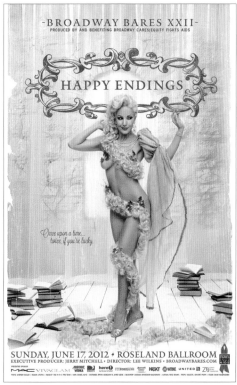

Broadway Bares XXII—Happy Endings, USA, 2012. **client**: Broadway Cares / Equity Fights AIDS, **agency**: SpotCo, **cd**: Vinny Sainato, **ad/d**: Jacob Cooper, **p**: Andrew Eccles, **rt**: Rob Kolb. "Bares XXII" features Broadway dancers as beloved fairy tale characters, with a naked twist.

Broadway Bares XVII—Myth Behavior, USA, 2007. **client**: Broadway Cares / Equity Fights AIDS, **agency**: SpotCo, **cd**: Vinny Sainato, **ad/d**: Jacob Cooper, **p**: Andrew Eccles, **rt**: Rob Kolb. "Bares XVII" features dancers from the Broadway community as subjects of Greek mythology, photographed in a soft, painterly style.

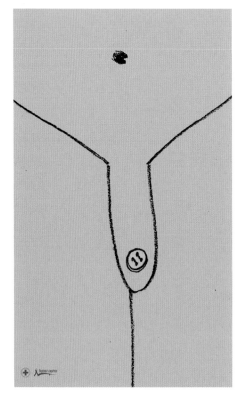

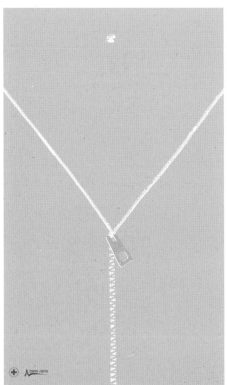

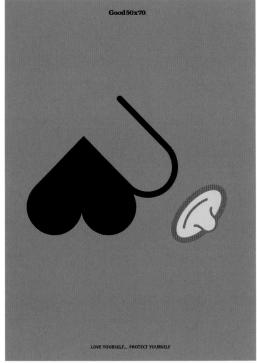

Button Up, USA, 2010. **client**: AntiAIDS Ukraine, **cd/d/ill**: Scott Laserow. AIDS awareness posters promoting abstinence among Ukrainian youth.

Zip Up, USA, 2010. **client**: AntiAIDS Ukraine, **cd/d/ill**: Scott Laserow. AIDS awareness posters promoting abstinence among Ukrainian youth.

AIDStop, Argentina, 2013. **client**: Centro de Diseño in Rosario, Argentina, **cd/d/c/ill**: Finn Nygaard.

Protect Yourself, 2008. **client**: Associazione Culturale Good Design, **cd/ad/d/c/ill**: Taber Calderon.

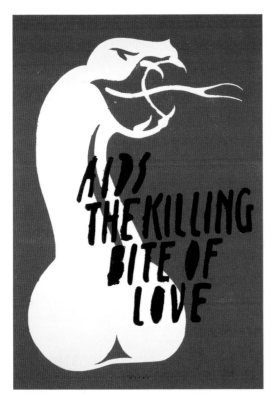

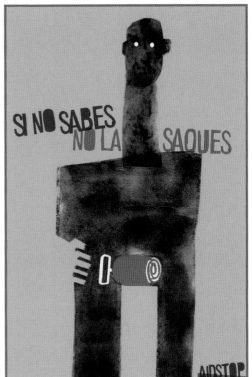

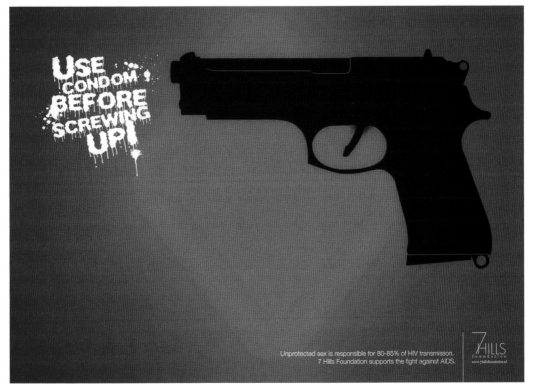

AIDS, The Killing Bite of Love, France, 1993. **client**: French government, **cd/d**: Anthon Beeke. This was commissioned by the French government to make the issue of AIDS clear to secondary-school children.

If you don't know how to use it, then don't put it out there, Bolivia, 2013. **client**: 14 BICM, **d/ill**: Frank Arbelo. Protection, education, consciousness.

Use Condom Before Screwing Up!, Turkey, 2011. **client**: 7 Hills Foundation, **studio**: THE Agency, **cd/ad/d**: Caglar Eser, **c**: Alper Pala. "We ascribed the trigger of a gun with a penis. We wanted to say that HIV is an issue for both men and women."—Caglar Eser

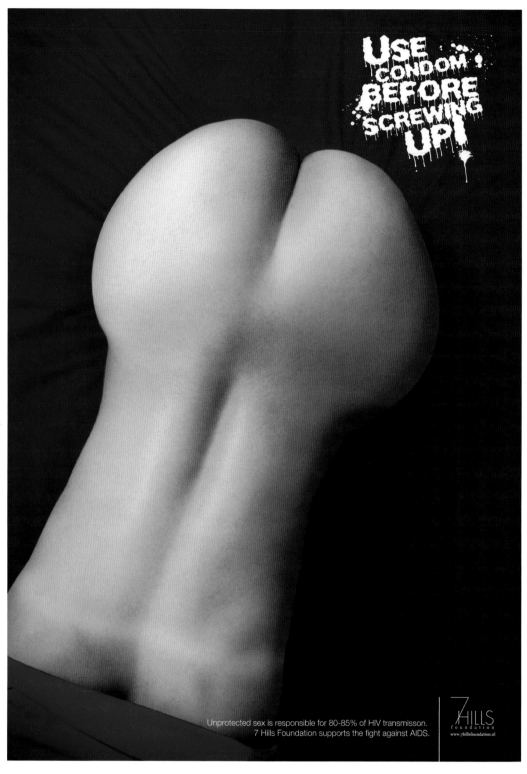

Use Condom Before Screwing Up!, Turkey, 2011. **client**: 7 Hills Foundation, **studio**: THE Agency, **cd/ad/d/ill**: Caglar Eser, **c**: Alper Pala, **p**: Serkan Sedele.
"We made a design with sexual appeal which also implies and emphasizes the idea that HIV transmits not only from a woman, but also from men."—Caglar Eser

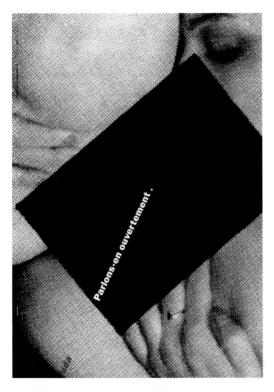

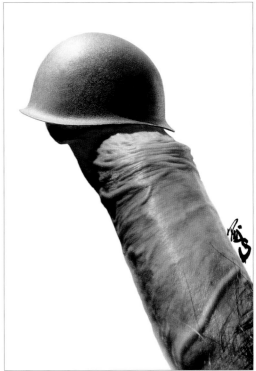

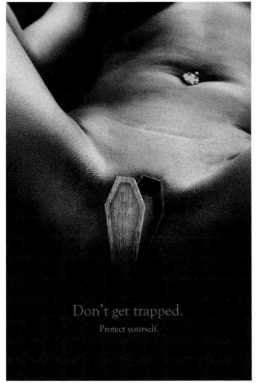

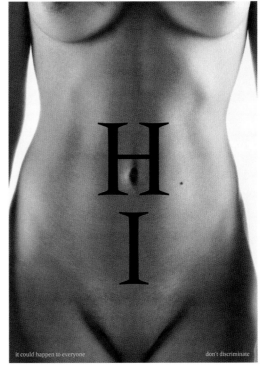

AIDS—Let's speak free about it, Germany, 1993. **client**: AFLS–French Association for the fight against AIDS, **d/c**: Uwe Loesch.

"Don't Get Trapped" Anti-AIDS Poster, Serbia, 2010. **client**: Chervona Strichka, Ukraine, **cd/d**: Kosta Rakićević. A poster raising awareness of the deadly consequences of AIDS, using a seductive aspect combined with terrifying grave images.

AIDS!, USA, 2003. **agency**: Fang Chen. The war against AIDS is literally depicted in this poster prompting awareness. The helmet, used as a visual metaphor, reminds us that war has casualties, but this image's strength lies in its deliberate provocation to discuss a subject too often ignored.

Don't Discriminate (HIV), Italy, 2009. **client**: LILA–Italian league for the fight against AIDS, **ad/d/c**: Andrea Castelletti, **p**: Matteo Engolli. A poster that communicates that being HIV positive is not a criminal offense. In fact, AIDS sufferers are discriminated against every day.

The Skull, France, 2001. **client**: AIDES ONG, **agency**: TBWA\Paris, **cd**: Erik Vervroegen, **ad**: Marianne Fonferrier, Stephanie Thomasson, **c**: Guilaine Degermon, Bertrand de Demandoxl, Mathieu Elraim, **p**: Eric Traoré. This campaign aims to remind people that HIV still kills, so it's important to keep using condoms.

Stoppa kvinnlig könsstympning. SMS:a AMNESTY till 72900 sM bidrar du med 50 kronor* till vMrt arbete för mänskliga rättigheter.

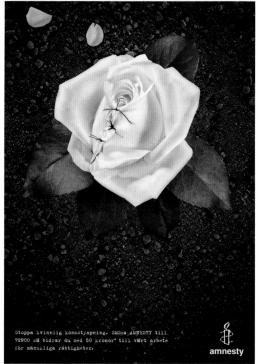

Stoppa kvinnlig könsstympning. SMS:a AMNESTY till 72900 sM bidrar du med 50 kronor* till vMrt arbete för mänskliga rättigheter.

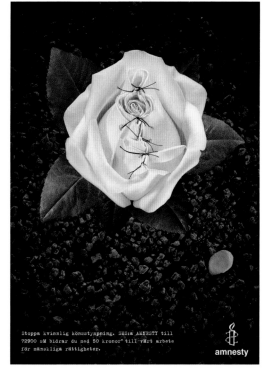

Stoppa kvinnlig könsstympning. SMS:a AMNESTY till 72900 sM bidrar du med 50 kronor* till vMrt arbete för mänskliga rättigheter.

Swedish Amnesty: Rose, Sweden, 2008. **client**: Amnesty International, **Studio**: Volontaire, **ad/d**: Yasin Lekorchi, **c**: Malin Åkersten, **p**: Niklas Alm.
These posters were created for Amnesty International to use for free, in a worldwide campaign against female genital mutilation (FGM).

290

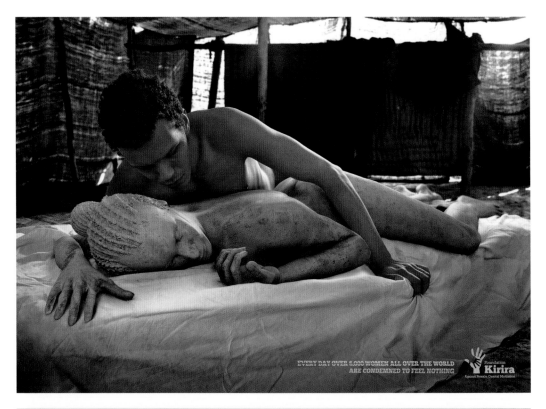

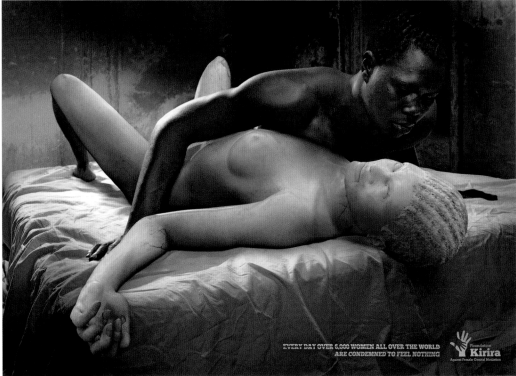

Bronze Woman / Ivory Woman, Spain, March 2012. **client**: Kirira Foundation, **agency**: ContrapuntaBBDO, **cd**: Carlos De Javier, **ad/d**: Carles Nuñez, **c**: Patricio Marrone, **p**: Carles Nin, **c.g. composer/rt**: Lucas Pióciacampo. Female genital mutilation is still a painful common practice in many countries. Spain is not an exception. Kirira, a Spain-based foundation created by women who suffered genital mutilation, commissioned this campaign to raise awareness for the problem among the African community in Spain.

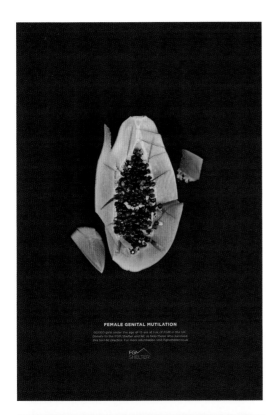

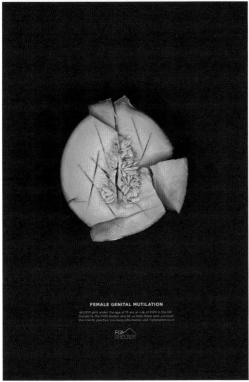

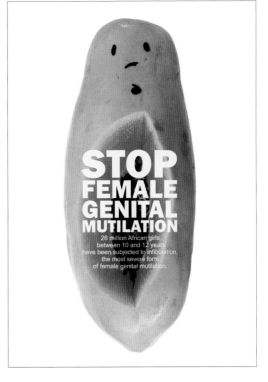

Female Genital Mutilation, London, 2015. **client**: Creative Conscience Awards, **cd/ad/d/c/ill/p**: Fatma Al Mansoury. "Female genital mutilation is a very serious cause, and a grotesque practice. Because it is a difficult topic to talk about, it is easy to look past. I wanted to create something that demonstrates the topic in a digestible way."—Fatima Al Mansoury

Stop Female Genital Mutilation, Mexico, July 2009. **client**: Amarillo Centro de Diseño, **studio**: Yomi Yomi Studio, **ad/d/ill/p**: Elmer Sosa. Poster designed to demonstrate abuse of African girls, who were victims of female infibulation.

Every 11 seconds,
a girl or a young woman
is victim to Female Genital Mutilation

EVERY 11 SECONDS,
A GIRL OR A YOUNG WOMAN
IS VICTIM TO GENITAL MUTILATION

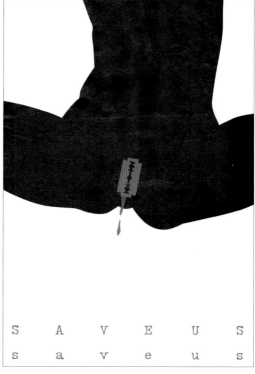

FGM, May 2015. **client**: N/A, **d/ill/p**: Winston Elliott. This was designed with the intention of bringing awareness to female genital mutilation. Most people are unaware of such a harsh practice and tradition. One version is jarring and almost visceral while the other is symbolic.

Pornography, Severni Bunker magazine nr. 21 cover, Serbia, 2013. **client**: Cultural Centre Kikinda, **cd/c**: Srđan Tešin, **ad/d/ill**: Mila Melank. *Severni Bunker* (North Bunker) was a magazine of culture and literature, published by the weekly newspaper *Kikindske*, and later by the Cultural Center.

Save Us, Poland, 2007. **client**: Good 50x70 Poster Collection, **d**: Weronika Kowalska. This poster touches on the problem of violence against women. It is part of the Good 50x70 Poster Collection exhibited in Sweden, Italy, and, the USA.

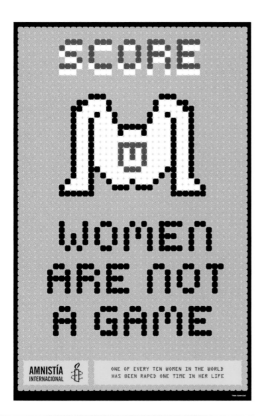

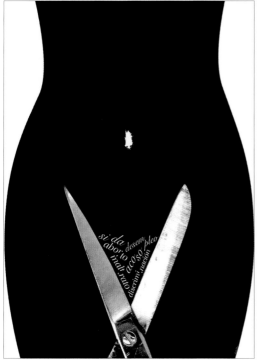

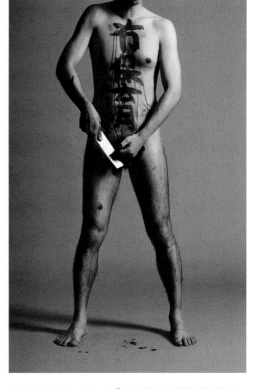

Score—Women are not a game, Mexico, 2006. **client**: Amnistia Inernacional, **d/ill**: Yann Legendre. The image was part of a large campaign to raise awareness for a young generation about rape.

Against violence to woman, Mexico, 2000. **client**: self-initiated. **ad/ill/p**: Lourdes Zolezzi. A personal project focusing on AIDS, abortion, unemployment, discrimination, harassment, and other issues effecting women.

Stop FGM, Germany, 2012. **studio**: Studiokonter, **d**: Michelle Flunger, **font provided by**: Hubert Jocham. A poster aimed at stopping the practice of FGM or female genital mutilation.

Moyouk (Castrated Culture), Hong Kong, 2008.
client: Jiuu Group of Creatives, **cd**: Brian Lau, **ad**: Brian Lau, Lilian Chan, Jonas Lillie, **d**: Brian Lau, **p**: Jonas Lillie. Protesting the destruction of local cultural artifacts. *Moyouk* means a destroying of the future when we destroy out past.

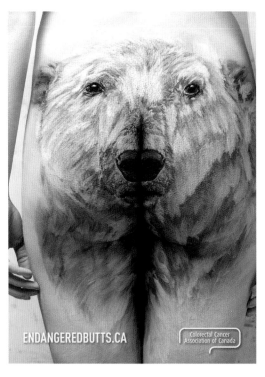

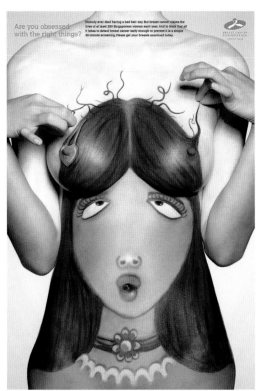

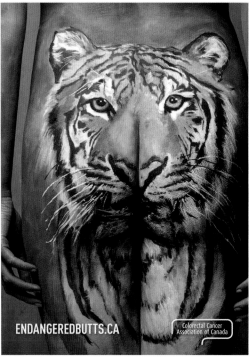

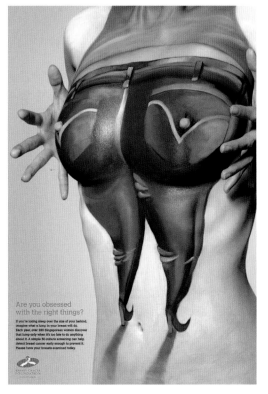

Endangered Butts.ca, Canada, 2015. **client**: Colorectal Cancer
Association of Canada, **agency**: Ogilvy, Montreal, **cd**: Martin Gosselin,
Gavin Drummond, Bernardo Andrada, **ad**: Bernardo Andrada,
c: Gavin Drummond, **ill**: Nicole Dunbar (makeup), **p**: Jorge Camarotti.
On the occasion of Colorectal Cancer Awareness month, the Association
(CCC) launched a campaign that draws a parallel with species facing
the threat of extinction.

Obsessions, Singapore, 2012. **client**: Breast Cancer Foundation,
agency: DDB Singapore, **cd/ad**: Thomas Yang, **ad/d**: Andrea Kuo,
c: Khairul Modzi, **ill**: Andy Yang, **p**: Allan Ng (Republic Studio).

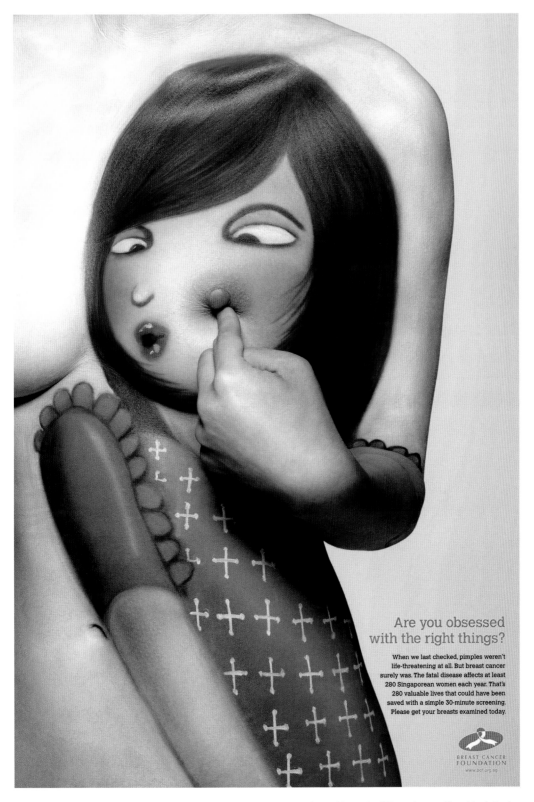

Are you obsessed
with the right things?

When we last checked, pimples weren't
life-threatening at all. But breast cancer
surely was. The fatal disease affects at least
280 Singaporean women each year. That's
280 valuable lives that could have been
saved with a simple 30-minute screening.
Please get your breasts examined today.

BREAST CANCER
FOUNDATION
www.bcf.org.sg

Women spend more time worrying about trivial things like hair and skin than on issues that could mean the difference between life and death. Bearing this in mind, the creative execution took a novel approach—body painting—where life's little things were beautifully illustrated on a model's upper torso using Kryolan grease paint.

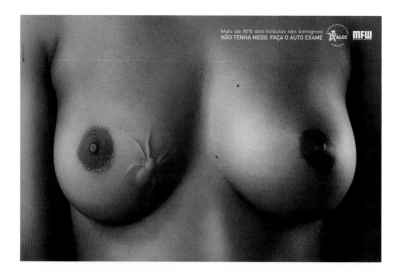

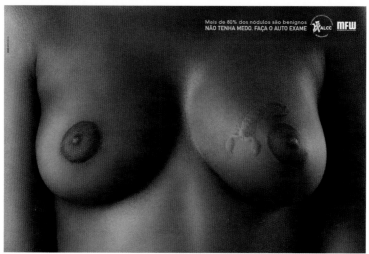

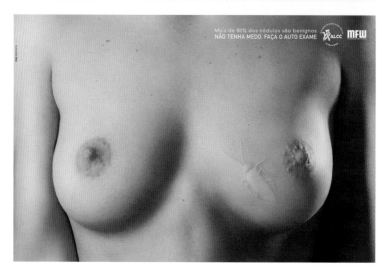

Scorpion / Spider / Cockroach, Mozambique, 2007. **client**: ALCC & Mozambique Fashion Week, **agency**: DDB Mozambique, **cd**: Lenilson Lima, **ad/d**: Victor Holanda, **c**: Cauby Tavares, **p**: Estudio Paredes. Mozambique Fashion Week teamed up with ALCC for a fight against breast cancer. The campaign's goal was to demystify the disease, reducing the fear of female self-examination and helping contribute to early diagnosis. "A poll said 80 percent of nodules found in breasts are benign. Thus, we could tell the target that there are no grounds for fear of self-examination because even with a lump in the breasts, the chances of it being malignant are small. In this scenario, we made a visual comparison between the nodule and animals that usually frighten women."–Victor Holanda

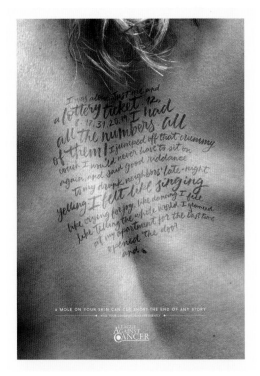

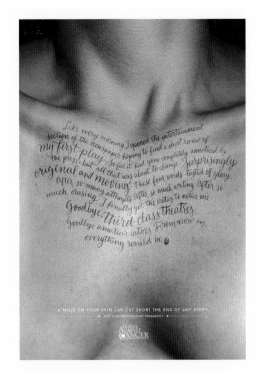

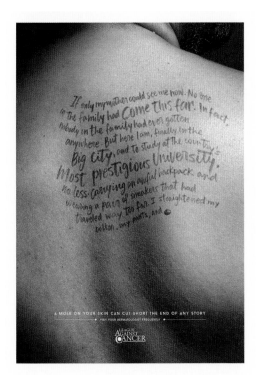

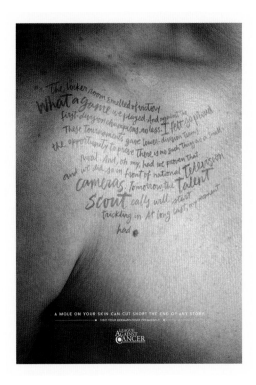

Skins, Peru, 2015. **client**: Liga Peruana De Lucha Contra El Cancer, **studio**: Y&R Lima, **cd**: Tin Sanchez, Fernando Iyo, **ad**: Edher Espinoza, **ad/d**: Jorge Rocca, **c**: Seco Cuenca, Nonoy Magga, **p**: Alex Freundt, **typographer**: Lucia Nolasco. Print campaign showing successful stories being abruptly ended by a mole, symbolizing skin cancer.

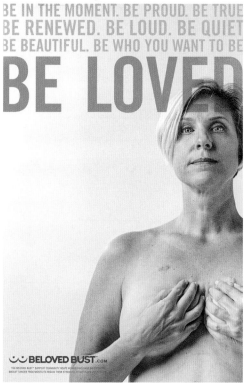

Komen Italia Onlus Breast Cancer Awareness Campaign, Italy, 2008.
client: Komen Italia Onlus, **studio**: LS&Blue SRL, **ad**: Simone Santese,
c: Daniele Papa. Komen Italia Onlus commissioned this print advertisement
encouraging readers to donate funds for breast cancer prevention.

Beloved Bust Poster Series, September 2016. **client**: Beloved Bust, **cd/ad/d/c**: Lynn Ullman, **p**: Brian Cummings, **producers**: Amanda Bjornson &
Melissa Russell. A poster series to promote Beloved Bust, a support community for women recovering from breast cancer surgery. Beloved Bust provides
community support, hands on manual therapy and instruction.

Make Pink Lemonade, USA, October 2015. **client**: HealthAwareNext, **studio**: The Bloc, **cd**: Elizabeth Elfenbein, **ad/d**: Lucy Tomkiewicz,
c: Benjamin Birdie, **p**: Dan Wittaman. A fresh take for October's Breast Cancer Awareness Month, a cause that has seen widespread adoption
by mass media and popular culture. The campaign was part of The Bloc's monthly disease awareness initiative #HealthAwareNext.

Stay Aware—Breast Cancer Awareness, USA, 2015. **client**: Breast Cancer Awareness, **cd**: Saxon Campbell. October is Breast Cancer Awareness
Month, which is an annual campaign to increase awareness of the disease. This campaign delivers the message to stay aware not only in the month
of October, but always.

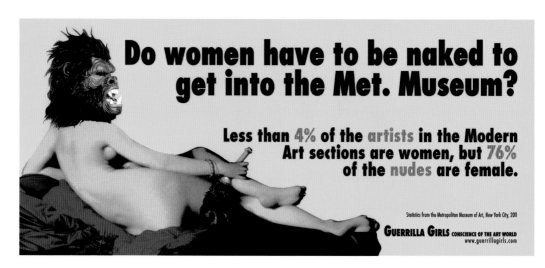

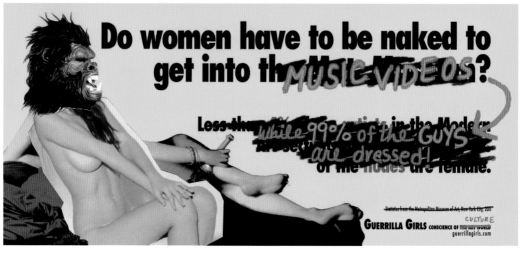

Do women have to be naked to get into the Met. Museum?, USA, 2012. **cd**: Guerrilla Girls. "This is an update of a poster we first made in 1989. Asked to design a billboard for the Public Art Fund in New York, we welcomed the chance to do something that would appeal to a general audience. We conducted a 'weenie count' at the Metropolitan Museum of Art in New York, comparing the number of nude males to nude females in the artworks on display. The results were very 'revealing'—as much so today as when we did our first count."—Guerrilla Girls spokesperson

Do women have to be naked to get into music videos?, USA, 2014. **client**: Made for the exhibition "GIRL" curated by Pharrell Williams at Galerie Perrotin, Paris, **cd**: Guerrilla Girls. "After watching a lot of videos we had a question for Pharrell: Why do women have to be naked to get into music videos while 99% of the guys are dressed? We did a remix of one of our classic posters with a still from Robin Thicke's 'Blurred Lines'."—Guerrilla Girls spokesperson

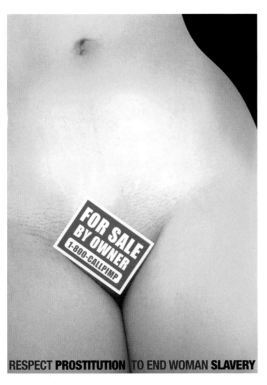

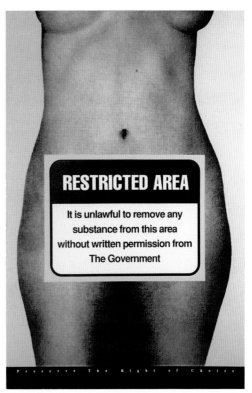

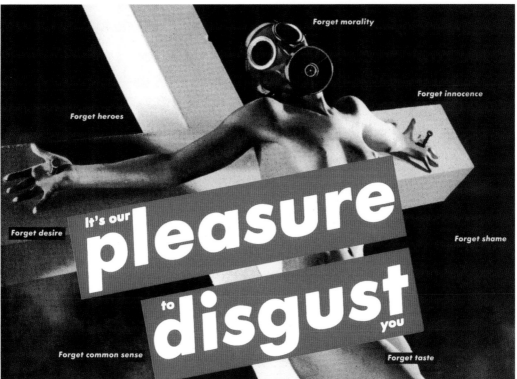

For Sale, Mexico, 2007. **client**: LILA / Good 50x70, **cd/d**: Natalia Delgado. The poster was created for LILA (Italian League for the Fight Against AIDS) as part of the international poster competition Good 50x70. The brief addressed the importance of the legalization of prostitution in the fight against AIDS.

Restricted Area: Preserve the Right of Choice, USA, 1992. **cd**: Trudy L. Cole. This poster was designed to emphasize that a woman has the exclusive right to decide what she does with her own body.

Untitled (It's Our Pleasure to Disgust You), USA, 1991. **d**: Barbara Kruger. Billboard.

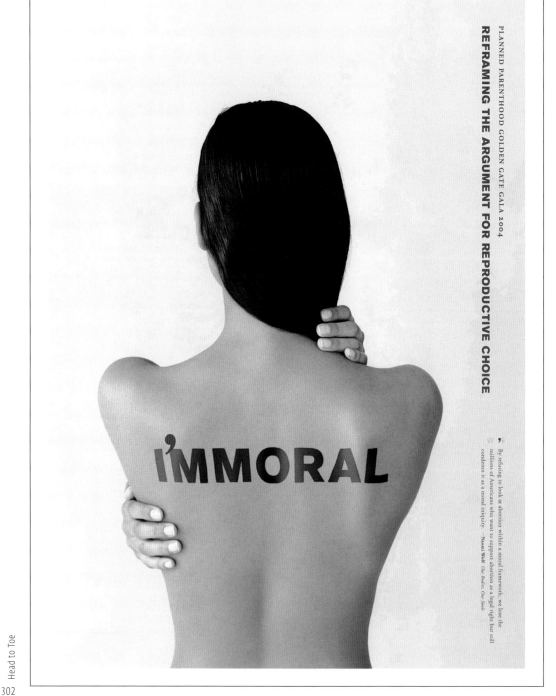

PLANNED PARENTHOOD GOLDEN GATE GALA 2004

REFRAMING THE ARGUMENT FOR REPRODUCTIVE CHOICE

By refusing to look at abortion within a moral framework, we lose the millions of Americans who want to support abortion as a legal right but still condemn it as a moral iniquity. —*Naomi Wolf, Our Bodies, Our Souls*

I'mmoral USA, 2004. **client**: Planned Parenthood, **ad/d**: AddisGroup, John Creson, Monic Schlaug. For this poster announcing the "reframing the Argument for Reproductive Choice" gala, an apostrophe was added to change the meaning of the tattooed word immoral to "I'm moral." The image also evokes *The Scarlet Letter* and the pain felt by a stigmatized woman.

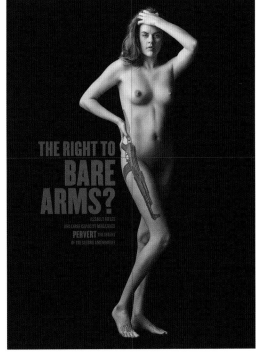

Humans Are Sponges, USA, January 2015. **client**: HealthAwareNext, **studio**: The Bloc, **cd**: Elizabeth Elfenbein, **ad/d**: Marc Law, **c**: Conchita Funcia, **p**: Dan Wittaman. Poster intended to educate about the powerful life-saving benefits of preventative vaccines.

Nothing to Hide, Denmark, 2013. **cd/ad/d/c/p**: Erika Stanley, **model**: John Erik Wagner. A very unique campaign poster.

The right to BARE ARMS?, USA, 2016. **client**: Donald Miller, **cd/ad/d/c/p**: Donald Miller, **d**: Eric Heintz. A visual depiction of the moral outrage over the use of military hardware in a civilian marketplace.

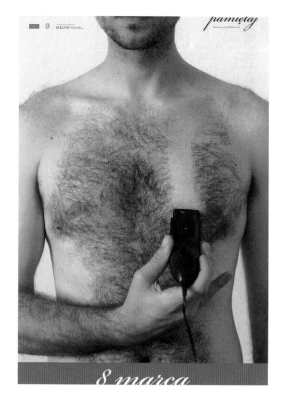

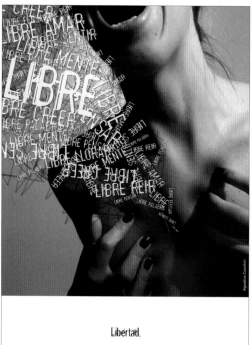

Libertad.

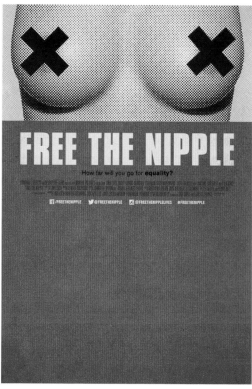

Freedom, Argentina, 2009. **client**: The International Poster Biennial in Mexico, **d/p/model**: Agustina Cosulich. Poster designed for the International Poster Biennial in Mexico. This poster ponders the idea of inner freedom.

8th of March, REMEMBER!, Poland, 2008. **client**: Ministry of Culture and National Heritage, **cd/ad/d/c/ill/p**: Stephan Lechwar. Inspired by the poster of Wladyslaw Pluta dedicated to International Women's Day. This poster is a virile gesture of solidarity toward contemporary women.

Free the Nipple, USA, December 2012. **client**: IFC, **studio**: Gravillis Inc, **cd**: Kenny Gravillis, **ad**: Jed Ramos Poster for a documentary based on a gender equality campaign. It follows a group of women, who take to the streets of New York City to protest.

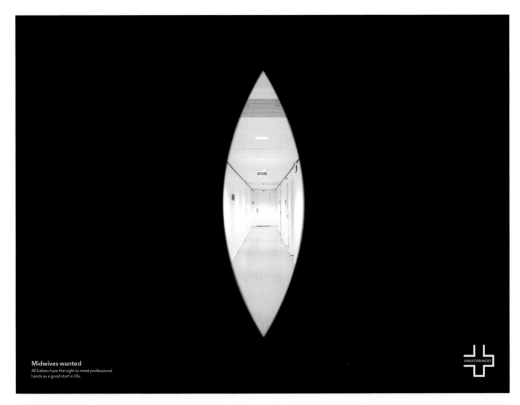

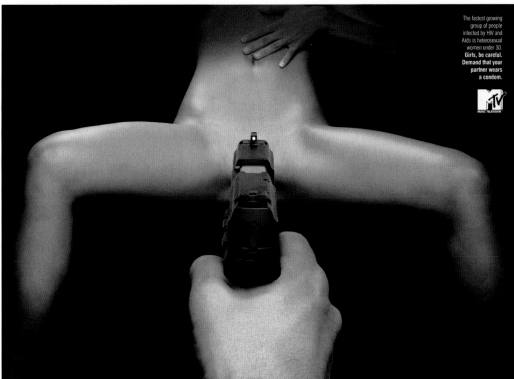

Midwives Wanted, Sweden, 2013. **client**: Vårdförbundet, **agency**: FamiljenPangea, **cd**: Marcus Enström, **ad**: Niklas Ackerstedt, **c**: Pontus Holmgren. The unfair working conditions for midwives and nurses in our country must change. More babies are born, but the professional hands of midwives are often missing.

Shot-Woman, Portugal, 2006. **client**: MTV, **agency**: Ogilvy, Portugal, **cd**: Edson Athayde, **ad**: Maria Amorim, **c**: Edson Athayde, **p**: Claus Stellfed. This piece was part of a worldwide campaign from Ogilvy Europe for MTV about AIDS and one of its most concerning at-risk groups: young women.

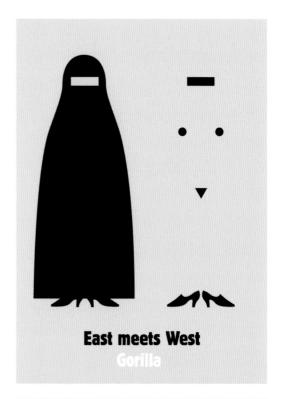

East meets West
Gorilla

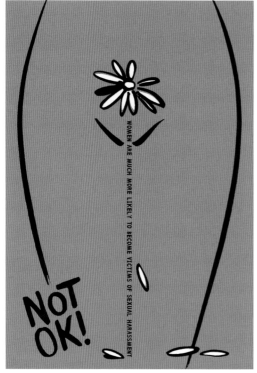

WOMEN ARE MUCH MORE LIKELY TO BECOME VICTIMS OF SEXUAL HARASSMENT

NOT OK!

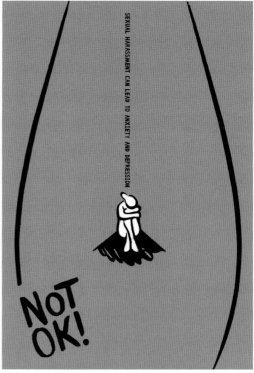

SEXUAL HARASSMENT CAN LEAD TO ANXIETY AND DEPRESSION

NOT OK!

Head to Toe

East Meets West, The Neatherlands, 2009. **client**: De Groene Amsterdammer, **cd**: The Gorilla Collective, **d/c/ill**: Lesley Moore. The Gorilla Collective creates visual commentary on current affairs. This poster is a comment on the clash between Western and Muslim culture.

NOT OK! Campaign Against Sexual Harassment, Hungary, 2016. **client**: Hungarian University of Fine Arts and Eötvös Loránd University, **d**: Anna Gizella. Sexual harassment is still a major issue at Hungarian universities, and it mostly happens to girls. The campaign titled "NOT O.K.!" makes the educational institutions aware of this problem and of their duty to provide a safe environment for students.

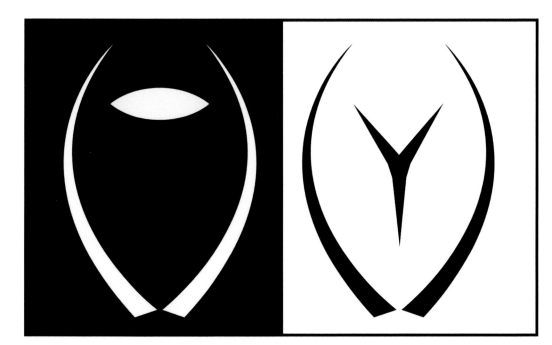

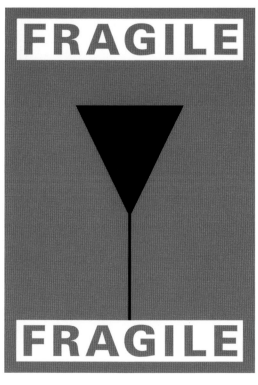

Prejudice Poster Design, UK, 2013. **client**: UAL–London College of Communication, **cd/ad/d/c/ill**: Laris Polat. A logo / poster design made to motivate the women of Turkey not to judge each other by their appearances.

Fragile, Germany, 1996. **client**: FriedensHaus, Berlin, **cd/ad/d/ill**: Lex Drewinski. Social protest poster targeting men's violence against women.

The Daily Gorilla: International Women's Day, The Netherlands, 2009. **client**: de Volkskrant, **studio**: De Designpolitie, **cd/ill**: Richard van der Laken, Pepijn Zurburg. The Daily Gorilla is a visual commentary on current affairs.

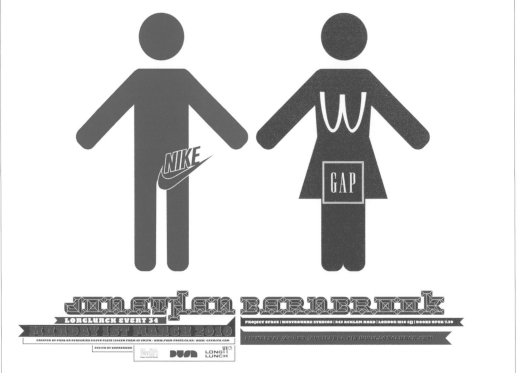

Head to Toe

G13 Dump, South Africa (exhibited in France), 2008.
client: Saint-Étienne International Design Biennale 2008,
cd/ad/d/c/ill/p: Garth Walker. International designer working around
the theme of "How Africa will see France in the year 2036."

Long Lunch Poster, UK, 2010. **client**: Long Lunch Lecture Series, **d/c**: Jonathan Barnbrook. This poster highlights the way brands are at the center
of all kinds of identity, such as gender or attractiveness to the opposite sex.

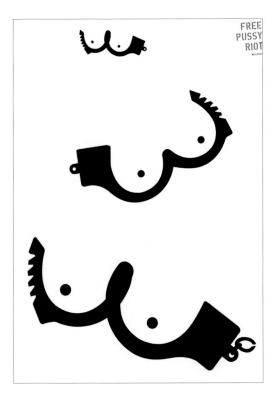

Free Pussy Riot, Germany, 2013. **client**: FriedensHaus, Berlin, **cd/ad/d/ill**: Lex Drewinski. A poster supporting Russian band Pussy Riot, whose members were arrested after performing of an anti-Putin song.

Political and Social Engagement, France, 2003. **client**: Chaumont International Poster Festival, **cd/ad/d/ill**: Atelier Nous Travaillons Ensemble. In France you use "2 mamelles de la Republique," (the 2 breasts of the Republic) to talk about things, events, and facts that are related.

Internet Pornography, China, 2015. **client**: Public Service Advertising Nesco CTTY of Design (Shenzhen China) Competition, **cd/d/c/ill**: Yin Zhongjun. There is no doubt that adolescents and children become the biggest victim of global Internet pornography!

Every Two Days in 2010 France a Woman is Beaten by Her Partner, France, 2015. **client**: La Forge, **cd/ad/d/ill**: Atelier Nous Travaillons Ensemble.

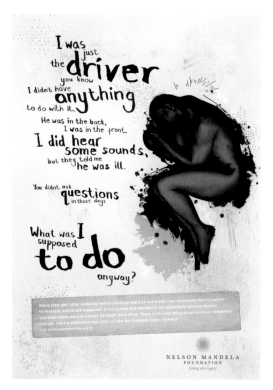

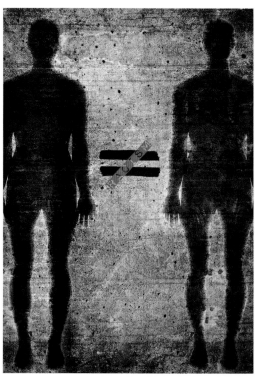

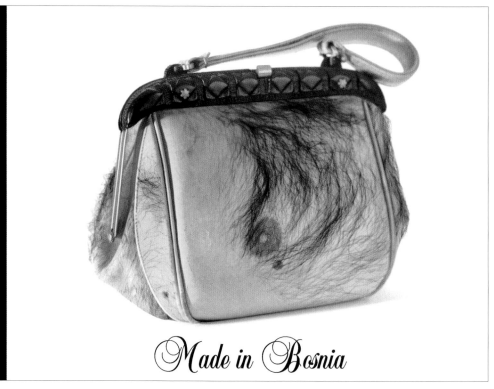

Made in Bosnia

Biko, South Africa, 2010. **client**: The Nelson Mandela Foundation, **agency**: Grey Africa, **cd**: Catherine Ireland, **ad/d/ill**: Kyra Antrobus, **c**: Annette de Klerk. This image forms part of a youth awareness campaign for the Nelson Mandela Foundation.

Not Equal, Germany, 2016. **client**: Plakat-Sozial platform (3rd International Leipzig Poster Exhibition), **cd/ad/d/ill**: Mario Fuentes. Racism is the stigma that makes us believe we are different.

Association for Saving Humans (from poster series, **Made in Bosnia**), Bosnia & Herzegovina, 1994 (remake 1997). **client**: Appeal Poster, **cd/ad/d/c/p**: Anur Hadžiomerspahić. Awareness raising poster juxtaposing animal rights activism with indifference towards the carnage of humans.

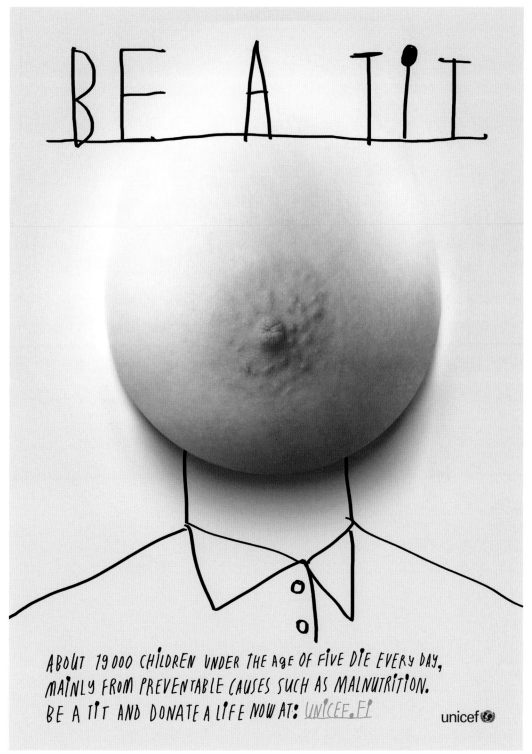

ABOUT 19000 CHILDREN UNDER THE AGE OF FIVE DIE EVERY DAY, MAINLY FROM PREVENTABLE CAUSES SUCH AS MALNUTRITION. BE A TIT AND DONATE A LIFE NOW AT: UNICEF.FI

unicef

Be a Tit, Finland, 2014. **client**: UNICEF, **cd**: Kiia Beilinson. This poster was created for an international UNICEF poster competition about reducing child mortality, and was chosen as the winning poster.

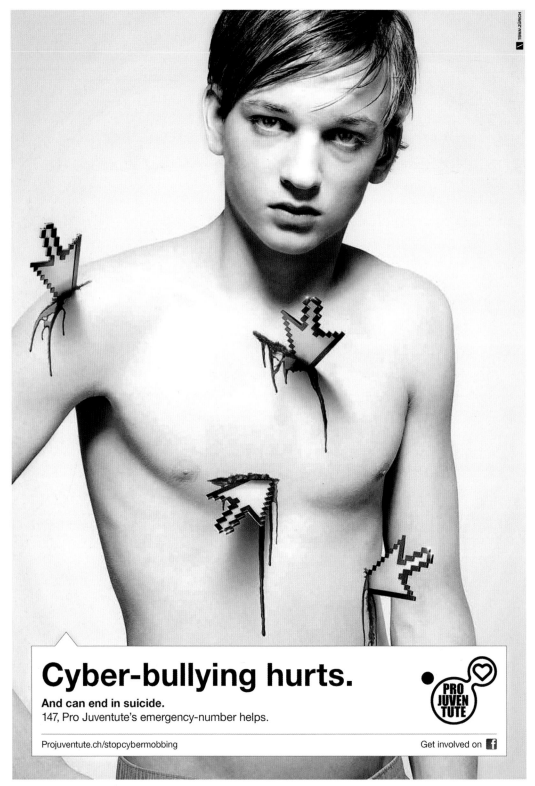

Cyber-bullying hurts., Switzerland, 2012. **client**: Pro Juventute, **agency**: TBWA\Switzerland AG, **ad**: Frederick Rossmann, Johannes Dörig, Barney Rees, Samuel Wicki, **d**: Matthias Kiess, Marion Schlatter, **p**: Mert Dürümoglu. Pro Juventute launched the first national campaign on cyberbullying in Switzerland. The goal was to raise awareness among young people about their online environment. A survey shows urgent need for information: two-thirds of respondents do not know where to get help.